The Guide to Kansas Birds

AND BIRDING HOT SPOTS

WATE

OTHE

WADING BIRDS

SHOREBIRDS

GULLS & TERNS

UPLAND GAME BIRDS

DIURNAL RAPTORS

OWLS & NIGHTJARS

DOVES & CUCKOOS

WOODPECKERS & KINGFISHERS

AERIALISTS

INSECT CATCHERS

WARBLERS

SMALL ACTIVE SONGBIRDS

THRUSHES & OTHERS

GROUND DWELLERS & SPARROWS

BLACKBIRDS, CORVIDS, & ALLIES

COLORFUL SONGBIRDS

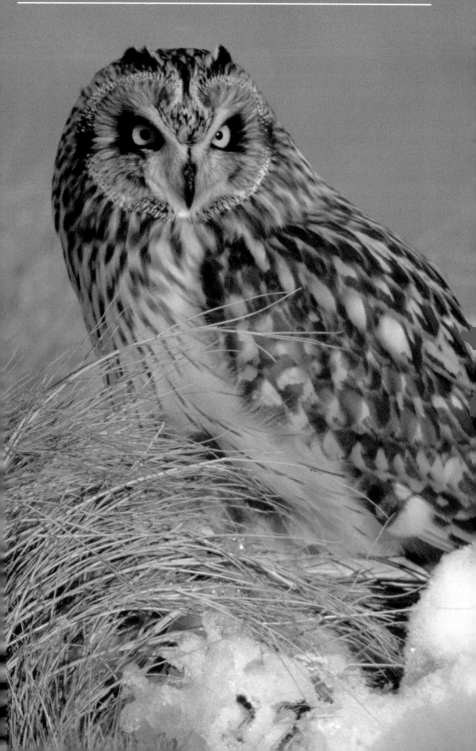

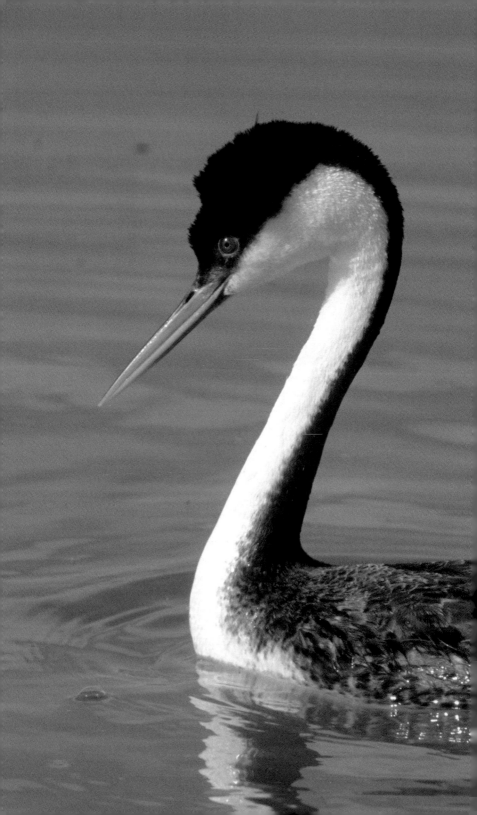

The Guide to
Kansas Birds
and
Birding Hot Spots

BOB GRESS AND PETE JANZEN

Foreword by KENN KAUFMAN

Good Birding !

Bob Gress

 University Press of Kansas

Publication made possible, in part, by a gift from the
Westar Energy Green Team

Published by the University Press of Kansas (Lawrence, Kansas 66045), which was
organized by the Kansas Board of Regents and is operated and funded by Emporia
State University, Fort Hays State University, Kansas State University, Pittsburg State
University, the University of Kansas, and Wichita State University

Library of Congress Cataloging-in-Publication Data
Gress, Bob.
The guide to Kansas birds and birding hot spots / Bob Gress and Pete Janzen.
p. cm.
Includes index.
ISBN 978-0-7006-1565-0 (pbk. : alk. paper)
1. Birds—Kansas—Identification. 2. Bird watching—Kansas—Guidebooks.
3. Kansas—Guidebooks. I. Janzen, Pete. II. Title.
QL684.K2G74 2008
598.09781—dc22
2007040486

Printed in China

10 9 8 7 6 5 4 3 2 1

The paper used in this publication meets the minimum requirements of the American
National Standard for Permanence of Paper for Printed Library Materials Z39.48-1992.

Contents

BLACKBIRDS, CORVIDS, & ALLIES

COLORFUL SONGBIRDS

KANSAS BIRDING HOT SPOTS 307

Foreword

Kansas first appeared to me as a golden state. It was the end of January, just past my ninth birthday, and my family was moving here from northern Indiana. For most of the drive the world had looked cold and gray, but as we angled south toward Wichita the sun came out, casting warm evening light over the tawny winter grass of the Flint Hills. It was a golden light, as bright as the sunflower on the state flag, as bright as the yellow on the meadowlarks that perched along the highway. For a boy already obsessed with birds and nature, this seemed an omen that the possibilities here would be pure gold, as limitless as the prairie horizon.

During the next several years, as I grew up and learned about birds in Kansas, that shining anticipation was borne out constantly. I was surrounded by variety and novelty, dazzled by new discoveries in every season. From spectacularly beautiful birds such as Scissor-tailed Flycatchers and Painted Buntings to elegant migrants such as Hudsonian Godwits and Buff-breasted Sandpipers, from smartly patterned Harris's Sparrows to big, ponderous American White Pelicans, I found abundant rewards every time I took to the field.

People who have not lived in Kansas, or who have not had the pleasure of extended visits, may be startled to learn that this is a phenomenally good state for birding. Several factors contribute to the diversity of birdlife here. A geographic location in the center of the continent means that birds typical of both the East and West can be found within the state's borders. As a boy in central Kansas I was delighted to find Eastern and Western Meadowlarks in the same fields, Eastern and Western Kingbirds along the same fence lines. If we travel to the corners of the state we find even more variety. Northeast of Topeka and Lawrence we can see essentially the same mix of birds that we might find in the forests of Pennsylvania, while southwest of Dodge City the birdlife takes on a distinct flavor of Arizona. It's a remarkable experience to see these utterly different bird communities thriving just a few hours apart.

Migration season brings even more rewards because Kansas lies in the center of the greatest bird migration corridor in the Western Hemisphere. A substantial number of species spend the winter on the grasslands of southernmost South America and then migrate thousands of miles north to nest on the prairies or tundra of North America, and these long-distance migrants come right across Kansas on their journey. Birds such as Swainson's Hawks and Upland Sandpipers fly north from the Argentinean pampas to raise their young in Kansas, while American Golden-Plovers, Baird's Sandpipers, and numerous others merely pause here before continuing to nesting grounds in the high Arctic. The hundreds of thousands of Franklin's Gulls that circle above Kansas prairies every spring have wintered on the coast of Peru, while the graceful Mississippi Kites that return each spring to our woodlots are arriving from the Amazon Basin. For the intercontinental travelers of the bird world, this is a superhighway, and Kansas birders are treated to a remarkable spectacle of migration every spring and fall.

I lived in Kansas for only about a decade before moving away, and since then I've lived in several states around the country, but I always find excuses to go back to Kansas for outstanding birding experiences. When my wife, Kim, and I go there now, we're always torn between visiting my family and dashing out to look for birds. (If my family members weren't such wonderful people, we'd never get around to seeing them at all!) Every season offers enticements to lure us outdoors. In summer, we have to go out to admire the Summer Tanagers in the oak woods. In winter, we're thrilled by the swirling flocks of Lapland Longspurs that have come down from the Arctic wilderness to the Kansas plains. In spring and fall, we're overwhelmed by the abundance and variety of migrating birds, a galaxy of waterfowl and shorebirds and songbirds to fill our days with excitement.

I have always thought that Kansas birds deserved first-class attention, so I'm particularly pleased to see the publication of this wonderful book by Bob Gress and Pete Janzen. Bob Gress, director of the Great Plains Nature Center, is a renowned wildlife photographer and interpretive naturalist who has done wonderful work in educating the public about all aspects of nature. Pete Janzen has observed more kinds of birds in the Wichita area than anyone else in history; he has also made extensive field studies of birds throughout Kansas and the surrounding states and has written about these birds in popular and technical publications. These two men have national reputations and world-class skills, and you could not ask for better guides to introduce you to the birdlife of the great state of Kansas. I encourage you to take this book in hand and discover the birds of this golden state for yourself.

<div align="right">Kenn Kaufman</div>

Introduction

The pursuit of birding is growing in popularity as a hobby each year. According to recent surveys, some 70 million people in the United States observe birds at least a few times each year. The state of Kansas offers wonderful birding opportunities. An amazing 470 species of birds have been documented in Kansas. Among the fifty states, only eleven others have recorded more species of birds: Alaska, Arizona, California, Colorado, Florida, Massachusetts, New Mexico, Nevada, Oregon, Texas, and Washington. In contrast to Kansas, each of these states benefits from being located on an ocean coast and/or on the border with Mexico or from having major mountain ranges within their borders.

In Kansas, there are thousands of avid birders and tens of thousands more who feed birds in their yards or occasionally venture a short distance away from home to view birds. It is difficult to broadly classify birders. Some "recreational" birders are highly competitive and build an impressive list of birds they have observed. Others are serious volunteer researchers who are primarily interested in contributing to scientific endeavors. Many birders become immersed in the pursuit of their hobby, traveling widely and often throughout Kansas and beyond. For others, one or two birding trips per year are enough. Some are mainly interested in birding in their local town or county, and still others restrict their interests to the birds they observe in nearby parks or their own yards. Regardless of their individual interests and perspectives, all birders share a love of these special winged creatures. Whatever aspect of birding you find enjoyable and rewarding, we hope this book helps you to know and appreciate birds even more. Along the way, we hope you come to love the subtly alluring aspects of the Kansas landscape and its unique natural treasures as much as we do.

Using This Guide

Today there are many books available to those wanting to learn more about birds. Among these are several field guides devoted to identifying North American species. Nearly half of the birds shown in these guides do not occur in Kansas. For a person new to birding, these guides may seem overwhelming.

This book is intended to be a less intimidating introduction to the birds of Kansas. It is not a comprehensive guide to all of the bird species that can be found in the state. Instead, from the 470 species on the Kansas checklist, we have selected 295 to be included in this book. These are the species that we feel are most likely to be encountered during the year by those who are developing a serious interest in Kansas birds.

Organization of Species

Typical bird guides are arranged in taxonomic order. This order is based on the classification of bird orders and families, which has been revised several times in the past and will undoubtedly be revised in the future. The full checklist of Kansas birds that appears at the end of this book is arranged in the current taxonomic order of species as it appears in the seventh edition of the American Ornithologists' Union's *Check-List of North American Birds* and its supplements. The order of species we have used only partially follows taxonomic order. We have freely departed from it throughout the book so that similar species can be grouped together. The selected species have been divided into eighteen groups, each consisting of birds that are similar in appearance, habitats, or behavior.

Species Profiles

There are 279 full-page species profiles that follow the format outlined below. A special section on migratory warblers includes an additional sixteen species. Seven additional species are briefly discussed within the species accounts and are highlighted in bold type.

Photographs: A color photograph of an adult of each species is provided. For selected species, additional photographs have been included to illustrate male and female plumages, additional color morphs, or juvenile plumages. Except where otherwise credited, all photographs are by Bob Gress.

Common Name: The common (English) name of each species is given. This and the scientific name that follows are those designated by the seventh edition of the American Ornithologists' Union's *Check-List of North American Birds* and its supplements.

Scientific Name: The scientific (Latin) name of each species is given. The first word of each scientific name designates the genus to which it belongs, and the second word designates the species name within that genus.

Field Identification: A brief discussion of the major field marks is presented. Where necessary, distinctions between male and female plumages are addressed, as are seasonal changes in plumage. If immature birds are markedly different from adults in appearance and are likely to be seen in Kansas, their field marks are also discussed.

Size: The measurements given are the length from the tip of the bill to the end of the tail, and the wingspan when the wings are fully extended. It should be remembered that these are average lengths, based on measurements of many specimens. Individuals observed in the field may vary substantially in size owing to age, gender, subspecies, or other factors.

Habitat and Distribution: The species' preferred habitat is briefly discussed. This section also includes information on where in Kansas the species is likely to be found.

Seasonal Occurrence: The presence of the species throughout the year is outlined, usually specifying the months of arrival and departure for migratory species. These are only general guidelines, and individuals often occur outside the dates given.

Field Notes: The field notes provide additional information about each species and its status in Kansas.

Birding Basics

Optics and Field Guides

Binoculars are necessary to view most birds well. There are many excellent binocular models on the market today. It is beyond the scope of this book to discuss the pros and cons of all the choices. The price range is also broad, but with careful shopping you can obtain a good-quality pair of binoculars for a relatively modest price. Some dealers will allow a free trial for a day to see if you like them. All binoculars are labeled with their magnification power and objective lens size, such as 7×50. The first number is the magnification power of the eyepiece, and the second is the diameter of the objective lens. For birding, many people prefer binoculars with a 7× or 8× magnification, as these are lighter in weight, easier to hold steady, and usually offer a closer focus. Smaller objective lenses allow the binoculars to be compact. Larger objective lenses offer a wider field of view and a brighter image. All of these factors should be considered before you make your selection.

Many birders eventually obtain another optical instrument called a spotting scope to view birds at greater distances. Scopes are most useful at large lake and wetland areas because they allow you to view areas that cannot otherwise be reached. Spotting scopes are more costly than binoculars and require a tripod.

This book is intended to be a useful introduction to Kansas birds, but you will eventually want to purchase one of the comprehensive field guides to birds. These guides illustrate all of the species that occur in the mainland United States and Canada, and some show all the plumages of each species. There are a number of these guides on the market today. In the opinion of many, the preferred field guide for those who are learning birds for the first time is the Kaufman Focus Guide *Birds of North America,* which uses digitally enhanced photographs and has pointers showing the critical field marks of each species. The *Sibley Guide to Birds* is by far the most comprehensive and advanced of all field guides, and virtually every serious birder in the United States owns a copy. The *National Geo-*

graphic Field Guide to the Birds of North America is another excellent and popular guide, which is smaller than the Sibley and therefore handier to carry.

Birding Techniques

A few tips are in order when you are birding in the field. Bird activity is greatest during the first few hours of daylight, and to a lesser degree in the late afternoon. Most birders are in the field at those times of the day. Avoid wearing brightly colored or white clothing, as birds perceive more of the light spectrum than humans and generally react negatively to humans wearing bright colors. When birding on foot, walk slowly and quietly. Pause frequently to look and listen. The longer you are motionless, the more birds become used to your presence. When you see a bird, restrain the impulse to hurry toward it. Instead, approach it slowly and avoid sudden movements. When you spot a distant bird, keep your eyes on it as you raise your binoculars. This is hard to do at first but soon becomes second nature.

Weather conditions are also an important consideration, especially during migration. When low-pressure systems dominate, birds sense them and are often more active. Particularly strong low-pressure fronts during the spring and fall migrations sometimes cause large numbers of migrating birds to interrupt their flight until the weather has moderated. Birders refer to these hoped-for events as "fallouts." When high pressure dominates, stronger winds and clear skies are the norm, and fewer migrants can be expected. In Kansas, the ideal weather conditions for birding are a combination of low wind speed, overcast skies, and low pressure. While awareness of these factors is useful, "perfect" days are few, so do not let less-than-ideal conditions keep you at home.

When you are first learning to bird, identifying the birds you encounter can seem bewildering. Do not grab your field guide and try to use it while observing a bird. Instead, observe the bird carefully and try to remember everything you can about it before it flies away. Then consult your field guide. After you learn to identify the common birds, it will be easier to identify species that are new to you. Enjoy the learning process, and remember: The best birders in the field today learned to identify birds one species at a time.

Most identification involves using a process of logical elimination. Several criteria should be taken into consideration as you study an individual bird.

Size and Shape: Compare the size of the bird to those you are already familiar with, such as the Canada Goose, American Crow, Blue Jay, or House Sparrow. The shape of a bird is another significant clue. Look for how slender or plump the bird is and how long its wings and tail are.

Bill and Legs: Observing the leg and bill structure of a bird will allow you to swiftly narrow your identification to a few families of birds. Herons have long legs for wading in water and a large spiked bill for catching fish. Sparrows have

short legs and conical bills for cracking seeds. Sandpipers have long, thin bills that allow them to probe in mud for invertebrates, and longer legs for wading in shallow water. Hawks have prominent talons and hooked beaks for catching and consuming prey.

Color and Pattern: Look for the presence or absence of plumage patterns such as spotting or streaking. The presence or absence of wing bars is often a good clue on songbirds. Head markings are often important. Look for eye rings, eye stripes, and any distinctive markings on the crown or nape (back of the neck). Tail patterns often provide clues to identification.

Posture: Note the bird's posture. Herons and shorebirds stand upright on long legs. Woodpeckers cling to tree trunks. Hawks perch on fence posts or utility poles.

Habitat: Habitat is often a major clue to identification. Herons and shorebirds wade in streams and marshes. Nesting Dickcissels sing from perches in the prairies and fields. Most warblers and vireos forage in the canopy of mature woodlands.

Vocalizations: In many cases you will hear birds before you see them. Seasoned birders identify as many birds by song as they do by sight. Learning the songs and calls of birds is an acquired skill. There are a variety of commercially available recordings of bird vocalizations that will assist you in becoming familiar with these songs. However, there is really no substitute for spending time in the field and learning these calls from your own experiences.

Sometimes making a sound that birders call "spishing" will draw birds into the open, as it mimics alarm or the scolding calls of other birds. Try saying the word "spish" using only your mouth (no vocal chords). Exaggerate the "s" sounds, eliminate the vowel sound, and extend the "sh" sound at the end of the word. You end up with a sound like "sssssspsssssssssssshhhhhh." Repeating this several times in a row, varying the speed and tempo, will often coax birds into the open. Some birders make wet, squeaking sounds instead of spishing.

Mixed flocks of songbirds will gather to noisily mob predators such as cats, snakes, and owls when they become aware of them. Playing the calls of Screech-Owls sometimes triggers this response and draws birds into view as they attempt to locate the "predator." This technique is effective but should not be overdone. Another method for attracting birds into view is by playing a recording of their own songs or calls. This can also be an effective technique but should not be overdone, as it can potentially cause birds to leave the area or even abandon their nests in response to what they perceive as competition from a more aggressive member of their species

Birding Ethics: As benign as birding may seem, there are ethical standards that you should adhere to. Birding ethics mostly involve using common sense. Avoid disturbance of natural habitats, nesting birds, and rare or threatened spe-

cies. Respect property rights. Birds should not be disturbed as a result of the actions of birders. If you discover an exceptionally rare bird, try to not disturb it so that others may have an opportunity to see it.

Where to Find Birds

If you are just becoming interested in birding, start in your own yard. You can attract many birds to your yard by providing their basic requirements. This usually involves a combination of landscaping, plantings that offer food and shelter, bird baths, bird feeders, and bird houses.

Once you have familiarized yourself with the birds around your home, you may decide to venture elsewhere in your local area to search for new species. When you are considering where to go looking for birds, remember that birders are not wired to observe the outdoors in the same way as most people. Birders do not really see landscapes—they see *habitats*. As they do so, they consider what species might be present within those habitats. Make an effort to sample a variety of habitats, and do so at different seasons of the year. Check woodlands along rivers and streams, especially in areas where trees are otherwise scarce. State or county parks usually have areas of native habitat. Native grasslands offer a different set of birds from those found in woodlands or urban situations. Lakes and wetlands should also be investigated. Is there a low-lying area that always floods after significant rains? It probably attracts migrating shorebirds in the spring and fall, herons in the summer, and waterfowl in the winter. The brushy fringes of both woodlands and grasslands (often referred to as "transitional" or "edge" habitats) typically provide the most productive birding in a given area. Weedy patches of sunflowers attract many birds in the fall and winter months. In many small towns, the local wastewater treatment ponds attract birds, especially in western Kansas, where other bodies of water are absent. These are not glamorous locations to visit, but they are great places to see birds you otherwise would not find. Cemeteries with numerous pines and cedars are another good place to look for birds, especially in the winter and during migration. These are some examples of the kinds of places that birders frequent, but there are many others. Each local area is different and has its own habitat dynamics.

If you become interested in visiting new or unfamiliar locations to see birds, consider one of the many field trips offered by the local Kansas chapters of the National Audubon Society. Most of the local chapters offer a variety of trips throughout the year, led by experienced birders. These trips are free and open to the public. The statewide organization of birders, the Kansas Ornithological Society, hosts meetings twice a year in addition to publishing two periodicals and maintaining an excellent Web site with a wealth of useful information and links. More information on these organizations is found in the Birding Resources section of this book.

Kansas Geography and Ecosystems

The exceptional diversity of Kansas bird life is due in large part to the state's location in the center of the continent. Species typical of both the Eastern and Western United States are well represented. Kansas is located far enough to the north that resident species of the Canadian boreal forests appear here, especially during the winter months. Yet it is also far enough south that species more typical of the Southern states and the desert Southwest also occur. Its location on the central flyway assures that huge numbers of migratory birds occur during the spring and fall migration. The diversity of birdlife in Kansas is consistent throughout the state. At least 14 of Kansas' 105 counties have recorded 300 or more species of birds, including counties located on the Colorado and Missouri borders.

Habitat diversity also contributes to the quality of birding in Kansas. Although it can seem to the traveler on Interstate 70 to be a barren and uniform landscape, Kansas in fact has a diverse variety of natural habitats. As one travels from the eastern border to the western border, the elevation above sea level increases by over three thousand feet. This change in altitude is largely imperceptible. Because of the "rain shadow" of the Rocky Mountains, average annual rainfall at the Colorado border is less than twenty inches a year, increasing to nearly forty inches a year at the Missouri border. These changes in altitude and precipitation create the diversity of habitat within the state. The easternmost counties are typified by moist deciduous woodlands. Traveling slightly farther west, one enters the Flint Hills, which contain the largest remaining expanse of tallgrass prairie in the world. Continuing westward, the tallgrass prairie gives way to mixed-grass prairie in the central part of the state and shortgrass prairie on the semiarid high plains of western Kansas. Within these broadly defined ecosystems are several more specialized habitats. Extending northward from Oklahoma into southeastern Kansas, in a somewhat narrow strip, are the beautiful Cross Timbers, which are typified by unique stands of upland woodland composed mostly of blackjack and post oaks. On the Oklahoma border farther to the west are the Red Hills, an

area of rugged rocky buttes and deep wooded ravines. Adjacent to the Arkansas River in central and western Kansas are stabilized sand dunes known as the Sand Hills, which are both visually appealing and biologically diverse. Also in central Kansas are two large wetland complexes that have been designated as Wetlands of International Importance under the intergovernmental Ramsar Convention on Wetlands: Quivira National Wildlife Refuge and Cheyenne Bottoms Wildlife Area. In southwest Kansas is another ecosystem known as sand-sage prairie, a semiarid habitat with abundant sagebrush, yucca, prickly-pear cactus, and other desert plant species. Throughout the state are numerous streams and river systems, along which riparian woodlands provide precious corridors of habitat for many birds amid the seemingly endless prairies and farmlands.

Calendar of Kansas Bird Activity

As the seasons advance throughout the year, Kansas bird populations are an ever-shifting tapestry of species. This Kansas birding calendar provides a brief summary of the most significant trends and likely birds that can be expected during each month of the year. This summary is intended as a broad and general overview. Weather conditions and variations in regional habitat can greatly affect the abundance and distribution of individual species from year to year and place to place. For more detailed information, consult the individual species accounts.

January

As the year begins in Kansas, the birds of winter hold full sway. The large reservoirs that have not frozen over host large massed flocks of Common Mergansers and Common Goldeneyes, with attendant flocks of hovering Herring Gulls and Ring-billed Gulls hoping to snatch fish from them. Large flocks of geese are present at some locations, especially in the south and east. Bald Eagles are at their greatest numbers, especially on major rivers and reservoirs. Red-tailed Hawks are abundant statewide, and by the end of the month, the males have begun courting females. Rough-legged Hawks and Northern Harriers patrol over open country, especially the open prairies. On the seemingly endless expanses of farmland in the western and central parts of the state, huge flocks of Lapland Longspurs and Horned Larks swirl restlessly over the wheat and milo fields, often pursued by Merlins and Prairie Falcons. This is the best time to look for Northern Shrikes in northern and western Kansas. In brushier habitats, Harris's and American Tree Sparrows join Dark-eyed Juncos in social foraging flocks. In the western third of Kansas, Harris's Sparrows become scarce and are largely replaced in these mixed sparrow flocks by White-crowned Sparrows. Huge roosts of Red-winged Blackbirds assemble at wetland locations in southern and central Kansas. Noisy flocks of Rusty Blackbirds roam along the wooded rivers of eastern Kansas, while flocks of Brewer's Blackbirds congregate at cattle-feeding areas statewide.

Several bird species of the northern and Rocky Mountain forests invade Kansas in substantial numbers during some winters but are nearly absent in others. January is often the best month to look for these unpredictable wanderers, which include Red-breasted Nuthatch, Pine Siskin, Red Crossbill, and Purple Finch. Especially in the Red Hills but also elsewhere in the West, Mountain Bluebirds sometimes invade in large flocks to consume cedar berries, often joined by Cedar Waxwings and American Robins.

The days lengthen as the month draws to a close, and species such as Carolina Wrens and Northern Cardinals begin to sing more frequently in response to the increasing hours of light. By the end of the month, Great Horned Owls are vocally engaged in courtship, and many are already incubating their eggs. Their telltale ear tufts can be seen protruding from large stick nests high in the bare trees.

February

The final month of winter is in many ways similar to January, but as February progresses, the first hints of spring can be detected. Killdeer are among the earliest migrants to return north, arriving in good numbers by the first week or two of the month. Their strident calls are a sure sign that winter's time is short. In central and western Kansas, vocal flocks of Sandhill Cranes begin moving north in large numbers, staging in areas such as Quivira National Wildlife Refuge and the playa areas of Meade County. Waterfowl populations are also on the move by the third week of the month. Large flocks of geese that have spent the winter in Kansas begin to migrate north, along with Common Mergansers and Common Goldeneyes that have wintered on the large reservoirs. As they depart, other waterfowl species begin to arrive. Northern Pintail is one of the first of the spring waterfowl to arrive in numbers, followed in short order by American Wigeon, Ring-necked Duck, Redhead, Canvasback, and Green-winged Teal. Bald Eagles and other wintering raptors begin to thin out as they move northward to their breeding grounds. Other wintering species that begin to migrate north in late February include Herring and Ring-billed Gulls, American Tree Sparrows, and Lapland Longspurs.

Red-tailed Hawks are now nesting statewide. Most of the large stick nests in tall trees that are not occupied by Great Horned Owls now have Red-tails sitting on them, their heads peering over the rims. Along the woodland rivers of southeast Kansas, Red-shouldered Hawks begin to call noisily as they establish territories. Both Greater and Lesser Prairie-Chickens begin booming activity on their prairie leks during the latter half of the month. More songbirds begin to sing, especially Black-capped and Carolina Chickadees, American Robins, Eastern and Western Meadowlarks, Red-winged Blackbirds, Harris's Sparrows, and Dark-eyed Juncos. The first American Woodcocks arrive in eastern Kansas, and their timberdoodle displays can be observed at dusk late in the month. At the very end of February, the first Eastern Phoebes appear along the southern border.

March

Many of the migration trends that began in February accelerate during March. Wintering species continue to depart northward, and the hardier migrants begin to arrive from their southern wintering grounds.

The first small flocks of migrating American White Pelicans and Double-crested Cormorants appear at the large wetlands and reservoirs, along with Common Loons and all of the grebe species. Sandhill Crane numbers peak in mid-March, after which they depart to join the huge flocks staging on the Platte River in Nebraska. The first Turkey Vultures reappear, lazily floating on the winds over the fields and prairies. On calm evenings, eastern Kansas birders visit locations such as Shawnee Mission Park and Linn County Park to view displaying American Woodcocks. Booming activity of Prairie-Chickens increases, and viewing their leks at dawn is a popular trip for birders, especially in the Flint Hills for Greater Prairie-Chickens, and on the Cimarron National Grassland for Lesser Prairie-Chickens. In the Flint Hills and other areas where prairie burns are conducted, American Golden-Plovers sometimes appear in large flocks to feed in the burned areas. At the large wetlands, shorebirds begin to arrive in a trickle early in the month. By the end of the month, thousands of individuals and numerous shorebird species will be represented. Mourning Doves return in large numbers, joining the small wintering population. Large numbers of migrating Northern Flickers are typically observed in March.

By mid-month, Eastern Phoebes arrive and begin singing along streams, especially near bridges. Say's Phoebes also arrive, staking claims to their nesting territories in western Kansas. The first male Purple Martins arrive to scout out nesting sites. The first Tree Swallows arrive at ponds and wetlands. The huge winter flocks of Horned Larks are suddenly gone, and the remaining resident individuals are paired up and beginning to nest in barren winter wheat fields and prairies. Northbound flocks of American Pipits appear at shorelines and in muddy farm fields, and Sprague's Pipits begin to arrive in prairie habitats. In the Flint Hills, Smith's Longspurs have shed their nondescript winter plumage for the more colorful summer plumage and will soon depart for their tundra nesting grounds. In the west, flocks of equally colorful Chestnut-collared Longspurs are on the move, and this is the best time to look for them in grassland habitats. For several transient species of sparrows, March marks the peak of their spring migration. These include Savannah and Vesper Sparrows in open country and Fox Sparrows in brushy areas of eastern Kansas. Field Sparrows return to their nesting grounds, and the pleasing song of territorial males is heard in a variety of brushy habitats. Huge flocks of Common Grackles and Red-winged Blackbirds arrive during March, often swarming bird feeders. The last of the northbound waterfowl, Blue-winged Teal and Northern Shovelers, are present in large numbers by the end of the month, just as most of the migrant goose and diving duck species are departing north-

ward. In the final days of March, the first few egret and heron species return to the large rookeries in southern Kansas and immediately begin courtship and nesting activity. In eastern and southern Kansas, a number of warmer-season woodland birds also arrive late in the month. Some of these, such as Ruby-crowned Kinglet and Hermit Thrush, are migrants; others will remain to nest, including Blue-gray Gnatcatcher, Black-and-white Warbler, and Louisiana Waterthrush.

April

Nearly all of the remaining wintering birds that did not depart in March depart northward in April. These include most of the wintering waterfowl, raptors, gulls, sparrows, and finches. The spring migration continues to increase in intensity, with new arrivals each week, especially after warm fronts have moved through the state from the south.

American White Pelicans and Double-crested Cormorants arrive in force, and flocks numbering in the thousands can be seen at the large reservoirs and wetlands. Several raptor species are also at their migration peak in April, including Swainson's Hawk, Broad-winged Hawk, and Osprey. While the greatest diversity of shorebirds will occur in May, many shorebird species are most numerous in April. Many birders make their first trip of the year to Quivira and Cheyenne Bottoms in mid- or late April, hoping to shake off the winter doldrums. This is also the time when many sparrow species move through Kansas. Chipping and Clay-colored Sparrows arrive in the middle of the month and are abundant and vocal in both rural and urban areas. Lincoln's and White-throated Sparrows are found in more wooded habitats. Song Sparrows begin to sing frequently. Large flocks of Yellow-headed Blackbirds are frequently observed, especially around cattle herds in central and western Kansas. In the last week of April, other migrants begin to arrive, including Least Flycatcher and other *Empidonax* species, Olive-sided Flycatcher, and Swainson's Thrush. Late April is when ardent warbler fans begin to haunt local hot spots in search of their quarry. April warbler migration is dominated by Yellow-rumped and Orange-crowned Warblers, but in the closing days of the month, Nashville, Tennessee, and a few others begin to arrive.

Most of the permanent resident bird species, including Wild Turkey, Bobwhite, Belted Kingfisher, woodpeckers, both chickadees, Tufted Titmouse, White-breasted Nuthatch, Carolina Wren, Eastern Bluebird, American Robin, Eastern Towhee, Northern Cardinal, and both meadowlarks begin nesting in April. The dawn chorus of singing robins, cardinals, and others increases in intensity as the month progresses. Both Greater and Lesser Prairie-Chickens continue to display on their leks throughout the month.

Many summer residents arrive in April. Among them are Mississippi Kite, Chuck-will's-widow, Whip-poor-will, Great Crested Flycatcher, Eastern and Western Kingbirds, Scissor-tailed Flycatcher, Red-eyed, Bell's, and Warbling

Vireos, all the swallow species, House Wren, Gray Catbird, Brown Thrasher, Lark and Grasshopper Sparrows, and Brown-headed Cowbird. Herons and egrets return to their huge colonies in Wichita and elsewhere early in the month, and immediately begin courtship and nest building. In the wetlands of central Kansas, arriving summer residents include American and Least Bitterns, White-faced Ibis, King and Virginia Rails, Snowy Plover, Black-necked Stilt, and Wilson's Phalaropes. Newly arrived Upland Sandpipers grace the Flint Hills and other grasslands with haunting wolf-whistle calls. Common Poorwills and Rock Wrens return to their specialized rocky-slope habitats. The beautiful display flights of Lark Buntings and Cassin's Sparrows brighten the arid western plains. In the eastern woodlands, several breeding warbler species arrive early in the month, and their songs can be heard frequently as they establish nesting territories. Among them are Northern Parula, Yellow-throated Warbler, and Prothonotary Warbler. In the last week of the month, a new set of summer songbirds arrives to establish nesting territories. These include Eastern Wood Pewee, White-eyed and Yellow-throated Vireos, Wood Thrush, Summer Tanager, Indigo Bunting, and Orchard, Bullock's, and Baltimore Orioles.

May

For many birders, the first two weeks of May represent the most exciting and rewarding time of the entire year. This is when the greatest variety and numbers of northbound migrants can be seen, especially among such popular bird families as plovers, sandpipers, vireos, warblers, grosbeaks, and buntings. The Kansas Ornithological Society holds its annual spring meeting in the first weekend of May in most years, usually in a location where interesting migrants will likely be found.

Cheyenne Bottoms, Quivira, and other wetlands across the state teem with huge flocks of migrating shorebirds. Most of them are now in full breeding plumage, including distinctively marked species such as Black-bellied Plover, American Golden-Plover, Whimbrel, Ruddy Turnstone, Dunlin, and Wilson's Phalarope. Migrating Peregrine Falcons lurk nearby, appearing seemingly out of nowhere to dive on the feeding shorebird flocks in dramatic plunges out of the sky. As the month passes, numbers of shorebirds drop slowly and steadily. Last to arrive in numbers are the White-rumped Sandpipers, a sure sign that the shorebird flight is nearly over. Restless flocks of Franklin's Gulls and Black Terns roam over wetlands, lakes, and prairies statewide as they move north to their nesting grounds.

This is also the "warbler time," when birders comb the woodland hot spots of eastern Kansas, hoping for a significant fallout of these feathered jewels of color. At one of the eastern hot spots such as Marais Des Cygnes, Schermerhorn Park, or Weston Bend, twenty or more warbler species can be found on an exceptional day. The peak of the warbler flight usually falls between May 5 and May 15,

although many are seen in the weeks before and after this period. Also at the peak of their migration are many species of flycatchers, vireos, thrushes, tanagers, grosbeaks, and buntings. By the third week of the month, the majority of these migrants have passed northward, but birders searching for stragglers are often rewarded with rare or unexpected species. In western Kansas locations such as the Cimarron National Grassland, Meade State Park, and Scott State Park, some of these same "eastern" species are encountered in May. They are joined by western migrants that are either rare or absent in central and eastern Kansas, including species such as Dusky Flycatcher, Townsend's Warbler, Lazuli Bunting, Black-headed Grosbeak, and Bullock's Oriole.

Arriving with these waves of northbound migrants in May are the last of the species that will remain to nest in Kansas in the coming months. These include wetland species such as Common Moorhen and Least Tern. The last of the breeding insectivorous species also arrive in May. These include Yellow-billed Cuckoo, Common Nighthawk, American Redstart, Yellow-breasted Chat, Scarlet Tanager, Blue Grosbeak, Painted Bunting, and Dickcissel. By the final week of May, the spectacle of migration has spent itself, giving way to the vibrant energy of breeding activity.

June

After the frenetic activity of May, June is a comparatively quiet time of year for birding in Kansas. There is virtually no migration activity either northward or southward, so the population of birds is composed entirely of nesting species. Early in the month, the dawn chorus of singing birds reaches its crescendo in forests, prairies, and wetlands. Early-morning visits to local birding locations, regardless of habitat, reward birders with excellent views of singing territorial males. Remember that most singing activity tapers off rather abruptly after about ten o'clock in the morning. This is a good time to learn the songs and calls of the nesting species in your local area. During June, Breeding Bird Surveys are conducted for the U.S. Geological Survey by volunteer birders all across the state. These surveys are conducted throughout the United States and Canada and make up one of the most valuable databases of information on bird populations in North America.

At Quivira and Cheyenne Bottoms, flocks of White-rumped Sandpipers linger into the first week of the month, representing the last echoes of the spring migration. A few nonbreeding shorebirds of other species are usually found during June. These are sometimes late migrants, but many are simply subadult individuals who will not continue north to the arctic nesting grounds. Similarly, many of the large reservoirs host a few nonbreeding Double-crested Cormorants, American White Pelicans, gulls, and terns.

July

High heat and humidity dominate the weather during July. Most breeding species have fledged their first brood. Some will begin their second or third broods during July, and these species continue to sing during the early-morning hours throughout the month. In agricultural areas, Dickcissels and Meadowlarks continue to sing throughout the day. Yellow-billed Cuckoos, Great Crested Flycatchers, Bell's Vireos, Warbling Vireos, Red-eyed Vireos, and Indigo Buntings are among the other species that continue to sing even in the hottest weather. Many other woodland and grassland species, even though they are still present, fall silent and therefore become much more difficult to find.

It is the middle of summer, but by mid-July the first signs of the southbound "fall" migration are already apparent. At the large reservoirs, small flocks of post-breeding gulls and terns begin to arrive. The first migrating Upland Sandpipers can be heard giving their liquid, chortling flight calls at night as they migrate overhead. A few Least Flycatchers, earliest of the southbound migratory songbirds, also appear. Kansas hummingbird fans have learned to have their feeders full and ready by early July. Ruby-throated Hummingbirds that have nested to the north begin to arrive at nectar feeders throughout Kansas, and in western Kansas towns such as Elkhart, Garden City, and Larned they are often joined by rare western hummingbird species, especially Rufous Hummingbird. Some locally nesting songbirds, especially those that arrived early in the spring, begin to migrate south in July. These include Yellow-throated and Kentucky Warblers, Louisiana Waterthrush, and Orchard Oriole.

The most notable sign of the approaching fall season is the return of southbound shorebirds to the large central wetlands. Early in July, the first Lesser Yellowlegs, Long-billed Dowitchers, and small "peep" sandpiper species appear. By the end of the month, thousands of shorebirds can be found at Quivira and Cheyenne Bottoms. At this time of the year, most of the adults are still in breeding plumage. During the fall migration, many juvenile shorebirds can be observed, and this is a good time to learn their field marks, which often differ from those of the adults.

Trips to Quivira, Cheyenne Bottoms, and other Kansas wetlands during July are rewarding for other reasons. The young of most of the nesting marsh species have either hatched or fledged, and the adults are active as they engage in their parental duties. Look for Least Bitterns flying low over the cattails as they forage and go to the nest with food for their young. Adult King and Virginia Rails can sometimes be sighted leading their broods of fuzzy black chicks along the edge of the cattails. Common Moorhens are easier to find as well and are often sighted swimming near the edges of cattails. Mixed flocks of swallows are a familiar sight at the large wetlands in late July, with many immature birds among them. These are postbreeding individuals that are slowly migrating southward, taking advan-

tage of the abundant supply of insects. These flocks gradually increase in size, sometimes numbering in the thousands. They remain well into August before moving on.

August

August marks the end of the breeding season, and migration continues to pick up in pace as the month progresses. By August, most species have finished nesting, and many immature birds are seen, often in family groups with the adults. American Goldfinches and Sedge Wrens are the only species still nesting to any significant degree. Once the young have fledged from the large heron rookeries in Wichita, Hutchinson, and elsewhere, the birds begin to disperse, and herons and egrets wander widely throughout Kansas, often well north of their breeding range. They often congregate at large wetlands, reservoirs, and other locations with abundant food.

Migration continues to increase in intensity throughout August. Shorebird numbers reach their peak early in the month, and shorebirds remain numerous through the rest of the month. This is the time to look for Buff-breasted Sandpipers at sod farms, as most are sighted during August. Cool fronts approaching from the north trigger large flights of Upland Sandpipers in the night skies. Flocks of Franklin's and Ring-billed Gulls and Black and Forster's Terns appear at wetlands and large reservoirs. This is also the peak of migration for hummingbirds, and hummer-feeder watchers are entertained throughout the month. Large roosts of southbound Purple Martins gather, often in urban areas. These flocks sometimes number in the tens of thousands. Late in the month, several other species begin to gather into conspicuous foraging flocks as they prepare to migrate southward. These include Mississippi Kite, Eastern Kingbird, Western Kingbird, Dickcissel, Red-winged Blackbird, and others.

Although comparatively few birders are in the field looking for them, flycatchers, vireos, warblers, orioles, and other migrants returning from their northern breeding grounds are moving through Kansas throughout August, especially during the last ten days of the month. Songbirds migrating in the fall do not sing and are generally more furtive and retiring than they are in the spring, but birders who spend time in the field in late August at songbird hot spots are usually rewarded with a good day of birding.

September

September is a month that many birders in Kansas look forward to with great anticipation. The variety of species that can be seen is greater than at any other time of year except May. Many of the birds of summer are still present early in the month. In addition, a large percentage of the fall bird migration from the northern states and Canada takes place during September. These factors combine

to create exceptional birding for those who spend time in the field. Cool fronts from the north will sometimes trigger substantial flights of migrants, but these are rarely as dramatic as the fallouts that are observed in late April and early May. On the other hand, fall migration is generally steady throughout the month, and birders who make a series of visits to local birding areas generally accrue a long and varied list of bird species.

September migration activity varies among the various bird families. Some waterfowl begin to return from the north, starting with Blue-winged Teal, Northern Shoveler, and Lesser Scaup early in the month, followed by Northern Pintail, American Wigeon, and Redhead in the last week of the month. Herons and egrets are numerous and widespread as the month begins, but by the end of the month they have either become scarce or have departed altogether. Many raptors are also on the move. Mississippi Kites gather into ever-larger flocks prior to their abrupt departure in midmonth. Most fall records of Broad-winged Hawk occur in September. Swainson's Hawks begin to arrive in numbers from the north, sometimes in large soaring flocks. The first few returning Northern Harriers and accipiters begin to arrive. Shorebirds and terns are still numerous as the month begins, but their numbers and species diversity both drop noticeably as the weeks pass. Franklin's and Ring-billed Gulls are increasingly numerous at the large wetlands and reservoirs. Hummingbirds are still common and widespread at the beginning of September but mostly have departed by month's end.

Songbird migration in September is quite diverse. Insectivorous species are abundant early in the month. The greatest variety of warblers and vireos is seen at this time. By the end of the month, most of these species will be absent. A few sparrow species such as Chipping, Clay-colored, and Vesper arrive early in the month, especially in the west. As October nears, several other sparrow species, especially Lincoln's and White-crowned, also begin to appear.

During September, many birders visit western Kansas, especially the Cimarron National Grassland. This is the best time of year to observe western migrants such as Dusky Flycatcher, Western Tanager, and Black-headed Grosbeak. These species and others routinely drift eastward onto the plains during their southward migration. As a group, these western species tend to be more numerous in the fall than in the spring. Many birders visiting this part of the state in September are hoping for these sought-after western birds. Most of these species were omitted from this book because of their rarity even in this part of Kansas, but each year a few of them are found in Elkhart and the Cimarron National Grassland. Of equal interest in western Kansas are the many eastern species of birds that are often found in the small towns that provide islands of trees and water in the arid plains. After driving across long miles of wheat fields and arid plains, a stop at parks and cemeteries in towns such as Garden City, Goodland, Sharon Springs, and Tribune can provide an amazing variety of migratory birds in early September.

October

October often seems like a quiet transitional period between the earlier warm-season migrants of September and the later cool-season migrants that will arrive in November. However, there is still substantial migratory activity.

Flocks of migrating Swainson's Hawks peak in numbers early in the month until a significant cool front triggers their sudden mass departure. Those lucky enough to be in the right place when this happens can observe hundreds or even thousands of these beautiful hawks as they slowly wheel southward in large "kettles." Noteworthy numbers of many other migratory hawk and falcon species are seen in October, sometimes migrating with the large flocks of Swainson's Hawks.

On about the twentieth of the month, the first large flocks of diving ducks arrive somewhat abruptly at lakes and wetlands. They are often accompanied by the first Common Loons and Horned Grebes of the fall season. Sandhill Cranes begin to arrive in central and western Kansas in the latter half of October. At the central wetlands, shorebird diversity continues to slowly diminish, but it is still possible to see fifteen or so species on a typical day early in the month. Terns also thin out rapidly, and by the end of the month they have departed. Franklin's Gulls are present in huge numbers, especially at the large reservoirs, where hundreds of thousands are sometimes recorded in late October. These are accompanied by large numbers of Ring-billed Gulls and a few Herring and Bonaparte's Gulls. A few hardy Scissor-tails represent the only flycatchers remaining in the state. Other bird families such as vireos, swallows, thrushes, and warblers have for the most part migrated southward, but each family has a few species that are still present as October begins. Nearly all of these are gone by the end of the month.

Sparrows are numerous in Kansas during October. Early and late migrating sparrows are present as well as lingering summer species. Adding to this mix of species, several winter resident sparrows, such as Harris's Sparrow, and Dark-eyed Junco begin to arrive late in the month. As a result, birders visiting areas such as the Baker Wetland or Slate Creek Wetlands can potentially observe twenty sparrow species during a morning's walk in October. Most highly sought are several wetland sparrows, including Le Conte's, Nelson's Sharp-tailed, and Swamp Sparrows, which are easier to find and more numerous in the fall than in the spring, especially in the last half of October. While searching for these wetland sparrows, be alert for Sedge and Marsh Wrens, which inhabit these same areas.

November

The cool fronts give way to genuine cold fronts in November, and the last of the warm-weather migrants are now gone. But this is the best month of the year for viewing many of the later migrating species. Many of these are more numerous and easier to see in the late fall than they are during their flight north in early

spring. The last of the winter resident species that have not already arrived will do so by the end of the month.

Quivira National Wildlife Refuge remains a popular destination during November. The herons, egrets, rails, and terns are long gone, and only a handful of shorebirds remain, but early in the month, usually after a major cold front, huge flocks of geese, ducks, and Sandhill Cranes appear, seemingly en masse. They remain throughout the month and into December in most years. The Sandhill flocks usually number between 50,215 and 100,215 individuals. Goose populations often exceed 500,215 birds, including all five species shown in this book. As many as 100 Bald Eagles at a time may gather to prey on these waterfowl. These massive flocks of waterfowl and cranes disperse each day to forage in adjacent agricultural areas, returning near dusk to roost for the night. Birders often gather on the Wildlife Loop to watch these waves of birds descend into the Big Salt Marsh at sunset. If you are really lucky, you might spot a Whooping Crane at Quivira or Cheyenne Bottoms in early November. Your odds are not favorable, but each November several such sightings occur, usually at one or both of these wetlands, as the cranes pass through Kansas. Cheyenne Bottoms and Neosho Wildlife Area can produce similar birding spectacles at this time of the year, but because of the location of the public hunting areas near the dike roads, they offer a less peaceful wildlife viewing venue during the waterfowl hunting season in November.

Large lakes and reservoirs are also popular birding destinations during November. Waterfowl migration is at its autumn peak, although the early fall species, such as Blue-winged Teal and other dabbling ducks, are becoming scarce. Diving ducks such as Redhead and Lesser Scaup are abundant. Late in the month, flocks of Common Merganser and Common Goldeneye make their appearance. They are the last of the waterfowl to arrive. Common Loons can be seen in the dozens at the large reservoirs. Eared, Horned, and Pied-billed Grebes are also widespread and fairly common on water impoundments throughout the state. Western Grebes are far less often seen but can appear on lakes anywhere in Kansas during November. Depending on the weather fronts, the huge flocks of Franklin's Gulls usually remain in Kansas until midmonth, when they abruptly depart for their wintering grounds in the Pacific Ocean off the coast of Peru. As they depart, the numbers of Herring and Ring-billed Gulls are growing rapidly. By the end of the month, flocks of Ring-billed Gulls often number in the thousands and Herring Gulls in the hundreds of individuals at impoundments such as Cheney, John Redmond, Milford, Tuttle Creek, and Wilson.

Sparrows represent the majority of songbirds that are still migrating in significant numbers in November. While some are present in lower numbers than they were in October, others are at their peak, and many sparrow species can still be found through midmonth. By the end of the month most of those that remain

are winter resident species, primarily American Tree, Song, Fox, Harris's, White-crowned, and White-throated Sparrows, Spotted Towhee, and Dark-eyed Junco.

Several winter resident species that began to trickle into Kansas during October have all arrived in force by the end of the month. This is a diverse group of birds. Raptors include Bald Eagle, Northern Harrier, Rough-legged Hawk, and Merlin. Other late migrants include Long-eared and Short-eared Owls, Yellow-bellied Sapsucker, Red-breasted Nuthatch, Brown Creeper, Winter Wren, Golden-crowned Kinglet, Hermit Thrush, and Rusty Blackbird. Some late-migrating winter residents are restricted mostly to the western half of Kansas, including Ferruginous Hawk, Prairie Falcon, Northern Shrike, Townsend's Solitaire, and Mountain Bluebird.

December

In general, the December bird population across Kansas is composed mostly of the winter resident species described for January, but if the weather has been mild, a few fall migrants are still on the move early in December. A number of waterfowl species remain through the month, especially in the southern half of the state. Examples of other mostly migratory birds that sometimes linger into December include Common Loon, Horned Grebe, Double-crested Cormorant, Virginia Rail, American Coot, Wilson's Snipe, Eastern Phoebe, Marsh Wren, Brown Thrasher, and Orange-crowned and Yellow-rumped Warblers. American Crows gather into immense roosts of tens of thousands of birds in Wichita, taking advantage of the absence of predators and dispersing into surrounding agricultural areas to feed during the day. At wetland areas such as Quivira National Wildlife Refuge and Slate Creek Wetlands, Red-winged Blackbirds and other blackbird species gather in even larger flocks, usually numbering in the hundreds of thousands of birds. These flocks literally blacken the sky as they leave the roost in the morning and return at dusk.

The primary focus of many birders in Kansas during December is participation in one or more of the Christmas Bird Counts (CBCs), which are held throughout the state from mid-December through early January. The Christmas Counts are part of a continentwide effort administered by the National Audubon Society. Thousands of counts are held across the United States and Canada during a three-week period beginning on December 14 of each year. Each count takes place within a circle fifteen miles in diameter. Birders spend an entire day counting all of the birds they hear and see within the circle. Their findings are then entered into a national database. With over one hundred years' worth of count data to draw on, this database is the most extensive source of information on bird populations in the world. Over fifty counts are conducted each year in Kansas, some of which have been held for well over fifty years.

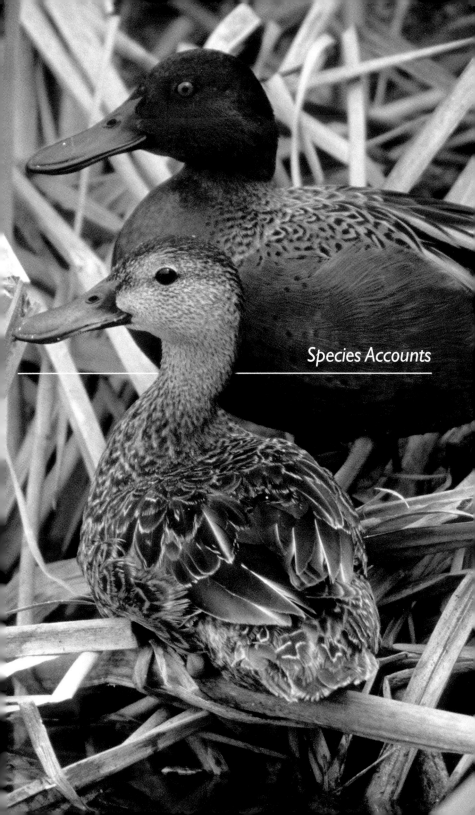

Species Accounts

Canada Goose

Branta canadensis

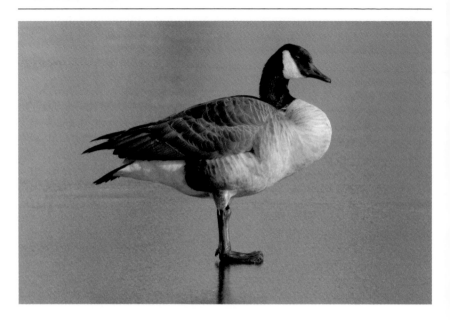

Field Identification: This common goose is recognized by nearly everyone. Some individuals are very large; others can be as small as the closely related Cackling Goose. The Canada Goose always has a longer neck, with a larger, more tapered head and bill than the Cackling Goose. **Size:** Length 36–45 inches; wingspan 53–60 inches.

Habitat and Distribution: Statewide on wetlands, marshes, lakes, ponds, city parks, and golf courses. Feeds in agricultural areas and on urban lawns.

Seasonal Occurrence: Present year-round. Large numbers migrate through the state, and many of these migrants remain throughout the winter. Widespread as a breeding species.

Field Notes: Canada Geese are quite common in most of Kansas. In the 1980s, the Kansas Department of Wildlife and Parks introduced some of these birds to establish a breeding population. These efforts succeeded so well that they now are considered a nuisance species at many urban parks and golf courses. Wintering populations in Wichita have exceeded 20,215 individuals. Pairs of adults with family groups of downy yellow young are frequently observed in the summer.

Branta hutchinsii

Cackling Goose

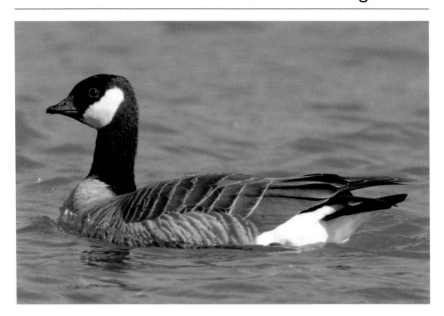

Field Identification: The Cackling Goose is a miniature version of the familiar Canada Goose. Differs from the Canada Goose by its much shorter neck, more rounded head, and small, stubby bill. Some Canada Geese can be as small, but Canada Geese always have a more tapered head and proportionately longer bill. **Size:** Length 25 inches; wingspan 43 inches.

Habitat and Distribution: Statewide on wetlands and lakes, often in urban areas. Feeds in grain fields.

Seasonal Occurrence: Migrant and winter resident. Arrives in October and departs in March.

Field Notes: The Cackling Goose was formerly considered to be one of several small subspecies of the Canada Goose, but it has been reclassified as a full species by the American Ornithologists' Union. Cackling Geese are frequently found with other geese but tend to gather in segregated flocks. They prefer shallower water than Canada Geese.

Greater White-fronted Goose

Anser albifrons

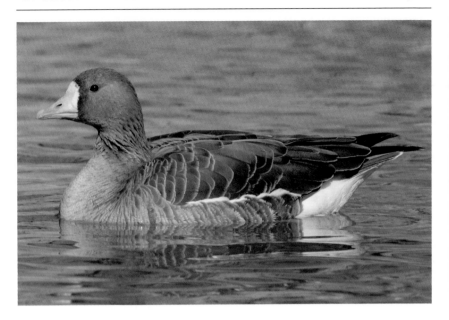

Field Identification: This light-colored goose is smaller than most Canada Geese. The body is mostly brown, with prominent black speckling on the belly of adult birds. Note the bright orange legs and pink bill. It is named for the white plumage at the base of the bill. **Size:** Length 28 inches; wingspan 53 inches.

Habitat and Distribution: Found statewide on or near marshes, lakes, and farmlands, where they feed in grain fields.

Seasonal Occurrence: Migrant and winter resident. Arrives in October and departs in March. Most numerous in migration, but some remain in winter as long as open water is present.

Field Notes: These geese are often referred to as "speckle-bellies" by hunters. They occur in large flocks at locations such as Neosho Wildlife Area or Quivira National Wildlife Refuge. Flocks can be distinguished by their calls, which are more rapid and higher-pitched than those of other geese.

Chen caerulescens

Snow Goose

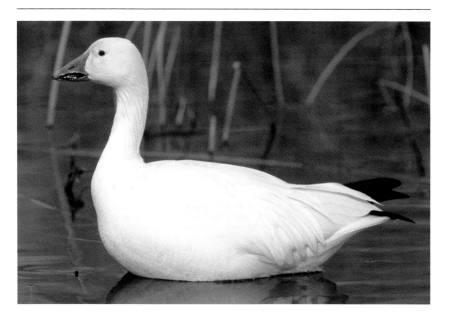

Field Identification: There are two color morphs, known as the Snow Goose and the Blue Goose. Some birds are intermediate in plumage between these two colors. The bill and legs are pink. Bill mandibles have a black edge where they meet, forming a "grin patch" that helps to distinguish this species from the similar Ross's Goose. **Size:** Length 28–31 inches; wingspan 53–56 inches.

Habitat and Distribution: Found statewide on wetlands, lakes, and farmlands, where they feed in grain fields.

Seasonal Occurrence: Migrant and winter resident. Arrives in October and departs in March. Locally abundant in migration, especially in late fall and early spring. Remains in winter as long as open water is present.

Field Notes: Snow Geese have become very abundant in North America in recent decades, and concentrations in the hundreds of thousands are sometimes seen at locations such as Quivira National Wildlife Refuge. They roost in these wetland areas at night and during the day disperse to surrounding agricultural areas to feed. Few sights are more inspiring than watching wave after wave of these geese return at sunset on a calm evening.

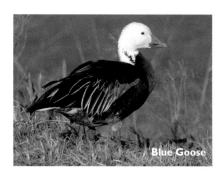
Blue Goose

27

Ross's Goose

Chen rossii

Field Identification: The Ross's Goose looks like a small version of the Snow Goose. Like the Snow Goose, it also has light and dark color morphs, although the dark morph is seldom seen. It is distinguished from the Snow Goose by its smaller size, more rounded head, shorter neck, and small, stubby bill, which lacks the black "grin patch" of the Snow Goose. **Size:** Length 23 inches; wingspan 45 inches.

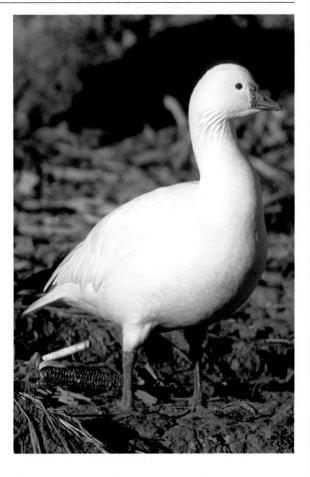

Habitat and Distribution: Statewide on lakes, ponds, and marshes. Often feeds in agricultural fields.

Seasonal Occurrence: Migrant and winter resident. Arrives in late October and departs in March.

Field Notes: Ross's Geese were considered very rare until the 1990s. As populations of the more abundant Snow Goose climbed in recent decades, so have those of the Ross's Goose. Flocks of Snow Geese often have some Ross's mixed with them. Single white geese seen with flocks of Canada Geese often prove to be Ross's.

Cygnus buccinator

Trumpeter Swan

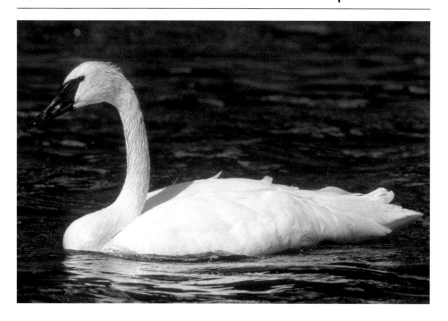

Field Identification: Trumpeters are the largest waterfowl species in North America. Adults are all white, with a prominent all-black bill. Juveniles are dingy gray-white, with some pink coloration on the bill. Typically this species has a straight neck posture. It can be confused with the similar **Tundra Swan**, which is seen less frequently and also differs in bill shape, with a yellow spot at the base of the bill. Another swan species that is sometimes reported in Kansas is the introduced **Mute Swan**, which sometimes escapes from captivity. Mute Swans can be easily identified by their bright orange bill and curved neck posture. **Size:** Length 60 inches; wingspan 80 inches.

Habitat and Distribution: Wetlands and lakes, often in urban areas.

Seasonal Occurrence: Migrant and winter resident. Seen from November through March.

Field Notes: Trumpeter Swans have been the beneficiaries of a vigorous effort to reintroduce them in several northern states, including Iowa, Minnesota, and Wisconsin. Most if not all of the birds seen in Kansas are from these reintroduced populations. Frequently they have neck collars to assist researchers to identify individuals in the field.

Wood Duck

Aix sponsa

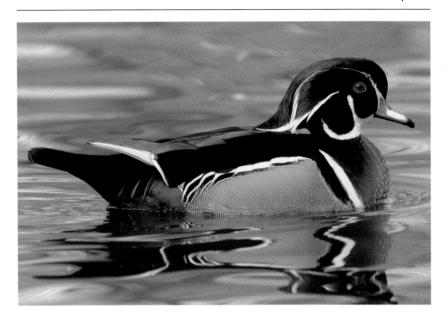

Field Identification: The ornate colors of the male make it unmistakable. Females are soft gray overall, with white spotting on the flanks and a large white teardrop-shaped area around the eyes. Both sexes have a relatively long tail. Distinctive wheezy calls are given when individuals are alarmed or excited. **Size:** Length 18 inches; wingspan 30 inches.

Habitat and Distribution: Found on rivers, streams, and small ponds with trees along the banks. It is most numerous in the eastern half of the state but has been recorded throughout western Kansas, especially in recent years.

Seasonal Occurrence: Permanent resident. Most birds are present from March through November, with the greatest numbers seen in April and October. Small numbers remain in winter as long as open water is available.

Field Notes: This is one of the most colorful birds found in Kansas and one of the few waterfowl species that nests widely in the state. It readily adapts to urban areas. Wood Ducks nest in tree cavities as high as 50 feet above the ground. They were nearly exterminated by habitat loss in the early twentieth century but have made a strong recovery throughout their range.

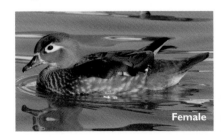
Female

Anas strepera

Gadwall

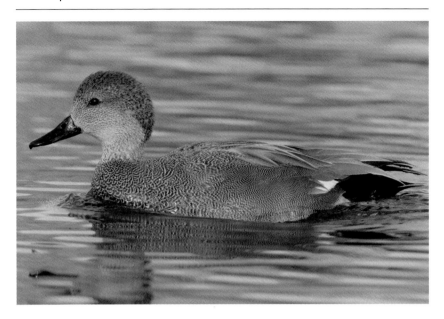

Field Identification: The Gadwall is a relatively nondescript waterfowl species. The male has a pale head and neck, contrasting with gray flanks. Swimming males show a prominent black rump, which is the most useful field mark. Females are mostly light brown, with white fringes on the feathers and a pale throat. Flying birds of both sexes clearly show white secondary wing feathers, which are usually visible on swimming birds of both sexes. **Size:** Length 20 inches; wingspan 33 inches.

Habitat and Distribution: Found statewide on shallow ponds and marshes.

Seasonal Occurrence: Migrant and winter resident. Arrives in September and departs in May. Some remain throughout the winter as long as water remains open. Occasionally nests in Kansas.

Field Notes: Ducks are often separated into "dabbling ducks," which feed in shallow water by tipping vertically to reach aquatic vegetation, and "diving ducks," which are usually found in deeper water, where they dive completely below the surface to feed. During migration, Gadwall are one of the most numerous dabbling duck species in Kansas. They tend to forage in somewhat deeper water than most of the other dabbling duck species.

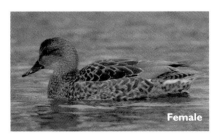
Female

American Wigeon

Anas americana

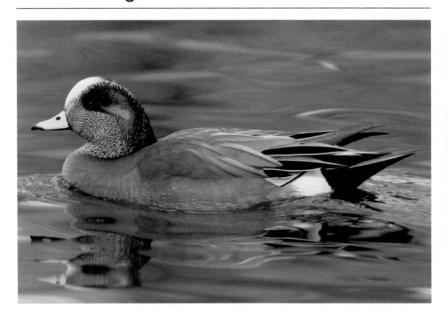

Field Identification: Males are mostly pinkish-brown, with gray cheeks, a broad green eye stripe, and a prominent white crown. Females are also pinkish-brown with an entirely gray head. On flying males, note the broad white upper wing. **Size:** Length 20 inches; wingspan 32 inches.

Habitat and Distribution: Statewide on shallow lakes, ponds, and wetlands.

Seasonal Occurrence: Migrant and winter resident. Arrives in September and departs in May. Common in migration. Winter resident as long as water remains open. Often found in large flocks in March and October.

Field Notes: This is one of the most colorful ducks found in Kansas. They are often seen in small groups near flocks of other ducks. They sometimes graze on grass and winter wheat with flocks of geese.

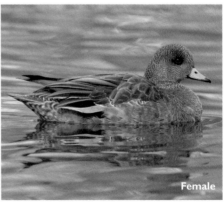

Female

Anas platyrhynchos

Mallard

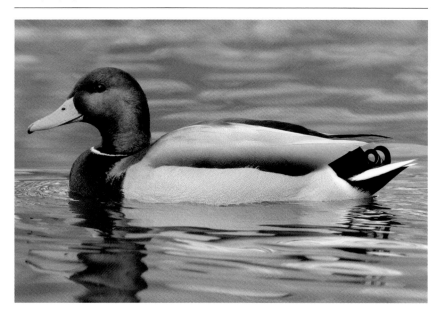

Field Identification: This duck is recognized by nearly everyone. In flight, look for blue secondaries bordered with white on both males and females. **Size:** Length 23 inches; wingspan 35 inches.

Habitat and Distribution: Found statewide on lakes, ponds, streams, and wetlands of all sizes. Mallards are not picky and readily adapt to almost any habitat with water, including flooded fields. Large flocks are seen at reservoirs and marshes in the nonbreeding season. Mallards sometimes graze in corn and milo fields like geese.

Seasonal Occurrence: Permanent resident. Most numerous during migration and in winter, but many remain to nest, often in urban areas.

Field Notes: This dabbling duck is the most abundant and widespread waterfowl species in Kansas. Nests are usually near ponds or streams, although sometimes they select nest sites several hundred yards from water. Females with family groups of up to twelve young are often seen in the summer months.

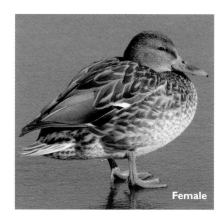
Female

33

Northern Shoveler

Anas clypeata

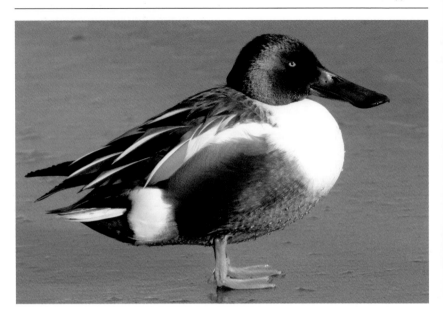

Field Identification: The most prominent field mark on both sexes is the unusually long and broad bill. In flight, males show a blue wing patch similar to that of the Blue-winged Teal. The patch is grayer on females. **Size:** Length 19 inches; wingspan 30 inches.

Habitat and Distribution: Statewide on wetlands and shallow bodies of water, including sewage lagoons.

Seasonal Occurrence: Migrant and summer resident. Spring migrants are seen from March through May, fall migrants from July through November. Occasionally nests in central and western Kansas. Found in winter in southern Kansas if water remains open.

Field Notes: This is an abundant waterfowl species in Kansas, especially during migration in central and western areas of the state. The large bill is used to skim water for small aquatic life. Sometimes these ducks form large rotating groups that feed together in a big swirling pinwheel, with heads almost submerged in the water. They often associate with Blue-winged Teal. Formerly they were considered rare in winter, but in recent years flocks of one hundred or more birds have wintered in southern Kansas.

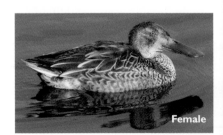
Female

Anas crecca

Green-winged Teal

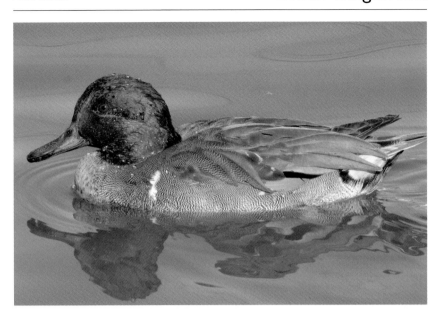

Field Identification: This is a small, fast-flying dabbling duck. The male has a broad green eye stripe, a prominent vertical white slash mark on the gray flanks, and a horizontal yellow stripe on the tail. Females are dark brown and lack the white around the eye and the long bill of other female teal. In flight, both sexes show a green trailing edge on the wing. **Size:** Length 14 inches; wingspan 23 inches.

Habitat and Distribution: Statewide on wetlands, rivers, and ponds.

Seasonal Occurrence: Common migrant and uncommon winter resident. Fall arrival is in September, spring departure in May.

Field Notes: These ducks are sometimes seen in flocks of up to several hundred birds. They fly in compact groups that execute deft maneuvers. When excited or alarmed, the flocks make distinctive high-pitched peeping calls.

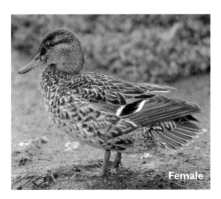

Female

Blue-winged Teal

Anas discors

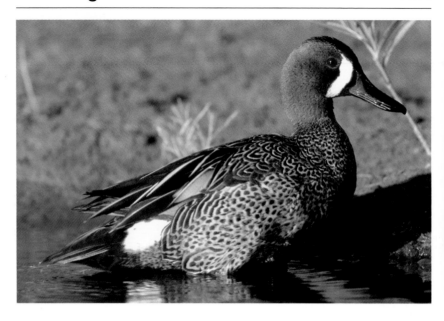

Field Identification: The Blue-winged Teal is a small dabbling-duck species. The male has a dark-blue head with a prominent white crescent mark at the base of the bill. Males in late summer and early fall are similar to females. Females have brown feathers with pale edges, a thin dark line through the eye, and a thin white eye ring. The three teal species can be distinguished from most other waterfowl species at some distance by their noticeably smaller size and fast flight. At all seasons, both sexes show a large blue patch on the upper wing, visible only in flight. **Size:** Length 15 inches; wingspan 23 inches.

Habitat and Distribution: Statewide on wetlands and shallow ponds. During migration they can be found on even the smallest bodies of water.

Seasonal Occurrence: Migrant and summer resident. Arrives in April and departs in October. A few remain to nest, especially at larger wetlands.

Field Notes: This is one of the most abundant and widespread waterfowl species in Kansas. In the spring they tend to arrive later than other duck species, and in the fall they are among the first to depart for the south.

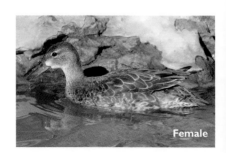

Female

Anas cyanoptera

Cinnamon Teal

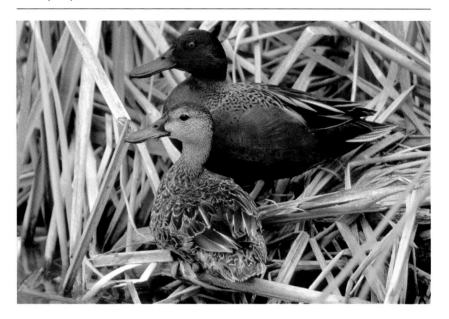

Field Identification: Males are a rich rusty-red color for most of the year. Females and early-fall males are similar to the female Blue-winged Teal, except the bill is longer and wider at the tip. In flight, they show blue patches on the upper wings similar to those of the Blue-winged Teal. **Size:** Length 16 inches; wingspan 22 inches.

Habitat and Distribution: Wetlands and shallow ponds, mostly in the western half of the state. They are seen annually at Quivira National Wildlife Refuge and Cheyenne Bottoms but can turn up almost anywhere in the state.

Seasonal Occurrence: Migrant, reported most often in April and May. In some years, a few pairs remain to nest at Cheyenne Bottoms and southwest Kansas.

Field Notes: It is always a treat to find one of these teal in Kansas. Check large flocks of Blue-winged Teal, and you might be lucky enough to pick one of these birds out of the flock. A close relative of the Blue-winged Teal, it sometimes hybridizes with it. In the early fall, it is difficult to tell these two teal species apart.

Northern Pintail

Anas acuta

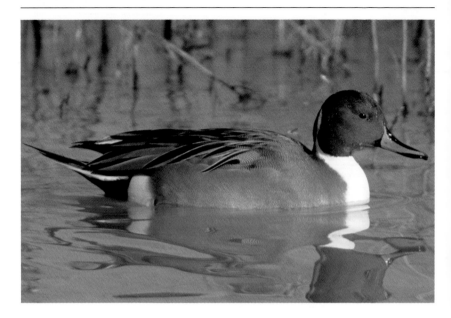

Field Identification: The Northern Pintail is a large, slender dabbling duck. Both sexes have a dark gray bill, long neck, and a long, pointed tail, longest in the male. Males have a long white stripe on the neck. Females are brown and white, with strong V-shaped markings over most of the body. Flying birds can be identified by their long wings and tails. **Size:** Length 21 inches; wingspan 34 inches.

Habitat and Distribution: Statewide on wetlands, lakes, and ponds.

Seasonal Occurrence: Migrant. Spring migrants are seen from February through May, fall migrants from September through November. Occasionally remains to nest, most often at Cheyenne Bottoms. Small numbers remain through the winter as long as water remains open.

Field Notes: One of the first signs of spring in Kansas is the arrival of large Northern Pintail flocks during the last half of February. Some flocks number well into the thousands. Many regard this as the most elegant and graceful of the waterfowl family.

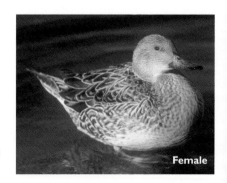

Female

Aythya valisineria

Canvasback

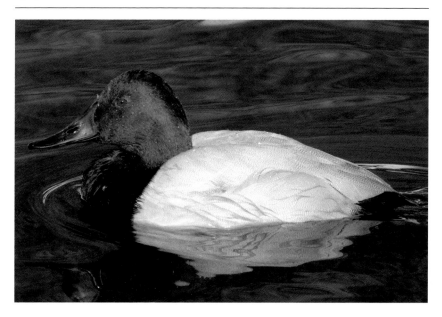

Field Identification: Both sexes have a distinctively sloped head and large, curved black bill. Males have a white body, black breast and tail, and red head. Females have a grayish body and brown head. The underwings of both sexes are white. Canvasbacks can be identified at some distance by the bright white plumage of the males.
Size: Length 21 inches; wingspan 29 inches.

Habitat and Distribution: Statewide on marshes, ponds, and lakes.

Seasonal Occurrence: An uncommon migrant. Remains during winter as long as water remains open. Arrives in October and departs in April. Occasionally nests at Cheyenne Bottoms and Quivira National Wildlife Refuge.

Field Notes: This duck feeds by diving below the surface of the water to forage. Most diving duck species feed on shellfish and other aquatic animals, but the diet of Canvasbacks consists mostly of aquatic vegetation. Their population has declined because of the loss of nesting habitat in the prairie pothole region of the northern plains states. Flocks of several hundred birds can be seen in March and October.

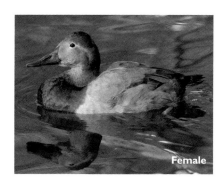

Female

Redhead

Aythya americana

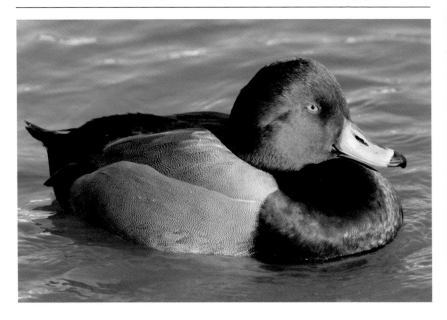

Field Identification: Males are superficially similar to Canvasbacks, but their body is gray instead of white, the head is a brighter shade of red, and the bill is blue with a dark tip. Females are a uniform soft brown, somewhat paler on the face. Redheads have a more rounded head and less prominent bill than Canvasbacks.
Size: Length 19 inches; wingspan 29 inches.

Habitat and Distribution: Statewide on lakes and marshes.

Seasonal Occurrence: Common migrant, uncommon winter resident. Winter populations arrive in October and depart in April. A few usually remain to nest at Cheyenne Bottoms and Quivira National Wildlife Refuge.

Field Notes: This colorful duck is often seen in large flocks on deepwater lakes and reservoirs in spring and fall. It is the only diving duck likely to be seen during the summer in Kansas, especially along Quivira National Wildlife Refuge's Wildlife Drive, where adults with downy young can usually be seen during July.

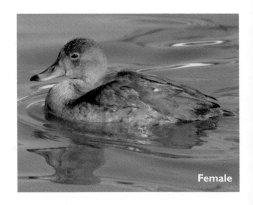

Female

Aythya collaris

Ring-necked Duck

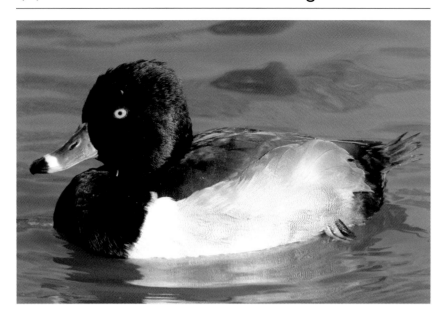

Field Identification: The most prominent field marks on the males are the white slash mark on the side of the breast and the distinct white ring around the bill. Females are mostly dark brown, with lighter gray cheeks and a distinct white eye ring.
Size: Length 17 inches; wingspan 25 inches.

Habitat and Distribution: Statewide on wetlands, lakes, and ponds.

Seasonal Occurrence: Common migrant, uncommon in winter. Arrives in October and departs in April.

Field Notes: These ducks are usually seen in smaller flocks than the other diving duck species. They are also more frequently observed on small ponds than other diving ducks. The species is named for a chestnut-colored collar on the male that is very difficult to see in the field, even at close range.

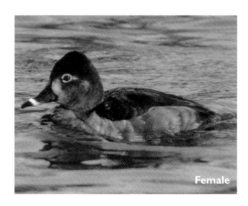
Female

Lesser Scaup

Aythya affinis

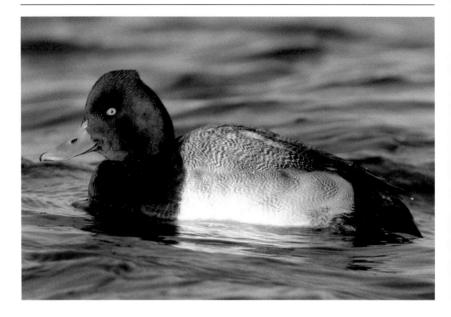

Field Identification: Males have a blue-black head and breast, gray back with whitish flanks, and a black tail. They are "black on the ends and light in the middle." Males can be easily separated from Ring-necked Ducks, which have black backs. Females are a uniform dark brown except for a bright-white area surrounding the base of the bill.

Size: Length 17 inches; wingspan 25 inches.

Habitat and Distribution: Statewide on large reservoirs, lakes, ponds, and marshes.

Seasonal Occurrence: Common migrant and uncommon winter resident. Arrives in October and departs in April.

Field Notes: Large rafts of these diving ducks can be seen in migration, often with other diving duck species, especially Redheads.

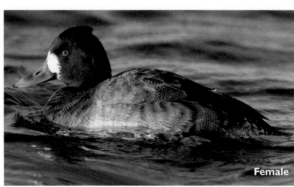

Female

Bucephala clangula

Common Goldeneye

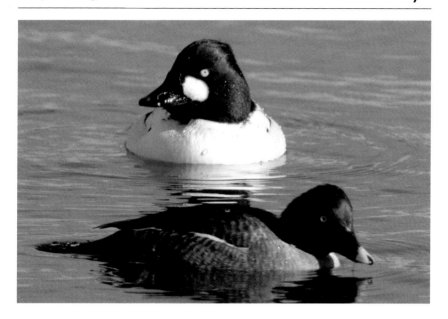

Field Identification: Males are mostly white, with a prominent white oval at the base of the bill. Females have a soft gray body with a warm brown head. Both sexes show large white wing patches in flight. The wings make a metallic whistling sound when these birds are in flight. **Size:** Length 19 inches; wingspan 26 inches.

Habitat and Distribution: Statewide on lakes and reservoirs with deep water.

Seasonal Occurrence: Common migrant and winter resident. Fall arrival is in November; spring departure is in March. They are the last ducks to arrive in the fall and the earliest to depart northward again in the spring.

Field Notes: Common Goldeneyes thrive in cold weather. When cold weather drives other waterfowl south, Common Goldeneyes remain present in good numbers on rivers and large reservoirs until no patch of open water remains. In February the males begin to court females with a dramatic display. They throw their heads back and give a loud nasal vocalization, then jerk the head forward with great emphasis.

Bufflehead

Bucephala albeola

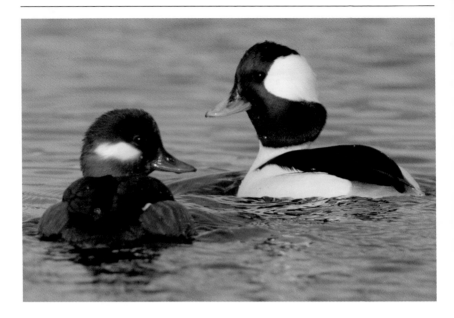

Field Identification: This is the smallest duck species found in Kansas. Males have a white body, black back, and black head with a unique white pattern. Females are mostly dark gray but have a large oval white spot on the head. Both sexes have large white wing patches, which are visible when they are in flight. **Size:** Length 13 inches; wingspan 21 inches.

Habitat and Distribution: Statewide on wetlands, lakes, ponds, and reservoirs.

Seasonal Occurrence: Common migrant. Uncommon but regular in winter as long as open water remains. Arrives in October and departs in May.

Field Notes: The name is derived from the disproportionately large head because it is a trait in common with the buffalo. Buffleheads typically linger later in both spring and fall migration than most other diving duck species. They do not gather in large flocks for the most part, preferring smaller groups that forage on the edges of large rafts of other diving duck species.

Lophodytes cucullatus

Hooded Merganser

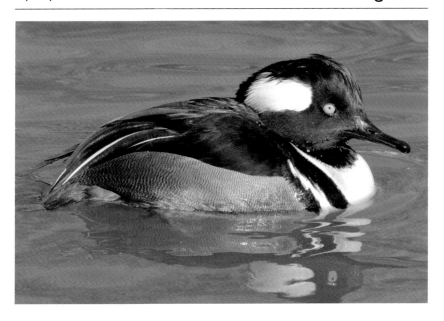

Field Identification: This is the smallest of the mergansers, almost as small as a teal. Their flight is fast and agile. The male has a black back, reddish-brown flanks with two black bars near the breast, and a black head with a large white patch that can be raised into a puffy crest. The female is dark gray with a smaller frosty-brown crest. **Size:** Length 18 inches; wingspan 24 inches.

Habitat and Distribution: Statewide on wetlands, lakes, and streams in or near wooded areas.

Seasonal Occurrence: Migrant and winter resident. Most are observed between October and March. They have nested in Kansas on a few occasions, mostly at eastern wetlands such as Marais des Cygnes and the Neosho Wildlife Area.

Field Notes: This is one of the most attractive duck species in Kansas. Males displaying for females raise and lower their prominent crests with dramatic flourishes. Mergansers are diving ducks that feed primarily on fish and have narrow pointed beaks with serrated edges that allow them to catch their prey efficiently.

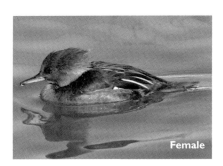

Female

Common Merganser

Mergus merganser

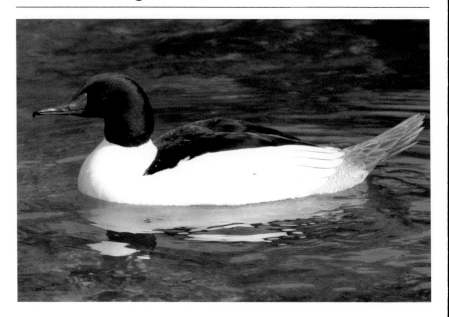

Field Identification: The Common Merganser appears long and slender, both when swimming and in flight. The male is mostly white, with dark back and tail, green head, and orange bill. Females are gray with a brown head and short crest, clean-cut white throat, and orange bill. **Size:** Length 25 inches; wingspan 34 inches.

Habitat and Distribution: Large reservoirs and deepwater lakes, mostly in the eastern two-thirds of the state.

Seasonal Occurrence: Migrant and winter resident. Fall arrival is in November, spring departure in March. Like the Common Goldeneye, they are among the last of the duck species to arrive in the fall and among the earliest to depart in the spring.

Field Notes: These are familiar diving ducks during the winter months, when they form large flocks on large reservoirs. These flocks may number in the tens of thousands of birds. If the lakes freeze, they move south into Oklahoma and Texas but return immediately when open water is again available. They feed on fish, primarily gizzard shad. They are social and usually swim and fly in tight flocks.

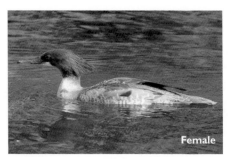

Female

Mergus serrator

Red-breasted Merganser

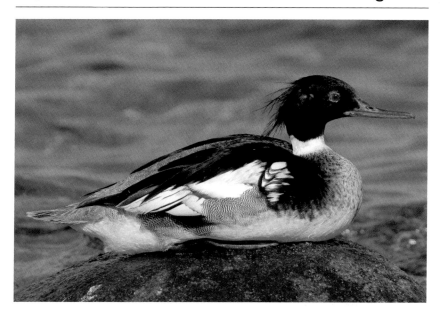

Field Identification: This merganser has a long, slender appearance, both on the water and in flight. The male has a green head with shaggy crest, white collar, dark reddish-brown breast, gray flanks, and black back. The female is similar to the female Common Merganser except for the more evenly brownish-gray throat and more prominent crest. Both sexes have a longer, thinner bill than Common Mergansers. **Size:** Length 23 inches; wingspan 30 inches.

Habitat and Distribution: Statewide on wetlands, reservoirs, and deep lakes.

Seasonal Occurrence: Migrant. Spring migrants are seen in March and April, fall migrants mostly in November. Occasionally seen in winter.

Field Notes: This is the least-often-observed merganser species in Kansas, and finding one is always a notable event. It is never found in the huge flocks that Common Mergansers form. Most sightings are of just a few individuals, although flocks of up to thirty birds can sometimes be seen in November at locations such as Cheney Reservoir.

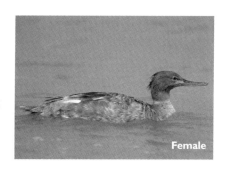

Female

47

Ruddy Duck

Oxyura jamaicensis

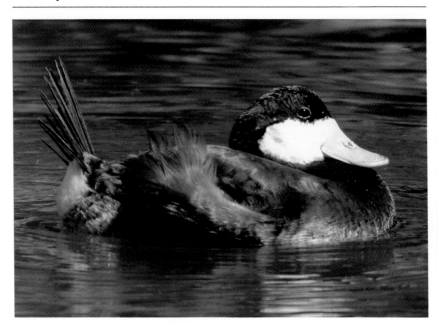

Field Identification: Males have black caps and white cheeks and are colorful in full breeding plumage, when their bills are bright powder blue and their bodies brick red. Females have a dark line crossing the white cheek. They often swim with their tail held stiff and upright. **Size:** Length 15 inches; wingspan 18 inches.

Habitat and Distribution: Statewide on marshes, reservoirs, and lakes.

Seasonal Occurrence: Common migrant and uncommon winter resident. Winters locally on lakes with open water, mostly in the southeastern third of the state. Fall arrival is in October, spring departure during May. In some years, a few pairs remain to nest at the large wetlands.

Field Notes: In winter, the dark plumage blends well with dark water, and they can be difficult to spot until their white cheeks are seen. Their flight is direct and rapid.

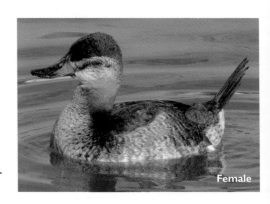

Female

Gavia immer

Common Loon

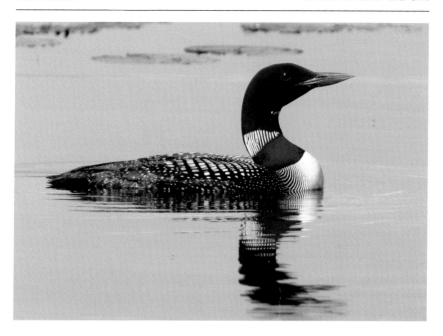

Field Identification: The Common Loon is a large swimming bird, seldom seen in flight, that dives and remains submerged for long periods of time. It rides low in the water and has a large dagger-shaped bill. In spring, the male has a black head, striped white collar, checkered black-and-white back, and white breast and belly. In winter, the head and back are an even grayish-brown, and the throat and chin are white. **Size:** Length 32 inches; wingspan 46 inches.

Habitat and Distribution: Found in large reservoirs and deep lakes. Most records come from the eastern two-thirds of the state.

Seasonal Occurrence: Migrant in early spring, especially in March. Late-fall migrant, mostly in November. Usually seen more frequently in the fall. A few sometimes linger on lakes with open water during the winter months.

Field Notes: Almost all loons seen in Kansas are this species. There are three other loon species (Pacific, Red-throated, and Yellow-billed) that have been reported in Kansas, all of which are extremely rare. Most Common Loon sightings are of single birds, but at reservoirs such as Wilson, Perry, and Cheney, up to thirty can be seen on a single day. If you are lucky, you may hear their wild and haunting primordial calls.

Pied-billed Grebe

Podilymbus podiceps

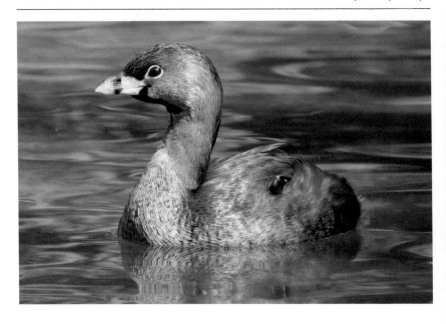

Field Identification: The Pied-billed Grebe is often mistaken for a small duck. Both sexes have a pale, chicken-like bill with a black ring near the tip. In winter the black chin and ring on the bill are lost. This species is seldom seen in flight and prefers to dive when disturbed. **Size:** Length 13 inches; wingspan 16 inches.

Habitat and Distribution: Reservoirs, lakes, ponds, and wetlands.

Seasonal Occurrence: Seen year-round, but populations fluctuate significantly. Most numerous during spring and fall migration. Remains to nest in wetland areas. A few remain through the winter, especially in southern Kansas.

Field Notes: This is the most common grebe in Kansas and is not overly selective in its choice of habitats. Almost any body of water can attract this species, including those located in urban areas. When submerging, they frequently sink out of sight like a submarine and sometimes swim with just their head remaining above water. At Quivira National Wildlife Refuge and Cheyenne Bottoms, numerous family groups can be seen during the summer. The young have striped faces. Their loud, echoing song is one of the familiar summer sounds of the marshes.

Podiceps auritus

Horned Grebe

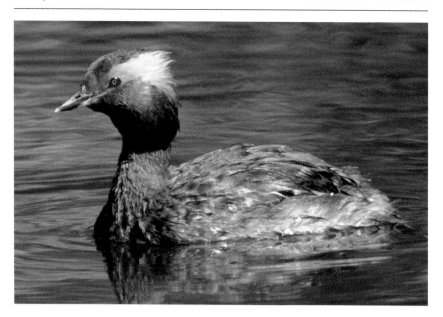

Field Identification: In size and shape, this grebe resembles a small duck. Adults in breeding plumage have a bright rufous neck and flanks, a black head with flared yellow "horns," and red eyes. The bill is short and pointed. In winter, they are all black and white, with a broad white cheek patch and clean-cut black cap. In general, this grebe is more flat-headed in appearance than the similar Eared Grebe. **Size:** Length 14 inches; wingspan 18 inches.

Habitat and Distribution: Reservoirs, deep lakes, and wetland areas with large areas of open water.

Seasonal Occurrence: Spring migrant from March through May; fall migrant in October and November. A few linger into December in mild years.

Field Notes: Horned Grebes are found on wetlands, small lakes, and large reservoirs in central and eastern Kansas. Observing them in their brightly colored plumage in spring is always a treat. They are most numerous in late fall.

Eared Grebe

Podiceps nigricollis

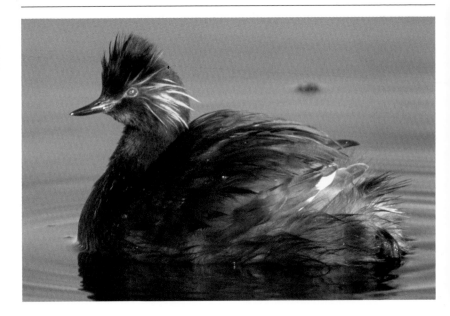

Field Identification: In spring and summer, look for the black head, neck, and back; large feathered yellow "ears" on the sides of the head; and a bright red eye. In winter, they are confusingly similar to the Horned Grebe. On winter Eared Grebes, look for the dark plumage of the crown extending onto the side of the face, giving them a smudgy look. Their peaked crown is unlike the flatter head of the Horned Grebe.
Size: Length 13 inches; wingspan 16 inches.

Habitat and Distribution: Statewide, but most likely to be found in central and western Kansas. Prefers shallow ponds and marshes but also seen regularly on large reservoirs.

Seasonal Occurrence: Spring and fall migrant. Northbound spring migrants can be seen from March well into early June. Fall migrants begin to arrive in September and linger into December in some years.

Field Notes: This grebe prefers shallow marshy habitats, more so than the closely related Horned Grebe. On several occasions large colonies have nested in central and western Kansas.

Aechmophorus occidentalis

Western Grebe

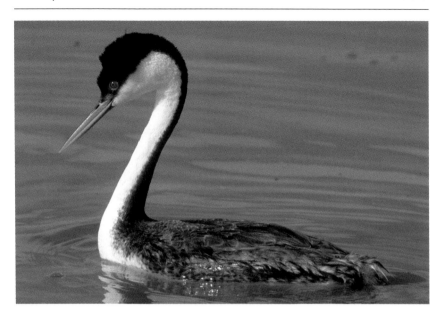

Field Identification: This large grebe has a long, slender neck and long, thin yellowish bill. The crown, hind neck, and upperparts are all dark gray to black. The white throat and breast are cleanly separated from the darker plumage. The closely related **Clark's Grebe** is seen occasionally in Kansas. It differs by having a more restricted black crown and a brighter yellow bill. **Size:** Length 25 inches; wingspan 24 inches.

Habitat and Distribution: Statewide at large reservoirs and wetlands. Most often observed in central and western Kansas.

Seasonal Occurrence: Spring migrant in April and May; fall migrant in October and November. A few are seen during the winter.

Field Notes: These handsome birds are often seen in small flocks of three to ten birds in late fall on large reservoirs. In recent years, they have nested at Cheyenne Bottoms when water conditions are favorable. If you are lucky, you may see their dramatic courtship ritual, which involves both adults dancing across the water in unison with curved necks outstretched.

Common Moorhen

Gallinula chloropus

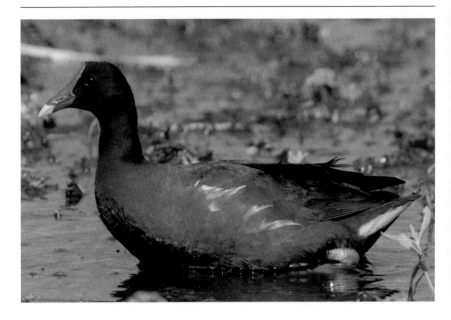

Field Identification: The Common Moorhen is a secretive bird of the dense marshes, closely related to rails. Though often seen swimming like a duck, it readily walks around like a shorebird. Breeding adults are slate gray with a scarlet bill. The bill is grayer on juveniles and winter adults. Also look for the long white slash mark on the sides, a field mark not shared by the similar and much more abundant American Coot.
Size: Length 14 inches; wingspan 21 inches.

Habitat and Distribution: Most recent sightings come from Quivira National Wildlife Refuge and Cheyenne Bottoms, although it has been recorded in other central and eastern counties.

Seasonal Occurrence: Summer resident. Present from early April through October.

Field Notes: A drive along the dikes at Cheyenne Bottoms or Quivira National Wildlife Refuge in summer may yield a glimpse of one of these enigmatic birds lurking at the edge of cattails. Most sightings are brief, as they swiftly swim or walk into dense cattails.

Fulica americana

American Coot

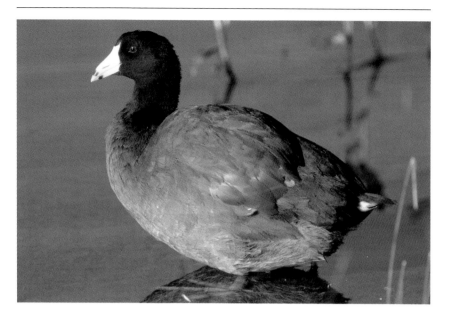

Field Identification: Coots are relatives of rails, but in size, shape, and habits they are more reminiscent of waterfowl. The plumage is uniformly slate gray, darkest on the head. On adults, the bill is bright white and chicken-like. Juveniles are lighter gray with a grayish bill. This is a vocal species with a variety of resonant calls. Coots typically bob their heads while swimming, creating a somewhat comical impression.
Size: Length 16 inches; wingspan 24 inches.

Habitat and Distribution: Statewide at marshes, lakes, ponds, and streams. They are a conspicuous nesting species at wetlands throughout the state.

Seasonal Occurrence: Permanent resident. Abundant in migration, especially in April and October. Fairly common in summer at large wetlands. Least numerous in winter, but a few will linger as long as water remains unfrozen.

Field Notes: This is an abundant aquatic bird in Kansas. Flocks numbering in the thousands are seen during migration. Coots are not shy and are frequently seen in urban areas. In order to become airborne, coots run across the water to gain momentum.

American White Pelican

Pelecanus erythrorhynchos

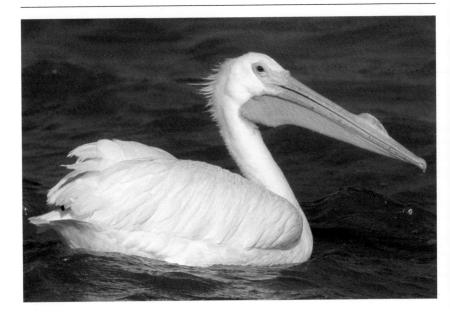

Field Identification: This pelican is a huge white water bird. The long, broad orange bill separates this species from swans, the only species with which confusion is possible. The trailing half of the wing is black, visible only when the birds are in flight. **Size:** Length 62 inches; wingspan 108 inches.

Habitat and Distribution: Marshes, lakes, and reservoirs, mostly in the eastern two-thirds of Kansas.

Seasonal Occurrence: Common and conspicuous migrant in spring and fall, especially in April and October. In the summer and winter months, a few linger at wetlands and reservoirs.

Field Notes: This is the largest bird found in Kansas. The large pouched bill is used to scoop up fish in shallow water. Sometimes a group of these birds will feed communally, forming a long line of birds that swims toward the shore, driving fish in front of it. White Pelicans migrate in large flocks, soaring on thermal air currents in surprisingly graceful formations.

Phalacrocorax auritus

Double-crested Cormorant

Field Identification:
This large, dark water bird is similar in habits and appearance to waterfowl. Adults are mostly black, with orange throat and bill. Birds less than two years old are brownish and paler on the throat and breast. It usually swims with the head angled upward, giving it a rather comical appearance.
Size: Length 33 inches; wingspan 52 inches.

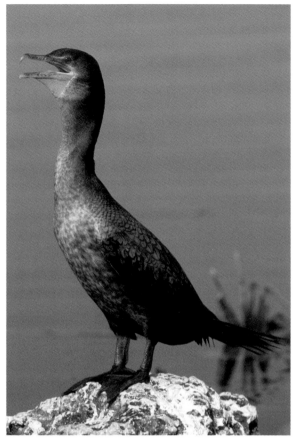

Habitat and Distribution:
Wetlands, reservoirs, and lakes statewide.

Seasonal Occurrence:
An abundant migrant in spring and fall, especially in April and October. Nests in colonies at a few Kansas sites, including Cheyenne Bottoms, Glen Elder Reservoir, and Kirwin National Wildlife Refuge. Nonbreeding individuals may be seen throughout the state in summer. A few linger in winter as long as water remains unfrozen.

Field Notes: These birds are a familiar sight at wetlands and lakes of all sizes during migration. They fly in a V-formation like geese and are fond of roosting on islands or sandbars surrounded by water. They are disliked by some fishermen, who are concerned that they are depleting game-fish populations, but studies have shown that most of their diet consists of food-fish species such as gizzard shad.

Sandhill Crane

Grus canadensis

Field Identification:
A large heron-like species, the Sandhill Crane is mostly gray in color except for the red crown. Juvenile birds lack the red crown and show more brownish color on the back. In flight, the neck is held straight out from the body, unlike herons, which always curl the neck back while flying. Their loud, rattling calls can be heard up to a mile away. **Size:** Length 46 inches; wingspan 77 inches.

Habitat and Distribution: Most birds are seen in central and western Kansas. Found at wetlands and in grain fields.

Seasonal Occurrence:
Spring migrant in March and early April, fall migrant in October and November. Winter flocks of over a thousand birds have been seen in Barber and Meade counties.

Field Notes: Concentrations of Sandhill Cranes sometimes number in the thousands. They usually roost together at night and fan out to forage on waste grain during the day. For a true wildlife spectacle, visit Quivira National Wildlife Refuge's Big Salt Marsh near sundown on an early November evening and watch as wave after wave of these huge birds return to the roost, usually with many thousands of geese. It is a sight not soon forgotten.

Ardea herodias

Great Blue Heron

Field Identification:
The Great Blue Heron is the largest heron species in Kansas. Most of the plumage is blue-gray. The head is mostly white with black plume feathers.
Size: Length 46 inches; wingspan 72 inches.

Habitat and Distribution: Found throughout the state at almost any stream or body of water.

Seasonal Occurrence: Permanent resident. Most migrate south during the coldest winter months, but a few are present year-round.

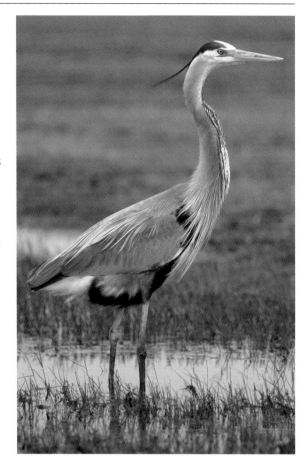

Field Notes: This is the most widespread and visible heron in Kansas, occurring even in urban areas. Great Blue Herons nest in colonies, which are used year after year. Their nests are large stick platforms placed high in mature cottonwood and sycamore trees.

Little Blue Heron

Egretta caerulea

Field Identification:
Adults are similar in size and shape to Snowy Egrets but are a slate-blue color on most of the body, with a dark reddish head and neck and a blue bill with a black tip. Juveniles are completely white and are most easily distinguished from the other white herons by their pale bill with a black tip. At about one year of age, the white plumage starts giving way to the dark adult plumage, and for several months the birds have a unique, patchy, calico appearance. **Size:** Length 24 inches; wingspan 40 inches.

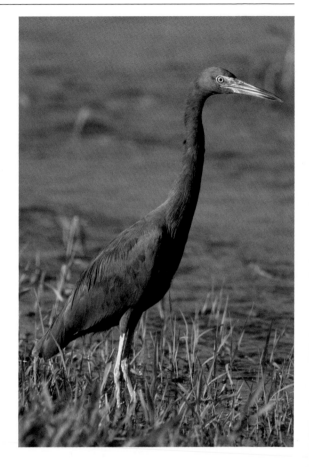

Habitat and Distribution: Wetlands, streams, and lakeshores, mostly in the eastern two-thirds of Kansas.

Seasonal Occurrence: Summer resident. Present from April through October.

Field Notes: This heron nests in large mixed-species colonies. In late summer, postbreeding birds wander widely and can be found across the state. It sometimes feeds along wooded streams and shores where other egrets are not often found.

Grus americana

Whooping Crane

Field Identification:
This crane is all white,
like an egret, but
much larger and more
heavy-bodied, with a
red crown. In flight,
look for the black outer
wing feathers, lacking
on any heron or egret
species. **Size:** Length 52
inches; wingspan
87 inches.

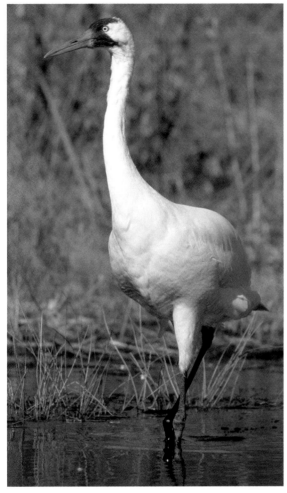

**Habitat and
Distribution:** Most
Kansas records are
from Kirwin National
Wildlife Refuge,
Quivira National
Wildlife Refuge, and
Cheyenne Bottoms,
but whoopers have also
been observed in other
central Kansas counties
along their narrow
migration flyway.

Seasonal Occurrence:
Migrant in spring
and fall. Most spring
records are from April;
fall records are from late October
and early November.

Field Notes: This well-known
endangered species has a wild
population of several hundred
individuals, most of which pass
through central Kansas each year. If
weather conditions are favorable for
migration, their stay is brief or they
fly over the state without stopping.
Occasionally a weather front will
induce them to remain for a few days
until the winds shift. At least a few
are seen each year at Quivira National
Wildlife Refuge and Cheyenne
Bottoms, more often in the fall than
in the spring.

Great Egret

Ardea alba

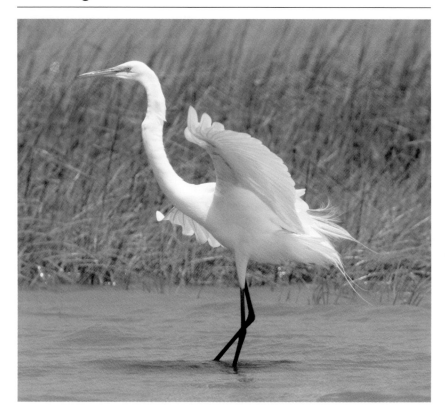

Field Identification: This is the largest of the white herons. The colors of the bill and legs are the most helpful field marks to easily differentiate the white heron species. Great Egrets have a large yellow bill, and the long legs are completely black. **Size:** Length 39 inches; wingspan 51 inches.

Habitat and Distribution: Mostly found in central and eastern Kansas, but has been seen west to the Colorado border. In late summer, wandering birds can turn up almost anywhere in the state. Seen at lakes, ponds, streams, flooded fields, and wetlands.

Seasonal Occurrence: Summer resident. Arrives in late March, and most depart in October. A few linger into November.

Field Notes: Great Egrets are much more numerous and widespread in Kansas today than they were several decades ago. They typically nest in large mixed-species heron rookeries. These wanderers are sometimes found in large numbers when an abundance of prey is present. Like the Great Blue Heron, they feed on a variety of aquatic prey such as fish and frogs.

Egretta thula

Snowy Egret

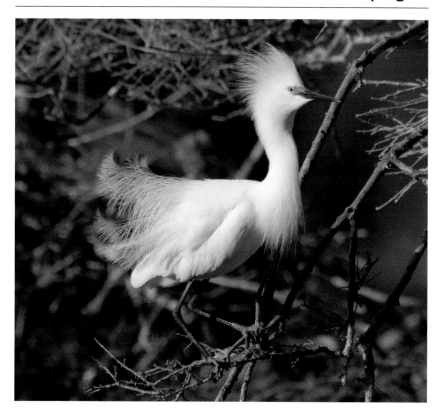

Field Identification: This is another all-white heron, about two-thirds the size of the Great Egret. Graceful head plumes appear in spring and early summer. The bill is all black and is more slender that that of the Great Egret. The legs are black, with bright yellow feet. Remember to look first at the bill and legs when observing white herons. **Size:** Length 24 inches; wingspan 41 inches.

Habitat and Distribution: Shallow wetlands and streams. Found most often in the eastern half of the state but can turn up almost anywhere in Kansas.

Seasonal Occurrence: Summer resident. Arrives in early April and departs in late September.

Field Notes: This egret often favors shallower water than the Great Egret. Sometimes feeding birds raise their wings over their head and run erratically through the water as they attempt to capture fish. In late summer, hundreds of Snowy Egrets often gather at Quivira National Wildlife Refuge, where they offer excellent views from the wildlife drive.

63

Cattle Egret

Bubulcus ibis

Field Identification:
This is the smallest of the white herons and the most likely to be seen away from water. In spring and early summer, adults have patches of light orange on the head, back, and breast. Compared with the other white herons, the Cattle Egret has a shorter neck, legs, and bill. The bill is all yellow. The legs are orange-yellow in the breeding season, darker the rest of the year.
Size: Length 20 inches; wingspan 36 inches.

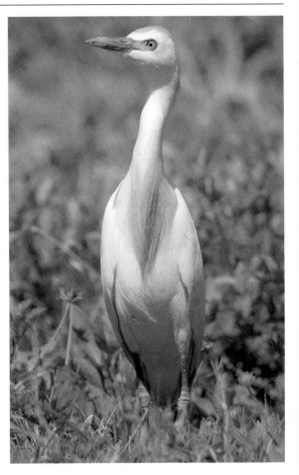

Habitat and Distribution: Found mostly in the eastern two-thirds of Kansas but has occurred west to the Colorado border. Often seen in pastures and other grassy areas following livestock but also frequents marshes and other aquatic areas.

Seasonal Occurrence: Summer resident. Present from April through October.

Field Notes: This is an Old World species that arrived in Brazil from Africa in the nineteenth century. It has expanded its range to include much of North and South America and arrived in Kansas in the 1960s. During the late-summer months, small flocks roam widely across Kansas. They feed on insects stirred up by the movement of the cattle they are often seen with and also descend on recently mowed areas to feed on insects.

Butorides virescens # Green Heron

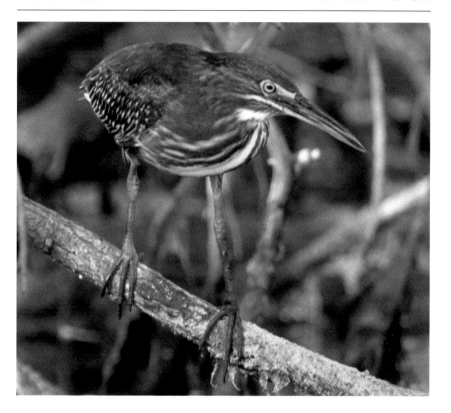

Field Identification: This small, chunky heron has a greenish-blue back and crown, dark chestnut-brown neck and face, and orange legs. Juvenile birds have broad white and brown streaking on the breast. Flying birds can be mistaken for crows at first glance but can be identified by their long bill and trailing legs. **Size:** Length 28 inches; wingspan 26 inches.

Habitat and Distribution: Found throughout Kansas. Favors small wooded streams but also frequents marshes and lakeshores.

Seasonal Occurrence: Summer resident. Present from April through early October.

Field Notes: Green Herons are an inconspicuous and usually solitary species. They utter a squawk and fly up the creek and out of sight when startled. They crouch motionless for long periods of time on branches near the bank or over the water and wait for an opportunity to catch minnows or other prey. At some urban locations, they have become quite accustomed to humans and can be easily observed.

Least Bittern

Ixobrychus exilis

Field Identification: This is the smallest heron in Kansas, and by far the most secretive. Look for the black back and crown and the white breast with broad streaks. The rest of the plumage is mostly orange or buff. In flight, large buff patches on the upper wings are apparent. It walks through dense wetland vegetation by grasping plants with its feet. Like the American Bittern, it will freeze with bill held upright to avoid detection.
Size: Length 13 inches; wingspan 17 inches.

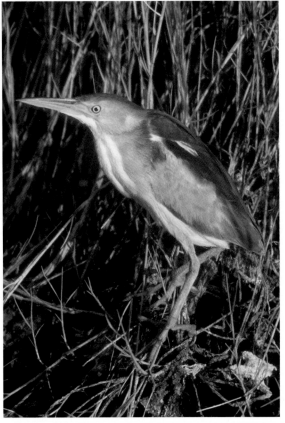

Habitat and Distribution: Dense cattail marshes of central and eastern Kansas. Stands of cattails near small impoundments are often sufficient to attract this species.

Seasonal Occurrence: Summer resident. Present from May through October.

Field Notes: Although relatively common at marshes such as Quivira National Wildlife Refuge and Cheyenne Bottoms, the Least Bittern is difficult to observe. The best opportunity to see one is during the late-summer months, when the adults are actively feeding nestlings. At these times, the adults are seen flying low over the cattails as they come and go from the nest. Carefully check the edge of the reeds near the water-control structures at these refuges, where Least Bitterns can sometimes be spotted as they wait for prey. Their song is a clue to their presence. It is a rhythmic, descending series of monotone cooing notes.

Botaurus lentiginosus

American Bittern

Field Identification:
This is an elusive brownish heron of dense cattail marshes. It is mostly a cryptic brown color, with broad vertical stripes on the neck and breast, a long greenish-yellow bill, and bright yellow eyes. **Size:** Length 28 inches; wingspan 42 inches.

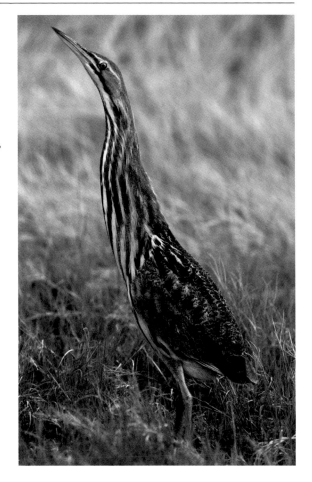

Habitat and Distribution: Can be found almost anywhere in Kansas during migration, but especially where tall vegetation is found near shallow water. Nests at Cheyenne Bottoms, Quivira National Wildlife Refuge, and other smaller wetlands in the central part of the state.

Seasonal Occurrence: Migrant and summer resident. Present from early May through mid-October.

Field Notes: American Bitterns often conceal themselves in tall vegetation by stretching out vertically with the bill pointed skyward and then freezing in position, rendering themselves virtually invisible. Their "song" is a deep guttural pumping sound that is often the best clue to their presence. It is heard most often at night or near dawn and dusk. Like many other wetland birds, this species is not observed as often in Kansas as it used to be because of the loss of marsh habitat. Carefully watch the edges of the cattail stands while driving on the dike roads at Quivira National Wildlife Refuge or Cheyenne Bottoms, and you might be rewarded with a good look at one of these unique birds.

Black-crowned Night-Heron

Nycticorax nycticorax

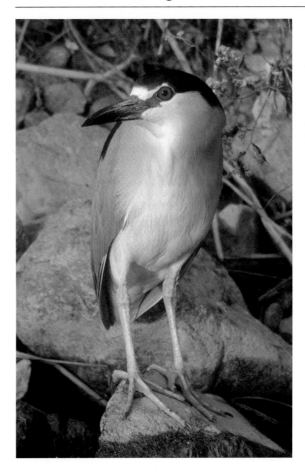

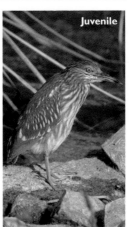

Juvenile

Seasonal Occurrence: Migrant and summer resident. Present from April through October. In some years, a few remain for the winter in southern Kansas.

Field Notes: This interesting heron forages mostly at night, although it is frequently seen during the day. Groups of up to twenty birds will gather at productive feeding areas. It is most easily seen at Cheyenne Bottoms and Quivira National Wildlife Refuge, but it is a widespread species in Kansas. This is one of the herons most likely to be found in southwest Kansas, where it nests in shelterbelts adjacent to foraging areas. At the Elkhart wastewater lagoons in semiarid southwest Kansas, flocks of up to fifty birds are seen each year, especially in September.

Field Identification: This is a short, stocky, large-headed heron. It has a black crown and back and is mostly white and gray otherwise, with a shorter, thicker bill than most heron species. Juveniles are mostly brown, heavily streaked below and speckled with white above. **Size:** Length 25 inches; wingspan 44 inches.

Habitat and Distribution: Statewide at marshes and other aquatic habitats.

Nyctanassa violacea

Yellow-crowned Night-Heron

Field Identification:
This species is similar in proportions to the Black-crowned Night-Heron but is more slender and longer necked. Adults are mostly lavender colored with a striking black-and-white facial pattern. Juveniles are very similar to juvenile Black-crowns but have much smaller white spots on the back.
Size: Length 24 inches; wingspan 42 inches.

Habitat and Distribution: Mostly in the southern half of the state, at marshes and along shorelines.

Seasonal Occurrence: Summer resident. Present from April through October.

Field Notes: Unlike the more social Black-crowned Night-Heron, this species is generally seen feeding alone. Its favorite food is crayfish, and it usually hunts in shallow pools and streams. These herons are not shy around humans, and on many occasions they have nested in mature trees located in suburban yards, sometimes adjacent to major highways. They readily feed in ditches along busy roads if hunting is productive.

White-faced Ibis

Plegadis chihi

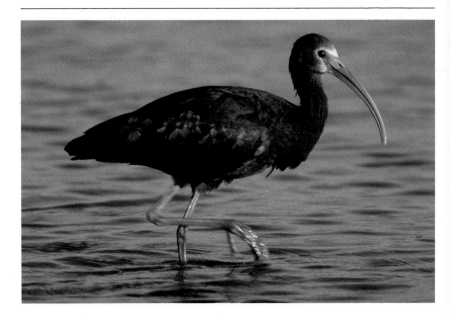

Field Identification: This is a dark, heron-like bird with a long, curved bill. Adults in breeding season are chestnut brown on the head, neck, and breast, with iridescent green wings and back. Juveniles and winter adults are less colorful. It is easily identified in flight by the dark color, trailing legs, and prominently curved bill. **Size:** Length 23 inches; wingspan 36 inches.

Habitat and Distribution: Found statewide at wetlands, lakeshores, and flooded fields.

Seasonal Occurrence: Migrant and summer resident. Present from April through October.

Field Notes: Nesting populations in Kansas are mostly restricted to Quivira National Wildlife Refuge and Cheyenne Bottoms, but small flocks of this ibis appear in many areas during migration. These birds often feed in tall wetland vegetation, and despite their relatively large size, they often go undetected. When disturbed, they take flight with unique nasal grunting calls.

Rallus elegans

King Rail

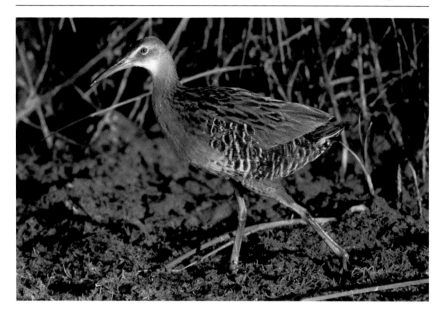

Field Identification: Rails are chicken-like birds of the marshes. King Rails are the largest rail species in the United States and are twice the size of any other rail species in Kansas. Adults are deep orange on the throat and breast, with contrasting black-and-white bars on the flanks and belly and a long, spike-shaped bill. The loud grunting call is often the first clue to their presence. **Size:** Length 15 inches; wingspan 20 inches.

Habitat and Distribution: A resident of dense marshes. Most are reported from central Kansas sites such as Quivira National Wildlife Refuge, Cheyenne Bottoms, and the Slate Creek Wetlands in Sumner County, although historically they have been recorded nesting in ten counties in central and eastern Kansas.

Seasonal Occurrence: Summer resident, present from March through October.

Field Notes: King Rails are in decline across much of the interior United States because of wetland destruction. The population at Quivira National Wildlife Refuge probably numbers less than fifty pairs, which makes it one of the most robust populations remaining anywhere west of the Mississippi River. A drive through the Big Salt Marsh at Quivira may provide the sharp-eyed observer with a glimpse of one. Carefully watch the edges of the cattails for these well-camouflaged birds.

Virginia Rail

Rallus limicola

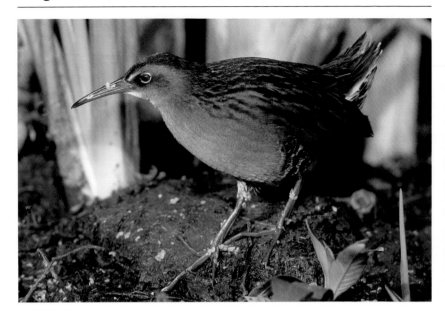

Field Identification: The Virginia Rail is similar to the King Rail in proportions and plumage but is about half the size. The face is gray; the bill and legs are orange-red. The most often-heard call is a peculiar series of oinking sounds. **Size:** Length 10 inches; wingspan 13 inches.

Habitat and Distribution: Statewide in wetlands, especially dense cattail marshes.

Seasonal Occurrence: Found year-round, but populations fluctuate greatly. Uncommon migrant, especially in May and September. Local summer resident. A few remain in winter in areas with open water and suitable cover.

Field Notes: This rail is more numerous and widespread than the King Rail, although like all rails, it is difficult to observe. It is fairly common in summer at Quivira National Wildlife Refuge and Cheyenne Bottoms as well as the many smaller wetlands throughout the state. If you play a recording of the calls of this species in wetland areas, it is often surprising how many will respond. This technique should not be overdone, as it can disturb territorial birds. As with the King Rail, patiently watching the edges of cattail stands is the best strategy for seeing one.

Porzana carolina # Sora

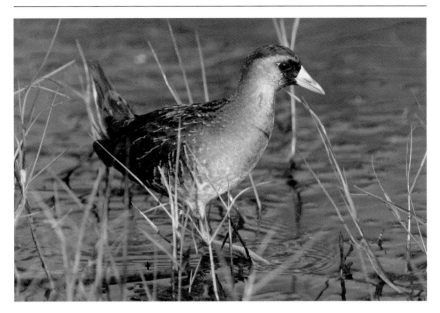

Field Identification: This rail is similar in size to the Virginia Rail but with a shorter and thicker bill, gray plumage on the throat and breast, and an area of black at the base of the bill. The barring on the flanks is less distinct than on other rails. When it is flushed into flight, the long legs dangle below the body. **Size:** Length 9 inches; wingspan 14 inches.

Habitat and Distribution: Generally seen in marshes, but during migration it is sometimes found in upland thickets far from water.

Seasonal Occurrence: Migrant. Spring migrants are seen in April and May, fall migrants during September and October. Occasionally nests in Kansas.

Field Notes: Soras often make their presence known by their vocalizations. The call is a high-pitched descending whinny; they also have a one- or two-note squeak call. Soras are more apt than other rails to feed in the open, although they are still quite secretive. Walking along the drier edge of marshy areas will sometimes flush these birds into brief flight.

Black-bellied Plover

Pluvialis squatarola

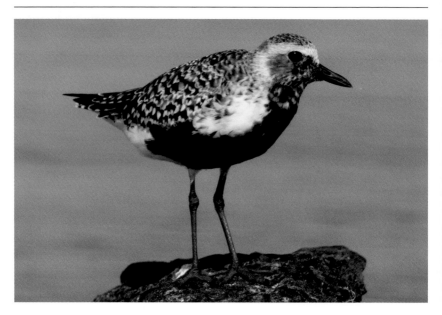

Field Identification: This is the largest plover in Kansas. Plovers have proportionately shorter and thicker bills than most sandpipers. In spring, the Black-bellied is checkered white and black on the back, with jet black underparts bordered by snowy white. Winter birds are mostly dull gray, but look for black "wingpits" and a prominent white wing stripe when they are flying. **Size:** Length 12 inches; wingspan 29 inches.

Habitat and Distribution: Statewide in wetland areas. Usually seen at mudflats, playas, plowed fields, or open shorelines. The largest numbers are seen at Quivira National Wildlife Refuge and Cheyenne Bottoms.

Seasonal Occurrence: Spring and fall migrant. Most spring migrants are seen in April and May and most fall birds during September and October. A few linger into November.

Field Notes: When in full breeding plumage, this is one of the most impressive shorebird species in Kansas. Sometimes sizable flocks can be seen at the larger wetlands, but most sightings are of small groups or single birds. Their plaintive flight call is a memorable sound of the marshes.

Pluvialis dominica

American Golden-Plover

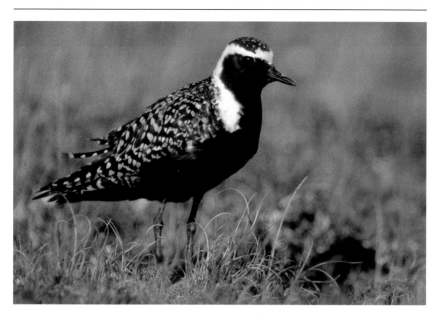

Field Identification: This species is similar in appearance to the Black-bellied Plover. Breeding-plumaged birds seen in spring have rich gold-and-black checkering on the back. The undertail is completely black, unlike the white undertail of the Black-bellied. Winter birds are similar to Black-bellied but usually have a more noticeable white stripe above the eye. In both spring and fall, these birds often show a transition between breeding and winter plumage, and flocks can contain individuals with a variety of plumages. **Size:** Length 10 inches; wingspan 26 inches.

Habitat and Distribution: Statewide at wet mudflats, wetlands, sod farms, and burned prairies.

Seasonal Occurrence: Migrant in spring and fall. Uncommon in spring, especially during late March and early April. Even less numerous in fall, when many move south along the Atlantic seaboard instead of through the interior of the continent.

Field Notes: Flocks of up to several hundred birds can be seen on freshly burned prairies in the Flint Hills during the early spring. Watch for their pale bodies contrasting with the blackened prairies.

Snowy Plover

Charadrius alexandrinus

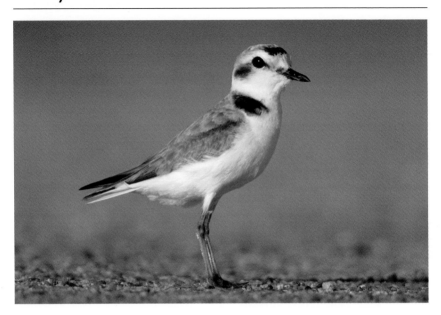

Field Identification: A small, pale plover, the Snowy Plover is all white below, with sandy upper parts and a black bill. The male has black patches on its head and shoulders, which are brown on the female. **Size:** Length 6 inches; wingspan 17 inches.

Habitat and Distribution: Most are found on the white alkali flats of Quivira National Wildlife Refuge and at Cheyenne Bottoms, but they have nested elsewhere in western Kansas. In early spring, migrants regularly turn up throughout the state.

Seasonal Occurrence: Summer resident. Most arrive in early April and depart by early September.

Field Notes: Central Kansas represents the eastern edge of the breeding range for this small plover in North America. Their pale colors are an adaptation to the environment in which they live, and they can be very difficult to see when they are motionless. Be careful when walking the roadsides at Quivira National Wildlife Refuge, because the eggs are even better camouflaged than the adults!

Charadrius melodus

Piping Plover

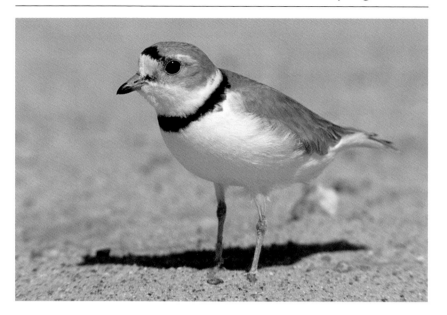

Field Identification: Similar to the Snowy Plover in many respects, the Piping Plover is differentiated by its narrow black breast band, orange legs, and orange bill with black tip. In flight, the upper tail is all white at the base with a black tip, whereas the Snowy Plover's upper tail is sandy brown with white edges. **Size:** Length 7 inches; wingspan 19 inches.

Habitat and Distribution: Migrants are seen on mudflats and sandy shorelines statewide but most often in the marshes of central Kansas. A few pairs nest on the Kansas River between Manhattan and Lawrence.

Seasonal Occurrence: Migrant in spring and fall, with the exception of the small nesting population mentioned above.

Field Notes: This species is considered threatened or endangered throughout its range. Kansas is located on the flyway for the inland population, which nests in the northern Great Plains. This is one of the more sought-after shorebird species for avid birders in Kansas.

Semipalmated Plover

Charadrius semipalmatus

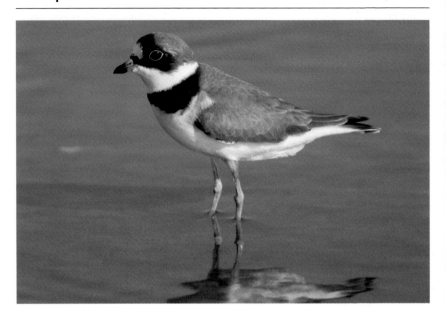

Field identification: This small plover is like a miniature Killdeer in some respects and like the Piping Plover in others. It is dark brown above and white below. It has a single black band on the breast and a black mask. The legs are orange, and the bill is orange with a black tip. **Size:** Length 7 inches; wingspan 19 inches.

Habitat and Distribution: Statewide at wetlands and marshes, almost always on open mudflats.

Seasonal Occurrence: Spring and fall migrant. Spring migrants are seen in April and May; fall migrants from July through September.

Field Notes: Look for this species on the wettest mudflats. At large wetlands, the darker-brown Semipalmated Plover is found on the equally dark wet mud nearest to the open water, whereas the pale-colored Piping and Snowy Plover prefer the drier, lighter-colored mud located farther from the water's edge.

Charadrius vociferus

Killdeer

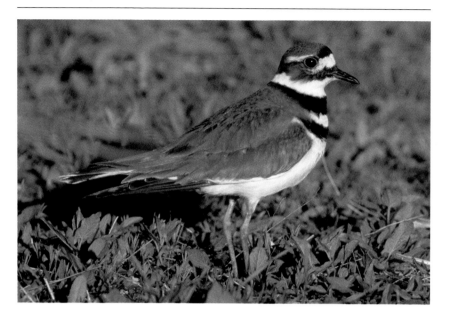

Field Identification: This is an abundant and familiar large plover of rural and urban areas. It is similar in color and pattern to the Semipalmated Plover but larger and longer-legged, with two black breast bands. In flight, look for the orange-and-black tail and broad white wing stripe. It is vocal at all seasons, and its two-note "killdeer" call is a familiar sound of farm country. **Size:** Length 11 inches; wingspan 24 inches.

Habitat and Distribution: Common statewide in thinly vegetated areas in urban parks, plowed fields, wet areas, gravel roads, and parking lots.

Seasonal Occurrence: Migrant and summer resident. Most numerous in migration; common in summer. A few hardy individuals remain for the winter in southern Kansas.

Field Notes: The arrival of the first northbound migrant Killdeer in mid-February is one of the earliest signs of spring in Kansas. Killdeer frequently nest on gravel parking lots and roadsides and will feign injury in order to distract humans and other predators from the nest site. In the summer, most are seen singly or in family groups, but during migration they typically occur in flocks.

Black-necked Stilt

Himantopus mexicanus

Field Identification: This large, slender, black-and-white shorebird has extremely long, bright-red legs. It is impossible to confuse with any other bird species. **Size:** Length 14 inches; wingspan 29 inches.

Habitat and Distribution: Wetlands of central and western Kansas. Wandering birds have appeared throughout the state, especially in the spring.

Seasonal Occurrence: Summer resident. Arrives in early April and departs in late August.

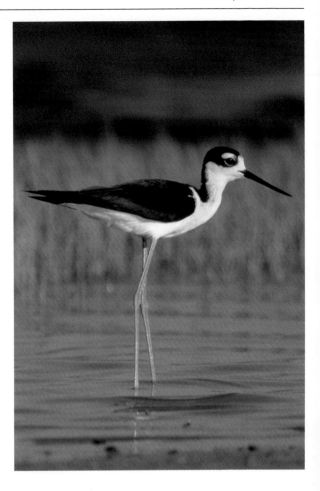

Field Notes: In Kansas, this conspicuous bird is easily found at Quivira National Wildlife Refuge. It is easily found at Cheyenne Bottoms in years when water conditions are favorable and has also nested in several counties in southwest Kansas. A summer cruise along the wildlife drive at Quivira should provide numerous looks at these distinctive birds. When you drive near one of their nests, they become agitated and fly about, giving a variety of alarm sounds. Several decades ago they were rare in Kansas, but in recent years the population has become more numerous, and sightings throughout the state have increased.

Recurvirostra americana

American Avocet

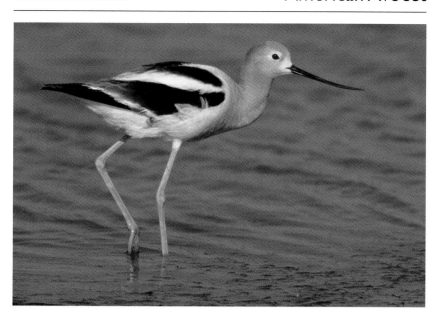

Field Identification: Avocets are an easily identified shorebird with exceptionally long blue-gray legs and a thin, upcurved bill. They have a bold black-and-white pattern on the body. The head and neck are pinkish-brown in summer, pale gray in winter. **Size:** Length 18 inches; wingspan 31 inches.

Habitat and Distribution: Statewide at lakes and wetlands. Nests at Cheyenne Bottoms and Quivira National Wildlife Refuge and occasionally at other wetlands in central and western Kansas.

Seasonal Occurrence: Migrant and summer resident. Arrives in early April and departs in late October.

Field Notes: This species is closely related to the Black-necked Stilt. Avocets typically feed by sweeping the bill back and forth across the surface of the water. Sometimes an entire flock will be found feeding together in this manner. During migration, it is not uncommon to see them swimming in lakes and ponds in fairly deep water. Avocets show agitation and vocalize loudly when their nests are approached.

Greater Yellowlegs

Tringa melanoleuca

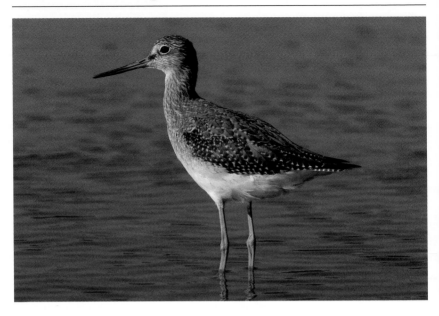

Field Identification: This is one of the larger sandpipers. Look for the long legs and the slender overall build. The best field mark is the bright-yellow leg color. In breeding plumage, it has black bars on the flanks. It is distinguished from the closely related Lesser Yellowlegs by the larger size as well as the longer, slightly upcurved bill. The two- or three-note call is a familiar sound of the marshes.
Size: Length 14 inches; wingspan 28 inches.

Habitat and Distribution: Statewide at wetlands and shorelines.

Seasonal Occurrence: Spring and fall migrant.

Field Notes: Greater Yellowlegs are one of the more common shorebird species in Kansas. They tend to arrive earlier in the spring and linger longer in the fall than the closely related Lesser Yellowlegs.

Tringa flavipes

Lesser Yellowlegs

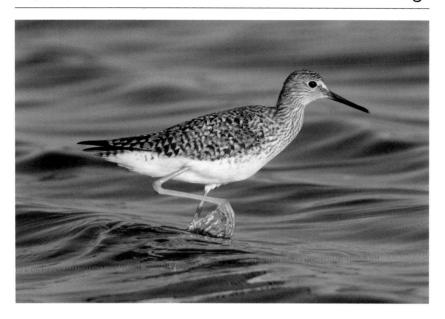

Field Identification: Lesser Yellowlegs are similar to the Greater Yellowlegs. They differ by their smaller size and the shorter, straighter bill. Their calls are less strident and are usually given in one or two notes, in contrast to the two- or three-note call of the Greater Yellowlegs. On both yellowleg species, look for the all-white tail and rump in flight. This is helpful in distinguishing them from other flying shorebirds. **Size:** Length 11 inches; wingspan 24 inches.

Habitat and Distribution: Found statewide at wetlands, flooded fields, and a variety of shoreline habitats. More of a generalist than most other shorebird species, it readily adapts to a variety of habitats as long as some shallow water is present.

Seasonal Occurrence: Spring migrant from March through June; fall migrant from July through October.

Field Notes: This is one of the most common migratory sandpipers in Kansas. At the peak of migration, hundreds can be seen at the large wetlands.

Solitary Sandpiper

Tringa solitaria

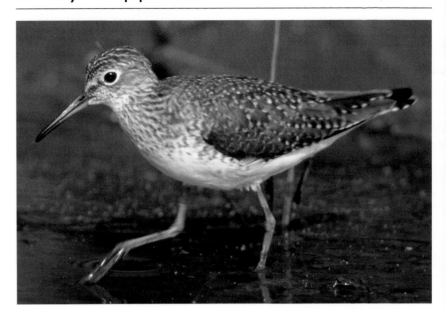

Field Identification: The Solitary Sandpiper is closely related to the yellowlegs, which it resembles in many ways. The legs are shorter and more greenish. Look for the fine white speckling on the back and a prominent eye ring. In flight, the center of the upper tail is black with prominent black bars. Gives a loud, clear two-note call when flushed, accented on the second note. Sometimes bobs its head while walking. **Size:** Length 8 inches; wingspan 22 inches.

Habitat and Distribution: Statewide. Favors small temporary pools but often seen at large wetland areas and other shoreline habitats.

Seasonal Occurrence: Migrant. Seen in spring from March through May and in fall from July through October.

Field Notes: True to its name, this species is rarely seen in groups of more than two or three birds. It is fairly inconspicuous until flushed, flying away while giving its clear, two-note call.

Tringa semipalmata

Willet

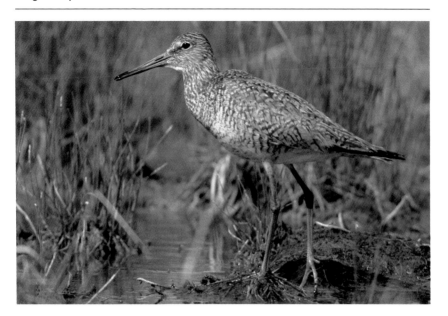

Field Identification: This large shorebird is heavy-bodied with a long, stout bill and gray legs. It is mostly grayish colored, with a scalloped or patterned look in breeding season that gives way to a plainer appearance in winter plumage. When it takes flight, strongly patterned black-and-white wings are seen. **Size:** Length 15 inches; wingspan 26 inches.

Habitat and Distribution: Statewide at large wetlands, small prairie pools, lakeshores, and riverbanks.

Seasonal Occurrence: Spring migrant from April through June; fall migrant from August through October.

Field Notes: This large sandpiper is one of several shorebirds that show a strong preference for temporary rain pools. Despite the subtle plumage colors, it is conspicuous because of its large size and striking wing pattern in flight.

Spotted Sandpiper

Actitis macularius

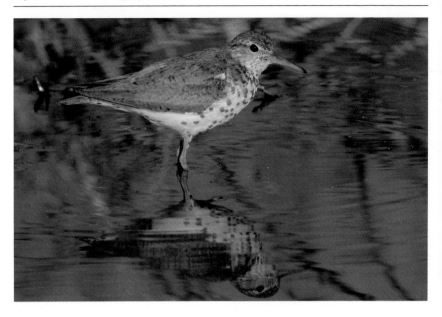

Field Identification: A small shorebird of streams and ponds, the Spotted has a short neck and an elongated, tapered body. It walks with an odd bobbing gait. When flushed, it flies low across the water with flicking wingbeats, usually uttering a two-note alarm call. Summer birds have heavy black spotting below, bright orange legs, and a thin white eye line. Winter birds lose the spots and have a dull brown wash on the breast. **Size:** Length 7 inches; wingspan 15 inches.

Habitat and Distribution: Statewide. Favors rivers and streams more than any other Kansas shorebird, although it is also found at ponds and lakes.

Seasonal Occurrence: Migrant and summer resident. Most numerous during migration, but some remain to nest where appropriate habitat exists.

Field Notes: Its preference for rivers and streams, distinctive gait and flight style, and the fact that it is never observed in flocks make this one of the most unique sandpipers found in Kansas. It is widespread throughout the state.

Bartramia longicauda

Upland Sandpiper

Field Identification: A large shorebird found on the open prairies, the Upland Sandpiper appears round-headed, with large, dark eyes on a pale face. It has a potbellied look; long, yellowish legs; and a relatively short bill. **Size:** Length 12 inches; wingspan 26 inches.

Habitat and Distribution: Native prairies and hay fields throughout the state. Nests mostly in the eastern two-thirds of Kansas, most abundantly in the Flint Hills.

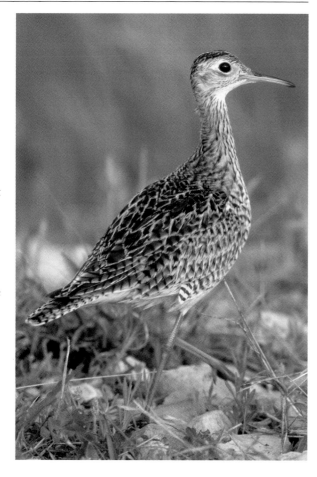

Seasonal Occurrence: Migrant and summer resident. Arrives in April and departs in early September. Fairly common during fall migration in late July and August.

Field Notes: This is truly an upland bird, almost never seen near water. A summer drive through the Flint Hills and other prairie areas should provide several good looks at this species. They are fond of perching on top of wooden fence posts. The unique song is often referred to as the "wolf whistle" and is one of the most memorable sounds of the Kansas prairies. Their nesting range extends north to Alaska, and many are already moving south by mid-July. On a quiet night in late summer, you can hear their unique four-note flight calls as they pass overhead. In July and August, large numbers sometimes gather in freshly mown hay fields to feed on insects.

Long-billed Curlew

Numenius americanus

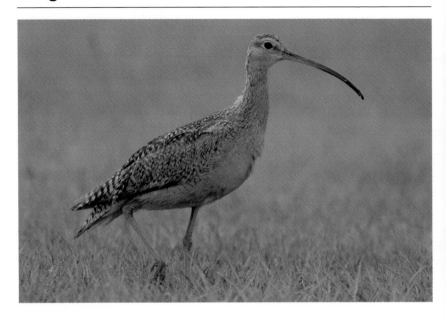

Field Identification: This is the largest shorebird in Kansas, with an absurdly long and deeply curved bill. It is mostly mottled brown above, unmarked and paler on the belly. In flight, the bright cinnamon underwings are prominent. **Size:** Length 23 inches; wingspan 35 inches.

Habitat and Distribution: A few nest in shortgrass prairies of far western Kansas, mostly in Morton County. During early spring, large flocks are sometimes found in irrigated crop circles in the Garden City area. Smaller numbers are found in central Kansas during migration, usually at the large wetlands.

Seasonal Occurrence: Migrant and summer resident. Spring migrant from March through May; fall migrant from August through September. The small breeding population is present throughout the summer months.

Field Notes: This species was once more widespread in Kansas. Overhunting and habitat alteration during the settlement period reduced the breeding range and overall population significantly. Its large size and unusually large bill make it one of the most distinctive shorebirds in the world. For most Kansas birders, the best opportunity to find them is in early spring at Quivira National Wildlife Refuge or Cheyenne Bottoms.

Numenius phaeopus

Whimbrel

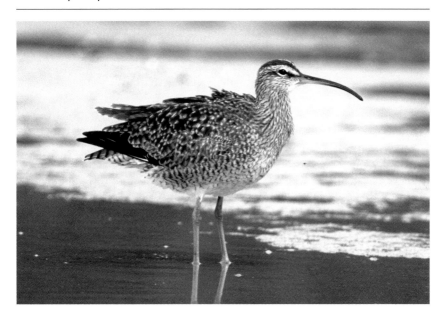

Field Identification: This large, brownish-gray shorebird with a long, deeply curved bill is smaller than the Long-billed Curlew, and the bill is not as long. The distinct black-and-white stripes on its head separate it from the plainly marked Long-billed Curlew. It also lacks the cinnamon wing linings of the Long-billed Curlew. **Size:** Length 17 inches; wingspan 32 inches.

Habitat and Distribution: Found in wetlands and on shorelines, mostly in the central and western parts of Kansas.

Seasonal Occurrence: Migrant in spring and fall. Most spring sightings are in April and May. Fall records are few but have occurred between August and October.

Field Notes: This species is one of the harder-to-find migratory shorebirds in Kansas. Most sightings have come from Quivira National Wildlife Refuge and Cheyenne Bottoms. Flocks of up to several dozen have been reported elsewhere in the state. Look for them in flooded grass, mudflats, recently burned grasslands, and wastewater treatment facilities in western Kansas.

Hudsonian Godwit

Limosa haemastica

Field Identification: A large sandpiper with a long, two-toned bill, the Hudsonian Godwit in breeding plumage is deep rusty red on the breast and belly and darker above, with a pale head. Some seen in early spring are still in winter plumage, which is mostly a uniform light gray. In flight, the tail is black with a clean-cut white rump, and a narrow white wing stripe is visible. **Size:** Length 15 inches; wingspan 29 inches.

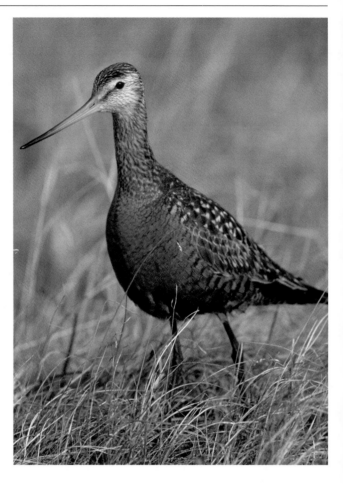

Habitat and Distribution: Prairie marshes, playa wetlands, burned prairies. Most are seen in the central part of the state, but migrants occur throughout Kansas.

Seasonal Occurrence: Spring migrant in April and May. In fall, most migrate south along the Atlantic Coast, and only a few stragglers return south across the plains.

Field Notes: Most of the entire world population of this species passes through Kansas in the spring, and flocks numbering in the hundreds can sometimes be seen at Quivira National Wildlife Refuge and Cheyenne Bottoms when habitat and feeding conditions are favorable.

Limosa fedoa

Marbled Godwit

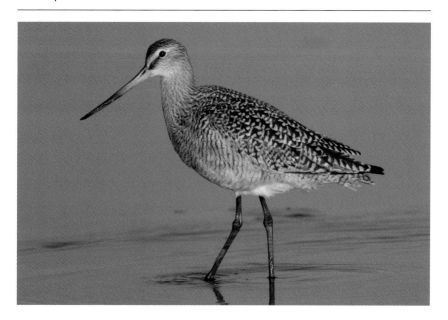

Field Identification: The Marbled is larger and heavier-bodied than the Hudsonian Godwit, with a longer bill. Adults in breeding season are barred brown and black, becoming a plainer brown by late summer. In flight, the bright cinnamon underwings are visible. **Size:** Length 18 inches; wingspan 30 inches.

Habitat and Distribution: Statewide at marshes and other shoreline habitats.

Seasonal Occurrence: Migrant. Spring migration is in April and May; fall migration from August through October.

Field Notes: This large shorebird has been observed throughout the state. It is more likely to be seen on lakeshores than is the Hudsonian Godwit. Any godwit seen in late summer and fall is most likely to be this species, since the Hudsonian Godwit migrates along the Atlantic Coast in fall. The two godwit species are often seen together during the spring migration, as they prefer to forage in water of similar depth.

Ruddy Turnstone

Arenaria interpres

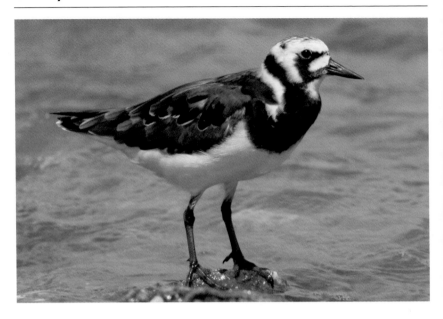

Field Identification: Adults in spring are patterned with bright chestnut and black on the back and wings and have an intricate black-and-white facial pattern and orange legs. Fall birds have the same basic pattern, but less colorful and more poorly defined. **Size:** Length 9.5 inches; wingspan 21 inches.

Habitat and Distribution: Found in wetlands and along shorelines, often those with rocks, gravel, or woody debris. They can be found statewide, but most reports are from Quivira National Wildlife Refuge and Cheyenne Bottoms.

Seasonal Occurrence: Migrant in both spring and fall. Spring migrants are seen in May and fall migrants from August through October.

Field Notes: Ruddy Turnstones have slightly upturned bills, which they use to flip over rocks and other shoreline debris in search of food. When water and shoreline conditions are favorable at Cheyenne Bottoms, several can be seen in a single day along the rocky riprap adjacent to the dike roads.

Calidris alba # Sanderling

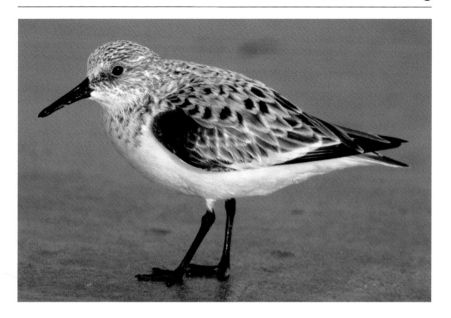

Field Identification: Birds in winter plumage are pale gray above, sometimes with black checkering on the back and an obvious black shoulder mark. Summer birds have a rich rusty head, breast, and upperparts. The bill is proportionately longer and stouter than on other small sandpipers. In flight, look for the broad, prominent white wing stripe. As with many other shorebird species, individuals in winter and summer plumage can often be seen side by side during migration. **Size:** Length 8 inches; wingspan 17 inches.

Habitat and Distribution: Statewide, though most likely to be seen in central Kansas at shallow mudflats and sandy shorelines.

Seasonal Occurrence: Migrant. Spring migrants are seen in April and May; fall migrants from August through October.

Field Notes: This is one of the most common shorebirds along the ocean coasts but is one of the less frequently seen shorebirds in Kansas and elsewhere in the interior states. To find Sanderlings, scan large feeding flocks of sandpipers for birds that are perceptibly larger than the "peeps" and either noticeably pale white or else bright rusty-red in color.

Semipalmated Sandpiper

Calidris pusilla

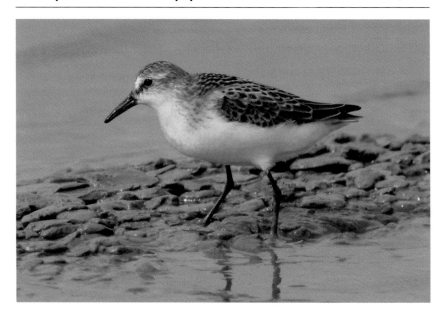

Field Identification: This is one of the small "peep" sandpiper species. The dark legs separate it from the Least Sandpiper. The bill is shorter and straighter than that of the similar Western Sandpiper. When the bird is standing, the wingtips do not extend beyond the tail feathers. In spring, it is mottled brownish above and streaked on the breast. Winter birds are gray above with grayish breast. **Size:** Length 6 inches; wingspan 14 inches.

Habitat and Distribution: Mudflats, flooded fields, and shorelines statewide.

Seasonal Occurrence: Spring migrant from March through late May; fall migrant from late July through October.

Field Notes: Several of the small shorebird species in the genus *Calidris* are often collectively referred to as "peeps" by birders. They share many field marks and can be difficult for the beginning birder to tell apart, especially since they are often seen at a distance, are very active when feeding, and occur in mixed flocks. Semipalmated is probably the most abundant peep in Kansas, and hundreds or even thousands can be seen on mudflats at Cheyenne Bottoms and Quivira National Wildlife Refuge. They are commonly observed at small wetlands across the state.

Calidris mauri

Western Sandpiper

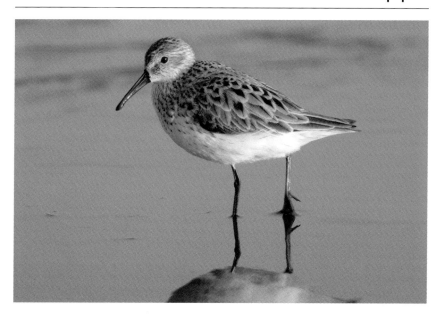

Field Identification: One of the small "peep" sandpiper species, the Western is often difficult to differentiate from the similar Semipalmated Sandpiper. Most adults have a longer bill than the Semipalmated, with a slight droop at the tip. It is also more brightly rufous in spring plumage than the Semipalmated and has more unmarked white on the breast in nonbreeding plumage. **Size:** Length 6.5 inches; wingspan 13 inches.

Habitat and Distribution: Statewide, but most numerous in the western half of Kansas.

Seasonal Occurrence: Migrant. Seen in spring from April through early June and in fall migration from late July through October.

Field Notes: This is a fairly common species in migration but can be difficult to differentiate from the Semipalmated Sandpiper, although typical adults observed at close range are relatively easy to identify. This species is most easily found at the large central wetlands.

Least Sandpiper

Calidris minutilla

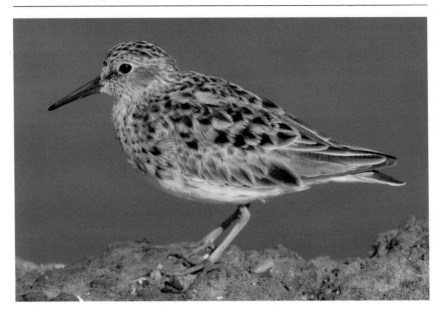

Field Identification: This is the smallest of the "peep" sandpiper species and is in fact the smallest sandpiper species in the world. When identifying peeps, one of the first things to look for is leg color. Any peep with yellow legs is this species. Spring birds show fairly bright rufous markings; winter birds are a dull grayish-brown. When the bird is standing, the wingtips do not extend beyond the tail feathers. **Size:** Length 6 inches; wingspan 13 inches.

Habitat and Distribution: Statewide at wetlands, shorelines, and river sandbars.

Seasonal Occurrence: Spring migrant from March through late May; fall migrant from August through November. Some remain into early winter in southern Kansas, especially along the Arkansas River.

Field Notes: Along with the Semipalmated, this is one of the most abundant shorebirds in Kansas. Large numbers can be seen during migration, often in association with other species of peeps.

Calidris bairdii

Baird's Sandpiper

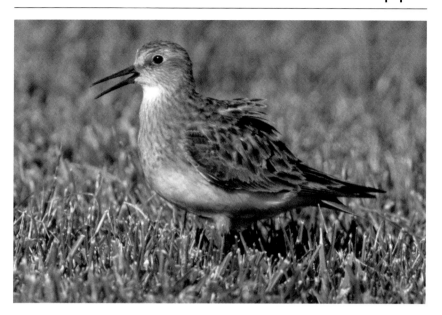

Field Identification: One of the largest "peep" sandpiper species, Baird's is a bit larger than the preceding three species, with a longer and more tapered body shape. When the bird is standing, the wingtips extend beyond the tail feathers. In spring, the back feathers have a scaly appearance, giving way to a dull grayish-brown in winter. **Size:** Length 7.5 inches; wingspan 17 inches.

Habitat and Distribution: Statewide at wetlands and other shoreline habitats, more often found on pastures and sod farms than other peeps.

Seasonal Occurrence: Spring migrant from March through June; fall migrant from July through October.

Field Notes: This is often the first shorebird to arrive in Kansas on the journey north in spring, and in fall they tend to linger longer than most other shorebirds. With practice, it becomes easier to recognize their longer, tapered shape, especially when they are seen with other small sandpipers for comparison.

White-rumped Sandpiper

Calidris fuscicollis

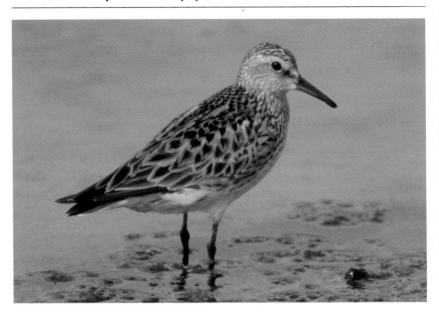

Field Identification: One of the large "peep" sandpiper species, the White-rumped is similar in size to Baird's but is more heavy-bodied in shape. When the bird is standing, the wingtips extend beyond the tail feathers. It has gray-and-rufous-patterned plumage on the back, with well-defined streaks on the breast and flanks. Seen in flight, it has an all-white rump. All other peep sandpipers in Kansas have white rumps divided by a black bar. **Size:** Length 7.5 inches; wingspan 17 inches.

Habitat and Distribution: Statewide at wetlands, prairie playas, and shorelines.

Seasonal Occurrence: Spring migrant. Most are seen in late May and early June. Seen only occasionally in fall.

Field Notes: Like the Hudsonian Godwit, most of the population of this species migrates north through the central plains to arctic nesting areas in spring but returns south along the Atlantic seaboard in the fall. A large percentage of the world population passes through Kansas in the spring. When you observe large numbers of White-rumps, you know the spring shorebird migration is nearly over, as they are the last of these species to pass through Kansas on the long flight to the arctic tundra nesting grounds.

Calidris melanotos

Pectoral Sandpiper

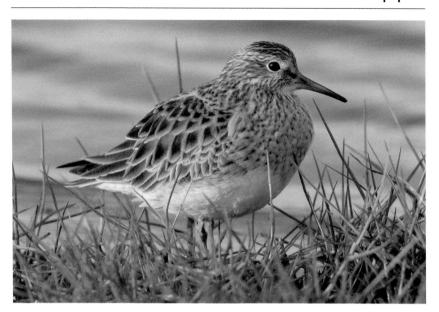

Field Identification: A plump, barrel-chested, and medium-sized sandpiper, the Pectoral has heavy streaking on the breast with a clearly defined bottom edge and yellow legs. **Size:** Length 9 inches; wingspan 18 inches.

Habitat and Distribution: Statewide at wetlands and shorelines. Like the Baird's Sandpiper, it is often found at sod farms, pastures, and other grassy habitats.

Seasonal Occurrence: Spring migrant in April and May; fall migrant from August through October.

Field Notes: This sandpiper is less numerous than some of the other shorebirds but can be seen on most trips to the major wetland areas during spring and fall migration. The plumage is somewhat similar to that of the Least Sandpiper except for the significantly larger size and fuller breast.

Dunlin

Calidris alpina

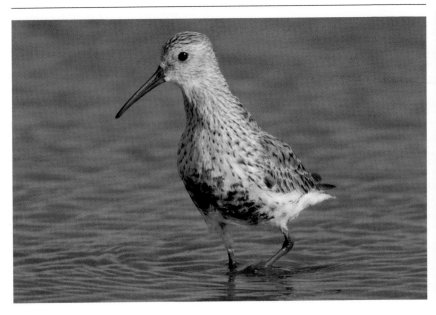

Field Identification: This medium-sized shorebird has a long, drooped bill. Adults in spring have a bright rufous back and a large black patch on the white underparts. In fall, the plumage is uniformly brownish-gray on the head, upperparts, and breast, and the belly is white. In flight, it shows a fairly extensive white wing stripe, although it is not as extensive as that of the Sanderling. **Size:** Length 8.5 inches; wingspan 17 inches.

Habitat and Distribution: Found on wetland mudflats, sandy or muddy shorelines, and occasionally flooded fields. Most sightings are in central and eastern Kansas.

Seasonal Occurrence: Spring migrant in April and May; fall migrant from September through late November.

Field Notes: Careful scanning of large flocks feeding on mudflats will often turn up a few of these shorebirds. Dunlins are more likely to be seen in the fall than in the spring. They are hardy and often linger later in the fall than most other shorebirds.

Calidris himantopus

Stilt Sandpiper

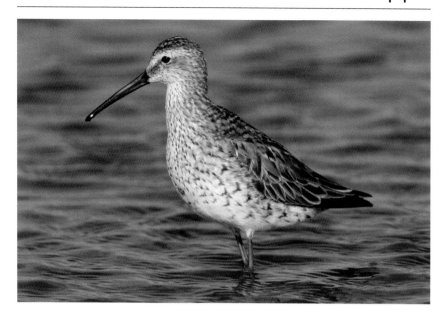

Field Identification: The Stilt Sandpiper is a plump, medium-sized sandpiper with long legs and a heavy, drooped bill. Spring birds have dense bars on the breast and a bright chestnut ear patch. In fall, they are pale gray with no prominent markings. **Size:** Length 9 inches; wingspan 18 inches.

Habitat and Distribution: Statewide at wetlands and shallow ponds.

Seasonal Occurrence: Spring migrant from April through early June; fall migrant from July through September.

Field Notes: Stilt Sandpipers often associate with dowitchers but usually forage in slightly shallower water. They feed in a distinctive "sewing machine" style, much as dowitchers do. The long legs allow them to feed in deeper water than many other sandpipers. They are one of the latest-lingering species in spring and can often be seen in large numbers in late May.

Buff-breasted Sandpiper

Tryngites subruficollis

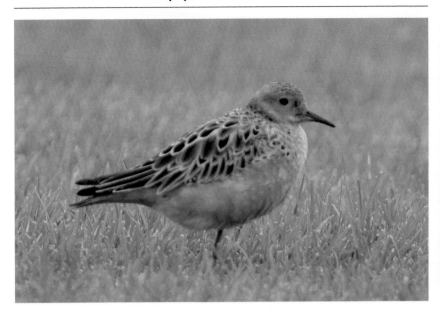

Field Identification: This distinctive sandpiper has a pigeon-headed look. It has a scaly pattern on the back and is evenly buffy-brown below, with a short, plover-like bill and yellow legs. Snowy white wing linings are prominent on flying birds. **Size:** Length 8 inches; wingspan 18 inches.

Habitat and Distribution: Found at sod farms, airports, short prairies, and plowed fields, mostly in central and eastern Kansas.

Seasonal Occurrence: Spring migrant in May; fall migrant in August.

Field Notes: This is one of the rarest shorebirds in North America. Some authorities estimate the entire world population to number fewer than ten thousand birds. Their migration path passes directly through the Great Plains in both spring and fall. Most Kansas sightings come from sod farms during the month of August, when southbound birds are fattening up for the long flight south to the Argentine pampas. Sod farms in Douglas, Johnson, and Sedgwick counties produce sightings of these birds each year. In the spring, they are in a hurry to reach the arctic breeding grounds and do not linger long.

Limnodromus scolopaceus

Long-billed Dowitcher

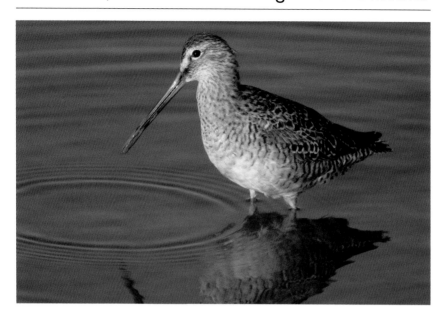

Field Identification: Dowitchers are large sandpipers with a chunky appearance and a prominent long, straight bill. In breeding plumage, they have a scalloped pattern on the back and orange underparts. Winter-plumaged birds are a nondescript gray but are easily identified by shape and bill. The narrow white wedge on the back is a good field mark on flying birds. **Size:** Length 11 inches; wingspan 19 inches.

Habitat and Distribution: Statewide at wetland areas.

Seasonal Occurrence: Spring migrant in April and May; fall migrant from August through October.

Field Notes: This sandpiper can be found in large flocks during migration at wetlands with appropriate water conditions. It is often seen feeding in association with other sandpipers, especially the Stilt Sandpiper. Dowitchers probe the mud in a methodical up-and-down motion that is often compared to the motion of a sewing machine. They typically feed in water that reaches their bellies. The closely related **Short-billed Dowitcher** is also seen in Kansas during migration. The two species are difficult to tell apart, even for experienced birders. Despite the names, bill length is not a reliable way to tell them apart.

Wilson's Snipe

Gallinago delicata

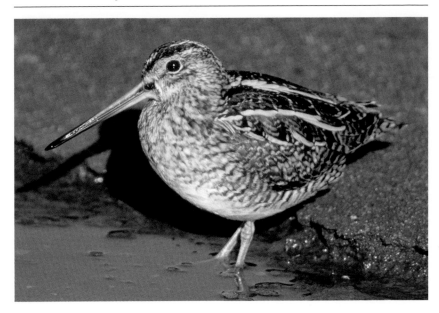

Field Identification: This is a large, chunky sandpiper with a long, straight bill, short legs, barred flanks, and bold striping on the head and back. When flushed, it gives a harsh call note while flying away swiftly on pointed wings. **Size:** Length 10 inches; wingspan 18 inches.

Habitat and Distribution: Statewide in densely vegetated, shallow wetland areas. Sometimes seen in the open on mudflats and shorelines.

Seasonal Occurrence: Spring migrant in March and April; fall migrant from September through November. A few remain for the winter.

Field Notes: Although it is sometimes seen on open mudflats in small flocks, this sandpiper typically goes unnoticed until it is startled into flight from its grassy wetland haunts. Its plumage provides excellent camouflage. This species and the American Woodcock are the only shorebirds that are hunted as game birds in Kansas.

Scolopax minor

American Woodcock

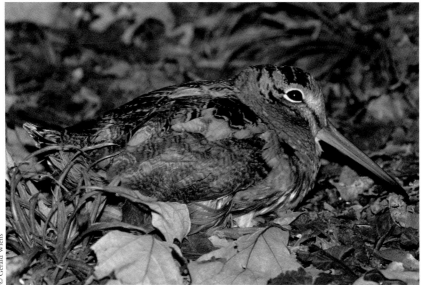

© Gerald Wiens

Field Identification: The woodcock is a medium-sized, plump shorebird with odd proportions. The legs are extremely short for a shorebird. It is pale orange below, gray and black above, with a long, straight bill. **Size:** Length 11 inches; wingspan 18 inches.

Habitat and Distribution: Spring and fall migrant in the forested eastern third of Kansas. Stray migrants have been seen west to the Colorado state line. During migration, Woodcocks have turned up in a variety of odd locations but are usually flushed from the ground in moist wooded areas. A few remain to nest in wet, brushy meadows, west to Harvey and McPherson counties.

Seasonal Occurrence: Migrant and summer resident. Arrives in late February and departs in November.

Field Notes: This species is mostly nocturnal and as a result often goes unseen. It typically nests in the same areas from year to year, and birders enjoy visiting these areas on calm evenings in early spring to observe the courtship flight of the males. Migrating birds sometimes display in areas where they will not remain to nest. With twittering wings, the male flies up into the sky and performs a complex display flight while giving a loud, nasal *"peent"* call every few minutes. Among the many places to observe these displays are the La Cygne Wildlife Area in Miami and Linn counties, the bottomlands at Fort Leavenworth, and the nature trail at Harvey County West Park.

Wilson's Phalarope

Phalaropus tricolor

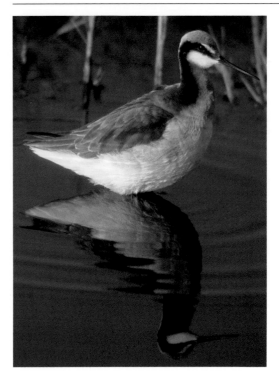

Field Identification: This is a small shorebird with long legs and a thin, pointed bill. In spring, the female has colorful black and reddish markings on the head and neck. The male has a similar pattern, but the colors are more subdued. Winter-plumaged birds are pale gray above and white below. **Size:** Length 9 inches; wingspan 17 inches.

Habitat and Distribution: Statewide at marshes, playas, and wastewater treatment ponds.

Seasonal Occurrence: Spring migrant from April through June; fall migrant from July through October. A few remain to nest at Quivira National

Wildlife Refuge, Cheyenne Bottoms, and other areas with suitable wetlands.

Field Notes: Phalaropes are a unique group of shorebirds. Unlike the females of most bird families, female phalaropes are more colorful than their male counterparts. Most phalaropes migrate and winter on the open oceans, but Wilson's migrate through the interior of the continent and are a familiar sight on the prairie marshes in spring and fall. Although they sometimes feed on shorelines with other shorebirds, Wilson's Phalaropes are most often seen swimming in large flocks, where they spin around in circles to stir up insects, which they then pick from the surface of the water. Watching hundreds of these birds spinning around on a prairie pool is one of the many enjoyable aspects of visiting a Kansas wetland during migration.

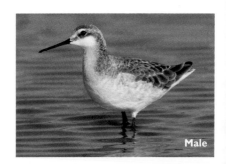

Male

Franklin's Gull

Larus pipixcan

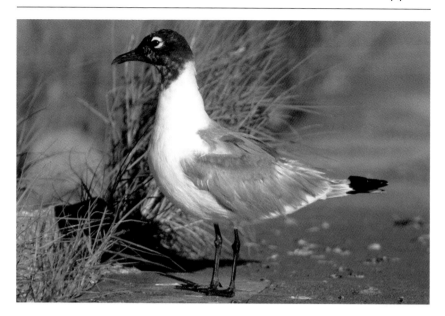

Field Identification: A small gull of the prairies, Franklin's is darker gray on the back than other gulls in Kansas. The head is all black in spring, but much of the black is lost by autumn. The wings have white trailing edges and black tips. Gulls go through a complex series of plumages as they mature, and have different plumages in summer and winter. For this reason, many birders find learning how to identify gulls to be difficult. To find Franklin's amidst large mixed flocks, look for smaller gulls that are obviously darker than the rest. **Size:** Length 14 inches; wingspan 36 inches.

Habitat and Distribution: Lakes, marshes, and plowed fields throughout Kansas. Loose flocks of migrating birds fly low and are frequently observed.

Seasonal Occurrence: Spring migrant in April and May; fall migrant from September through November. A few linger in summer at reservoirs and wetlands.

Field Notes: This species nests on prairie wetlands in the northern United States and Canada and winters along the coast of Chile and Peru. A large percentage of the entire population passes through Kansas. In the spring, large flocks are seen following the plow in farm country. In October and November, concentrations of up to several hundred thousand birds gather at large reservoirs.

Bonaparte's Gull

Larus philadelphia

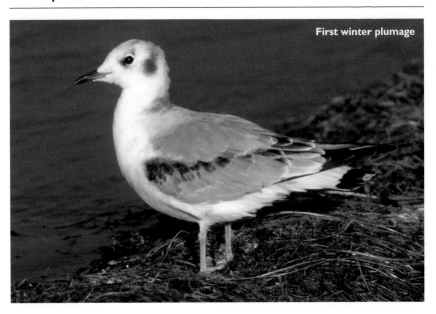

First winter plumage

Field Identification: Bonaparte's is slightly smaller and more slender than the Franklin's Gull and much paler gray on the back. The head is black in spring, white with a black ear spot in winter. On flying birds, the wings have prominent white outer wing feathers with black tips that separate them from all other gulls. Their flight style is more light and graceful than that of Franklin's Gull. **Size:** Length 13 inches; wingspan 33 inches.

Habitat and Distribution: Lakes, rivers, and wetlands, mostly in the eastern two-thirds of Kansas.

Seasonal Occurrence: Spring migrant from March through May; fall migrant from September through November.

Field Notes: Seventeen species of gulls have been recorded in Kansas, but the four species illustrated in this book represent the only ones that are seen regularly. Bonaparte's is the least common of these four species in Kansas. It is usually seen in small flocks at lakes and reservoirs. In late fall, flocks numbering in the hundreds sometimes occur at reservoirs in eastern Kansas.

Larus delawarensis

Ring-billed Gull

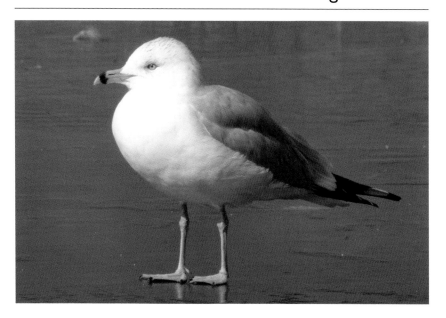

Field Identification: This is the most abundant winter gull in Kansas. The white head is streaked brownish in winter. Adults are pale gray on the back and wing; wingtips are black with white spots. The bill is yellow with a black ring near the tip, and the legs are also yellow. For several years prior to adulthood they have a variety of plumages, but one consistent mark on these individuals is a dark band at the end of the tail. **Size:** Length 18 inches; wingspan 48 inches.

Habitat and Distribution: Statewide at lakes, ponds, marshes, and rivers.

Seasonal Occurrence: Migrant and winter resident. Fall migrants begin

to arrive as early as July, becoming numerous in late fall. Many winter to the south, but some remain throughout the winter at large lakes and urban areas with open water. Most have departed by May.

Field Notes: Other than the strictly migratory Franklin's Gull, this is the most frequently observed gull in Kansas. In late October, Ring-bills are abundant at large reservoirs and landfills. They also follow plows in the spring, foraging for insects and other prey. When significant water releases are made at reservoirs such as Tuttle Creek, large numbers of Ring-bills gather to feed on stunned fish in the spillways.

Herring Gull

Larus argentatus

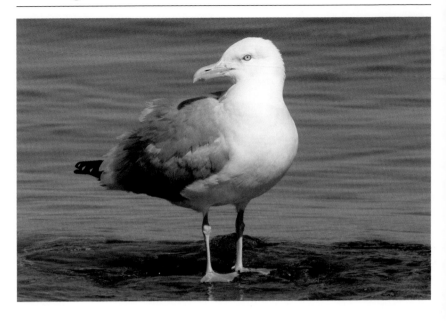

Field Identification: This large, white-headed gull is similar to Ring-billed Gull in some respects. However, it is much larger and more barrel-chested, the yellow bill is proportionately larger, and the legs are pink. Many immature birds are seen in Kansas, and most are entirely mottled dark brown, with black outer wings and tails. As stated previously, gull identification can be complex, and in Kansas, this complexity is probably most epitomized by this species, which does not attain its adult plumage until it is five years old and has a bewildering succession of plumages as it matures. The large size and pink legs are the only real constants throughout. **Size:** Length 25 inches; wingspan 58 inches.

Habitat and Distribution: Lakes, rivers, and wetlands, mostly in central and eastern Kansas, occasionally west to Colorado.

Seasonal Occurrence: Migrant and winter resident. Most arrive in October, and spring birds depart by April. Straggling birds have been observed in Kansas in all months of the year.

Field Notes: During winter, Herring Gulls may occur in flocks at large reservoirs and near landfills. A few are usually found within large flocks of Ring-billed Gulls.

Hydroprogne caspia

Caspian Tern

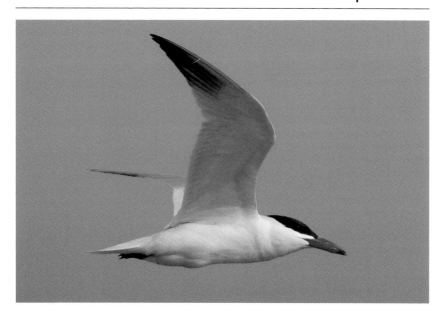

Field Identification: This large tern is nearly the size of the Ring-billed Gull but is slimmer, with more angular, pointed wings. It has a pale-gray back and upper wings. The undersides of the wingtips are black, visible in flight. The tail is short in comparison to the long, streaming tail of the Forster's Tern. Also look for the swept-back black crown and the blood-red bill, which is much thicker than the bill of other terns. **Size:** Length 21 inches; wingspan 50 inches.

Habitat and Distribution: Lakes, reservoirs, and wetlands in eastern and central Kansas.

Seasonal Occurrence: Spring migrant from April through June; fall migrant from August through October.

Field Notes: Terns are closely related to gulls but are more graceful in both appearance and behavior. This is the largest tern found in Kansas, and its size alone separates it from other tern species. It is most likely to be found at large reservoirs in eastern Kansas, where it patrols above the surface of the water in search of fish. Uncommon anywhere in Kansas, it is scarce west of the Flint Hills.

Forster's Tern

Sterna forsteri

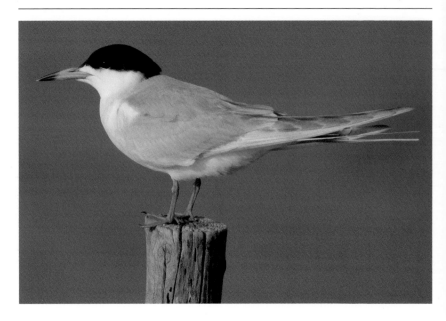

Field Identification: This is a medium-sized tern with frosty-white outer wings, pale-gray back and inner wings, and long tail streamers. It has a black cap in spring and a clean-cut black mask in fall and winter. The bill is orange with a dark tip in spring, black in fall. **Size:** Length 13 inches; wingspan 31 inches.

Habitat and Distribution: Statewide at lakes, wetlands, and wastewater treatment ponds.

Seasonal Occurrence: Spring migrant in April and May; fall migrant from July through November. In years when habitat conditions are favorable, some will remain to nest at Quivira National Wildlife Refuge or Cheyenne Bottoms.

Field Notes: This tern is a familiar sight throughout Kansas during migration. Like other terns, it forages by flying over water in graceful fashion, suddenly diving into the water when a fish or minnow is spotted. Unlike the Caspian Tern, Forster's is quite common at the larger, shallow wetlands of central Kansas. Sewage lagoons in western Kansas, in the absence of any other bodies of water, also attract them.

Sternula antillarum

Least Tern

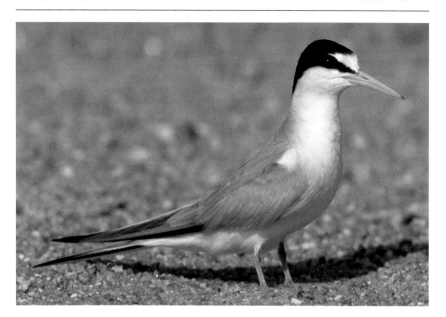

Field Identification: The smallest tern in Kansas can be identified by its black outer wings, gray back, and bright-yellow bill. The white forehead contrasts with a black cap and eye line. Sharp alarm notes are often heard as it flies overhead. **Size:** Length 9 inches; wingspan 20 inches.

Habitat and Distribution: Prefers sandbars, salt flats, and other unvegetated areas near water. It is observed in many parts of the state during migration. It nests in colonies at a few locations on or near the Arkansas, Cimarron, and Kansas rivers. In most years, the largest Kansas colony is located on the alkali flats of the Big Salt Marsh at Quivira National Wildlife Refuge. Recently it has nested at the Jeffrey Energy Center near Topeka, and in Wichita.

Seasonal Occurrence: Migrant and summer resident. Spring arrival is in April, and fall migrants depart in September. Kansas nesting birds usually depart by August.

Field Notes: This tern is small but plucky. It is classified as an endangered species in Kansas and the United States. It formerly nested on river sandbars throughout Kansas, but reduced flow and dam construction have led to habitat changes that make many of its former nesting sites unsuitable. Because it nests on sandbars, it is vulnerable to rising water, a variety of human-caused disturbances, and predation by coyotes and other species.

Black Tern

Chlidonias niger

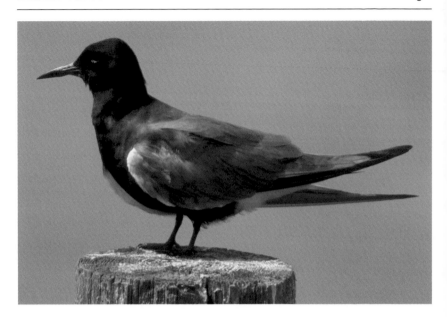

Field Identification: A distinctive small, dark tern, the Black Tern is much darker in color than any other tern species in Kansas. In breeding plumage, the head and underparts are uniformly black. Winter-plumaged birds are white below and on most of the head, with a blackish nape and ear patch. **Size:** Length 10 inches; wingspan 24 inches.

Habitat and Distribution: Migrant statewide at marshes and lakes and over prairies.

Seasonal Occurrence: Spring migrant in April and May; fall migrant from July through October. Small colonies nest at Cheyenne Bottoms and Quivira National Wildlife Refuge in years when habitat conditions are favorable.

Field Notes: Large flocks of Black Terns are often observed migrating low over the Kansas prairies during the spring, acrobatically foraging for insects as they journey north. Unlike other terns, they do not dive for fish but instead feed almost entirely on insects captured on the wing. Their primary breeding grounds are in the northern United States and Canada.

Ring-necked Pheasant

Phasianus colchicus

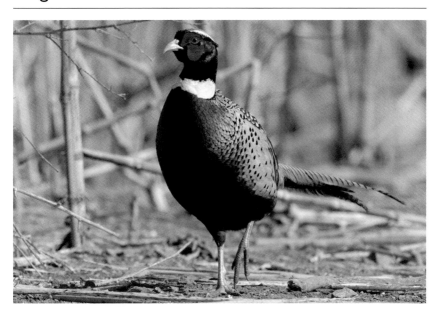

Field Identification: Both sexes are easily identified by their large size and long, pointed tails. The loud, squawking call of the male is a familiar sound in rural areas.

Size: Length 21 inches; wingspan 31 inches.

Habitat and Distribution: Found in or near grain fields, also in cattail marshes and brushy areas. Found over most of the state but absent or rare in the southeastern counties and along most of the Missouri border. It is most abundant in the western two-thirds of Kansas.

Seasonal Occurrence: Permanent resident.

Field Notes: Ring-necked Pheasants are a species native to China. They were introduced as a game bird in the early 1900s and have thrived in Kansas, where hundreds of thousands are taken each year by hunters. They are often seen along roadsides in farm country. They remain still when hiding, then burst into flight with whirring wings and a loud squawk.

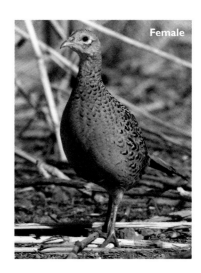

Female

Greater Prairie-Chicken

Tympanuchus cupido

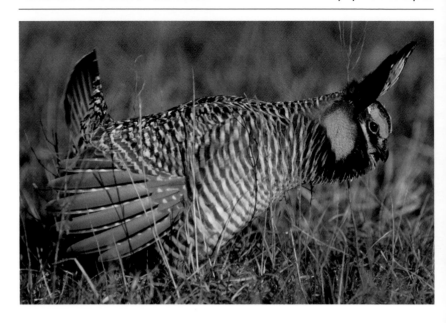

Field Identification: The Greater Prairie-Chicken is plump and chicken-like in appearance. Most of the body is patterned with brown-and-white barring. **Size:** Length 17 inches; wingspan 28 inches.

Habitat and Distribution: Found in tallgrass prairies in the Flint Hills and mixed prairies in north-central Kansas.

Seasonal Occurrence: Permanent resident.

Field Notes: In early spring, males of this member of the grouse family gather to compete for the attention of females at specific areas on the prairie called "booming grounds,"

or leks. The orange sacs on the side of the neck are used to create a unique "booming" sound, which can be heard at some distance. The males face off in a series of ritual confrontations involving raising the long neck feathers, making vigorous clucking sounds, and jumping into the air. The female observes the activity and, if she is sufficiently impressed, allows the dominant male to mate with her. In the Flint Hills, Greater Prairie-Chickens are declining in numbers due to habitat fragmentation and management practices that leave little grass cover for hiding from predators or for nesting. Populations in north-central Kansas are more stable. Their presence is a sign of wisely managed prairie.

Tympanuchus pallidicinctus

Lesser Prairie-Chicken

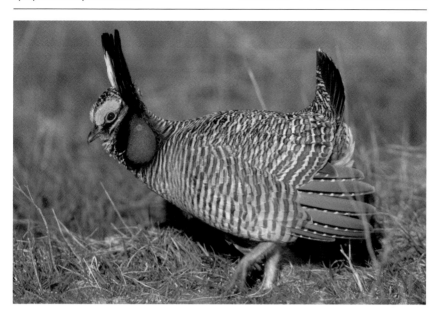

Field Identification: This species is similar to the Greater Prairie-Chicken but is paler, with less contrasting brown-and-white barring. The neck sacs of the male are plum colored instead of orange, and the "booming" is a rapid bubbly sound, quite unlike the slow, deep tones of the Greater Prairie-Chicken. **Size:** Length 16 inches; wingspan 25 inches.

Habitat and Distribution: Sand-sage and other prairies in the southwestern part of the state, north to Trego County and east to Barber County.

Seasonal Occurrence: Permanent resident.

Field Notes: This is a close relative of the Greater Prairie-Chicken. In Kansas, it favors sandy, semiarid prairies. The population of this species declined in the twentieth century due to habitat loss. It is found in appropriate habitat scattered throughout southwest Kansas, northeast New Mexico, southeast Colorado, and the Panhandle region of Oklahoma and Texas. Because of its rarity, specialized habitat, and restricted range, this species draws birders to Kansas from across the United States and the world. On the Cimarron National Grassland in Morton County, the U.S. Forest Service usually has viewing blinds available to allow observation of the fascinating booming activity.

Wild Turkey

Meleagris gallopavo

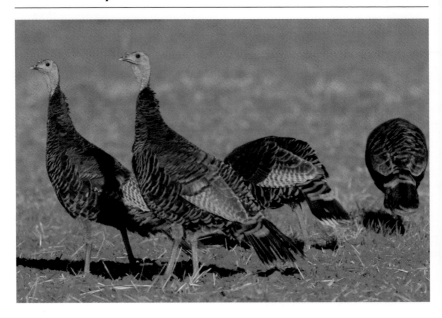

Field Identification: This large game bird is unlikely to be mistaken for any other species. Males are larger than females and have a "beard" that grows from the middle of their chest.
Size: Length 46 inches; wingspan 64 inches.

Habitat and Distribution: Statewide where woodlands and brushy areas are present, especially those near rivers and streams.

Seasonal Occurrence: Permanent resident.

Field Notes: Early in the twentieth century, this formerly abundant species was almost eliminated from Kansas by residents killing them for food. Populations have recovered since the Kansas Department of Wildlife and Parks began reintroducing the birds. It is a memorable sight to see males displaying for females in the spring. The tail is raised and fanned, the wings are held straight down, and the body feathers are raised, giving the bird a unique appearance. After the nesting season, large flocks, some numbering in the hundreds of birds, gather and forage for waste grain and acorns. The large tracks of these birds in wooded areas are obvious clues to their presence.

Colinus virginianus

Northern Bobwhite

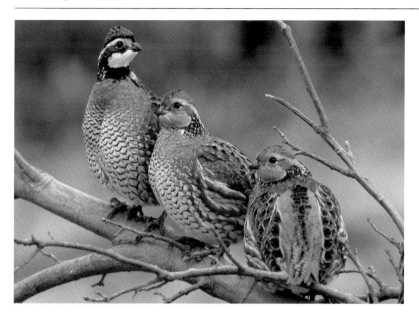

Field Identification: The Northern Bobwhite is a small, plump game bird. Males have a white stripe above the eye and a white throat. Females are similar, but the head markings are buff instead of white. **Size:** Length 10 inches; wingspan 13 inches.

Habitat and Distribution: Statewide in brushy and wooded areas.

Seasonal Occurrence: Permanent resident.

Field Notes: The clear, two-note call of the male is a familiar sound across Kansas in the spring. Bobwhites are most numerous in the eastern half of the state but are also found in the west where they can locate their preferred habitat. In the fall and winter, they gather into small flocks called coveys, which flush in unison when alarmed. Populations of Northern Bobwhites fluctuate from year to year.

Scaled Quail

Callipepla squamata

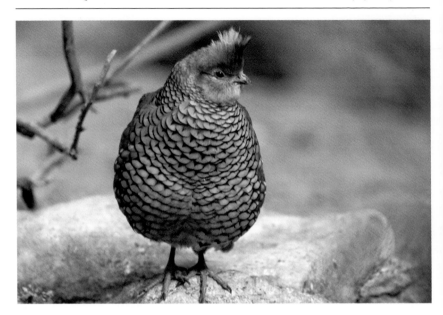

Field Identification: The most notable field mark is the "cotton-top" crest on the head. Feathers on the underparts and hind neck have clean black edges, creating a unique scaled appearance. **Size:** Length 10 inches; wingspan 14 inches.

Habitat and Distribution: Sand-sage prairies of southwestern Kansas, mostly south of the Arkansas River and west of Clark County.

Seasonal Occurrence: Permanent resident.

Field Notes: These are birds of the southwestern desert, and southwest Kansas is at the northern extreme of their range. They are found around farms, idle farm equipment, auto salvage yards, and old junk piles in sagebrush country. They frequent these places because of the shelter they offer from the elements and predators. Their loud, piercing calls are quite unlike those of the Bobwhite, and many hearing them for the first time are surprised to learn they are hearing a species of quail. They prefer to run rather than fly. They can be found on the Cimarron National Grassland in Morton County. Look for them at the Tunnerville Work Station and nearby farmyards north of Elkhart.

Cathartes aura

Turkey Vulture

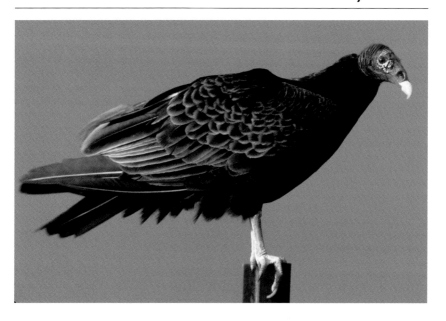

Field Identification: This is a large, soaring bird of the summer skies. The two-tone gray-and-black wings are always tilted upward. It flaps its wings only reluctantly, preferring to soar on warm thermal air currents. Perched birds are all black with a bare red head. **Size:** Length 26 inches; wingspan 67 inches.

Habitat and Distribution: Found statewide. Can be seen soaring overhead anywhere but most often observed in summer along river valleys and near dams of large lakes and reservoirs.

Seasonal Occurrence: Summer resident. Present from late March until late October.

Field Notes: Turkey Vultures roam widely in search of carrion and are frequently seen attempting to feed on road-killed animals along highways. They often gather in large communal roosts at night. As air currents warm in the morning, the entire roost takes flight and begins foraging. Although vultures are similar to hawks and eagles in appearance, DNA analysis has shown that they are most closely related to the stork family.

Osprey

Pandion haliaetus

Field Identification: This large, unique bird of prey is always seen near water. It is distinguished by its black back and crown, white underparts, and white face with a prominent black eye stripe. Flying birds have a noticeable crook in the long wings and show a black-and-white pattern below. **Size:** Length 23 inches; wingspan 63 inches.

Habitat and Distribution: Statewide along rivers, lakes, and wetlands. Less common in the western part of the state because of the scarcity of open water.

Seasonal Occurrence: Migrant. Seen in spring during April and May and in fall during September and October.

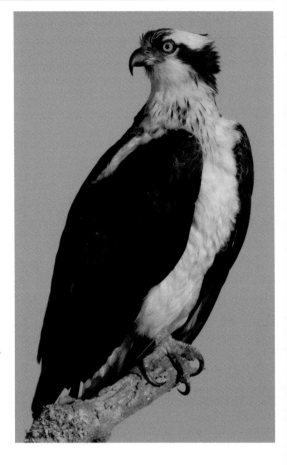

Field Notes: Ospreys feed exclusively on fish. They soar over lakes and rivers in search of prey. When a fish is spotted near the surface, they plunge dramatically into the water, sometimes completely submerging, while capturing fish in their talons. They fly with the fish in their grasp, streamlined with the head of the fish pointing in the direction of their flight. They perch on utility poles or trees to consume their catch. Ospreys are not shy and are frequently seen in busy urban areas.

Ictinia mississippiensis

Mississippi Kite

Field Identification: This slender, graceful bird of prey is evenly gray, lighter on the head, with a black tail. The white secondary wing feathers are prominent on flying birds. Juveniles have broad streaks below and a banded tail and can be mistaken for accipiters or falcons. **Size:** Length 14 inches; wingspan 31 inches.

Habitat and Distribution: Most common in south-central Kansas. Its range is expanding to the north and east and has recently reached the Kansas City metro area. Its historical habitat was open prairies with stands of trees, but the species has adapted quite well to nesting in cities and towns.

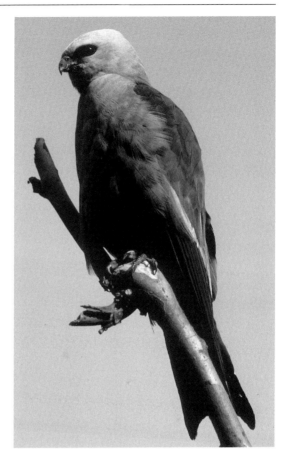

Seasonal Occurrence: Summer resident. Arrives in late April and departs in mid-September.

Field Notes: These raptors can be seen "kiting" by skillfully manipulating their flight feathers to navigate the wind currents. They feed mostly on cicadas and other large insects. In many south-central Kansas towns, several can be seen at once as they soar overhead. When the young are near fledging, the adults sometimes become quite aggressive and will dive at people who come too close to the nest.

123

Bald Eagle

Haliaeetus leucocephalus

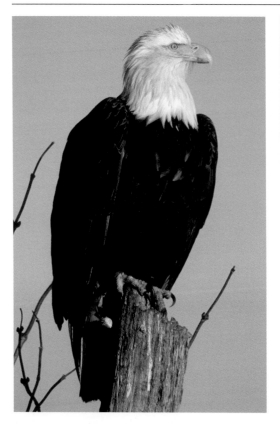

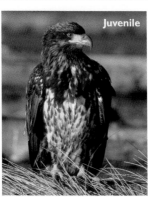

Juvenile

Seasonal Occurrence: Migrant and winter resident, rare and local in summer. The greatest numbers are present from November through March, when up to several thousand individuals are present in the state, concentrated around large reservoirs or along rivers. About twenty pairs nest in Kansas, mostly near reservoirs and rivers in the eastern half of the state.

Field Identification: This is the largest bird of prey in Kansas. Adults are unmistakable, with the dark body contrasting with the white head and tail. Younger birds are uniformly dark in their first year, gradually gaining more white plumage until they reach adulthood at four years of age. **Size:** Length 31 inches; wingspan 80 inches.

Habitat and Distribution: Statewide. Mostly found near lakes, rivers, reservoirs, and wetlands but can also be seen in semiarid upland areas of western Kansas.

Field Notes: In some winters, large numbers move into Kansas when open water in the northern states freezes. At these times, watch for them at reservoirs such as Cheney, Milford, Perry, and Tuttle Creek and along rivers such as the Arkansas, Kansas, and Neosho. Look for large, dark birds perched in trees near the shore and also on the ice at the edge of open water. They feed on fish, which they snatch from the water surface; crippled waterfowl; and carrion.

Circus cyaneus

Northern Harrier

Field Identification: This is a large, low-flying hawk of open country. Flying birds are easily identified by the prominent white rump and long tail. Males are pale gray above, white below, with black wingtips. Females are brown above, mottled with paler brown below. Harriers are usually seen cruising low over grasslands, marshes, and farmlands with wings tilted upward, rocking back and forth as they fly. **Size:** Length 18 inches; wingspan 43 inches.

Habitat and Distribution: Found statewide. Prefers marshes and grasslands with thick cover. Also seen over grain fields. It is common in the Flint Hills, Smoky Hill River Valley, Quivira National Wildlife Refuge, and Cheyenne Bottoms.

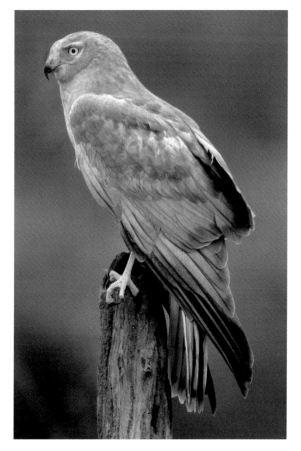

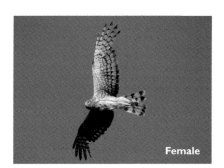
Female

Seasonal Occurrence: Migrant and winter resident, most numerous from September through April. A few pairs remain to nest.

Field Notes: The low flight allows it to surprise prey that is captured with a sudden plunge. Its preferred food is small rodents. This species frequently shares hunting grounds with Short-eared Owls, although they hunt at different times of the day.

125

Sharp-shinned Hawk

Accipiter striatus

Field Identification: This is one of two members of the accipiter family commonly seen in Kansas. Accipiters are small, agile hawks with long tails and short wings. They fly with quick wingbeats, followed by a glide. These characteristics distinguish them from other hawk species. Distinguishing the Sharp-shinned Hawk from the closely related Cooper's Hawk is difficult. Sharpies are smaller, but there is overlap in size. Probably the most useful field mark is the square-cornered tail. **Size:** Length 13 inches; wingspan 23 inches.

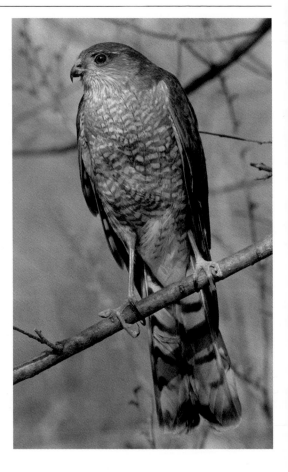

Habitat and Distribution: Statewide. Usually seen in wooded or brushy areas. It readily adapts to urban areas.

Seasonal Occurrence: Migrant and winter resident. Present from September through mid-May.

Field Notes: Sharp-shinned Hawks are usually seen suddenly and briefly as they stealthily fly through wooded areas in search of small birds, their primary prey. In winter, they sometimes learn that bird feeders are easy places to capture prey. Most birders find this hawk to be an exciting visitor to their yard. People who do not want them to hunt their feeder birds should discontinue feeding for a few days. In the absence of birds to prey on, the hawks will move elsewhere.

Accipiter cooperii

Cooper's Hawk

Field Identification: This accipiter is similar to the Sharp-shinned Hawk but is larger on average. In both species, the female is about 20 percent larger, so male Cooper's and female Sharp-shinned nearly overlap in size. The corners of the tail are rounded, and this is the easiest field mark to observe. **Size:** Length 17 inches; wingspan 31 inches.

Habitat and Distribution: Statewide. Typically seen in or near wooded areas but also hunts in open country.

Seasonal Occurrence: Permanent resident. Most common in winter, as many move into Kansas from the north. There is a small but increasing nesting population.

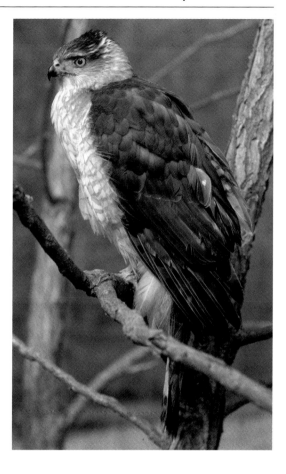

Field Notes: Any accipiter seen during the summer is probably this species. Cooper's Hawks are one of the success stories of bird conservation. Once severely decimated by DDT poisoning and illegal shooting, this species has made a major comeback in Kansas. Since the late 1980s, Cooper's Hawks have enjoyed a healthy growth in population as a nesting species. They typically nest in mature woodlands.

Red-shouldered Hawk

Buteo lineatus

Field Identification:
This elusive hawk of riparian woodlands is similar in shape and posture to the Red-tailed Hawk, but smaller. Loud, plaintive cries are often the first clue to their presence. Perched birds have checkered black-and-white marks on the wings and back and dense reddish bars on the breast. When they are seen soaring overhead, look for prominent translucent crescents at the base of the primary (outer wing) feathers in the wings and a black tail with three or four narrow white bands.
Size: Length 17 inches; wingspan 40 inches.

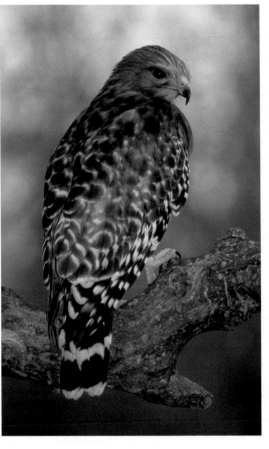

Habitat and Distribution:
Southeastern Kansas, along rivers and streams with mature woodlands. These hawks were once scarce in Kansas but are currently increasing in numbers and slowly expanding their range to the north and west.

Seasonal Occurrence: Permanent resident.

Field Notes: These hawks are seldom seen far from the wooded streams. They hunt from inconspicuous perches but are often seen soaring high above the forest. In early April, the males perform a dramatic courtship flight that includes steep dives and piercing cries.

Buteo platypterus

Broad-winged Hawk

Field Identification: This is another small buteo, usually seen only during migration. It has a brown back, white breast with reddish bands, and solid reddish throat. The tail has broad black-and-white bands. In flight, the underwings are mostly white, neatly bordered with black on the wingtips and trailing edge of the wing. Remember that the Red-tailed Hawk always has a black border on the leading edge of the wing; this border is never found on the Broad-winged Hawk. There is a rare dark morph that retains the banded tail. **Size:** Length 15 inches; wingspan 34 inches.

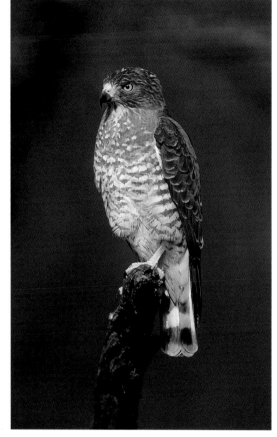

Habitat and Distribution: During migration, Broad-wings can be seen statewide, although they are much more likely to be seen in the eastern half of Kansas. Most Kansas nesting records have come from extreme eastern Kansas, but there are recent records of summering Broad-wings from the Cross Timbers region.

Seasonal Occurrence: Migrant and rare summer resident. Spring migrants are seen from mid-April through mid-May; fall migrants from early September through early October.

Field Notes: Broad-winged Hawks are often seen in small flocks during the spring migration. They are more tame and approachable than other raptors. In the fall, most sightings are of single birds.

Swainson's Hawk

Buteo swainsoni

Field Identification: This is a buteo of the open country. Typical adults are dark brown on the back, white on the underparts, with a reddish chest and white face. On soaring birds, look for the two-toned underwing, white on the leading edge and dark gray on the trailing portion. Immature birds are heavily streaked. Some adults are uniformly dark. **Size:** Length 19 inches; wingspan 51 inches.

Habitat and Distribution: Found statewide, but more numerous in the western half of Kansas. Usually found near large expanses of open country.

Seasonal Occurrence: Migrant and summer resident. Spring arrival is in early April; fall departure in early October.

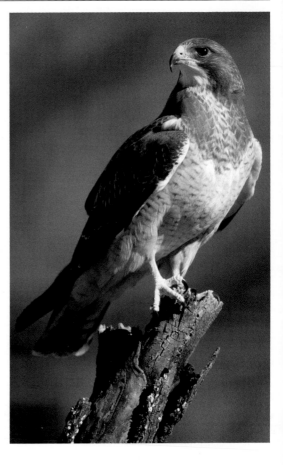

Field Notes: This is a long-range migrant. The entire population winters in the grasslands of Argentina and nests in western North America, as far north as central Canada. Sometimes Swainson's migrate in large flocks that can number in the hundreds or even thousands, especially during the fall migration. These flocks sometimes rest for the night in hay or plowed fields. It is an amazing sight to see hundreds of hawks calmly perched on the ground, awaiting a favorable north wind to carry them south.

Buteo jamaicensis

Red-tailed Hawk

Field Identification: This is a large and familiar buteo species. Typical adults have a red tail, brown back with an irregular white V-marking, and white underparts crossed by a band of dark streaks. Juveniles are heavily streaked below, with a banded tail. On soaring birds, look for a prominent black bar on the leading edge of the wing, which separates Red-tails from all other buteos. **Size:** Length 19 inches; wingspan 49 inches.

Habitat and Distribution: Found statewide in a variety of habitats where a few trees are present.

Seasonal Occurrence: Permanent resident. Most numerous in the winter months as additional birds move in from their northern breeding areas.

Field Notes: Red-tails are the most common species of hawk in Kansas. During winter, there may be one or more per mile in a typical highway drive through rural areas. Although most appear as described here, they

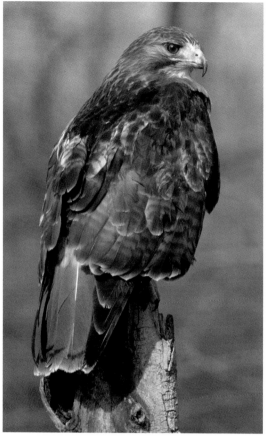

have a confusing variety of plumages, ranging from some that are almost completely black to pale, mostly white individuals. One major field guide has thirty-nine illustrations to show all of these plumages! Red-tails begin nesting as early as January but most often in early March. Their large platform nests are easy to find before the trees have leafed out.

Ferruginous Hawk

Buteo regalis

Field Identification:
This is the largest buteo in Kansas. Typical adults are pale red on the back, with white head and breast, pale-whitish tail, and dark-reddish legs that are easily seen on soaring birds. Look for large white patches on the upper wings. There is a rare dark morph. **Size:** Length 23 inches; wingspan 56 inches.

Habitat and Distribution:
Found in the western half of Kansas in open country, especially near prairie-dog towns. During the winter months a few wander into eastern Kansas.

Seasonal Occurrence:
Permanent resident. Uncommon but widespread during migration and in winter, from late September through early April. Nesting pairs are found in the shortgrass prairies of western Kansas and the chalk bluffs of the Smoky Hill River Valley.

Field Notes: This large, beautiful hawk is a western Kansas specialty. It is relatively tame outside the nesting season and sometimes will allow close

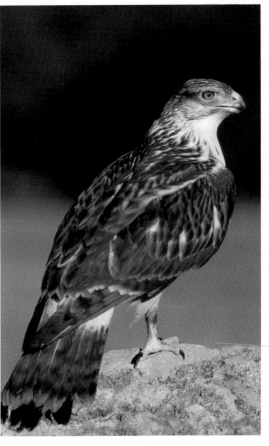

approach. Where prairie-dog towns have not been eliminated, these hawks often gather and perch on prairie-dog mounds. The Cimarron National Grassland in southwest Kansas is a good place to look for these striking raptors during the winter. The Christmas Bird Count there often records more of them than any other CBC in North America.

Buteo lagopus

Rough-legged Hawk

Field Identification:
Like other buteos, the Rough-legged Hawk occurs in light and dark morphs. Soaring birds viewed from below have a white tail with a broad black band and mostly white underwings with a large black patch at the wrist. Light-morph birds have a pale head and a broad black belly band. Dark-morph birds look uniformly black when perched. **Size:** Length 21 inches; wingspan 53 inches.

Habitat and Distribution:
Statewide in open country. Prefers prairies rather than agricultural fields.

Seasonal Occurrence:
Present in Kansas from October through April. Nests in the arctic tundra.

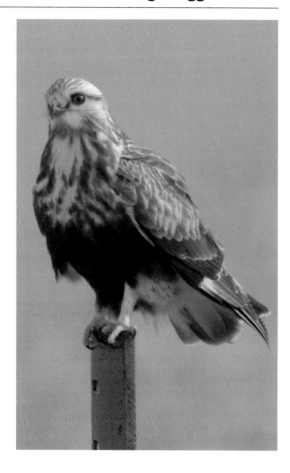

Field Notes: This hawk moves into Kansas during the winter. It often hovers while foraging. The dark morph makes up a larger percentage of the population than in other species of buteos. In grasslands such as the Flint Hills, this species will sometimes outnumber the Red-tailed Hawk.

Golden Eagle

Aquila chrysaetos

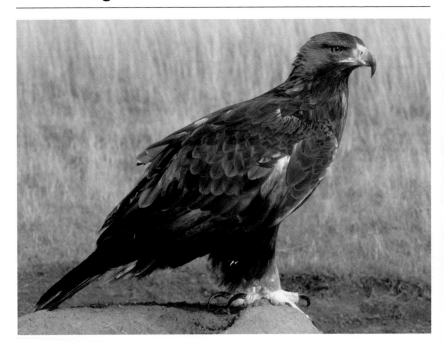

Field Identification: This is a large, dark-colored raptor of the western plains. Both adults and immature birds have golden feathers on the head and at the base of the tail. Adults have a banded tail with a dark terminal band. Immature birds have a white tail with broad black terminal band and oblong light patches in the wings. **Size:** Length 30 inches; wingspan 79 inches.

Habitat and Distribution: Seen most regularly in western Kansas. Generally prefers rugged, open country.

Seasonal Occurrence: Migrant and winter resident. Most are seen from September through March. There are a handful of nesting pairs in several western Kansas counties.

Field Notes: Golden Eagles are majestic birds of the arid plains. Like the Ferruginous Hawk, they are likely to be seen near prairie-dog towns, which are unfortunately disappearing from the Kansas landscape because of deliberate eradication. Only a few nesting sites are known in Kansas. A location in northwest Kansas has hosted a nesting pair for over twenty consecutive years. Golden Eagles are sometimes confused with immature Bald Eagles, which are also all dark. When sightings of Golden Eagles with Bald Eagles at large reservoirs in the winter are reported, the birds almost always prove to be young Bald Eagles.

Falco sparverius

American Kestrel

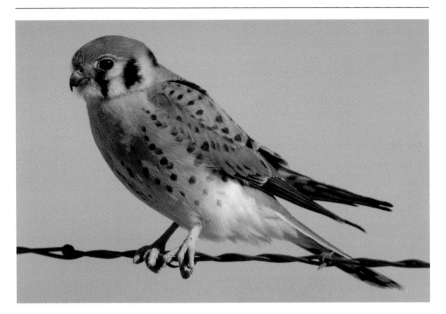

Field Identification: This small, dove-sized falcon has a double mustache mark on the face and a rufous back with black bars. The wings are blue on males, rufous on females. Females have coarse red streaks on the breast. All falcons have angular, pointed wings. This helps to distinguish them from accipiters, which have rounded wings. **Size:** Length 9 inches; wingspan 22 inches.

Habitat and Distribution: Statewide. Found in open areas, usually with a few trees.

Seasonal Occurrence: Permanent resident. Most common in summer and during migration. Smaller numbers remain during the winter months.

Field Notes: These small falcons are common along roadsides and are frequently seen perched on power lines or fences. They often hover when hunting. They nest in tree cavities and will readily use nesting boxes when they are placed in appropriate habitat. In September, migrating kestrels moving through Kansas take advantage of abundant grasshoppers to fatten up for the leaner winter months ahead.

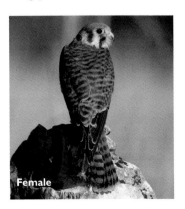

Female

Merlin

Falco columbarius

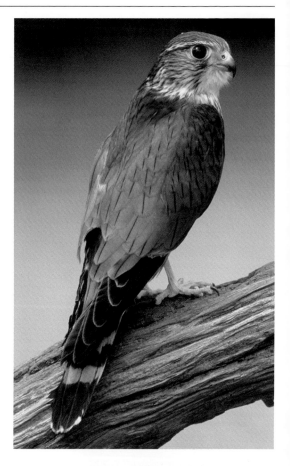

Field Identification: This is a small falcon, slightly larger than a kestrel. The plumage is variable in color, but all individuals have a strongly banded tail. Males are blue on the back and wings; females are brown. The breast is heavily streaked. Their flight is more powerful and direct than that of the American Kestrel.
Size: Length 10 inches; wingspan 24 inches.

Habitat and Distribution: Occurs statewide. Seen in a variety of habitats, including prairies, wetlands, woodlands, and urban areas.

Seasonal Occurrence: Migrant and winter resident. Present from mid-September through late March.

Field Notes: Merlins are typically seen in fast, brief encounters. They are exceptionally aggressive and frequently harass other raptors, including much larger birds. There are two subspecies seen in Kansas. Those of the *columbarius* (Taiga Merlin) subspecies are fairly dark colored and show an indistinct mustache mark. The *richardsonii* (Prairie Merlin) subspecies is very pale in comparison and lacks the mustache mark.

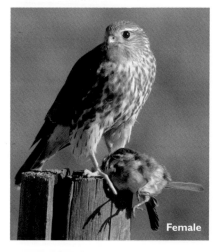

Female

Falco peregrinus

Peregrine Falcon

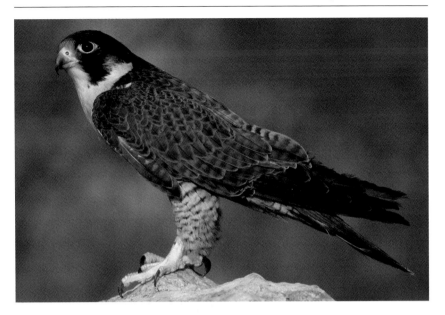

Field Identification: Peregrines are large, powerful falcons with long, pointed wings and are swift in flight. Adults are dark blue above, with a prominent "helmet" marking on the head, fine bars on the belly, and a banded tail. Immature birds are similar but browner, with heavier streaking on the breast. **Size:** Length 16 inches; wingspan 41 inches.

Habitat and Distribution: Has been recorded throughout the state. Migrating birds can be seen almost anywhere. Frequently seen at reservoirs and along rivers. Also reported regularly in the downtown areas of Wichita, Topeka, and Kansas City, where they hunt Rock Pigeons and roost atop tall buildings.

Seasonal Occurrence: Migrant in spring and fall. Most spring birds are seen in April and May; fall birds are seen in August and September. A few are seen in the winter months. Peregrines have nested on nesting platforms in downtown Topeka and Kansas City.

Field Notes: Peregrines usually hunt by diving out of the sky at speeds that can reach almost two hundred miles per hour and killing their prey with a blow from their large feet. They are regularly seen at Quivira National Wildlife Refuge, where several individuals at a time can be found at the peak of shorebird migration. When large flocks of shorebirds suddenly take flight, it may be due to a cruising Peregrine.

Prairie Falcon

Falco mexicanus

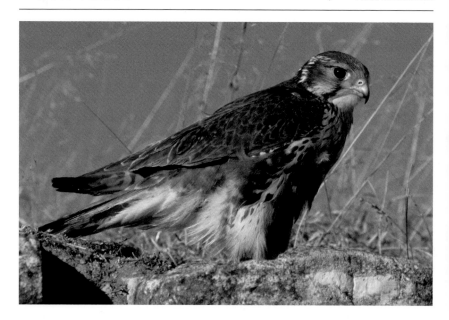

Field Identification: Similar in size and shape to the Peregrine Falcon, the Prairie Falcon is pale sandy brown on the upper body, with a thin mustache mark on the white face. The underparts are white and streaked with brown. On flying birds, look for the black "wingpits" where the wings meet the body. **Size:** Length 16 inches; wingspan 40 inches.

Habitat and Distribution: Found in open country, mostly in the western two-thirds of the state. They are rarely seen east of the Flint Hills.

Seasonal Occurrence: Migrant and winter resident. Present from July to March.

Field Notes: After the nesting season, Prairie Falcons move onto the plains from the western mountains. Their numbers are greatest in the winter months. They are raptors of open country and are most likely to be seen in the western counties. They typically hunt by flying swiftly at low altitude and taking birds they startle into flight. They will also take small mammals. Like Merlins, they show aggression toward Red-tailed Hawks and other raptors. Their favorite perch is atop utility poles in open country.

Tyto alba

Barn Owl

Field Identification: A large, pale owl of open country, the Barn Owl has a heart-shaped facial disk with dark eyes and stands upright on long legs. The wings and upperparts are blue and tawny with white speckling. **Size:** Length 16 inches; wingspan 42 inches.

Habitat and Distribution: Occurs statewide but is most numerous in the western half of Kansas. It favors areas that are dominated by grasslands.

Seasonal Occurrence: Permanent resident.

Field Notes: Barn Owls are most numerous in the Red Hills and Smoky Hill Valley regions, where there are many abandoned barns and the natural crevices

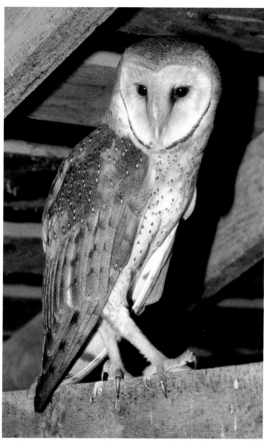

they prefer are widespread. Elsewhere they select abandoned or seldom-used buildings as nest and roost sites. Large Barn Owl nest boxes on poles were erected at the Baker Wetland in Lawrence, and these are used by Barn Owls in most years. The Cimarron National Grassland in Morton County also has a substantial population of these owls. A walk through the tree rows at the Tunnerville Work Station north of Elkhart may flush a Barn Owl into view.

Eastern Screech-Owl

Megascops asio

Field Identification:
This small owl has ear tufts, large yellow eyes, and vertical streaks on the breast. Most are gray, but in Kansas about 10 percent of the population is red. **Size:** Length 8 inches; wingspan 20 inches.

Habitat and Distribution:
Found statewide anywhere there are wooded areas. It is common in cities and towns.

Seasonal Occurrence:
Permanent resident.

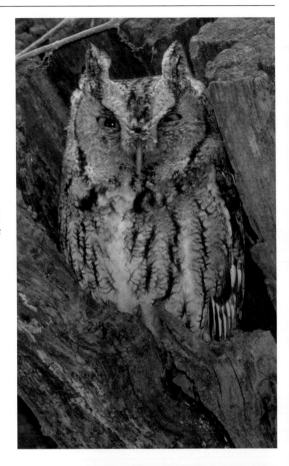

Field Notes: Although many urban residents are unaware of them, these small owls are common across most of Kansas. Look for them in areas with mature trees, which provide cavities for nesting and roosting. Listen for their whinnying calls at dusk and after dark. Flocks of songbirds often noisily mob predators. While the predator may prove to be anything from a house cat to a rat snake, Screech-Owls are frequently the object of these attentions. Check carefully when you observe mobbing behavior and you will often find a Screech-Owl frozen in position, attempting to conceal itself.

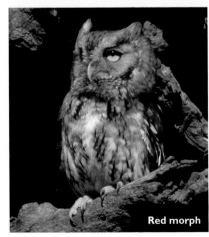

Red morph

Bubo virginianus

Great Horned Owl

Field Identification: This large gray-brown owl has widely spaced ear tufts and is barred below with a white bib. **Size:** Length 22 inches; wingspan 44 inches.

Habitat and Distribution: Found statewide in a variety of habitats.

Seasonal Occurrence: Permanent resident.

Field Notes: This is the familiar "hoot owl" of Kansas. Their deep, resonant hooting calls are unlike those of any other Kansas owl. It is often seen at dawn and dusk, especially on roadside utility poles. In early spring, check trees for nesting owls in large stick nests and look for their telltale "ears." These owls mate in January and are incubating eggs by February. In winter, crows gather in noisy flocks when they find a Great Horned Owl. These owls are at the top of the food chain and will take any prey they can kill, including mammals as large as skunks.

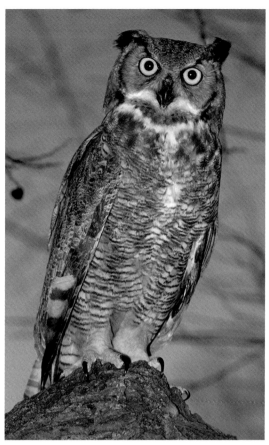

Barred Owl

Strix varia

Field Identification:
This large, earless owl
has dark eyes, a heavily
streaked breast, a brown
back marked with white,
and a facial disk with
concentric rings that
accentuate the round
head. Its loud, booming
call is often interpreted as
"Who-cooks-for-you?"
Size: Length 21 inches;
wingspan 42 inches.

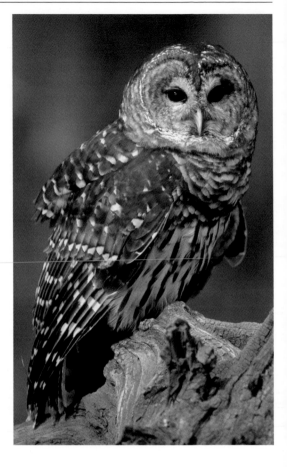

Habitat and Distribution:
Barred Owls prefer
densely wooded areas,
especially along rivers
and streams. They are
found throughout the
eastern half but are
most numerous in the
southeastern third of
the state. Their range
is gradually expanding
westward as woodlands
mature along rivers. They
are currently found west
to Meade and Ellsworth counties.

Seasonal Occurrence: Permanent
resident.

Field Notes: Barred Owls make
a variety of hooting and growling
sounds when aroused or responding
to other owls' calls. Sometimes they
can be seen perched on utility poles
during daylight hours. Barred Owls
have adapted well to humans and
regularly nest in cities and towns.
Playing a tape of their calls will
prompt an answer from any Barred
Owl within earshot, often attracting
them to fly closer to investigate.

Asio otus

Long-eared Owl

Field Identification:
This medium-sized owl
has long ear tufts and an
orange facial disk. It is
sometimes confused with
the Great Horned Owl
but is smaller and more
slender and has vertical
streaks on the chest
instead of the horizontal
barring found on the
Great Horned Owl.
Size: Length 16 inches;
wingspan 36 inches.

Habitat and Distribution:
Found statewide. It hunts
mostly in open country
but nests and roosts
nearby in densely wooded
areas. In winter, it often
seeks dense cedar groves
for roosting.

Seasonal Occurrence:
Present year-round in
Kansas, but in varying
numbers. A few nest in
central and western Kansas. They
are often seen in migration in April
and October. Wintering birds gather
in communal roosts near areas with
abundant rodents.

Field Notes: In addition to being
unpredictable in occurrence, Long-
eared Owls are stealthy and often go
undetected until they are startled from

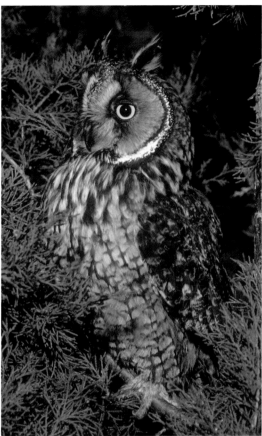

a concealed perch. The "ears" on this
and other species of owls have nothing
to do with hearing but are instead aids
to concealment. They typically perch
near the trunk of a tree and stretch
vertically with ears erect, blending
with tree branches. Although winter
roost sites often change from year to
year, a few areas such as Lyon County
State Lake and Cedar Bluff Reservoir
attract Long-eared Owls annually.

143

Short-eared Owl

Asio flammeus

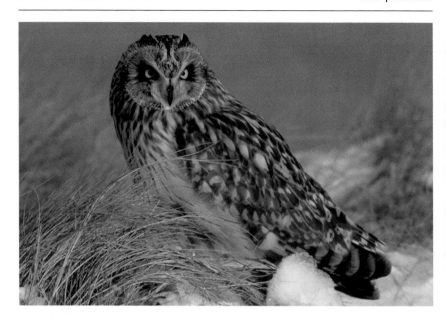

Field Identification: This round-headed owl of open country has short "ears" that are seldom visible. The brown upperparts are spotted with white and streaked below. The black plumage around the eyes is prominent on the pale face. **Size:** Length 15 inches; wingspan 38 inches.

Habitat and Distribution: Found statewide, always in grasslands or marshy areas.

Seasonal Occurrence: Present year-round in Kansas. Spring migrants are seen in March and April; fall migrants in October and November. They winter throughout the state but are erratic in numbers from year to year, probably due to fluctuations in rodent populations. A few nest in central and western Kansas.

Field Notes: Unlike most owls, this species frequently hunts in the hours before dusk and after dawn. During the winter, areas with substantial numbers of Northern Harriers often have Short-eared Owls. As the harriers end their hunting for the day, the Short-eared Owls begin, patrolling low over the grasslands in an erratic moth-like fashion, uttering peculiar high-pitched barking calls. Slate Creek Wetlands and Quivira National Wildlife Refuge are usually reliable locations for observing these birds during the winter if you get up early enough to be present when they are active.

Athene cunicularia

Burrowing Owl

Field Identification:
This unique prairie owl of western Kansas has long legs; a round, flat head; and a broad white band above widely spaced yellow eyes. It often perches on top of wooden fence posts. **Size:** Length 9 inches; wingspan 21 inches.

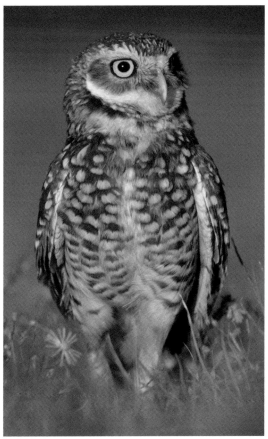

Habitat and Distribution:
Always seen in open country, most often in prairie-dog towns. Formerly more common and widespread in Kansas, it is now mostly restricted to the western half of Kansas, where prairie-dog towns still exist.

Seasonal Occurrence:
This summer resident arrives in April and departs in October. It occasionally lingers into December in milder winters.

Field Notes: Burrowing Owls can most easily be found in prairie-dog towns standing on the ground or on nearby fence posts. The owls nest in abandoned burrows of prairie dogs and other mammals. They do not prey on prairie dogs but eat insects.

Unfortunately, many prairie-dog towns in Kansas have been destroyed, and like many grassland birds, the Burrowing Owl population is declining as its habitat is eliminated. A small dog town near the town of Redwing, at the northern edge of Cheyenne Bottoms, has provided many birders with their first look at Burrowing Owls.

Common Nighthawk

Chordeiles minor

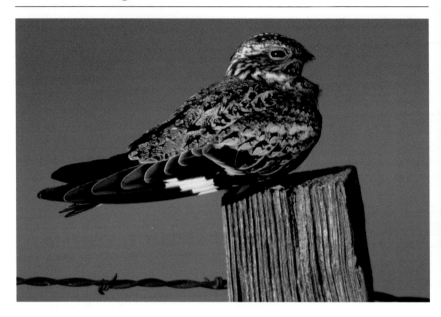

Field Identification: Common Nighthawks are mottled gray above and barred on the underparts and tail and have large eyes and a tiny bill. In flight, notice the long, crooked wings with a prominent white patch near the wingtips. **Size:** Length 9 inches; wingspan 24 inches.

Habitat and Distribution: Found statewide in grasslands; also around cities and towns.

Seasonal Occurrence: Summer resident. Arrives in early May and departs in September.

Field Notes: Less common than formerly, Common Nighthawks are still a fairly frequent sight in the summer skies of Kansas. Watch for them near dusk as they forage overhead for flying insects. In rural areas, they often perch and sleep atop wooden fence posts during the day. When the first cool-weather fronts push into Kansas during September, large migrating flocks of acrobatic Nighthawks take advantage of the favorable winds ahead of the storm.

Phalaenoptilis nuttallii

Common Poorwill

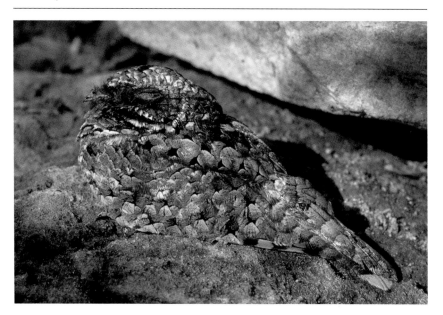

Field Identification: This is the smallest member of the nightjar family in Kansas. It is mottled gray above and barred below and has white tail corners visible in flight. **Size:** Length 8 inches; wingspan 17 inches.

Habitat and Distribution: Common Poorwills have a patchy distribution because of their specialized habitat. They are found in the Smoky Hills, Red Hills, Flint Hills, and other areas of dry, open country characterized by steep slopes capped with exposed rocky outcrops.

Seasonal Occurrence: This summer resident is present between April and October.

Field Notes: Like other nightjars, Common Poorwills are more often heard than seen. As dusk settles in hilly country, listen for their simple two-note call. At Konza Prairie near Manhattan, Common Poorwills, Whip-poor-wills, Chuck-will's-widows, and Common Nighthawks can all be heard calling simultaneously on quiet evenings in early summer. This is one of few places in the United States that this can be experienced. Poorwills are often flushed from dirt roads after dark.

147

Chuck-will's-widow

Caprimulgus carolinensis

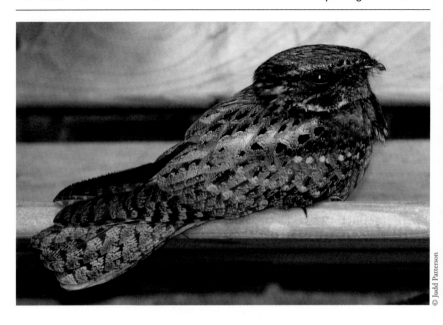

© Judd Patterson

Field Identification: This is the largest nightjar in Kansas, and the brownest. The male has long white shafts on the outer tail when flushed, and the female has buffy tail corners. It is named for the four-note call, given incessantly after dark. The call is accented on the last syllable.
Size: Length 12 inches; wingspan 26 inches.

Habitat and Distribution: They are always found in wooded areas along streams or hillsides. Although they are most abundant in the southeastern third of Kansas, they also occur in western Kansas in isolated areas with suitable habitat, such as Meade State Park.

Seasonal Occurrence: Summer resident. Present from April through mid-September.

Field Notes: Chuck-will's-widows are more numerous and widespread in Kansas than the closely related Whip-poor-will. At eastern Kansas sites such as Marais Des Cygnes Wildlife Area, Big Hill Reservoir, and Toronto Reservoir, their twilight chorus in spring and summer is impressive. Most sightings are of birds flushed from the ground in wooded areas. They blend in with leaf litter and remain motionless until you almost step on them.

Caprimulgus vociferus # Whip-poor-will

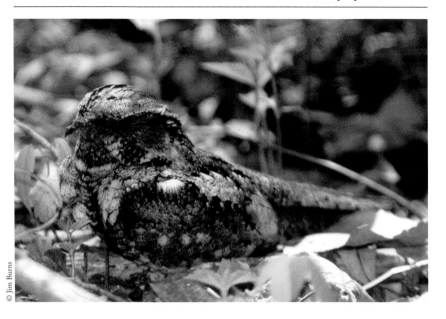

© Jim Burns

Field Identification: This woodland nightjar of eastern Kansas is smaller and grayer than the Chuck-will's-widow. The best field marks on birds that are flushed into flight are the clean-cut white tail corners and black upper tail of the male. The female is similar to the female Chuck-will's-widow except for the smaller size. The three-note call has a higher pitch and more rapid cadence than the Chuck-will's-widow, with the strongest accent on the first syllable. **Size:** Length 10 inches; wingspan 19 inches.

Habitat and Distribution: Found in woodlands of eastern Kansas, mostly east of the Flint Hills. Wanderers can appear farther west during spring migration.

Seasonal Occurrence: Summer resident. Present from April through October.

Field Notes: One of the best opportunities to observe this and other nightjars is to slowly drive quiet roads through wooded hills after sundown. Look for their glowing red eyes in the headlights. A cautious approach may allow you to illuminate them with your headlights and look at them through binoculars.

Rock Pigeon

Columba livia

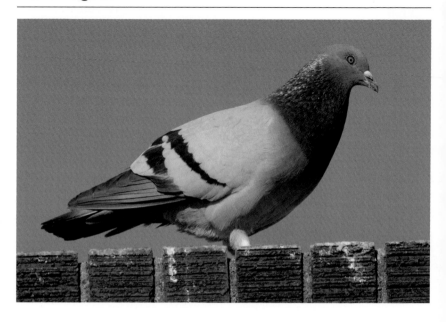

Field Identification: The Rock Pigeon is a large, stocky, and ubiquitous pigeon of urban areas. Its color is extremely variable. Adults are most commonly gray but can also be white, brown, black, or any combination of these colors. It almost always has a white rump and white wing linings. **Size:** Length 12 inches; wingspan 28 inches.

Habitat and Distribution: Cities and towns statewide, especially around tall buildings and grain elevators, as well as at farms and rural bridges.

Seasonal Occurrence: Permanent resident.

Field Notes: This species is not native to North America. It was introduced by European immigrants and has spread across North America. In Kansas, it is common in the larger cities, and even the smallest towns usually have a small resident population of these pigeons. In remote rural areas it is not uncommon to find a few pairs nesting under bridges far from the nearest town or farmyard.

Streptopelia decaocto

Eurasian Collared-Dove

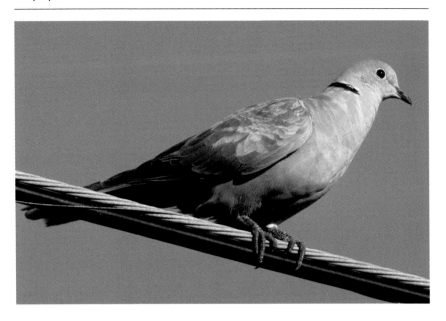

Field Identification: This large, pale dove has a sharply defined black collar on the back of the neck and a long, broad tail with large white corners. Dark wingtips are visible on perched birds as well as in flight. Often flies into the air and soars briefly. Likes to perch on top of utility poles and other high spots. Loud three-note cooing call is given throughout the day.
Size: Length 13 inches; wingspan 22 inches.

Habitat and Distribution: Cities and towns throughout the state. It is also moving into rural areas.

Seasonal Occurrence: Permanent resident.

Field Notes: This species is native to Eurasia and was introduced to the Bahama Islands several decades ago. From there it spread to Florida and since has rapidly expanded its range across the United States. It is now widespread and abundant in Kansas towns, especially in western Kansas. It has been recorded in almost every county in the state. It has recently been classified as a game bird by the Kansas Department of Wildlife and Parks.

White-winged Dove

Zenaida asiatica

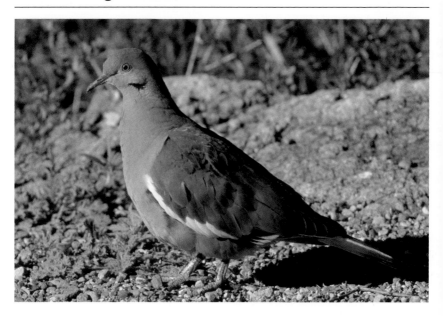

Field Identification: This large, stocky, brownish-gray dove has a relatively short tail. Prominent white wing patches are seen in flight, visible as a white crescent on the edge of the folded wing of perched birds. The tail is black with a broad white tip. **Size:** Length 11 inches; wingspan 19 inches.

Habitat and Distribution: Cities and towns of southwest Kansas. Wandering birds can appear elsewhere at any season.

Seasonal Occurrence: Recently established as a permanent resident in the southwest, especially in Garden City and Dodge City.

Field Notes: Only a few years ago, sightings of this southern dove in Kansas were events of great excitement for birders. It has now expanded its range throughout southwest Kansas, and roosts of over a hundred birds have been observed in Garden City. It readily comes to bird feeders, and many records from beyond southwest Kansas are of single birds seen at feeders with other dove species.

Zenaida macroura

Mourning Dove

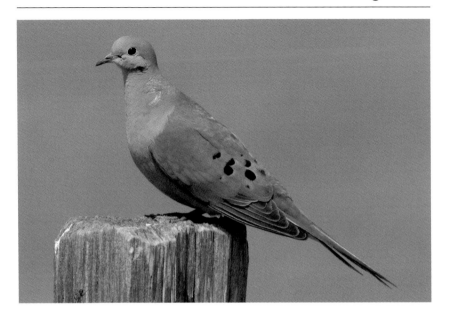

Field Identification: This familiar dove is brownish-gray with black spots on the wings and a long wedge-shaped tail with wide white borders. It flushes abruptly with loud, whistling wings. The song of low cooing notes is given most often at dawn and dusk. **Size:** Length 12 inches; wingspan 18 inches.

Habitat and Distribution: Statewide in a wide variety of rural and urban habitats.

Seasonal Occurrence: Permanent resident, but with substantial population movement. Abundant migrant and summer resident. A few remain for the winter, mostly in southeast Kansas.

Field Notes: This is one of the most abundant birds in Kansas from April through September. It is also one of the most popular game birds in the state. The hunting season for doves begins around Labor Day and is the traditional start of the hunting season in Kansas. During late summer, large, conspicuous flocks begin to gather; they peak in numbers in late August. The first cool fronts of September push more into Kansas from the northern states, and these birds linger until successive cold fronts send most of them farther south.

Inca Dove

Columbina inca

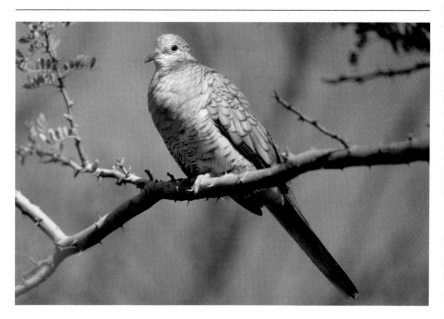

Field Identification: This small, pale, long-tailed dove has a unique scaly appearance on much of the body. The wings are mostly rufous above and below, but the rufous color is not visible on perched birds. The long tail has broad white edges. A monotonous two-note cooing is often the first clue to its presence. **Size:** Length 8 inches; wingspan 11 inches.

Habitat and Distribution: A rare resident of southwest Kansas towns. Wandering individuals appear elsewhere, mostly in the southern counties.

Seasonal Occurrence: Permanent resident in southwest Kansas. Vagrant birds in other parts of the state have been recorded throughout the year.

Field Notes: Like the White-winged Dove, the Inca Dove appears to be colonizing Kansas from the southwest. It has recently established a permanent presence in the southwest corner of the state, and sightings of this species from elsewhere in Kansas have also increased. Like the White-winged Dove, it is almost always seen at bird-feeding stations with other dove species.

Coccyzus americanus

Yellow-billed Cuckoo

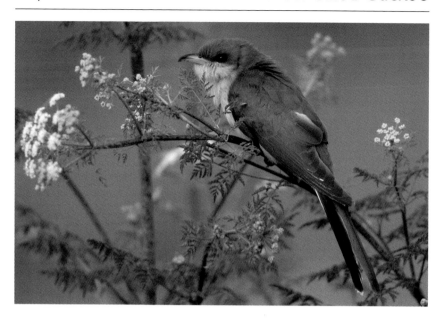

Field Identification: Long and slender, this bird can be confused with a Mourning Dove or a Brown Thrasher at first glance. It has a brown back and crown and pure white throat and underparts. The undertail has large white spots. Large rufous patches are visible on the wings of flying birds. The long, stout bill is mostly yellow. **Size:** Length 12 inches; wingspan 18 inches.

Habitat and Distribution: Statewide in brushy wooded areas, often near streams or ponds.

Seasonal Occurrence: Summer resident. Arrives in early May and departs by late September.

Field Notes: This is a fairly common but secretive bird. Many rural residents know it as the "rain crow." Its guttural song is often considered a harbinger of rainfall. Despite the loud vocalizations, it is often difficult to see. Because of its habit of flying low over the ground, it is often killed by vehicles on highways, and by flying into windows. Populations of this species are in serious decline in some parts of the United States, but Kansas populations appear to be stable. Much more rarely seen in Kansas is the **Black-billed Cuckoo**, which has an all-black bill, no rufous in the wings, and much smaller white tail spots.

Greater Roadrunner

Geococcyx californianus

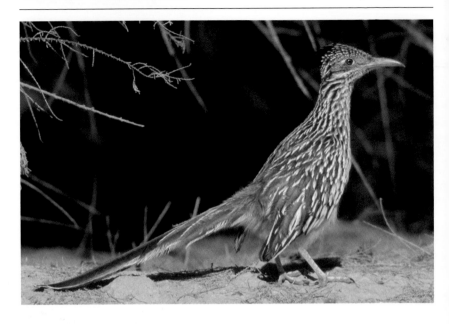

Field Identification: A unique terrestrial bird of rugged country, the Greater Roadrunner is easily identified by the extremely long tail and long, pointed bill. The ragged crest feathers are not always raised. It is occasionally seen flying for short distances but prefers to run on its strong legs. The song is a low series of cooing notes, often the first clue to its presence. **Size:** Length 23 inches; wingspan 22 inches.

Habitat and Distribution: Rugged arroyos and draws in the counties along the Oklahoma border, from Cowley County west to about Meade County. Wanders farther north fairly regularly and may be expanding its range in Kansas.

Seasonal Occurrence: Permanent resident.

Field Notes: Roadrunners are most likely to be seen in Barber and Comanche counties, where the rough terrain that they prefer is widespread. Often they are extremely wary, but they can also be peculiarly tame and approachable. Little is known about the Kansas population, which probably numbers a few hundred birds. Deliberate searching for them can be fairly frustrating because they are both scarce and elusive. The best strategy for seeing one is to explore rural roads in western Barber County. The drive between Sun City and Belvidere is a fairly reliable place to look for them.

Megaceryle alcyon

Belted Kingfisher

Field Identification:
This large-headed bird has a prominent ragged crest and big spiked bill. It is blue-gray above and white below. The male has one blue band across the breast; the female has an additional red band.
Size: Length 13 inches; wingspan 20 inches.

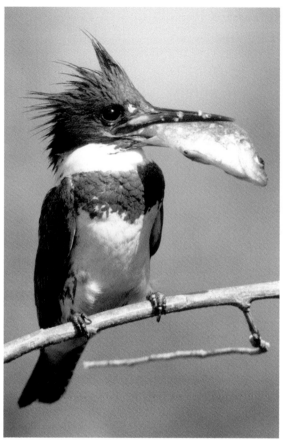

Habitat and Distribution: Found statewide at streams, rivers, lakes, and ponds. Nests in burrows excavated in steep banks. They seem to prefer smaller streams with slow-moving water.

Seasonal Occurrence: Permanent resident. Most numerous during migration, but many remain to nest. A few remain in winter as long as there is open water.

Field Notes: Kingfishers are easy to find because of their conspicuous perches and loud, rattling calls. They sometimes hover before diving into the water to capture small fish.

Red-headed Woodpecker

Melanerpes erythrocephalus

Field Identification: The adult is unmistakable, with a bright red head and black-and-white pattern on the body. Juveniles have the same color pattern, but the head is streaked brown instead of red. **Size:** Length 9 inches; wingspan 17 inches.

Habitat and Distribution: Found statewide. Prefers open country with some trees in summer, and oak and pecan woodlands year-round.

Seasonal Occurrence: Summer resident throughout the state. In the winter it occurs only in southeastern Kansas.

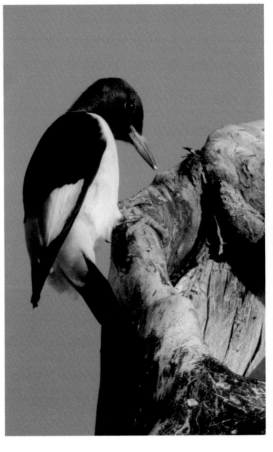

Field Notes: These boldly plumaged birds are conspicuous in the summer months, especially in open areas of western Kansas, where they subsist on insects and seeds. In the winter, they live on acorns and nuts and can be numerous in oak woodland and pecan groves in eastern Kansas when the acorn or nut crop has been good. Because of their habit of flying low over the ground, they are often hit by cars.

Melanerpes carolinus

Red-bellied Woodpecker

Field Identification: This woodpecker's back has horizontal black-and-white bars; it has a red cap and hind neck. The white rump and wing patches are conspicuous on flying birds. Their staccato "laughing" calls are often the first clue to their presence in wooded areas. **Size:** Length 9 inches; wingspan 16 inches.

Habitat and Distribution: Found statewide but is most numerous in the eastern two-thirds of Kansas. Prefers woodlands along streams, upland forests, and towns with mature trees. Its range is gradually expanding westward as woodlands mature in towns and along streams in western Kansas.

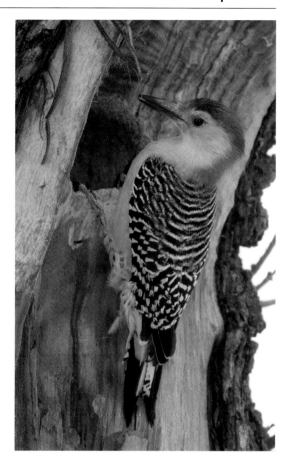

Seasonal Occurrence: Permanent resident.

Field Notes: Red-bellied Woodpeckers are named after one of their least noticeable plumage characteristics.

The red belly is at best a rosy wash visible only when the bird is in hand. They are often seen at bird feeders. When they show up, the rest of the feeder crowd must wait until the Red-bellied has had its fill of suet, nuts, or sunflower seeds.

159

Yellow-bellied Sapsucker

Sphyrapicus varius

Field Identification:
This medium-sized woodpecker is usually seen on pines. Look for the vertical white mark on the flanks, found on no other Kansas woodpecker. The head is boldly striped in black and white, with a red crown. Males have red throats; females have white. The back is barred with white and black. Juveniles are brownish on the head and breast.
Size: Length 8 inches; wingspan 16 inches.

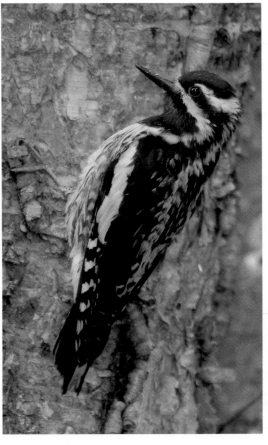

Habitat and Distribution:
Found statewide, usually in cemeteries, yards, parks, and other areas with numerous conifers. Although it prefers pines, it is frequently seen on deciduous trees as well, especially sweet gums. It is fairly numerous in the Red Hills, where cedars are abundant.

Seasonal Occurrence: Winter resident. Arrives in October and departs in April.

Field Notes: These woodpeckers are quiet and retiring and thus are easily overlooked. They hide on the back side of tree trunks and then quietly fly away. Look on pine and sweet-gum trees for long horizontal rows of holes drilled in the bark. Sapsuckers create these and then return for sap and trapped insects.

Picoides pubescens

Downy Woodpecker

Field Identification: This is the most common and widespread woodpecker in Kansas, and also the smallest. The most prominent field mark is the broad vertical white stripe on the back. The head is striped black and white, and it has black wings and white underparts. Its call is a shrill descending whinny, and also a single *"pik"* note. **Size:** Length 7 inches; wingspan 12 inches.

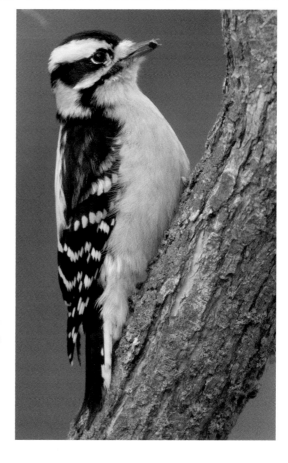

Habitat and Distribution: Found statewide anywhere trees are present. It is abundant in the east, less common in western Kansas.

Seasonal Occurrence: Permanent resident.

Field Notes: Downy Woodpeckers are not afraid of people and are found in nearly every city and town in the state. They are frequent visitors to bird feeders. Besides foraging on trees, they are often seen feeding on corn, milo, and weed stalks. In winter, small woodland birds form mixed-species flocks that forage for food together. These may include Downy Woodpeckers as well as chickadees, titmice, nuthatches, and wrens.

Hairy Woodpecker

Picoides villosus

Field Identification:
This species is similar to the Downy Woodpecker but is substantially larger, with a noticeably longer, stouter bill. Calls are also similar to those of the Downy, but louder. Hairy Woodpeckers found in western Kansas are often of the Rocky Mountain subspecies shown here. Those in central and eastern Kansas have more extensive white spots on the back and wings.
Size: Length 9 inches; wingspan 15 inches.

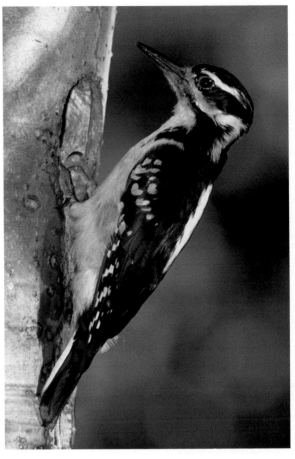

Habitat and Distribution:
Statewide, but requires larger and more mature tracts of woodland than Downy Woodpeckers.

Seasonal Occurrence: Permanent resident.

Field Notes: Hairy Woodpeckers are more selective of habitat than Downy Woodpeckers and have much larger feeding and nesting territories. They are fairly common in cities and towns but rarely visit bird feeders. Based on Christmas Bird Count and Breeding Bird Survey data, the Kansas population is roughly 25 percent that of the Downy Woodpecker.

Colaptes auratus

Northern Flicker

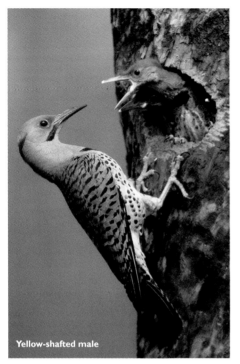

Yellow-shafted male

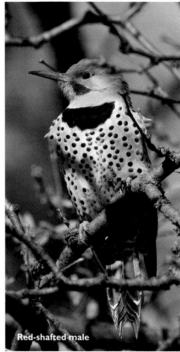

Red-shafted male

Field Identification: This large woodpecker has a brown back with narrow black bars, a white breast with round spots, and a black bib marking on the chest. The wing linings are yellow or red, depending on subspecies. Males of the red-shafted subspecies have a gray face and red mustache mark, whereas those of the yellow-shafted subspecies have a brown face with black mustache mark. Females lack mustache marks. **Size:** Length 12 inches; wingspan 20 inches.

Habitat and Distribution: Statewide in brushy open country, woodlands, and urban areas.

Seasonal Occurrence: Present year-round, although variable by seasons. During March and October, large flocks of migrating flickers are often observed.

Field Notes: Northern Flickers are named for their peculiar calls, which are often interpreted as *"flicker flicker flicker flic."* Most flickers seen in the summer in Kansas are yellow-shafted individuals. In winter, red-shafted birds move onto the plains from the mountain West. The two subspecies hybridize on the Great Plains, and intermediate birds are often observed. Flickers are fond of eating ants and other insects while perched on the ground.

163

Pileated Woodpecker

Dryocopus pileatus

Field Identification:
This exceptionally large woodpecker of the eastern woods is mostly black, with a broad white stripe on the neck and a large red crest. Bright white wing linings are visible when it is in flight. Calls are similar to those of the Northern Flicker but are louder and more primeval-sounding. The drumming is louder than that of any other woodpecker. **Size:** Length 17 inches; wingspan 29 inches.

Habitat and Distribution:
Mostly found in mature woodlands in the eastern fourth of Kansas, especially along rivers.

Seasonal Occurrence:
Permanent resident.

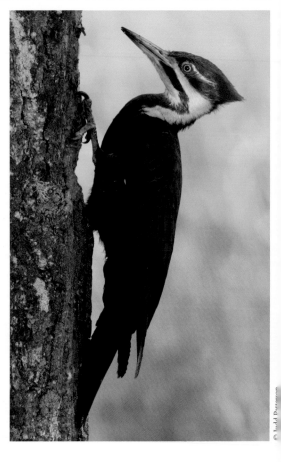

Field Notes: Formerly considered rare in Kansas, the Pileated Woodpecker has increased its range and population over the past several decades. It has recently been observed as far west as Kingman and Reno counties as woodlands along the Arkansas, Chikaskia, and Ninnescah, rivers have matured and spread. Despite its size and distinctive appearance, it is often elusive and difficult to see. When approached, it slips around to the back side of the tree and flies quietly away. Many sightings are of birds flying above the forest canopy. Their massive excavations for grubs in dead trees are deep and distinctive, a good clue to their presence.

Chaetura pelagica

Chimney Swift

Field Identification:
These birds have slender, streamlined bodies; long, pointed wings; and unmarked gray plumage, lightest on the throat. Their flight is rapid and acrobatic, alternating gliding with deft wingbeats. Their frequent chittering calls, given in flight, are a familiar summer sound in Kansas towns with older buildings. **Size:** Length 5 inches; wingspan 14 inches.

Habitat and Distribution:
Found statewide but more common in the eastern two-thirds of the state. Usually seen near human habitations.

Seasonal Occurrence:
Summer resident. Present from mid-April through mid-October.

Field Notes: Chimney Swifts have benefited significantly from human alterations to the landscape. Brick chimneys on houses, especially those constructed prior to the 1960s, offer perfect nesting habitat for them. Contemporary chimney construction is usually not suitable for Chimney Swifts. As older chimneys disappear, so do the swifts. During fall migration, Chimney Swifts travel in massive flocks, which roost in tall smokestacks at schools and industrial facilities. At sunset, they descend into these stacks in impressive swirling flocks.

Purple Martin

Progne subis

Field Identification:
The Purple Martin is a large member of the swallow family. The male is iridescent purple; females and juveniles are dark gray above and mottled white and gray below.
Size: Length 8 inches; wingspan 18 inches.

Habitat and Distribution: Found statewide but rare and local in the west. In summer, it is seen almost exclusively around man-made martin houses. Migrating birds are observed in a variety of habitats.

Seasonal Occurrence: Migrant and summer resident. Arrives in southern Kansas in late March; departs in September.

Field Notes: Many people go to considerable lengths to attract Purple Martins to multichambered martin houses they have installed in their yards. After nesting, martins begin gathering in large flocks prior to migrating. These flocks often number in the tens of thousands of birds and occur annually in Kansas City, Wichita, and elsewhere. They typically roost together at night, then forage widely during the day,

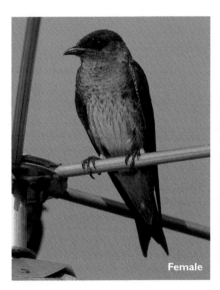

Female

returning to the roost at dusk. These large flocks depart for the tropics with the first cool fronts of September.

Tachycineta bicolor

Tree Swallow

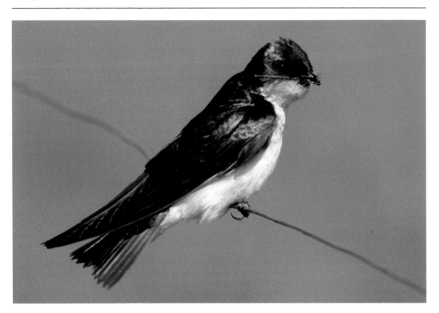

Field Identification: Adult males are blue-green above and white below. Females are similar but brownish above. **Size:** Length 6 inches; wingspan 15 inches.

Habitat and Distribution: Occurs statewide as a migrant, usually near water. In recent years, their breeding range has expanded to include many parts of the state where they had not previously nested.

Seasonal Occurrence: Migrant and summer resident. Arrives in March and departs in October. Occasionally lingers into early winter when the weather is mild.

Field Notes: Tree Swallows are among the hardiest of the swallow family and can be seen early in the spring and late in the fall. Look for them hawking for insects near the surfaces of marshes, lakes, and ponds. They typically nest in cavities of dead trees located in or near bodies of water. They will also use bluebird nesting boxes if they are located in or near water.

Northern Rough-winged Swallow *Stelgidopteryx serripennis*

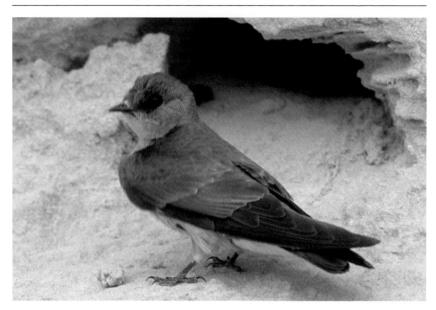

Field Identification: This widespread swallow is brownish above and white below. The throat and breast are always brownish, the best mark to separate this species from the somewhat similar Bank Swallow. The tail is wider and square-cut on the end, unlike the notched and thinner tail of the Bank Swallow. **Size:** Length 5 inches; wingspan 14 inches.

Habitat and Distribution: Statewide, especially in areas located near water, but also in grasslands far from ponds or streams where exposed dirt banks are present.

Seasonal Occurrence: Migrant and summer resident. Arrives in early April and departs in mid-September.

Field Notes: Rough-winged Swallows nest in holes excavated in soft dirt banks. During migration, they can be seen at any body of water, where they forage for insects low over the surface. Most sightings in spring and summer are of pairs or small flocks. In late July, they begin to gather in larger flocks, often with other swallow species. These flocks gather in areas with abundant insects, such as wetlands and reservoirs.

Riparia riparia # Bank Swallow

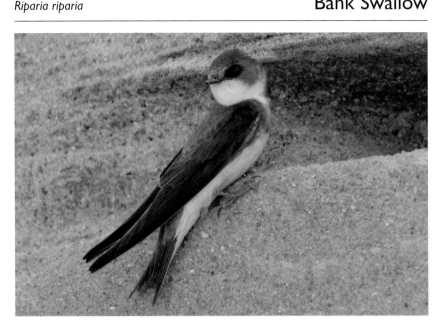

Field Identification: This smaller swallow is brown above and white below, with colors more cleanly separated than those on the dingier Northern Rough-winged Swallow. A sharply defined brown band on the white breast is the most definitive mark. **Size:** Length 5 inches; wingspan 13 inches.

Habitat and Distribution: Like other swallows, seen widely in migration near water. In summer, large colonies nest locally in exposed soil banks, usually along rivers or lakeshores. These colonies are scattered across Kansas but are scarce and widely separated.

Seasonal Occurrence: Migrant and summer resident. Arrives in mid-April and departs in mid-September.

Field Notes: Bank Swallows nest in burrows excavated from earthen banks in colonies of ten to a hundred pairs. Bank Swallows also nest throughout Canada and the northern states. They begin migrating south in July, gradually assembling into large flocks, often with other swallow species. By early August, flocks in the hundreds have gathered at wetland sites with abundant insects. These are excellent times to learn swallow identification, as numerous individuals of up to six species perch shoulder to shoulder on fences and utility lines.

Cliff Swallow

Petrochelidon pyrrhonota

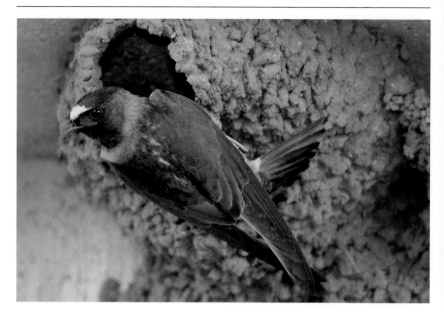

Field Identification: This distinctive swallow has a dark back, square-cut tail, reddish throat, and white belly. The most prominent markings are the orange rump, nape, and forehead. The orange rump is easily seen on flying birds, quickly separating the Cliff from all other swallow species. **Size:** Length 5 inches; wingspan 13 inches.

Habitat and Distribution: Statewide. Cliff Swallows always nest in large colonies. The nest colonies are usually under road bridges with a nearby source of mud. Most common in the western two-thirds of Kansas, but populations in eastern Kansas are increasing.

Seasonal Occurrence: Migrant and summer resident. Arrives in mid-April and departs in September.

Field Notes: Look for the gourd-shaped mud nests plastered to the undersides of concrete bridges. Bridges that harbor colonies nearly always have birds in the air. Beginning in late July, postbreeding Cliff Swallows gradually congregate into ever larger flocks. These flocks wander in search of abundant insect populations until the first cool fronts of September encourage them to depart southward.

Hirundo rustica

Barn Swallow

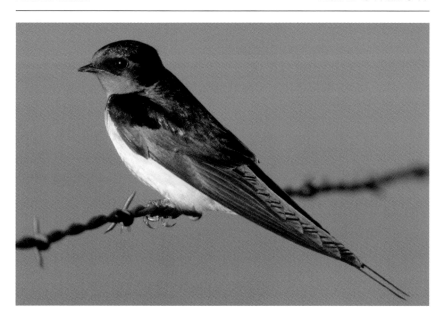

Field Identification: This common swallow is dark blue above. The underparts are orange on males and whitish on females. The throat is always dark orange. Best field mark is the long, deeply forked tail, found on no other swallow. **Size:** Length 7 inches; wingspan 15 inches.

Habitat and Distribution: Statewide, usually near barns or other rural buildings. Barn Swallows are one of the most widespread birds in Kansas and have been recorded nesting in almost every county.

Seasonal Occurrence: Migrant and summer resident. Arrives in mid-April and departs in early October, occasionally lingering to early November.

Field Notes: In summer, these birds are a familiar sight, flying low over fields and pastures in acrobatic fashion as they forage for insects. Their mud nests are placed on vertical walls under the eaves of homes or barns and inside older sheds and barns. They also frequently nest under bridges. They gather in large flocks with other swallow species in late summer before departing south for the winter.

Ruby-throated Hummingbird

Archilochus colubris

Field Identification: The adult male has a bright-red throat, black mask and chin, forked black tail, and metallic green back and crown. Females and immature birds are seen more frequently. They are also green above, with a white throat and a black tail with white tips.
Size: Length 4 inches; wingspan 4.5 inches.

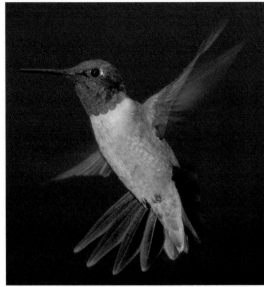

Habitat and Distribution: Uncommon in wooded areas and suburban yards east of the Flint Hills, becoming less numerous in central Kansas. Rare in the west.

Seasonal Occurrence: Migrant and summer resident. Arrives in May and departs in early October. Many Ruby-throats seen in Kansas are migrants, and northbound individuals do not linger in spring. Southbound fall migrants begin to arrive in late July and linger into early October.

Field Notes: This is the only hummingbird found in most of the eastern United States. Ten species of hummingbirds have been documented in Kansas, but the overwhelming majority of hummingbirds seen in the state are Ruby-throats. Although they are frequently observed in wild habitats, perhaps no family of birds is observed more exclusively at feeders

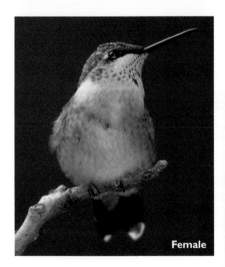

Female

than hummingbirds. Homeowners who diligently offer appropriate flower plantings and nectar feeders are usually rewarded with hummers, especially during the fall migration.

Selasphorus rufus

Rufous Hummingbird

Field Identification:
The adult male is mostly
orange with green wings
and an orange-red throat.
Females and immature
birds are seen more often
than adult males. They
are more green overall but
always show at least some
orange on their flanks
and at the base of the tail
feathers. **Size:** Length
4 inches; wingspan 4.5
inches.

Habitat and Distribution:
Almost always seen
at feeders, most often
in western Kansas.
Wandering migrants can turn up
anywhere in Kansas.

Seasonal Occurrence: Fall migrant.
Rufous Hummingbirds are found
from July through September as
postbreeding birds move out of the
Rockies and wander onto the plains.
There are only a handful of spring
records.

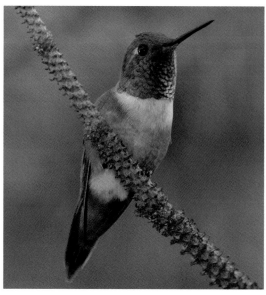

Field Notes: Dedicated hummingbird
enthusiasts always hope for a rare
western hummingbird, and this is
the most likely of those to make an
appearance in Kansas. Western Kansas
towns such as Elkhart, Garden City,
and Larned have earned a reputation
for attracting rare hummingbirds
during the late-summer migration.
In western counties, the Rufous
Hummingbird is actually seen more
frequently than the Ruby-throated
Hummingbird, which is rare in the
west.

Great Crested Flycatcher

Myiarchus crinitus

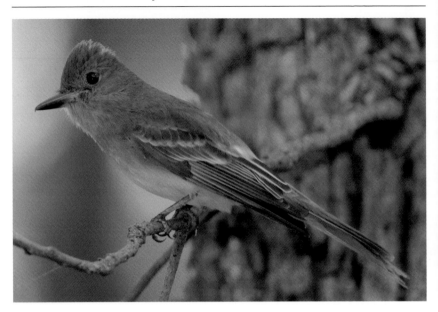

Field Identification: This large flycatcher of woodlands has a gray breast, yellow belly, rusty-red tail, and olive back. The head has an obvious crest. Its call is a loud, rough *"wheep,"* heard throughout the summer. Other vocalizations have the same tonal quality. **Size:** Length 9 inches; wingspan 13 inches.

Habitat and Distribution: Found statewide in woodlands but most common in the eastern two-thirds of Kansas. Prefers woodlands along rivers and streams but also found in drier upland woods.

Seasonal Occurrence: Summer resident. Arrives in late April and departs in early September.

Field Notes: In spring and early summer, these are among the most frequently heard woodland birds in central and eastern Kansas. They can be heard throughout the day, when most other birds are quiet. They aggressively scold intruders of all kinds. Unlike most flycatchers, they nest in tree cavities. After the nesting season, they fall silent and are easy to overlook as they quietly forage in the canopy.

Tyrannus verticalis

Western Kingbird

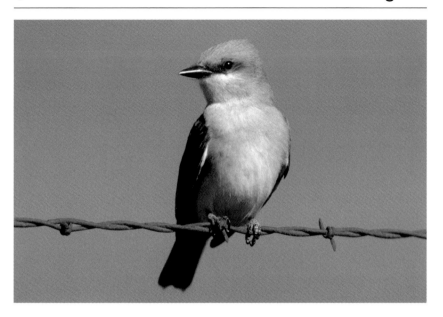

Field Identification: This large flycatcher of open areas has a gray head, light-olive back, pale breast, yellow belly, and black tail with clean-cut white edges. The sharp-sounding song and call notes are given incessantly in the nesting season, often even at night. **Size:** Length 9 inches; wingspan 16 inches.

Habitat and Distribution: Common in the western two-thirds of Kansas in open country and urban areas. Scarce and local east of the Flint Hills. From the Flint Hills eastward, they are seen less frequently in rural areas, and most nesting birds in eastern Kansas are found in towns.

Seasonal Occurrence: Summer resident. Arrives in early May and departs in late September.

Field Notes: Western Kingbirds are one of the most conspicuous summer bird species of central and western rural Kansas. They are usually seen perched on utility wires or fences, from which they fly out to capture insects. They are often seen in cities and towns.

Eastern Kingbird

Tyrannus tyrannus

Field Identification: Eastern Kingbirds are dark gray above and all white below. The crown and face are darker than the back. The tail has a clean-cut white tip. **Size:** Length 8 inches; wingspan 15 inches.

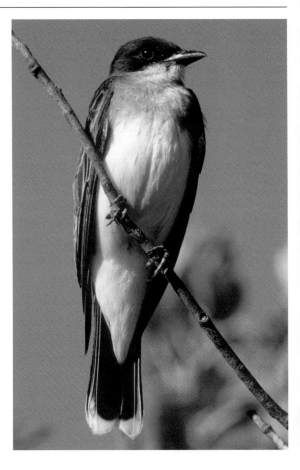

Habitat and Distribution: Found statewide but most common in the eastern two-thirds of Kansas. While both kingbirds are common in Kansas, they occur in subtly different habitats. Western Kingbirds prefer drier open country, whereas Eastern Kingbirds are most often found in slightly moister areas with woody vegetation.

Seasonal Occurrence: Summer resident. Arrives in late April; departs in mid-September.

Field Notes: Eastern Kingbirds tend to forage from low perches such as fences and shrubs. All kingbirds are known for their aggressive behavior toward other birds that they perceive as threats, especially crows and hawks. They fearlessly attack these intruders by repeatedly dive-bombing them and have even been seen landing on the backs of flying hawks and vigorously jabbing them with their beaks.

Tyrannus forficatus

Scissor-tailed Flycatcher

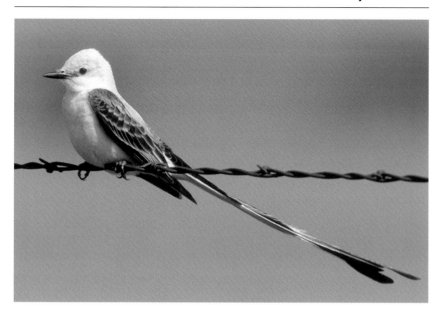

Field Identification: The long, streaming tail makes this species unmistakable. Adults are light gray, with salmon-pink flanks and dark wings. Juvenile birds have a shorter tail. The vocalizations are similar to those of the Western Kingbird.
Size: Length 15 inches; wingspan 15 inches.

Habitat and Distribution: Recorded statewide but most likely to be found in the south-central counties. Inhabits open country with scattered trees.

Seasonal Occurrence: Summer resident. Scissor-tails arrive in mid-April, earlier than most other flycatchers, and also linger longer in the fall than do most other flycatchers, sometimes as late as mid-October.

Field Notes: Scissor-tailed Flycatchers are one of the most well-known birds in Kansas. They are in the same genus as the kingbirds, and like kingbirds, they perch conspicuously in open country, flying out to capture insects. The long, divided tail allows them exceptional maneuverability in flight. Their nests are often located in isolated trees in open country. In late September and October, they gather in flocks prior to migrating. Lucky observers may find flocks of up to several hundred birds lined up on fences or utility wires.

Olive-sided Flycatcher

Contopus cooperi

Field Identification: This large-headed flycatcher is mostly drab olive gray in color. Dark flanks extend well onto the white breast, creating a "vested" look. The distinctive three-note call is often interpreted as *"QUICK three beers,"* trailing off on the last note.
Size: Length 7 inches; wingspan 10 inches.

Habitat and Distribution: Found statewide during migration. In spring, most are seen in the east, but in fall, they seem to be more common in the western counties.

Seasonal Occurrence: Spring migrant in late April and early May; fall migrant in late August and early September.

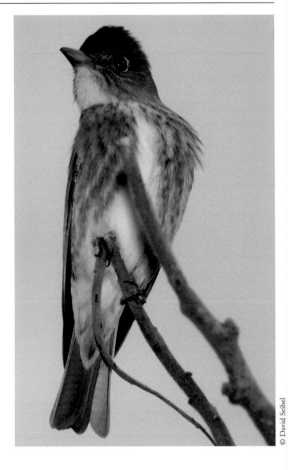

© David Seibel

Field Notes: This neotropical migrant nests in the boreal forests of Canada and winters in Central and South America. It is seen in Kansas only as a migrant. Olive-sided Flycatchers usually hunt from a high, bare branch, flying out to capture flying insects.

Contopus virens

Eastern Wood-Pewee

Field Identification:
This flycatcher is closely related to the Olive-sided Flycatcher but is smaller and has obvious wing bars. The vested look is muted, and its belly has a yellowish cast in early summer. It is named for its distinctive two-note song, which is plaintive and lazy in quality.
Size: Length 6 inches; wingspan 10 inches.

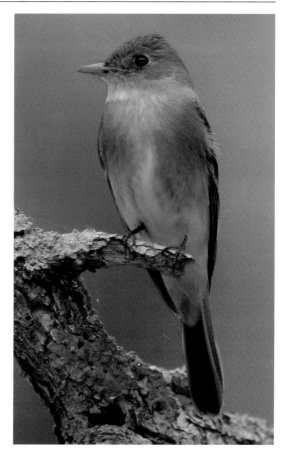

Habitat and Distribution:
Nests in eastern Kansas in mature riparian woodlands west to about Kingman and Russell counties. Migrants are seen statewide in a variety of habitats with trees.

Seasonal Occurrence:
Summer resident. Arrives in early May; departs by late September.

Field Notes: During the summer, this is one of the most common flycatchers in eastern Kansas woodlands. Its song is heard throughout the season, even at midday during the hottest weather. Like the Olive-sided, it is fond of high, exposed perches, from which it flies out to capture insects. In far western counties, **Western Wood-Pewees** are frequently seen in spring and fall migration. Telling the two species apart is challenging, although Westerns tend to be darker in color and have a much different song.

Eastern Phoebe

Sayornis phoebe

Field Identification:
The Eastern Phoebe is a medium-sized flycatcher lacking wing-bars. It is gray above, with a white or yellowish belly and a darker face and cap. Habitually dips the tail downward while perched. Song is a series of alternating pairs of burry notes, from which the name is derived. **Size:** Length 7 inches; wingspan 10.5 inches.

Habitat and Distribution:
Statewide along streams and around rural buildings.

Seasonal Occurrence:
Summer resident. Arrives in March and departs in late October. A few sometimes remain into early winter in southern Kansas.

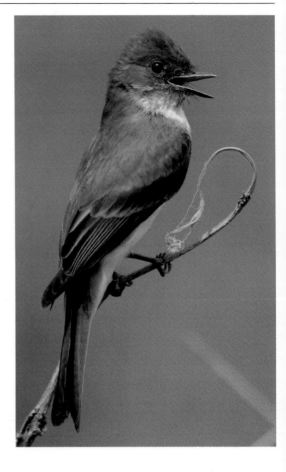

Field Notes: The trees may be bare and the wind cold, but the song of the plucky and hardy phoebe is a reminder that spring is near! Their arrival in March is among the earliest of the migratory songbirds, especially those that subsist on insects. During warm months, a stop at almost any rural bridge will produce a pair of these flycatchers. Look under the bridge and you will usually find their nest attached to a vertical surface or a ledge. They are also fond of nesting in barns or other rural buildings.

Sayornis saya

Say's Phoebe

Field Identification:
Closely related to the
Eastern Phoebe, the
Say's Phoebe is slightly
larger and found in drier,
western habitats. Mostly
light gray, with a darker
mask, a black tail, and
muted orange on the belly
and under the tail.
Size: Length 7.5 inches;
wingspan 13 inches.

Habitat and Distribution:
Prefers arid, open country.
Say's Phoebes are usually
seen in or near grasslands,
conspicuously perched
on fences, shrubs, or
weed stalks. Found in
the western half of the
state, east to Mitchell and
Kiowa counties. Wanders
farther east in migration.

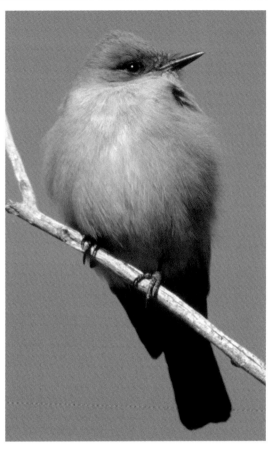

Seasonal Occurrence:
Migrant and summer
resident. Spring birds
arrive in late March, and most depart
in October. A few linger into early
winter in the southwest.

Field Notes: Like Eastern Phoebes,
they often select bridges or rural
structures such as barns or sheds for
nest sites. They are most common in
the Smoky Hill River watershed. They
are numerous in mid-September,
when many southbound migrants
can be seen at locations in western
Kansas such as the Cimarron National
Grassland or the river road west of
Syracuse.

Acadian Flycatcher

Empidonax virescens

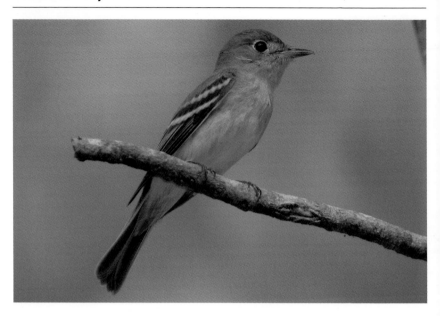

Field Identification: All *Empidonax* flycatchers are greenish-gray above and pale below, with two wing bars. They habitually flick their wings nervously. The best way to distinguish these similar species is by their songs. The Acadian's song is an emphatic *"peet-SUH."* It also shows a distinct eye ring. **Size:** Length 6 inches; wingspan 9 inches.

Habitat and Distribution: Found in swampy or wet woodlands with dense foliage in the eastern two tiers of counties, extending west along the Oklahoma border to Cowley County. Spring migrants are sometimes seen farther west.

Seasonal Occurrence: Summer resident. Arrives in May; departs in August and September.

Field Notes: Several small flycatchers belonging to the *Empidonax* genus are found in Kansas, but most are seen only in migration. The Acadian Flycatcher is the only *Empidonax* that is a summer resident in most of Kansas. Learning its song is helpful, as it can otherwise go unnoticed in the dense woodlands.

Empidonax alnorum & traillii

Alder & Willow Flycatchers

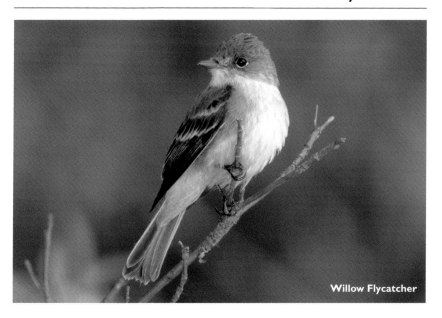

Willow Flycatcher

Field Identification: These two *Empidonax* flycatchers are so similar that until recently they were considered to be one species. Any *Empidonax* lacking an eye ring, or with only a narrow one, is likely one of these. They are best separated from each other and from other *Empidonax* species by voice. The Willow has a sneezy two-note call accented on the first syllable, and the Alder's is a somewhat similar three-note song accented on the second syllable. Both have a single call note that is softer than that of the Least Flycatcher. **Size:** Length 6 inches; wingspan 8.5 inches.

Habitat and Distribution: Both are seen statewide in a variety of wooded and urban habitats during migration. Willow Flycatchers remain to nest in a few counties in extreme northeast Kansas along the Missouri River.

Seasonal Occurrence: Spring migrants are seen in May and fall migrants in late August and early September. Singing Alders are often seen in late May, after other species of *Empidonax* have departed northward.

Field Notes: After the Least Flycatcher, these are the most frequently observed *Empidonax* flycatchers in Kansas. These two species are so similar to each other that silent birds often must go unidentified.

Yellow-bellied Flycatcher

Empidonax flaviventris

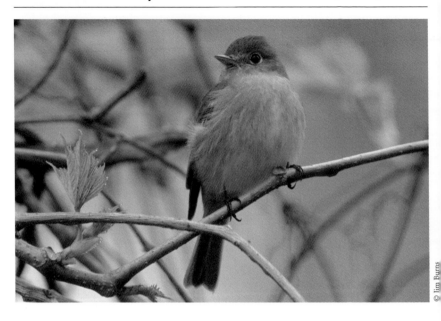

© Jim Burns

Field Identification: This *Empidonax* species is comparatively easy to identify because of the yellow underparts. Other *Empidonax* species sometimes show some yellow below, but only this species has a yellow throat, which blends with the yellowish belly. It is the only *Empidonax* with a yellow eye ring likely to be seen in Kansas. **Size:** Length 5.5 inches; wingspan 8 inches.

Habitat and Distribution: This species is usually seen in the undergrowth of woodlands in central and eastern Kansas.

Seasonal Occurrence: Spring migrant during May; fall migrant during August and September.

Field Notes: Yellow-bellied Flycatchers are most likely to be seen in the eastern third of the state. They are usually silent when in Kansas, so it is fortunate that they are marked more distinctly than other members of their genus.

Empidonax minimus

Least Flycatcher

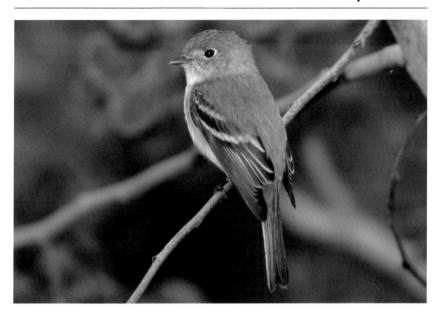

Field Identification: This flycatcher has a slightly shorter tail and wings than the other *Empidonax* species. The eye ring is obvious. It looks big-headed. The song is a dry *"che-bek,"* and the call note is a dry *"pit."* Both vocalizations are heard frequently, simplifying identification. **Size:** Length 5.25 inches; wingspan 8 inches.

Habitat and Distribution: Found statewide in a variety of habitats. Common in central and eastern Kansas; rare in the westernmost counties.

Seasonal Occurrence: Spring migrants are seen from late April through early June. Fall migrants are seen as early as mid-July and continue through mid-September.

Field Notes: This is the most abundant *Empidonax* in most of Kansas, and the one most likely to be heard singing. Leasts are most common in early May and in early September. On some days in early May, they seem to outnumber all other migratory songbirds.

Dusky Flycatcher

Empidonax oberholseri

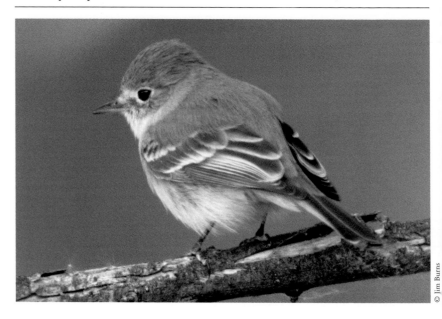

© Jim Burns

Field Identification: This species accounts for many *Empidonax* seen in the westernmost counties. Similar to the Least Flycatcher, but the grayer head contrasts with the olive back, the tail is longer, and it has less of a crested look. **Size:** Length 6 inches; wingspan 8 inches.

Habitat and Distribution: Found in the western two or three tiers of counties only, in woodlands, along streams, and in thickets in towns.

Seasonal Occurrence: Spring migrant in late April and May; fall migrant in August and September.

Field Notes: Identification of *Empidonax* flycatchers becomes even more complex in the western part of the state, where this species, along with three other western *Empidonax* species not included in this book, can be encountered. The majority of *Empidonax* seen in the far west are probably this species. Professional ornithologists are usually unwilling to identify most *Empidonax* unless they have been captured and identified in hand, but many birders consider it great sport to attempt field identification of these confusingly similar species.

Regulus satrapa

Golden-crowned Kinglet

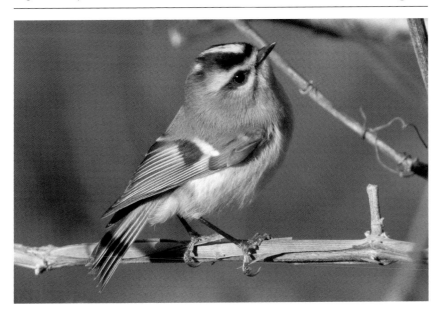

Field Identification: This tiny winter bird is olive green and gray above, whitish below, and has black wings with wing bars. The head is striped black and white with a bright-yellow crown (tinged with red on the male). The call is a series of three high-frequency *"seep"* notes, similar in pitch to the single call note of the Brown Creeper. **Size:** Length 4 inches; wingspan 7 inches.

Habitat and Distribution: Found statewide in wooded areas, especially those with cedars and pines. Regularly occurs in oak woodlands of eastern Kansas.

Seasonal Occurrence: Winter resident. Arrives in mid-October and departs in early April. Numbers fluctuate substantially from year to year. They can be abundant one winter and rare the next.

Field Notes: Kinglets are small but fearless and on many occasions can be observed from a distance of a few feet as they investigate the birder who has entered their territory. They often join mixed-species foraging flocks with chickadees, nuthatches, and titmice. Cemeteries and city parks with abundant cedars and pines are good places to look for these birds. In winters when Red-breasted Nuthatches have significant invasions into Kansas, this species is often numerous as well.

Ruby-crowned Kinglet

Regulus calendula

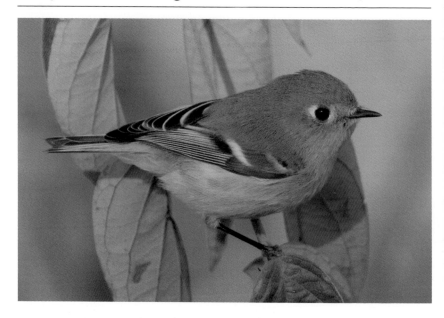

Field Identification: Like the Golden-crowned, the Ruby-crowned Kinglet has a mostly olive body, somewhat lighter on the underparts. Its head is also olive, with a tear-shaped white eye ring. Males have a red crown that is usually concealed, visible only when highly agitated. Listen for the brief two-note scold call, which is often heard before they are seen. **Size:** Length 4.25 inches; wingspan 7.25 inches.

Habitat and Distribution: Found statewide in open woodlands, cities, and towns.

Seasonal Occurrence: Migrant and winter resident. Formerly considered rare during winter, it is now more regularly observed at that season. Spring migrants are found from late March through mid-May; fall migrants from mid-September through late November.

Field Notes: Ruby-crowned Kinglets arrive earlier in spring and linger longer in the fall than do many other migratory songbirds. Like Golden-crowned Kinglets, they are fond of cedars and pines, but they are also found in brushy, deciduous woodland habitats. In early spring, they sing a loud and melodious song.

Vireo griseus

White-eyed Vireo

Field Identification: This woodland vireo is olive green above, with yellow flanks, a white throat, and two whitish wing bars. The combination of white iris and yellow "spectacle" plumage around the eye gives an impression of watchful alertness. It is often heard before it is seen. Its vocalizations are peculiar and highly variable, usually beginning and ending with guttural *"chek"* notes. **Size:** Length 5 inches; wingspan 7.5 inches.

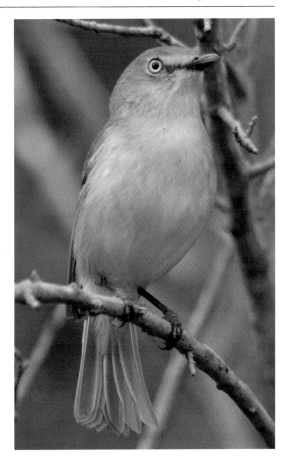

Habitat and Distribution: Found in the eastern fourth of the state, although migrants are occasionally seen farther west. Inhabits dense edge and brushy understory in riparian woodlands.

Seasonal Occurrence: Summer resident. Arrives in April and departs in early October.

Field Notes: Vireos are small songbirds with stouter, thicker bills than those of warblers. White-eyed Vireos are inquisitive and territorial and usually vocalize when humans approach their brushy haunts. They are most common in the Cross Timbers region of Chautauqua and Montgomery counties.

Yellow-throated Vireo

Vireo flavifrons

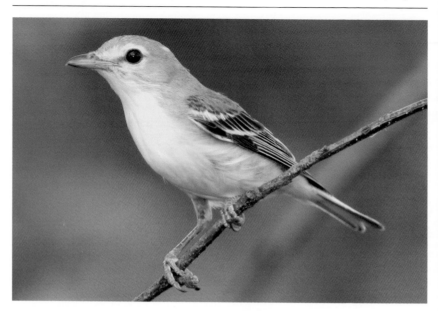

Field Identification: This woodland vireo is olive above with white wing bars, a yellow throat and breast, and yellow spectacles surrounding dark eyes. The song is a series of two- or three-note burry phrases. **Size:** Length 5 inches; wingspan 9 inches.

Habitat and Distribution: Mature woodlands east of the Flint Hills. Rare during migration farther west.

Seasonal Occurrence: Summer resident. Arrives in late April and departs in early September.

Field Notes: Yellow-throated Vireos are restricted to eastern Kansas, most often in woodlands with mature oaks, hickories, or pecans. The forests on Fort Riley in Geary County and in the Cross Timbers region are their western outposts in Kansas.

Vireo solitarius

Blue-headed Vireo

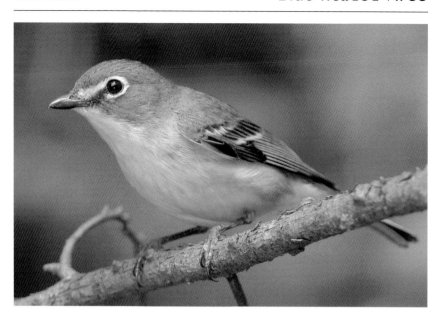

Field Identification: Look for the slate-gray head, prominent white spectacle markings, olive back, yellow flanks, and two yellow wing bars on this migratory vireo. The song is melodious and repetitive, similar to the song of the Red-eyed Vireo but usually more abbreviated. **Size:** Length 5.5 inches; wingspan 9 inches.

Habitat and Distribution: Found statewide in woodlands, parks, and cemeteries.

Seasonal Occurrence: Spring and fall migrant. Seen in spring during late April and May and in the fall during September and October.

Field Notes: Like most vireos, this species moves about a bit more deliberately than do warblers and other small songbirds. It is encountered in woodlands, towns, and parks during migration and often joins foraging flocks of chickadees, warblers, and other species. It remains in Kansas later into the fall than other vireo species.

Bell's Vireo

Vireo bellii

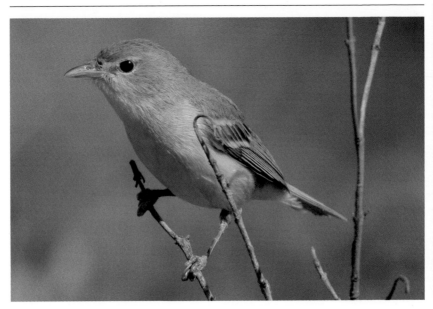

Field Identification: Bell's Vireo is olive above and yellow below, with a white throat, a whitish line above the eye, and a thin black line through the eye. There is one light wing bar that fades as plumage becomes worn. It is usually heard before it is seen. The song is a gurgling chatter that begins and ends abruptly. **Size:** Length 5 inches; wingspan 7 inches.

Habitat and Distribution: Found statewide but most common in the central counties. Inhabits large, shrubby thickets surrounded by prairies or pastures.

Seasonal Occurrence: Summer resident. Arrives in April and departs in September.

Field Notes: The open-country habitat this vireo prefers is typified by the upland prairies of Sandhills State Park and Quivira National Wildlife Refuge, where large stands of brushy plant species such as sandhill plum, sumac, and rough-leaf dogwood dot the sprawling mixed-grass prairie. Thickets found on slopes in the Flint Hills also attract this species.

Vireo philadelphicus

Philadelphia Vireo

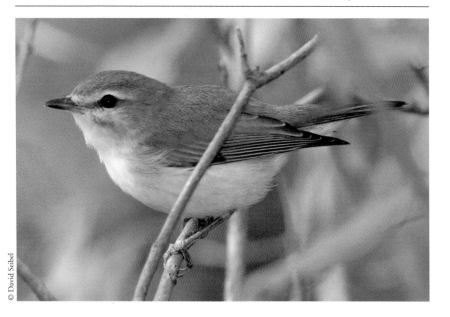

© David Seibel

Field Identification: This is a vireo without wing bars, almost as plain in appearance as the Warbling Vireo. It is separated from the Warbling by the dark line passing through the eye and a yellow or yellowish throat. Its underparts are more yellow overall than those of the Warbling Vireo. **Size:** Length 5 inches; wingspan 8 inches.

Habitat and Distribution: Seen mostly in the eastern third of the state, occasionally farther west.

Seasonal Occurrence: Seen only in migration. Spring birds are seen in May; southbound birds are observed most often in September.

Field Notes: This is one of the least-often-seen vireos in Kansas. It does not sing as frequently as other vireos, and when it does, the song is confusingly similar to that of the widespread Red-eyed Vireo.

Warbling Vireo

Vireo gilvus

Field Identification: A very plain-looking vireo without wing bars, the Warbling Vireo is pale gray above and white below. Some birds have a light yellow wash on the flanks. A white line above the eye is the only discernible field mark. The song is a rapid warbling ending in a single high note. A wheezy scold call is also often heard. **Size:** Length 5.5 inches; wingspan 8 inches.

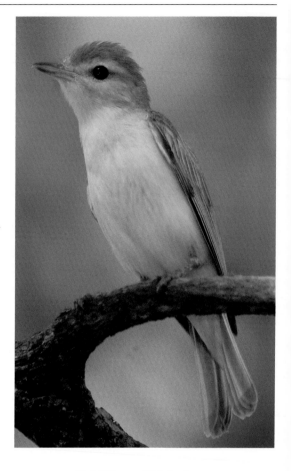

Habitat and Distribution: Found statewide in riparian woodlands, forest edges, cities, and towns. Although they can be found in a variety of open woodland habitats, they are especially fond of cottonwood trees for both foraging and nesting.

Seasonal Occurrence: Summer resident. Arrives in late April; departs by mid-September.

Field Notes: This is the most widespread and numerous vireo in Kansas. Its song is heard throughout the summer months, even on the hottest afternoons. The adults often sing while sitting on the nest, which is a woven cup hanging near the end of a branch in a clump of leaves.

Vireo olivaceus

Red-eyed Vireo

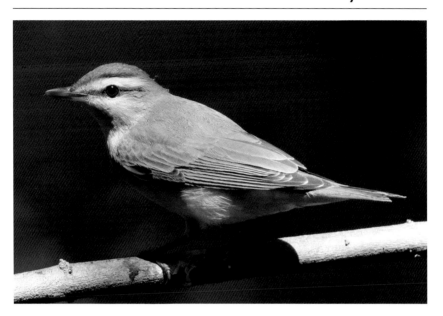

Field Identification: Another vireo lacking wing bars, this species has a prominent white eye line passing through the bright-red eye and a gray cap with a distinct black border. Otherwise it is olive green above and white below, although in spring and early summer, the lower belly shows a considerable amount of yellow. Its song is a repeated warbling phrase, somewhat similar to that of the Robin. **Size:** Length 6 inches; wingspan 10 inches.

Habitat and Distribution: Seen statewide during migration. In summer, breeds in riparian forests in the eastern half of Kansas and sometimes farther west where mature woodlands are found.

Seasonal Occurrence: Summer resident. Arrives in late April and departs in early October.

Field Notes: This is a common summer species in eastern Kansas woodlands. Like the Warbling Vireo, it sings persistently throughout the day, even in hot weather.

Tennessee Warbler

Vermivora peregrina

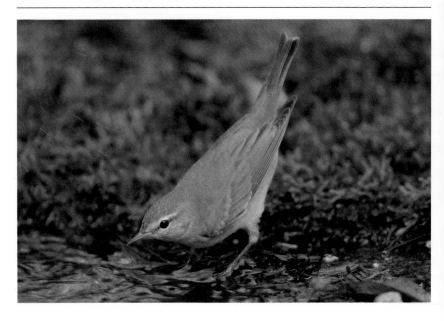

Field Identification: This is one of many wood-warbler species that migrate through Kansas. The gray cap of spring males contrasts with an olive-green back and white breast and throat. Spring females lack the contrasting cap and have a greenish throat. Fall birds are similar to the Orange-crowned Warbler but always have white undertail coverts.
Size: Length 5 inches; wingspan 8 inches.

Habitat and Distribution: Common migrant in eastern Kansas; rare in the west. Found in mature woodlands, wooded urban areas, and parks.

Seasonal Occurrence: Spring migrant from late April through mid-May; fall migrant from September through early October.

Field Notes: Although it is one of the most common migratory warblers, this species seems to be becoming scarce as habitat loss accelerates in both the tropical wintering areas and the boreal-forest nesting grounds. Learning the Tennessee Warbler's song is helpful in locating and identifying this species. Males sing incessantly as they journey north to their nesting grounds. Tennessee Warblers tend to remain high in the tree canopy.

Vermivora celata

Orange-crowned Warbler

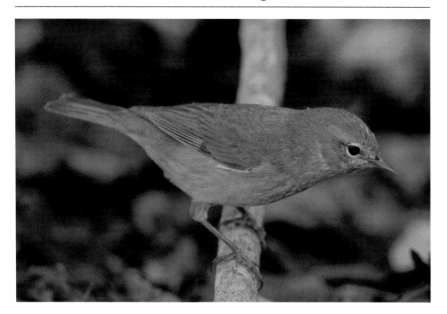

Field Identification: This is one of the most nondescript warbler species, and also somewhat variable in appearance. Males are greenish-yellow with poorly defined streaking on the breast and no wing bars. Females are similar, but some are grayer in color. This species always has yellow undertail coverts, which helps distinguish it from the Tennessee Warbler in fall. **Size:** Length 5 inches; wingspan 7 inches.

Habitat and Distribution: Statewide in woodlands, weedy fields, and brush.

Seasonal Occurrence: Spring migrant from early April through mid-May; fall migrant from late September through late October. A few remain into winter.

Field Notes: This is a common warbler in Kansas for much of the spring and fall migration. It is fond of weedy fields, especially stands of sunflowers. It lingers later in the fall than any other warbler except the Yellow-rumped Warbler. Exasperated birders seeking rare warblers have been heard to exclaim with frustration, "It's just another Orange-crown" after finally getting a good look at the elusive warbler they have been pursuing.

Nashville Warbler

Vermivora ruficapilla

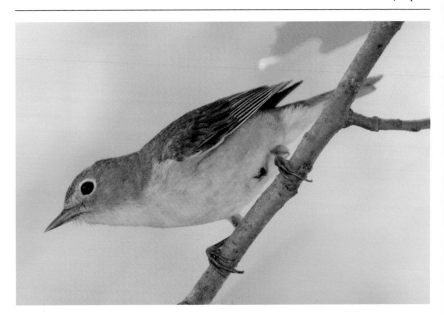

Field Identification: Nashvilles have a gray head, white eye ring, green back and wings, and yellow throat and underparts; they lack wing bars. Fall birds are often duller in color but always have the gray head and white eye ring. **Size:** Length 4.5 inches; wingspan 7.5 inches.

Habitat and Distribution: Found statewide in woodland edges, brushy thickets, and weedy areas.

Seasonal Occurrence: Spring migrant from mid-April through late May; fall migrant from early September through mid-October.

Field Notes: This is another common migrant warbler in Kansas. When identifying warblers, first and foremost look for the presence or absence of wing bars. This warbler has no wing bars and is quickly separated from the rest of the plain-winged species by the gray head and white eye ring. In the fall they are often found in small flocks, especially in rough-leaf dogwood thickets.

Wilsonia pusilla

Wilson's Warbler

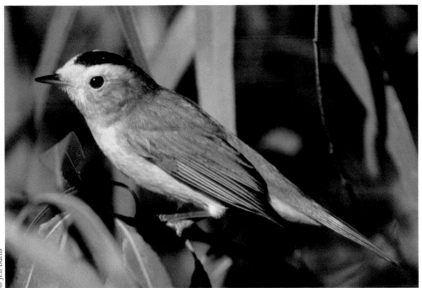

Field Identification: The male is olive green above and yellow below, with a black cap and no wing bars. The female is similar but has an olive-green cap. Females can easily be confused with female Yellow Warblers. **Size:** Length 5 inches; wingspan 7 inches.

Habitat and Distribution: Found statewide in dense thickets and forest understory.

Seasonal Occurrence: Spring migration occurs during the first two weeks of May. Fall migration occurs from late August through early October.

Field Notes: Wilson's Warblers are an uncommon species during the spring. In September, especially in western Kansas, they are often the most abundant warbler species. Learning their distinctive call note is useful when attempting to separate them from less common species.

Kentucky Warbler

Oporornis formosus

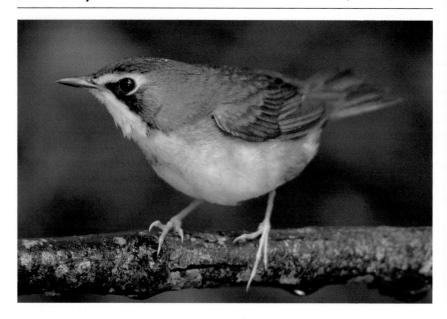

Field Identification: This forest warbler is olive above and entirely yellow below. It has a black mask and a broad yellow eyebrow and lacks wing bars. **Size:** Length 5 inches; wingspan 8 inches.

Habitat and Distribution: Found in eastern Kansas woodlands, always with substantial understory vegetation. Nesting birds occur west to Cowley and Riley counties. Migrants sometimes wander farther west, usually in the spring.

Seasonal Occurrence: Summer resident. Arrives in late April and departs in early September.

Field Notes: Kentucky Warblers are secretive and well camouflaged. They sing a song similar to that of the Carolina Wren from low perches in dense understory. Learn their song and you may be rewarded with a good look at this elusive warbler, but patience will be required.

Geothlypis trichas

Common Yellowthroat

Field Identification: This tiny marsh warbler has an olive back and wings, yellow on the throat and breast, and no wing bars. The male has a black mask bordered with white. Females have an olive-colored face. The song is usually interpreted as *"wichity-wichity-wichity-wich"* and is a familiar sound of wetlands.
Size: Length 5 inches; wingspan 7 inches.

Habitat and Distribution: Nests statewide in a variety of habitats with dense herbaceous (weedy) cover. Wetland areas dominated by cattails usually harbor substantial nesting populations of this warbler. Even small areas of habitat, such as a wet swale in a pasture, are often home to a nesting pair.

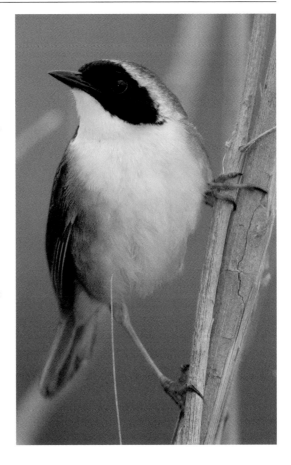

Field Notes: During migration, Common Yellowthroats are often seen in atypical habitats such as suburban yards and wooded areas.

Seasonal Occurrence: Summer resident. Arrives in mid-April and departs in early October. It occasionally lingers in fall through late November.

201

Yellow-breasted Chat

Icteria virens

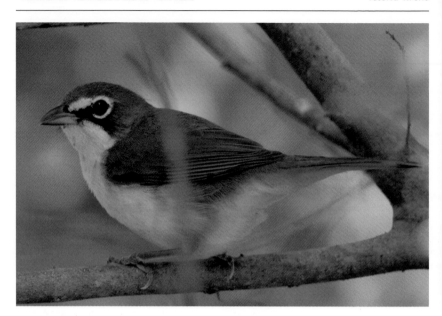

Field Identification: This unique warbler of brushy habitats is the largest warbler in North America. It is olive green above, with a yellow breast, a white belly, prominent white spectacle markings, and a long tail. The song and calls are varied and often bizarre. **Size:** Length 8 inches; wingspan 10 inches.

Habitat and Distribution: Nests in extensive stands of brushy thickets, usually with nearby prairie. Occurs throughout the state but highly localized.

Seasonal Occurrence: Summer resident. Arrives in late April and departs in late September.

Field Notes: Yellow-breasted Chats have a lot of personality. Their songs are a wild mix of scolds, hollow-sounding single notes, mimicked songs of other species, and a variety of other unusual sounds, often given from a concealed perch. In spring, the male gives a strange display flight. He flies high and then descends in a fluttering flight while singing vigorously. Formerly more numerous and widespread, chats are now absent in summer across much of the state but will nest in selected areas with the right habitat. Public areas with substantial nesting populations are Elk City Lake, Sand Hills State Park, Scott State Lake, and Wilson State Fishing Lake.

Dendroica petechia

Yellow Warbler

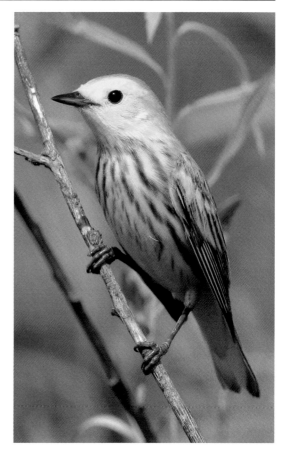

Field Identification:
Male Yellow Warblers are greenish-yellow above with yellow wing bars and yellow below with bold red streaks on the breast. Females are similar, but the breast is all yellow. The undertail coverts and large spots on the underside of the tail are yellow. **Size:** Length 5 inches; wingspan 8 inches.

Habitat and Distribution:
Found statewide but most common in eastern and north-central Kansas. Prefers to nest along streams and lakeshores with willow or cottonwood trees. During migration, occurs statewide in woodlands, cities, and parks.

Seasonal Occurrence:
Summer resident. Arrives in late April and departs in late September. It is abundant during migration. The nesting population is widespread but localized.

Field Notes: Only a few species of warbler remain to nest in Kansas, and, with the exception of the Common Yellowthroat, the Yellow Warbler is by far the most widespread of these.

Prothonotary Warbler

Protonotaria citrea

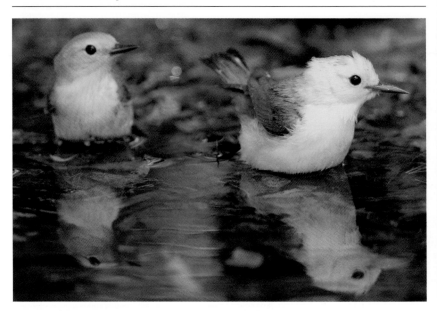

Field Identification: This eastern warbler has a brilliant gold plumage on the body and head and blue-gray wings. The dark eyes and bill contrast strongly with the golden plumage. **Size:** Length 5.5 inches; wingspan 9 inches.

Habitat and Distribution: Found in eastern Kansas around lakes, ponds, and slow-moving streams. Nests in tree cavities, frequently those in dead trees standing in or near the water. Nests westward to Cowley County in the south and Shawnee County in the north. Migrants can be seen farther west, especially in spring.

Seasonal Occurrence: Summer resident. Arrives in late April and departs in early September.

Field Notes: This beautiful warbler is usually observed on low branches near the water's edge. Listen for the ascending *"sweet-sweet-sweet-sweet"* call. They are not afraid of humans and can often be seen and heard near popular fishing and camping areas. Look for them at almost any lake or river in eastern Kansas with mature timber.

Dendroica coronata

Yellow-rumped Warbler

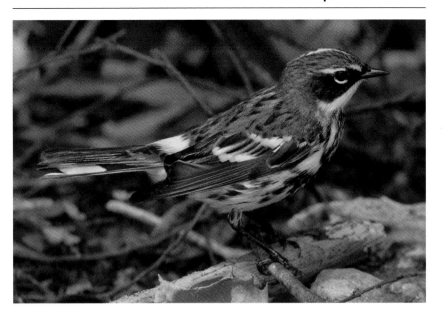

Field Identification: All plumages of this abundant warbler show obvious wing bars and a bright-yellow rump. Spring males have a bright-yellow blaze on the flanks and a black breast. Females have a similar but muted pattern. Winter birds are mostly brownish-gray, with blurry streaks below. **Size:** Length 5.5 inches; wingspan 9 inches.

Habitat and Distribution: Migrants are found statewide in almost any habitat containing trees or shrubs. Wintering birds favor areas with cedars or pines but also occur in deciduous woodlands.

Seasonal Occurrence: Spring migrants are seen from early April through mid-May; fall migrants from late September through late October.

Small numbers remain to winter in Kansas, mostly in the southern and eastern parts of the state.

Field Notes: This is the most common warbler in Kansas during migration, and the only one likely to be seen in the winter months. Dozens or even hundreds can be seen in a single day during migration. Yellow-rumps arrive earlier in the spring than other warblers, and most depart northward in early May, when many other warbler species are just beginning to arrive. In the fall, they pass through later than most other warblers. The eastern subspecies (Myrtle) warbler has a white throat and occurs throughout Kansas. In the westernmost counties, the Myrtle subspecies is largely replaced by the yellow-throated Audubon's subspecies.

Black-throated Green Warbler

Dendroica virens

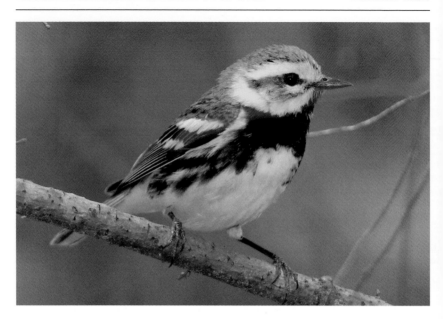

Field Identification: This boldly marked warbler has a green back and crown, yellow face, blackish wings with wing bars, and a white belly and flanks with heavy black streaks. The male has a black throat, whereas the female's is white. **Size:** Length 5 inches; wingspan 8 inches.

Habitat and Distribution: Migrant in eastern and central Kansas, mostly in wooded areas.

Seasonal Occurrence: Spring migrants are seen from late April through late May. Fall migrants are seen from mid-September to mid-October.

Field Notes: Black-throated Green Warblers are annual migrants but are fairly scarce in most of Kansas. They are most commonly observed in the easternmost counties. Their song is a series of buzzy notes that is easily distinguished from the songs of more frequently encountered migratory warblers. Unlike many warbler species found in Kansas, they are seen as often in the fall as in the spring—perhaps even more so.

Parula americana

Northern Parula

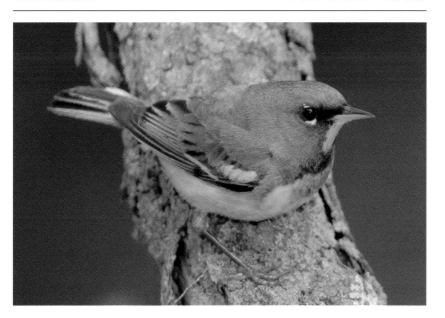

Field Identification: This tiny, short-tailed warbler of eastern woodlands has a blue head and wings, an olive back, and two bright wing bars. The male has a yellow throat and breast with a rufous breast band. **Size:** Length 4.5 inches; wingspan 7 inches.

Habitat and Distribution: Breeds in mature riparian forests from the Flint Hills eastward. Migrants wander west of the breeding range. Strongly associated with woodlands containing sycamore trees.

Seasonal Occurrence: Summer resident. Arrives in late April and departs in September.

Field Notes: Silent Northern Parulas can be difficult to spot as they forage high in the forest canopy. Fortunately, the ascending buzzy song is a frequently heard summer song along rivers and streams of eastern Kansas. Any eastern Kansas riparian woodland with sycamores is usually inhabited by a pair of these birds.

Yellow-throated Warbler

Dendroica dominica

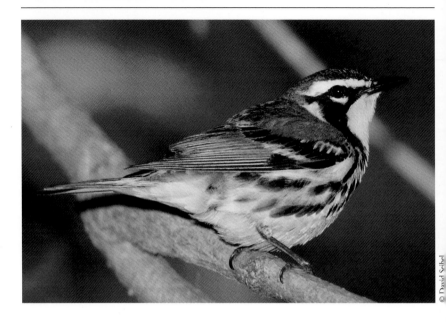

© David Seibel

Field Identification: This beautiful warbler has a blue-gray back and wings, white wing bars, a yellow throat, a black-and-white facial pattern, a white belly, and black streaks on the flanks. The bill is longer than that of most other warblers. **Size:** Length 5.5 inches; wingspan 8 inches.

Habitat and Distribution: Restricted to mature riparian forests with sycamore trees. Nests in the easternmost counties and along the Oklahoma border west to Chautauqua County. Wandering migrants may be seen elsewhere.

Seasonal Occurrence: Summer resident. Arrives in the first week of April and is seldom seen after July.

Field Notes: Yellow-throated Warblers have specialized habitat requirements that are only met at a few locations in Kansas. These areas include the Fort Leavenworth Bottomlands, Marais des Cygnes Wildlife Area, Schermerhorn Park in Galena, and areas along the Caney River in Chautauqua County. They arrive in the first week of April, earlier than most other warblers. Their song is a series of clear, descending notes. Like the Northern Parula, they are seldom found far from sycamore trees.

Mniotilta varia

Black-and-white Warbler

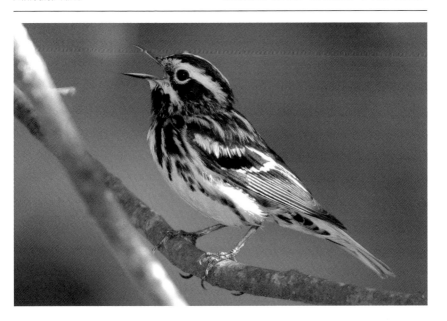

Field Identification: The plumage of the male consists of black-and-white stripes, with much black on the face and throat. Females are similar, but the face and throat are white. Usually forages on tree trunks and large branches. **Size:** Length 5 inches; wingspan 8 inches.

Habitat and Distribution: Migrants are found statewide in a variety of wooded areas. It is a summer resident in and east of the Flint Hills in mature oak woodlands, especially those with rocky slopes.

Seasonal Occurrence: Migrant and summer resident. Spring migrant from late March through early May; fall migrant from early September through early October. Present throughout the summer in eastern Kansas.

Field Notes: Black-and-white Warblers arrive in Kansas earlier than most other warblers. Their song is a series of repetitious, high-pitched double notes, often compared to the sound of a sewing machine. They are one of the typically encountered warbler species in eastern Kansas during the spring migration.

American Redstart

Setophaga ruticilla

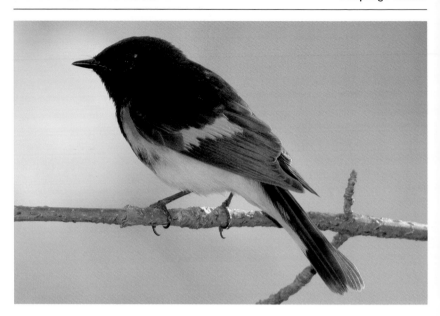

Field Identification: Adult males are jet black with a white belly and an orange pattern on tail, wings, and flanks. Females have a similar pattern but are gray and yellow instead of black and orange. **Size:** Length 5 inches; wingspan 8 inches.

Habitat and Distribution: Migrants are found statewide in a variety of wooded and urban habitats. Summer residents are found in mature woodlands along the Missouri border.

Seasonal Occurrence: Spring migrants are usually found in the first two weeks of May; fall migrants from late August to late September.

Field Notes: American Redstarts are vocal and active, often fanning their tails as they flit through the understory. This is another warbler that is as common in the fall as in the spring. During fall migration, look for them along quiet streams with brushy banks.

Seiurus aurocapilla

Ovenbird

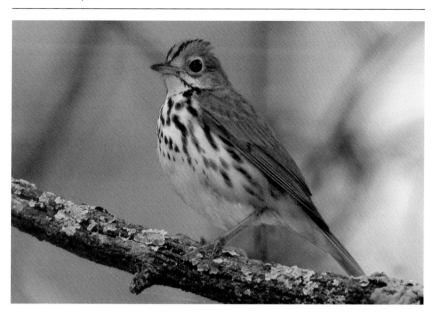

Field Identification: This ground-dwelling warbler has olive upperparts, white underparts patterned with bold black streaking, an orange crown bordered with black, and a large, dark eye surrounded by a broad eye ring. **Size:** Length 6 inches; wingspan 9.5 inches.

Habitat and Distribution: Occurs statewide during migration, most commonly in the east. A rare nesting species in the northeastern corner of Kansas, where it prefers to nest on hillsides in oak woodlands.

Seasonal Occurrence: Spring migrants are seen mostly in May. Fall migrants are seen from mid-August to early October. In summer, a small population remains to nest north and east of Geary and Franklin counties.

Field Notes: The Ovenbird is usually heard before it is seen. During the spring migration, its loud *"teacher-teacher-teacher"* call can be heard in forest undergrowth in the eastern third of Kansas. It spends most of its time foraging on the ground under bushes. A "spishing" sound will often entice it to hop into view.

Louisiana Waterthrush

Seiurus motacilla

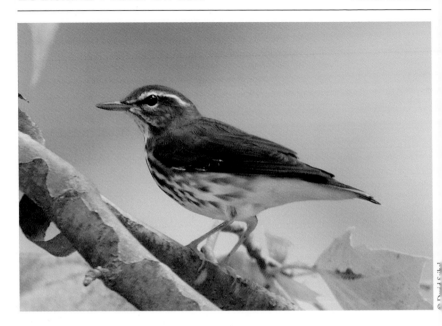

Field Identification: This large member of the warbler family has a brownish back and crown, white breast with bold black streaking, and a bold white eyebrow mark. It walks with a unique teetering gait on stream banks. **Size:** Length 6 inches; wingspan 9.5 inches.

Habitat and Distribution: Found in eastern Kansas woodlands along creeks with dense, mature timber, especially favoring rocky, steep-banked streams with abundant brush and exposed roots. Found from the Flint Hills eastward. There is a small population in the Red Hills.

Seasonal Occurrence: Summer resident. Arrives in early April and departs in late July.

Field Notes: The ethereal song of the Louisiana Waterthrush is often heard in early April along the wooded streams of eastern Kansas. If you watch closely along the banks, you might spot one as it teeters along at the water's edge, or on a log in the water. Even the smallest streams are attractive to these birds. During both spring and fall migration, the similar **Northern Waterthrush** may be encountered. It differs from the Louisiana Waterthrush by its narrower white eyebrow mark. It can be found almost anywhere in Kansas, although it is most frequently reported in the east.

Other Migratory Warblers

Forty-three warbler species have been observed in Kansas. Seeking these elusive and colorful migrants during spring and fall migration is one of the most exciting aspects of birding for many. Kansas lies on the western fringe of the flyway for many of these beautiful birds. As a result, the greatest numbers of warblers are generally observed from the Flint Hills eastward, especially at sites near the Missouri border, such as Marais des Cygnes and Fort Leavenworth. In urban areas, priceless preserved fragments of woodland habitat often attract these birds. Examples include Felker Park in Topeka, Oak Park in Wichita, and the Overland Park Arboretum in suburban Kansas City. Look for eastern species such as Blackburnian, Chestnut-sided, Golden-winged, Hooded, Magnolia, and Palm warblers in these areas. Although most of these warblers inhabit the woodland canopy,

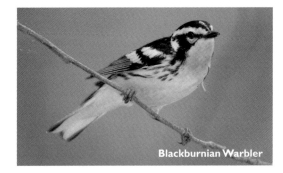

Blackburnian Warbler

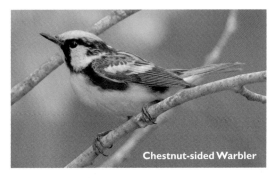

Chestnut-sided Warbler

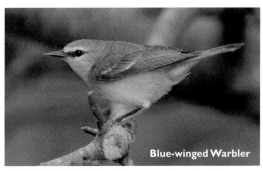

Blue-winged Warbler

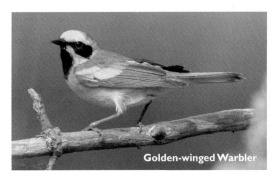

Golden-winged Warbler

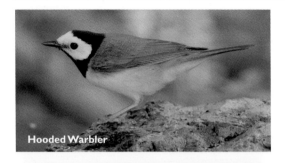

Hooded Warbler

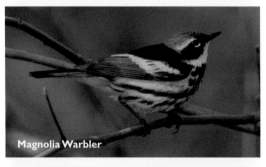

Magnolia Warbler

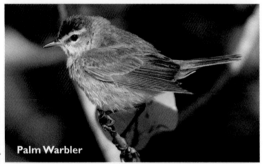

© Judd Patterson

Palm Warbler

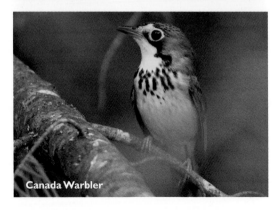

Canada Warbler

other species such as Canada and Mourning Warblers inhabit dense thickets in the understory.

In western Kansas, plantings of trees and shrubs in cities and towns on the otherwise treeless high plains serve as "migrant traps" in both spring and fall. Cemeteries such as those in Elkhart and Garden City are well-known locations for finding warblers. Small towns such as Goodland and Tribune have produced numerous records of rare migrant warblers. Riparian woodlands along major river systems of western Kansas, most notably the Arkansas, Cimarron, and Republican rivers, also attract warblers. Birders visit these destinations hoping for western species such as Townsend's and Black-throated Gray warblers.

The spring migration offers the best opportunity for seeing warblers, especially during the first two weeks of May. Their northward migration is often dramatic, as

214

they are urgently drawn to their boreal nesting grounds and tend to arrive rather suddenly in large numbers. In this season of the year, the males are in full song and at the peak of their colorful breeding plumage. The presence of a low-pressure weather front sometimes triggers a "fallout" as warblers and other migrants pause to await more favorable weather conditions before continuing north. When such weather is present, birders visit local hot spots in hopes of locating some of these birds.

The southward fall warbler migration reaches its peak during the last week of August and the first two weeks of September. Seeking warblers at this season is often rewarding, but the large fallouts of the spring migration do not occur as often. In the fall, most warblers are in less colorful plumage and are silent except for their brief chip notes. As a general rule, fewer birders venture into the field during

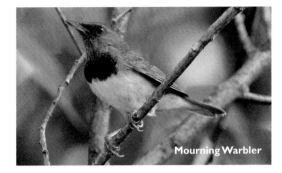

Mourning Warbler

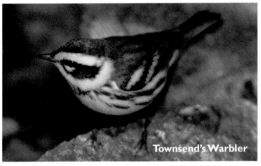

Townsend's Warbler

© Jim Burns

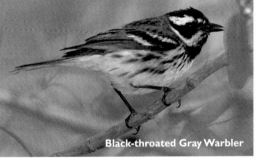

Black-throated Gray Warbler

© Jim Burns

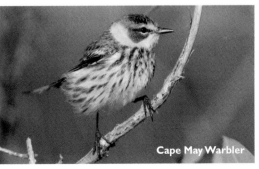

Cape May Warbler

© Judd Patterson

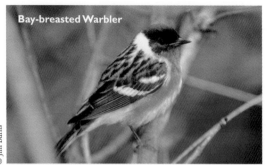

Bay-breasted Warbler

© Jim Burns

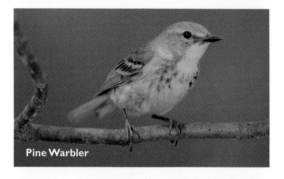

Pine Warbler

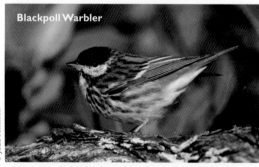

Blackpoll Warbler

© Judd Patterson

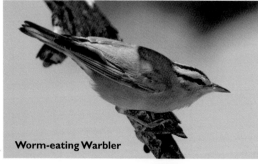

Worm-eating Warbler

© Judd Patterson

the fall migration, but an excellent variety of warblers can be observed by those who take the time to do so. This is a productive time of year to seek warblers in western Kansas. In contrast to eastern Kansas dynamics, western warbler species tend to be more numerous in fall than in spring.

Poecile carolinensis

Carolina Chickadee

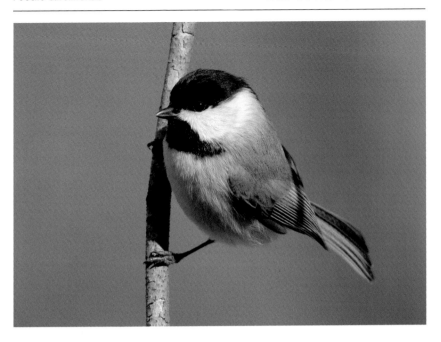

Field Identification: This chickadee differs from the Black-capped Chickadee in several subtle plumage characteristics. The wings on Carolinas lack the obvious white feather edges of the Black-capped, and the flanks are usually grayer and the black bib slightly smaller. The song is a four-note call usually written as *"fee-bee—fee bay,"* with the last two notes higher in pitch. Its familiar buzzy *"chick-a-dee-dee-dee-dee"* call is faster and higher-pitched than that of the Black-capped. **Size:** Length 4.75 inches; wingspan 7.5 inches.

Habitat and Distribution: Found in wooded areas south and east of a line between Meade County and Crawford County. Tends to inhabit moister woodlands than does the Black-capped Chickadee.

Seasonal Occurrence: Permanent resident.

Field Notes: Differentiating Carolina and Black-capped Chickadees is one of the challenges of birding in southern Kansas. The zone of overlap is narrow. Chickadees in the southernmost tier of counties in Kansas can generally be confidently identified as Carolinas. The isolated woodlands at Meade State Lake are the western extreme for Carolina Chickadees in Kansas. Look for their nest holes in softer dead wood, usually within ten feet of the ground.

Black-capped Chickadee

Poecile atricapillus

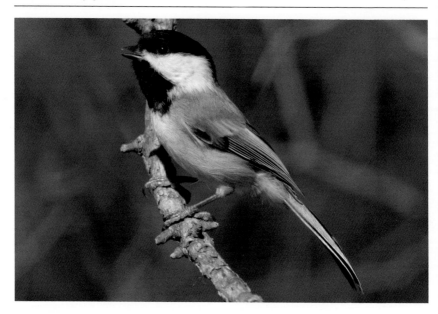

Field Identification: This species is closely related to the Carolina Chickadee and is almost identical in appearance. It is slightly larger; it shows distinct white edges to the wing feathers; and the bib is slightly more extensive, with a more ragged edge. Its song is also different: two whistled *"fee-bee"* notes. *"Chick-a-dee-dee-dee"* calls are huskier and deeper. **Size:** Length 5.25 inches; wingspan 8 inches.

Habitat and Distribution: Common in the eastern two-thirds of the state, except in the southernmost counties, where it is replaced by the Carolina Chickadee. Absent from much of the western Kansas high plains, especially south of the Smoky Hill River.

Seasonal Occurrence: Permanent resident.

Field Notes: This species is always a welcome and endearing visitor to the bird feeder, where it snatches a seed and retreats to a nearby tree branch to peck it open and devour it. Experienced birders always listen for calling chickadees, as they are often the most visible and vocal members of the mixed-species flocks of songbirds that forage together during migration and through the winter.

Baeolophus bicolor

Tufted Titmouse

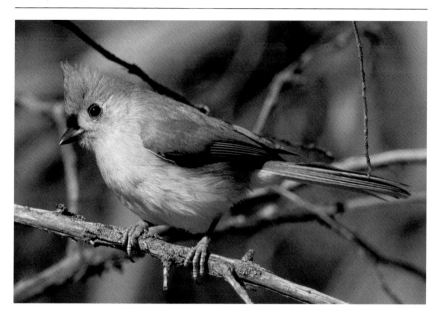

Field Identification: This crested relative of chickadees is gray above and white below, with orange flanks. The dark eye on the pale face creates a perky appearance. Its loud, clear, whistled song is a series of two-note phrases; its calls are buzzy scolding notes. **Size:** Length 6.5 inches; wingspan 10 inches.

Habitat and Distribution: Found in woodlands and towns in the eastern half of Kansas. Most common east of the Flint Hills.

Seasonal Occurrence: Permanent resident.

Field Notes: Titmice are active, vocal birds, often joining chickadees and other woodland species in loosely organized foraging flocks. They have adapted well to humans and are often observed at bird feeders. Titmice are one of the "traffic-cop" species of the woodlands and are often observed scolding predators or intruders.

Blue-gray Gnatcatcher

Polioptila caerulea

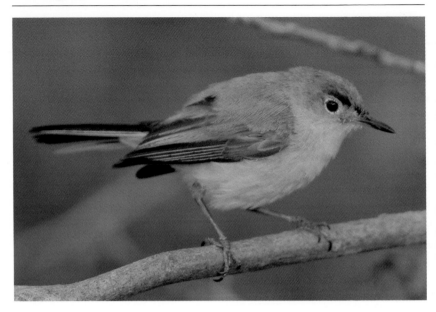

Field Identification: This small songbird is uniformly blue-gray, darker on the back. Field marks include a black tail with white edges and a distinct white eye ring. Gives a variety of wheezy songs and scolding calls. **Size:** Length 4.5 inches; wingspan 6 inches.

Habitat and Distribution: Nests from the Flint Hills eastward in northern Kansas and west to the Red Hills in southern Kansas. It occurs as a common migrant across the rest of the state. It prefers wooded areas for nesting but can be seen in a variety of habitats during migration.

Seasonal Occurrence: Summer resident. Arrives in late March and departs in late September.

Field Notes: Gnatcatchers are vocal, active residents of eastern woodlands. After the young have fledged, they remain with the parents for several weeks, and these noisy family groups are often encountered in July and August throughout eastern Kansas. These birds are not shy and can be attracted to close range by making squeaking or "spishing" sounds.

Sitta canadensis

Red-breasted Nuthatch

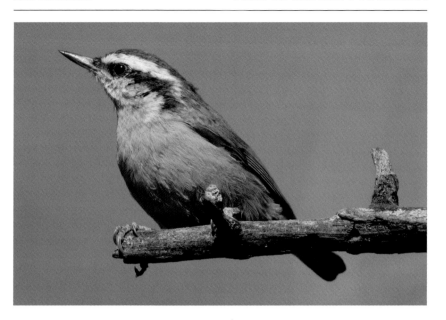

Field Identification: This small nuthatch has a blue back and orange breast. The head is striped with black and white. Its voice is a monotone series of high-pitched nasal notes.
Size: Length 4.5 inches; wingspan 8.5 inches.

Habitat and Distribution: Found statewide, almost always in or near pines or other coniferous trees.

Seasonal Occurrence: Winter resident, arriving as early as mid-August and departing in early May. It has nested in Kansas towns such as Junction City and Wichita several times.

Field Notes: Red-breasted Nuthatches are one of several birds of the northern forests that are classified as "irruptive," meaning that they move into Kansas in large numbers in some years but are virtually absent in others. These movements are responses to fluctuations in their food supply, nesting success, or both. They are widespread during these "invasion years" in areas with numerous pine trees. In the fall, they can be observed gleaning seeds from pine cones and caching them in crevices of trees for consumption later in the winter.

221

White-breasted Nuthatch

Sitta carolinensis

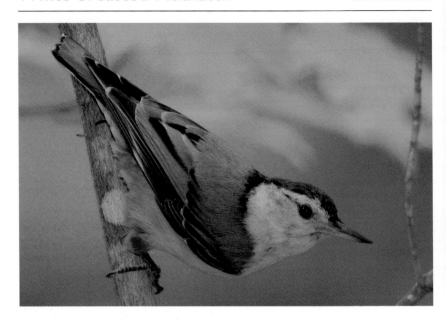

Field Identification: This larger nuthatch has a blue back, black cap, white face and underparts, and small rusty patch under the tail. Vocalizations are nasal notes, lower-pitched than those of the Red-breasted Nuthatch. **Size:** Length 6 inches; wingspan 11 inches.

Habitat and Distribution: Found statewide but more common in the east. Inhabits woodlands and towns with mature trees.

Seasonal Occurrence: Permanent resident in the east. In western Kansas, they are primarily a migrant and winter visitor but nest in a few areas with sufficient riparian woodlands.

Field Notes: White-breasted Nuthatches creep downward headfirst on tree trunks and branches, foraging for insects and grubs in tree-bark crevices. They often join chickadees and titmice in foraging flocks during the winter and visit bird feeders, consuming sunflower seeds and suet. They remain vocal during the winter, and their nasal chatter is one of the most frequently heard sounds of the deep woods.

Certhia americana

Brown Creeper

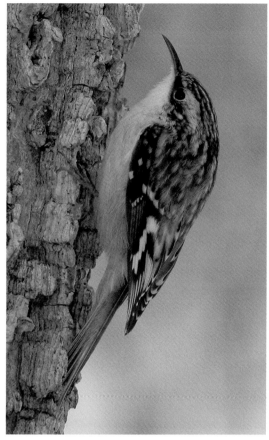

Field Identification:
Creepers have a brown back with white markings; white underparts; and a thin, decurved bill. They creep upward on tree trunks on their short legs. Their call is a high-pitched single *"seep"* note.
Size: Length 5 inches; wingspan 8 inches.

Habitat and Distribution:
Statewide in wooded areas and towns.

Seasonal Occurrence:
Winter resident. Arrives in October and departs in April.

Field Notes: Brown Creepers fly to the base of a tree and slowly work their way up the trunk, foraging for insects and grubs. When they near the top, they fly down to the base of another tree and start over. Their high-frequency call notes are often the first clue to their presence. Once heard, they can be located by carefully searching tree trunks and large branches. Creepers are not shy, relying on their cryptic coloration to protect them from detection. Their call note is almost identical in pitch to that of the Golden-crowned Kinglet, but the Brown Creeper gives a single long note, whereas the kinglet's call is three shorter notes given in a series. These two species are often found in similar habitats during the winter.

223

Rock Wren

Salpinctes obsoletus

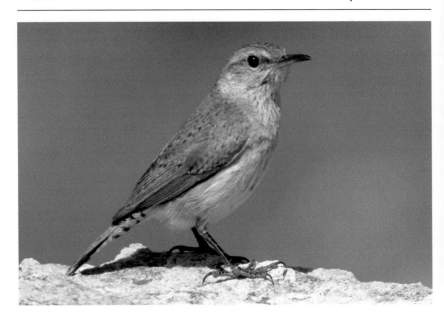

Field Identification: This fairly large wren has a gray back and crown, whitish underparts, buffy flanks, and long legs. The call heard most often is a sharp *"tick-eer."* Its songs are variable and complex. **Size:** Length 6 inches; wingspan 9 inches.

Habitat and Distribution: Found in the western half of Kansas, but only in areas with rock outcrops on steep slopes. Occasionally wanders to eastern Kansas during migration.

Seasonal Occurrence: Migrant and summer resident. Arrives in mid-April and departs in late September. A few remain into early winter in some years.

Field Notes: Rock Wrens are easy to find where their preferred habitat exists, especially in the Red Hills, the Smoky Hills, and the Arikaree Breaks in Cheyenne County. Good places to look for them on public lands include Cedar Bluff Reservoir, Point of Rocks in Morton County, and Scott State Lake. Their songs and calls carry good distances, partially because of the favorable acoustics of the rocky cliffs they inhabit. They are adept at slipping into rock crevices and reappearing a few feet away.

Thryothorus ludovicianus

Carolina Wren

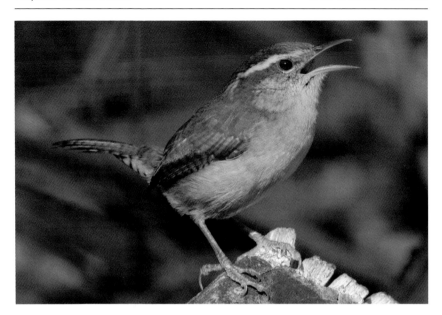

Field Identification: A wren of the eastern woodlands, the Carolina has a bright reddish-brown back and crown, orange-buff underparts, and a bright white eyebrow. The loud, ringing song is somewhat similar to that of the Cardinal and can be heard throughout the year. Its staccato scold notes are often heard. **Size:** Length 5.5 inches; wingspan 7.5 inches.

Habitat and Distribution: Found in brushy woodlands in the eastern half of Kansas. Also inhabits cities and towns. Its range is expanding to the west, and a few have reached the Colorado border.

Seasonal Occurrence: Permanent resident.

Field Notes: Carolina Wrens are common in cities and towns and are frequently seen at bird feeders. They often select nest sites in sheds and other man-made structures. The author once found a nest with young birds in the back of a rural mailbox. The mail carrier was aware of the nest and was careful not to disturb it when delivering the mail! In the past, Carolina Wrens have suffered significant population losses during cold, snowy winters.

225

Bewick's Wren

Thryomanes bewickii

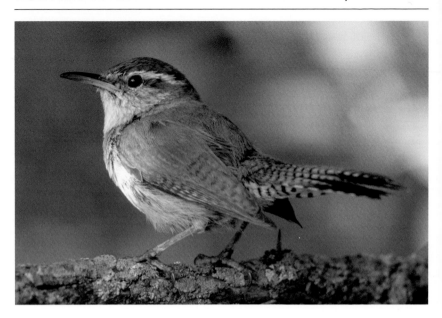

Field Identification: The tail of this wren is exceptionally long. Otherwise, look for the brown back, wings, and crown; distinct white eyebrow; and all-white underparts. The Bewick's can be confused with the Carolina Wren at first glance, but the long tail and white underparts make identification straightforward. **Size:** Length 5 inches; wingspan 7 inches.

Habitat and Distribution: Occurs across most of the state, except the northernmost counties. Least common on the high plains of western Kansas. Prefers brushy habitats in or near prairies, woodland edges, rural buildings, and towns. Bewick's Wrens are most numerous as a nesting species in the Flint Hills and Red Hills regions, but nesting has been documented in many areas of Kansas.

Seasonal Occurrence: Permanent resident. Many depart during the winter months, especially in northern Kansas.

Field Notes: Bewick's can be found anywhere in the state during migration. Their song is complex and melodious, similar to that of the Song Sparrow, and is usually given from a high, exposed perch. House Wrens compete with this species for cavity nesting sites and will sometimes destroy its nests and eggs.

Troglodytes aedon

House Wren

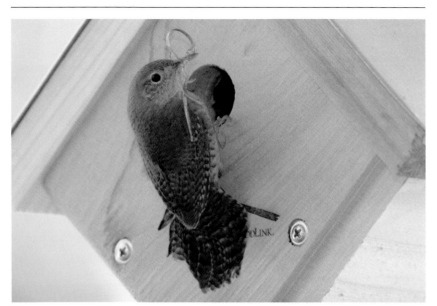

Field Identification: This wren is mottled brown above, gray and plain below, lacking prominent markings. Gurgling song and excited scolding calls are variable. **Size:** Length 4.5 inches; wingspan 6 inches.

Habitat and Distribution: Found statewide, often near human habitations but also in rural areas with brushy woodland edges.

Seasonal Occurrence: Migrant and summer resident. Arrives in mid-April and departs in late September.

Field Notes: This is the wren for which nest boxes are placed in many suburban yards. In the summer months, this wren is widespread and vocal. Its rich song is heard throughout the day, even in August, when most birds have ceased singing altogether. Kansas lies at the southern edge of the nesting range for House Wrens, and these wrens seem to be slowly shifting their range north as our climate becomes warmer. During fall migration, they are furtive and almost entirely silent and can be difficult to observe.

Winter Wren

Troglodytes troglodytes

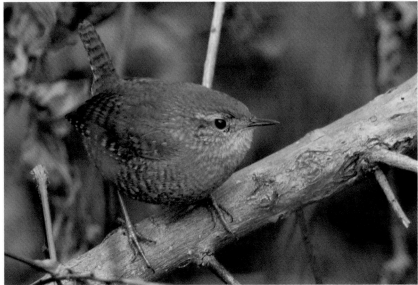

Field Identification: This is the smallest wren in Kansas. It is similar to the House Wren, but the tail is much shorter, the plumage is darker brown, and the barring on the flanks and underparts is more pronounced. A two-note call is often the first indication of its presence. **Size:** Length 4 inches; wingspan 5.5 inches.

Habitat and Distribution: Found statewide in wooded areas with dense brush. Preferred habitat is along small streams, where it lurks along the banks under exposed tree roots and logjams.

Seasonal Occurrence: Winter resident. Arrives in mid-October and departs northward in mid-March.

Field Notes: Winter Wrens often go overlooked, lurking undetected in the dense tangles and brush piles they inhabit. Sometimes they are flushed by intruders and rapidly flit in and out of view while vigorously scolding. Shortly after their arrival in early fall and just prior to their departure in spring, you might be lucky enough to hear their incredibly beautiful and complex song, which can have up to thirty-six notes per second.

Cistothorus platensis

Sedge Wren

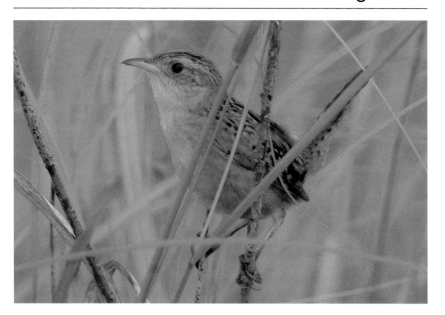

Field Identification: This prairie wren is light buffy overall, with strong black streaking on the back, an even buffy wash below, and barred wings. The crown is streaked. Its wet-sounding *"chap"* note is often heard. **Size:** Length 4.5 inches; wingspan 5.5 inches.

Habitat and Distribution: Found in wet meadows, tallgrass prairies, and densely vegetated wetland areas in central and eastern Kansas.

Seasonal Occurrence: Migrant and late-summer resident. Spring birds are usually seen in late April and early May. Fall migrants are observed from late September through early November. In northeastern Kansas, they nest in prairies with tall, dense grass during August and September.

Field Notes: Sedge Wrens are a mysterious species. Much remains to be learned about them in Kansas, especially their breeding biology. The late-summer nesting birds in northeast Kansas are thought to be birds that have nested earlier in the summer in the northern states and are making a second nesting attempt. The best chance of seeing this species is in the late summer and fall, when birds can be found in the dense grassy habitats at sites such as Baker Wetland, Neosho Wildlife Management Area (WMA), and Slate Creek WMA.

Marsh Wren

Cistothorus palustris

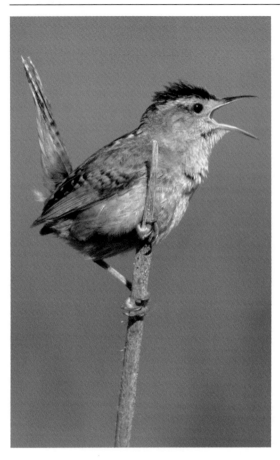

Habitat and Distribution: Found statewide and strongly associated with cattail marshes, but migrants are sometimes found in other habitats with dense vegetation.

Seasonal Occurrence: Migrant, also a rare summer and winter resident. Spring migrants are seen in April and May; fall migrants from late September through early November. Occasionally nests in Kansas. A few remain for the winter.

Field Notes: Marsh Wrens are more widespread and common in Kansas than Sedge Wrens. The habitats of the two species overlap during migration, but Marsh Wrens are more likely to be associated with cattails and bulrushes.

Field Identification: A wren of the cattail marshes, this species has rich reddish-brown wings and rump; white streaks on the black upper back; and a dark, unstreaked crown. The belly is reddish-brown, contrasting with the white throat. A white eye line is brighter and longer than that on the Sedge Wren. Call note is a dry *"chip"* sound. **Size:** Length 5 inches; wingspan 6 inches.

They have nested in several wetlands in the northern part of the state. In winter, they are found in areas with dense cattails, especially where open water persists, such as artesian springs or dam outlets. At all seasons, one must be patient to get a good look at this species, as they prefer to remain concealed deep in the cattails.

Sialia sialis

Eastern Bluebird

Field Identification: The male is deep blue above, orange and white below. The female has a similar pattern but is softer gray above and paler orange below. **Size:** Length 7 inches; wingspan 13 inches.

Habitat and Distribution: This species is found statewide in woodland edges and open woodlands with standing dead trees. In the east, they are numerous, becoming less so in western Kansas because of limited habitat. They are usually found in the west along rivers and streams with good stands of cottonwood trees.

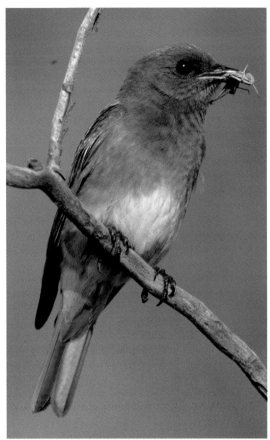

Seasonal Occurrence: Permanent resident in the eastern two-thirds of the state. Found throughout the west in summer, but most western populations depart during the winter.

Field Notes: Eastern Bluebirds are a familiar bird of rural areas. Because of competition with Starlings and House Sparrows for nest holes, populations of this species were severely reduced in the mid-twentieth century. A national effort promoting nest boxes along "Bluebird trails" has helped to increase Eastern Bluebird populations.

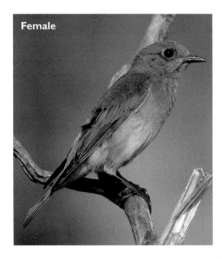

Female

Mountain Bluebird

Sialia currucoides

Field Identification: The male Mountain Bluebird is almost entirely sky blue. The female is light gray above and below, with sky-blue wings and tail. In contrast, all Eastern Bluebirds have orange breasts, simplifying identification of both species. Mountain Bluebirds also have noticeably longer wings and tail. **Size:** Length 7.25 inches; wingspan 14 inches.

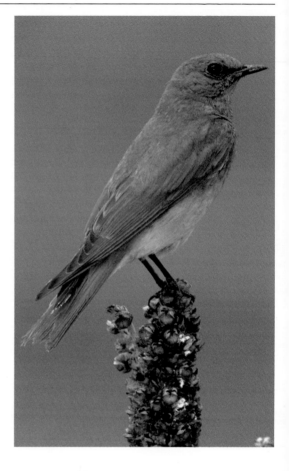

Habitat and Distribution: Found almost exclusively in areas with extensive cedar groves in western Kansas. They are seen across much of western Kansas, but the heart of their winter range is the Red Hills region of Barber and Comanche counties.

Seasonal Occurrence: Winter resident. Arrives in late October and departs in late March.

Field Notes: Mountain Bluebirds descend onto the plains from the Rocky Mountains in winter and congregate in areas where cedar berries are abundant. Because the cedar-berry crop can vary significantly from year to year, so do populations of these beautiful birds. During major invasion years, thousands can be seen on a single day's drive through the Red Hills.

Catharus ustulatus # Swainson's Thrush

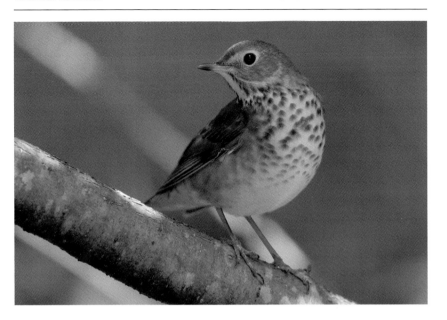

Field Identification: This thrush is mostly brownish-gray above. The underparts are white with much spotting on the breast. Buffy markings on the face separate this species from several similar species of thrush. Its song is heard often in the spring and is a complex series of high-pitched, ascending flute-like notes. **Size:** Length 7 inches; wingspan 12 inches.

Habitat and Distribution: Found statewide in wooded areas.

Seasonal Occurrence: Migrant. Spring migrants are found from late April through early June; fall migrants in September and October.

Field Notes: This is the most common migratory thrush in Kansas and can usually be observed during a morning walk in the woods in May. Swainson's typically flush from the undergrowth as they are approached, then perch on a low branch. In the spring, they linger in Kansas longer than most other migratory songbirds, and it is not uncommon to see small flocks devouring ripe mulberries in early June. During the fall migration, they are silent and retiring and are seen less frequently.

Hermit Thrush

Catharus guttatus

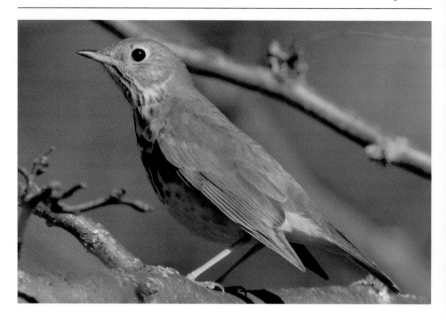

Field Identification: The Hermit Thrush is identified by the rusty tail, which contrasts with the brownish upperparts. It also has a complete white eye ring and a habit of raising and slowly lowering the tail. The western subspecies, which is similar but lighter gray above, is often seen in the far western counties. **Size:** Length 7 inches; wingspan 12 inches.

Habitat and Distribution: Statewide in wooded areas with brushy undergrowth or dense vines.

Seasonal Occurrence: Spring migrant from late March through mid-May; fall migrant from late September through late November. A few remain for the winter in eastern and southern Kansas.

Field Notes: In winter, they prefer areas with honeysuckle and other "evergreen" vines, usually in woodlands with abundant coralberry or other berry bushes. They often share winter habitat with Fox Sparrows.

Hylocichla mustelina

Wood Thrush

Field Identification: This large thrush has bright reddish-brown upperparts and white underparts with heavy black spots. Its ethereal flute-like song is often heard at twilight. **Size:** Length 8 inches; wingspan 13 inches.

Habitat and Distribution: Found in large tracts of mature woodlands in eastern Kansas, mostly east of the Flint Hills. Spring migrants are occasionally seen farther west.

Seasonal Occurrence: Summer resident. Arrives in late April and departs in September.

Field Notes: The haunting song of the Wood Thrush is often heard before the bird is seen. Because of habitat loss on both the nesting grounds in North America and the wintering grounds in Central and South America, Wood Thrushes are less numerous and have a more restricted range in Kansas than they did a hundred years ago. Discovering one today is a good find, although they are still locally common east of the Flint Hills in areas where large enough tracts of mature forest still exist. Reliable locations for them include the Fort Leavenworth Bottomlands, Marais des Cygnes Wildlife Area, and Woodson State Fishing Lake.

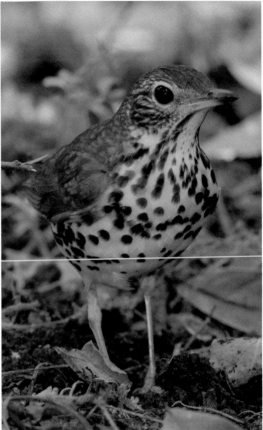

Brown Thrasher

Toxostoma rufum

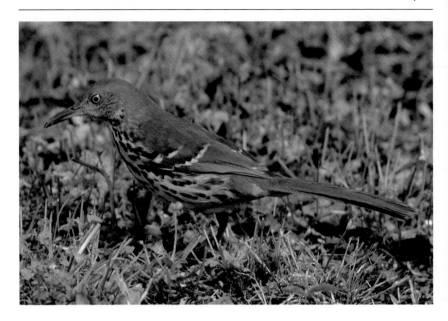

Field Identification: Brown Thrashers are rufous brown above and white with long black streaks below. They have a long tail and a long, slightly curved beak. The Brown Thrasher song is given in phrases that mimic the songs of other birds, each repeated two or three times. **Size:** Length 11.5 inches; wingspan 13 inches.

Habitat and Distribution: Found statewide in brushy and edge habitats. Frequently observed in urban parks and yards, where they often remain to nest.

Seasonal Occurrence: Summer resident. Arrives in April and departs in October. A few individuals remain for the winter in most years.

Field Notes: In the spring and early summer, Brown Thrashers sing persistently from high, exposed perches, making them easy to observe. Many Brown Thrashers migrate through Kansas in spring and fall on their way to and from nesting grounds in the northern states and Canada. These migrants often travel in loosely cohesive flocks, and large numbers can be seen in May and September.

Turdus migratorius

American Robin

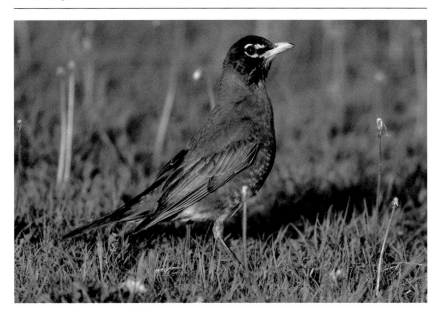

Field Identification: The adult is orange below and gray above, with a black head. Juveniles are scaly above and spotted below, retaining this appearance until September.
Size: Length 10 inches; wingspan 17 inches.

Habitat and Distribution: Found statewide in towns, cities, and a variety of rural habitats.

Seasonal Occurrence: Present throughout the year, although considerable population turnover occurs.

Field Notes: American Robins are familiar to most Kansans. Even on the mostly treeless high plains, every town and farmyard usually harbors them in the summer. Those seen in Kansas during the winter are birds that nest in Canada and the northern United States. These wintering robins congregate in large flocks in areas with abundant cedars or fruit trees, remaining until the food has been exhausted. Robins found in Kansas during the summer migrate south for the winter, returning in the spring. In April and May, the chorus of singing robins begins before dawn.

Gray Catbird

Dumetella carolinensis

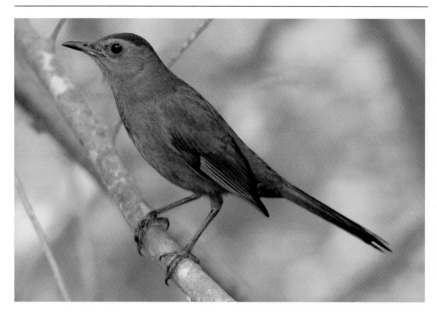

Field Identification: One of the mimic thrushes, the Catbird is slate gray except for its black cap, black tail, and rufous undertail coverts. It is named for the mewing call note. Its song is long and complex, usually with some mewing or squeaking notes. Catbirds do not repeat phrases, as mockingbirds and thrashers do. **Size:** Length 8.5 inches; wingspan 11 inches.

Habitat and Distribution: Found statewide but rare in the western third. Inhabits dense brushy habitats.

Seasonal Occurrence: Summer resident. Arrives in early May and usually departs in September.

Field Notes: Catbirds are more secretive than the closely related thrashers and mockingbirds and only reluctantly leave the security of dense thickets. Even when males are in full song, they usually sing from a concealed perch. However, Gray Catbirds are innately curious, and a patient birder can usually get a good look as they furtively approach to investigate the intruder.

Myadestes townsendi

Townsend's Solitaire

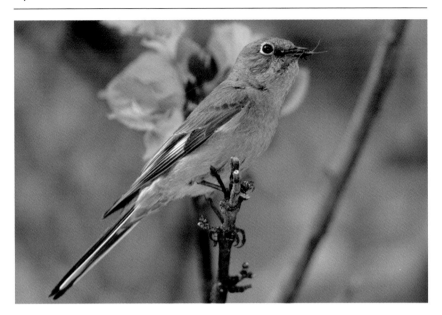

Field Identification: This is a unique thrush of the West. Its entire body is gray except for buffy wing markings, a white eye ring, and white edges on the long tail. A broad wing stripe is prominent on flying birds. It can be confused with the Northern Mockingbird at first glance, but mockingbirds are pale white below, with bright white wing patches, and lack an eye ring. **Size:** Length 8.5 inches; wingspan 14.5 inches.

Habitat and Distribution: Found in stands of pine and cedar trees in the western half of Kansas, occasionally farther east.

Seasonal Occurrence: Winter resident. Arrives in September and departs in March.

Field Notes: Townsend's Solitaires nest in the pine forests of the Rocky Mountains, and, like the Mountain Bluebird, they move onto the plains during the winter. True to their name, they are usually seen singly. Older cemeteries with abundant mature pines are good places to look for this species. Sometimes they give a single bell-like call note. They are retiring in nature and as a result can be easily overlooked.

Northern Mockingbird

Mimus polyglottos

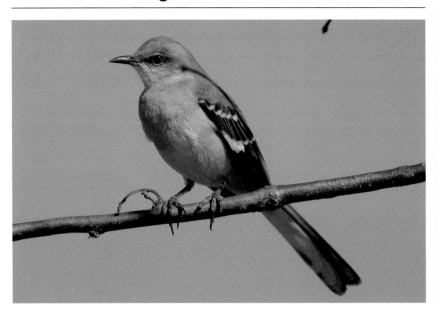

Field Identification: This mimic thrush is flashy and vocal. The plumage is gray above and white below, with large white wing patches and outer tail feathers. **Size:** Length 10 inches; wingspan 14 inches.

Habitat and Distribution: Found statewide in edge habitats and rural areas with scattered shrubs or thickets. Often observed near human dwellings.

Seasonal Occurrence: Permanent resident. Most depart south in late fall, but some remain throughout the winter in the east and south.

Field Notes: Northern Mockingbirds are conspicuous in summer. They loudly mimic the songs of other birds in repetitive fashion from high, exposed perches. When they fly, the white wing patches are obvious. Northern Mockingbirds can be confused with either of the two species of shrikes that occur in Kansas. Shrikes can be differentiated by their faster wingbeats and short, hooked beaks.

Lanius ludovicianus

Loggerhead Shrike

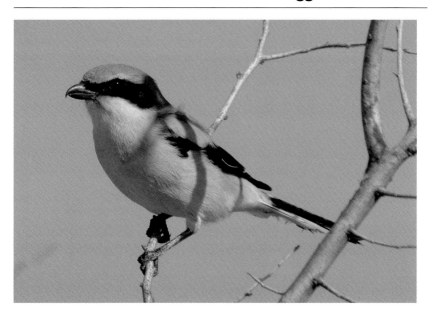

Field Identification: Loggerhead Shrikes have a black mask and wings, gray back, and white breast. Distinctive white wing patches are seen as the bird flies away with choppy, rapid wingbeats. Juveniles seen in late summer are similar but are brownish with fine barring on the breast. The beak is hooked on the upper mandible like a hawk's.
Size: Length 9 inches; wingspan 12 inches.

Habitat and Distribution: Statewide in summer, mostly in southern Kansas during the winter. Found in open country, especially prairies and pastures with scattered small trees.

Seasonal Occurrence: Permanent resident. Many birds depart southward during the winter.

Field Notes: Shrikes prey on insects, small birds, and rodents. They often impale their prey on long thorns, earning them the name "butcher bird." In recent years, their numbers have dropped significantly, both nationally and in Kansas, possibly because of pesticides.

241

Northern Shrike

Lanius excubitor

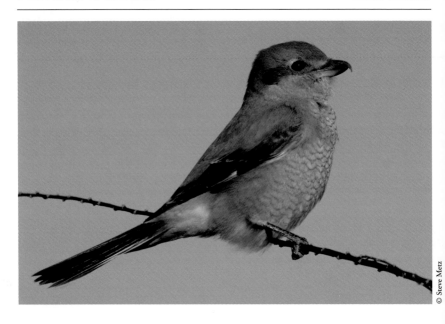

© Steve Metz

Field Identification: This shrike is similar in appearance to the Loggerhead Shrike but is larger and paler, with a slightly longer bill. The black mask is narrower than on the Loggerhead, and the black color does not meet above the bill. Birds in their first winter plumage are brownish in color, have a less distinct mask, and are finely barred below. **Size:** Length 10 inches; wingspan 15 inches.

Habitat and Distribution: Found in open country in northern and western Kansas, roughly north and west of a line from Barber County to Douglas County.

Seasonal Occurrence: Winter resident. Arrives in October and departs in March.

Field Notes: This shrike breeds in Canada and Alaska and moves into the northern states during winter. Any shrike seen in northern or western Kansas during the winter is likely to be this species, although all shrikes seen in the winter should be carefully identified.

Bombycilla cedrorum

Cedar Waxwing

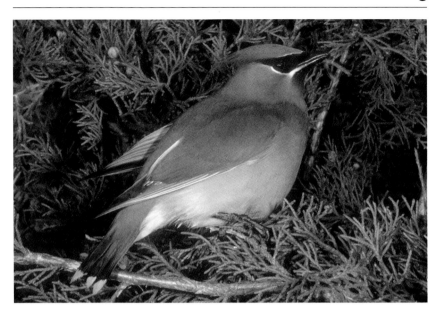

Field Identification: The swept-back crest, black mask bordered with white, and broad yellow band at the tip of the tail separate this species from any other. **Size:** Length 7 inches; wingspan 12 inches.

Habitat and Distribution: Found statewide in open woodlands, cities, and parks where berries are present.

Seasonal Occurrence: Winter resident and migrant. Winter residents arrive in October and depart in early June. Cedar Waxwings nest in northeastern Kansas and less commonly elsewhere.

Field Notes: Flocks of Cedar Waxwings roam widely during the winter, feeding on berries of cedars and other trees, consuming fruit as large as cherries and crabapples. When food is plentiful, waxwings are often abundant. In early spring, they feed on tree buds. Large numbers remain through May and early June, taking advantage of the mulberry crop. Their calls are thin, high-pitched notes and are given frequently, especially when the flocks are preparing to take flight or land.

Horned Lark

Eremophila alpestris

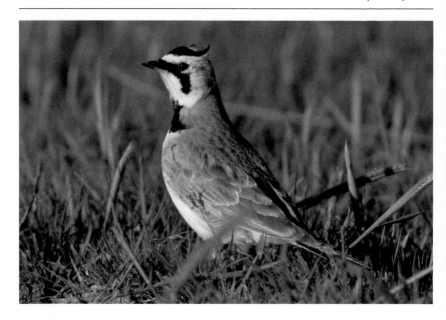

Field Identification: This common ground-dwelling bird of agricultural areas is sandy brown above and white below, with a black-and-yellow pattern on the face and breast. When flushed into flight, its black tail with thin white edges can be noted.
Size: Length 7 inches; wingspan 12 inches.

Habitat and Distribution: Statewide in open areas, especially short prairies, plowed fields, and winter wheat.

Seasonal Occurrence: Permanent resident. It nests commonly statewide. During winter, large numbers move into Kansas from breeding grounds in the far north.

Field Notes: Horned Larks are often seen when they are flushed from the sides of the road by approaching vehicles. In winter months, flocks of Horned Larks numbering in the hundreds of thousands of birds are often reported, especially on the endless expanses of winter wheat in western Kansas. These flocks usually have large numbers of Lapland Longspurs in them as well.

Anthus rubescens

American Pipit

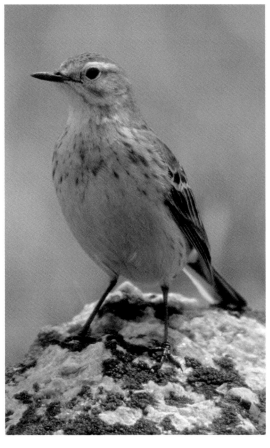

Field Identification: This long, slender, ground-dwelling bird of open country is bluish-gray above and pale yellow with streaks below; it has a thin, pointed bill. When it is seen in flight, look for the white outer tail feathers. **Size:** Length 6.5 inches; wingspan 10.5 inches.

Habitat and Distribution: Found statewide in plowed fields and prairies and along shorelines.

Seasonal Occurrence: Spring migrant during March and April; fall migrant from September through early November.

Field Notes: Hardier than many migratory songbirds, American Pipits can be found in early March and late October. Flocks numbering in the hundreds are sometimes seen in muddy, plowed fields. They forage on the ground and are often encountered on muddy shorelines at wetlands and reservoirs and in grassland habitats. Learn the two-note flight call of this species, as they are often heard as they fly overhead. They are never seen perching on fences or branches.

Sprague's Pipit

Anthus spragueii

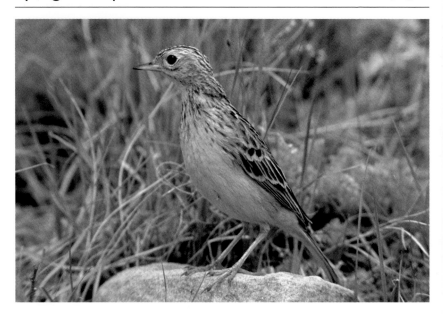

Field Identification: Similar to the closely related American Pipit, Sprague's differs by being browner and paler overall, with a streakier back, pale legs, and a mostly unmarked face. **Size:** Length 6.5 inches; wingspan 10 inches.

Habitat and Distribution: Always found in prairies with short grass. Migrant throughout Kansas but most often reported from the central part of the state.

Seasonal Occurrence: Spring migrant from late March through late April; fall migrant from late September through late October.

Field Notes: Sprague's Pipits nest on the northern prairies of the United States and Canada and winter in southern Texas and Mexico. They are seen in Kansas only during migration and can be common in proper habitat, although they are infrequently observed. Hiking through mowed or shortgrass prairies in April and October may result in flushing several of these birds. They do not flush until they are nearly under foot. As they take flight, they utter a loud, distinctive squeak call. Usually they fly for a short distance and then abruptly plunge back to the ground. Finding one perched on the ground is difficult and usually requires great patience.

Calcarius lapponicus

Lapland Longspur

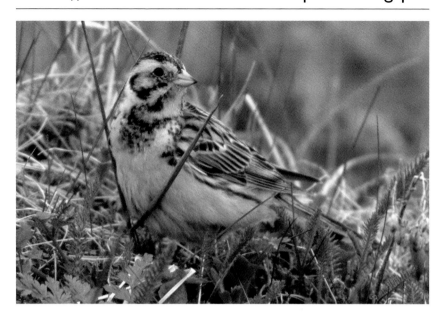

Field Identification: Longspurs are unique sparrows that are always found in barren grasslands or open fields. This abundant species is usually seen in its winter plumage. Unlike the other longspur species, it has bold streaking on the flanks and rufous coloring on the wings. Males have a black band on the breast, which is lighter brown on females. Also note the strong black facial markings and the clean-cut white outer tail feathers. The unique rattling calls are given frequently both in flight and on the ground. **Size:** Length 6.25 inches; wingspan 11.5 inches.

Habitat and Distribution: Statewide in open country, especially winter wheat fields and tilled areas. Most abundant in western and central Kansas.

Seasonal Occurrence: Winter resident. Arrives in November and departs in March.

Field Notes: The vast expanses of central and western Kansas wheat country can seem incredibly bleak and lifeless in the winter, but flocks of Lapland Longspurs, often in association with Horned Larks, can number in the tens of thousands in this habitat. These flocks restlessly swirl over the fields, noisily calling as they fly. After major snowstorms, Lapland Longspurs are often found along roadsides and can be observed at close range.

Smith's Longspur

Calcarius pictus

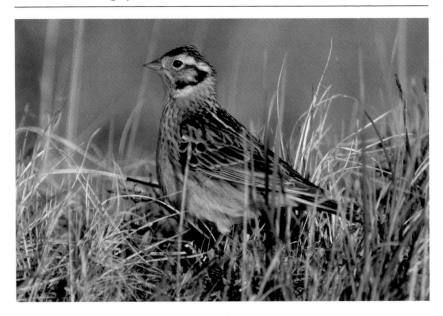

Field Identification: This longspur of the eastern prairies is much buffier in color than other longspurs. It also shows prominent white patches on the wings when in flight and is unique among longspurs in this regard. Smith's show about twice as much white on the outer tail feathers as do Laplands. Males begin to attain breeding plumage in late February and March and are mostly orange with a strong black-and-white pattern on the head. Rattling calls are harder and drier-sounding than those of the Lapland. **Size:** Length 6.25 inches; wingspan 11.25 inches.

Habitat and Distribution: Tallgrass prairie of eastern Kansas, mostly in the Flint Hills.

Seasonal Occurrence: Winter resident. Arrives in October and departs in April.

Field Notes: Smith's Longspurs are most often observed at mowed prairies in the Flint Hills, especially in the southern half of Kansas. They are sometimes observed in large flocks flying overhead in this habitat. When they are on the ground, their camouflage is superb, and they go unnoticed until they flush into flight a few feet ahead of approaching observers. They are fairly common in the southern Flint Hills, but since this area is almost entirely privately owned, gaining access to mowed fields where one can look for these birds is difficult. The best-known place to observe them is the area of mowed fields just south of Lyon State Fishing Lake. This area is privately owned, but the birds can often be seen in flight from the adjacent road.

Calcarius ornatus

Chestnut-collared Longspur

Field Identification: The breeding-plumaged male has black underparts, a yellowish throat, and a chestnut-red nape. Winter birds seen in flight have a mostly white tail with a black triangle at the tip and are paler and less strongly marked than are Lapland Longspurs. The winter male has light black bars on the breast, and the female has faint streaking on the flanks.
Size: Length 6 inches; wingspan 10.5 inches.

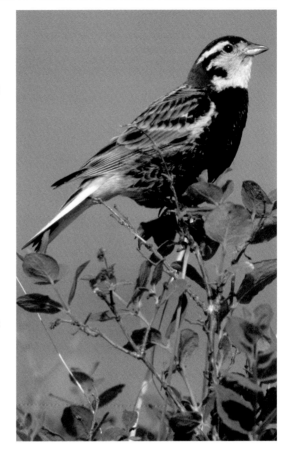

Habitat and Distribution: Found in semiarid grasslands and farmlands in western Kansas. It is rare in the east.

Seasonal Occurrence: Migrant and winter resident. Fall arrival is in October; spring departure is in late March.

Field Notes: This grassland bird is unfamiliar to many birders. Chestnut-collared Longspurs are seen most often in the early spring, especially when cold fronts delay their migration. Rural roads in Pawnee County have been a reliable location for finding these birds in March, but they may appear anywhere in the western half of the state. Some remain for the winter in the southwest, and they are usually recorded on the Cimarron National Grassland Christmas Bird Count.

Spotted Towhee

Pipilo maculatus

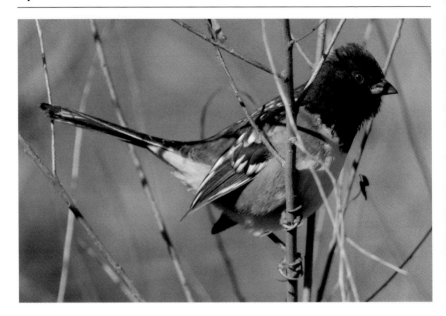

Field Identification: The male is black above with numerous white spots, broad rufous flanks, and white belly. The female is nearly identical, but the head is soft gray brown instead of black. White corners on the tail are prominent on flying birds. Its call note is a harsh mewing sound.
Size: Length 8.5 inches; wingspan 10.5 inches.

Habitat and Distribution: Found statewide but mostly west of the Flint Hills. A small nesting population is found along the Nebraska border in the western part of the state. Prefers brushy thickets and woodland edges.

Seasonal Occurrence: Winter residents arrive in late September and remain through mid-May. They are most common during migration, especially during April and October.

The nesting population along the Nebraska border is present all summer.

Field Notes: Spotted Towhees are generally seen singly or in small groups in dense brush, especially berry thickets. They are good at remaining concealed but are also inquisitive, and a few squeaking or "spishing" noises may draw them into the open. When they fly, the black-and-white pattern on the back can be well seen.

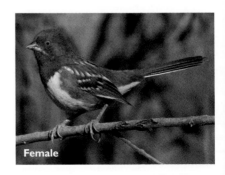
Female

Pipilo erythrophthalmus

Eastern Towhee

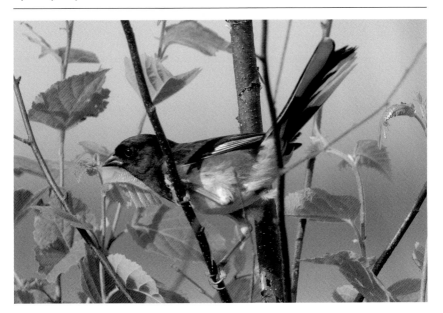

Field Identification: The Eastern Towhee is closely related to the Spotted Towhee and is similar to it in most respects. Males have an all-black head and back, with a single white wing patch. Females have the same pattern, but the black plumage is replaced with warm brown. Distinctive *"chewink"* call is quite unlike the raspy call of the Spotted Towhee. **Size:** Length 8.5 inches; wingspan 10.5 inches.

Habitat and Distribution: Found mostly from the Flint Hills eastward in brushy areas. Occasionally seen farther west.

Seasonal Occurrence: Permanent resident in the east. Additional migratory individuals move through, mostly in April and October.

Field Notes: In spring and summer, Eastern Towhees sing their loud *"drink-your-tea"* song from high, exposed perches on brushy hillsides of eastern and northeastern Kansas. During the winter, they are found in similar habitats but are less conspicuous. Eastern and Spotted Towhees were formerly considered to be the same species, then called the Rufous-sided Towhee. They were recently separated into two different species. Ornithologists and birders are still defining the range limits of these species in Kansas.

Cassin's Sparrow

Aimophila cassinii

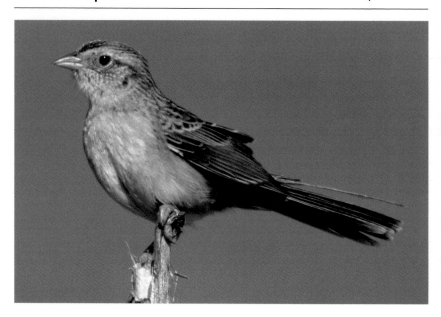

Field Identification: This western Kansas sparrow is plain brownish-gray with black spots on the back, an unmarked breast, and a relatively long tail. In flight, it shows white on the tips of the tail feathers. **Size:** Length 6 inches; wingspan 8 inches.

Habitat and Distribution: This sparrow is found in the semiarid grasslands of southwestern Kansas, especially where sand-sage is present. It also likes sandy prairies with thickets of aromatic sumac or other shrubs. It occurs mostly southwest of a line between Wallace and Barber counties. Populations of Cassin's Sparrows fluctuate from year to

year in response to rainfall. During drought years, they are found closer to the eastern and northern limits of their range.

Seasonal Occurrence: Summer resident. Arrives in April and departs in September.

Field Notes: In late spring and early summer, the display flight of the male is appealing to observe. He flies twenty to thirty feet in the air and then slowly descends in a stiff-winged fluttering flight while singing a beautiful trilling song. After the nesting season, Cassin's fall silent and are more difficult to observe.

Spizella arborea

American Tree Sparrow

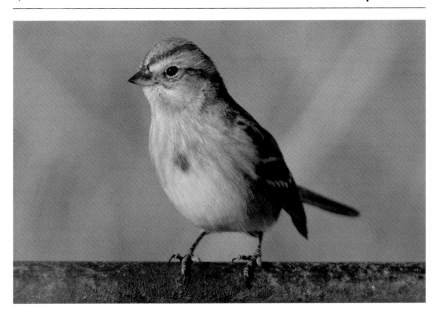

Field Identification: This common winter sparrow has an unmarked breast with a dark spot, a grayish face with a red crown, a brown back, a fairly long tail, and usually some brownish color on the flanks.
Size: Length 6 inches; wingspan 9 inches.

Habitat and Distribution: Found statewide in prairies with interspersed thickets, weedy fields, and brushy areas.

Seasonal Occurrence: Winter resident. Arrives in October and departs in March.

Field Notes: Winter flocks often number in the hundreds of birds and frequently include other wintering sparrows, especially Harris's Sparrows and Dark-eyed Juncos. Their tinkling call notes fill the air on chilly winter days. Despite being common in winter, they are not seen at bird feeders as often as other winter sparrows, usually only visiting when major ice storms or snowstorms have occurred.

Chipping Sparrow

Spizella passerina

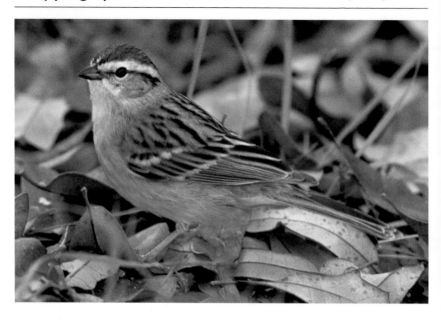

Field Identification: This migratory sparrow has a cap that is bright red in spring and summer, dull brown and streaked in fall and winter. Look for the white line above the eye and a dark line through the eye. The bright white line above the eye becomes dull in fall. Otherwise it is streaked brown above, with thin white wing bars, and clear grayish-white below. **Size:** Length 5.5 inches; wingspan 8.5 inches.

Habitat and Distribution: Found statewide in towns, parks, woodlands, agricultural areas, and a variety of other habitats. Nesting birds select areas of short grass with scattered trees. In the fall, they prefer weedy fields and other rural habitats.

Seasonal Occurrence: Spring migrant from mid-April through May; fall migrant from late September through early November. Common summer nesting species in northeastern Kansas, sporadically elsewhere in Kansas.

Field Notes: In the spring, this is one of the most common and conspicuous migratory songbirds in Kansas. Its mechanical, trilling songs fill the morning air as flocks of migrating birds feed on dandelions and seeds.

Spizella pallida

Clay-colored Sparrow

Field Identification: This species is similar to the Chipping Sparrow, to which it is closely related, but the rump is brown and the crown is brownish with a median stripe, there is no black line through the eye, and there is a broad "ear patch" that is partially bordered with black or brown. In the fall, they are usually brownish on the head and breast, unlike the grayer Chipping Sparrows.
Size: Length 5.5 inches; wingspan 7.5 inches.

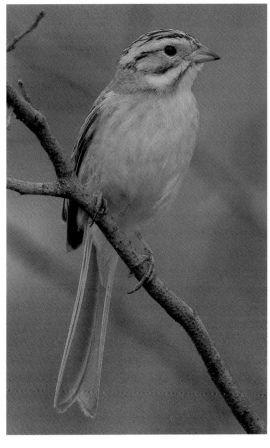

Habitat and Distribution: Statewide in towns, parks, open woodlands, and brushy areas.

Seasonal Occurrence: Spring migrants are seen from mid-April through mid-May; fall migrants are seen from early September through mid-October.

Field Notes: Migrating Clay-colored Sparrows are often seen in mixed flocks with Chipping Sparrows in both spring and fall. During the spring migration, listen for their song, which consists of two or three slow, monotone buzzing notes. They usually arrive about a week later than Chipping Sparrows and are often seen feeding on seeds on the ground.

Field Sparrow

Spizella pusilla

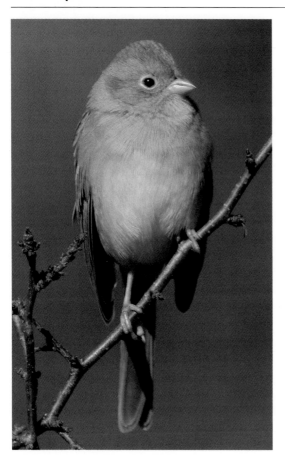

Habitat and Distribution: Found in grasslands, prairies, or pastures that are interspersed with thickets. It is common in the eastern two-thirds of Kansas and rare and local in the west.

Seasonal Occurrence: Summer resident. Arrives in late March and departs in late October. It is rare but regular in winter.

Field Notes: After arriving on their nesting territories in the early spring, Field Sparrows immediately begin to give their ascending, whistled song from the tops of dogwood and plum thickets. They continue to sing until early August. During migration and winter, they often join other sparrows in mixed-species flocks. In winter, beware of confusion with the more abundant American Tree Sparrow. If it has an eye ring and a pink bill, it is a Field Sparrow.

Field Identification: A sparrow of brushy open country, the Field Sparrow has a prominent eye ring, pink bill, and red crown. It is brown with black streaks above, unmarked grayish underparts, and a long tail. **Size:** Length 6 inches; wingspan 8 inches.

Pooecetes gramineus

Vesper Sparrow

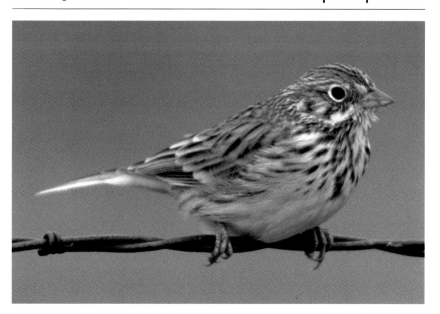

Field Identification: This streaked sparrow of open country has a brown back with black streaks and white underparts with streaking on the breast and flanks. The best field marks are the white eye ring and the white outer tail feathers that are obvious on flying birds. **Size:** Length 6 inches; wingspan 10 inches.

Habitat and Distribution: Statewide in grasslands and agricultural areas.

Seasonal Occurrence: Spring migrants are found from March through early May; fall migrants from September through mid-November. Remains as a nesting species in Brown and Doniphan counties in the extreme northeast and Morton County in the extreme southwest.

Field Notes: Vesper Sparrows are one of the earliest-arriving sparrows in spring. They are often seen in large numbers during the fall in western Kansas. In mid-September, hundreds can sometimes be seen during a day on the Cimarron National Grassland. They often feed along roadsides and fly a short distance when disturbed by vehicles, sometimes perching briefly on low fence wires, where they can be easily studied.

Lark Sparrow

Chondestes grammacus

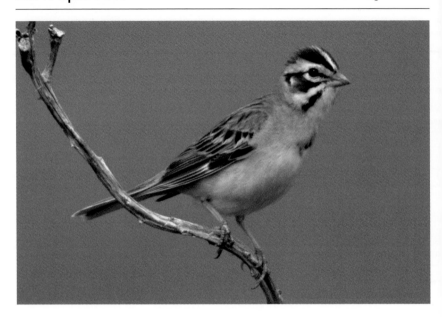

Field Identification: The intricate head pattern of black, white, and red along with the single breast spot makes this species unmistakable. The white-tipped tail feathers are a useful field mark on flying birds. **Size:** Length 6.5 inches; wingspan 11 inches.

Habitat and Distribution: Lark Sparrows nest throughout Kansas in short-grass habitats and are most numerous in the western part of the state. They do not inhabit dense grasslands but prefer more sparsely vegetated areas associated with grazing, mowing, rocky areas, or poor soils.

Seasonal Occurrence: Summer resident. Arrives in April and departs in October.

Field Notes: In the Red Hills region, where appropriate habitat is widespread, this is one of the most abundant species in summer. The song is complex and variable and can be heard at a considerable distance. In spring and early summer, look for males noisily performing their courtship displays on the ground, often on dusty rural roads.

Calamospiza melanocorys

Lark Bunting

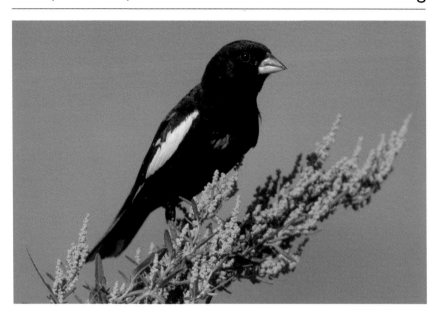

Field Identification: Summer males are all black, and winter males are brownish with prominent black streaking. Males have large white wing patches at all seasons. Females are similar to winter males but have lighter streaking and less white in the wing. **Size:** Length 7 inches; wingspan 10.5 inches.

Habitat and Distribution: Found in grasslands and fallow fields of western Kansas, east to Barber and Ellsworth counties. Migrants are sometimes seen farther east.

Seasonal Occurrence: Summer resident. Arrives in April and departs in September. Drought years often push nesting populations eastward to the periphery of their range. During some years, small flocks may remain for the winter in southwestern Kansas.

Field Notes: Lark Buntings are birds of the western Kansas plains, where they nest in loose colonies. Like Cassin's Sparrows, they perform unique display flights, singing as they climb into the air and slowly descend. During migration, they are sometimes seen in flocks of impressive size, but they more often appear in smaller flocks of ten to twenty birds.

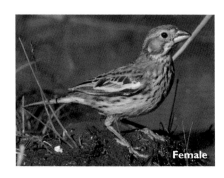

Female

259

Savannah Sparrow

Passerculus sandwichensis

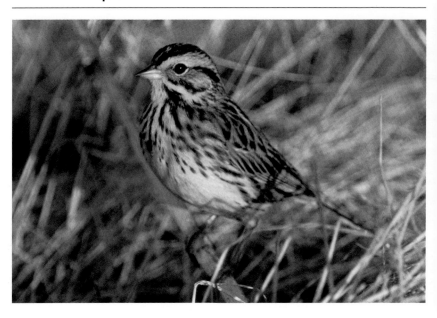

Field Identification: This streaked sparrow of grasslands has a short, notched tail; fine streaking on flanks and breast; and a white belly. The back and wing color varies from gray to warm brown. The line above the eye can be whitish or yellow. Look for the short tail and the yellowish line above the eye to quickly separate this species from the Vesper Sparrow.
Size: Length 5.5 inches; wingspan 6.75 inches.

Habitat and Distribution: Found statewide in grasslands and agricultural areas.

Seasonal Occurrence: Spring migrants are seen from late March through early May; fall migrants from mid-September through early November. Small numbers remain for the winter in the southernmost counties.

Field Notes: Savannah Sparrows are common migrants found in habitats similar to those preferred by Vesper Sparrows. The two species often occur together as they migrate through Kansas. Savannahs are often tame and can be viewed easily, but when they are in taller grasslands, they fly for short distances and then plop back into the grass, making it virtually impossible to view them.

Ammodramus savannarum

Grasshopper Sparrow

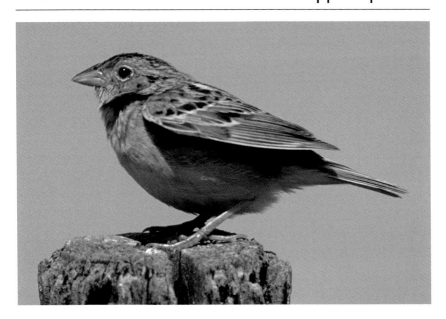

Field Identification: This grassland sparrow has a flat head, large bill, short tail, and buff-colored face. The black crown has a narrow white line down the center. The breast is buff colored and unstreaked. **Size:** Length 5 inches; wingspan 7.75 inches.

Habitat and Distribution: Found statewide, exclusively in grassland habitats.

Seasonal Occurrence: Summer resident. Arrives in April and departs in October.

Field Notes: Look for these prairie birds perched atop clumps of grasses or on fence wires. Their high, thin, trilling song sounds more like an insect than a bird and escapes the hearing of some people. Grasshopper Sparrows are one of the most widespread nesting sparrows in Kansas. Despite many concerns about habitat loss and declining populations, Kansas remains a stronghold for this and other grassland species in need of conservation.

Henslow's Sparrow

Ammodramus henslowii

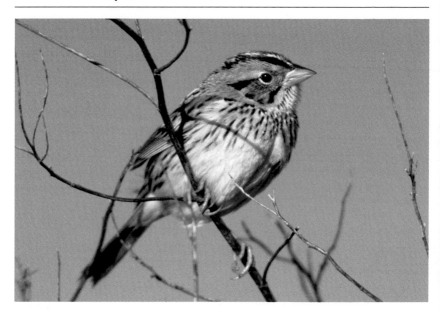

Field Identification: This short-tailed sparrow has a flat head, a large bill, and a narrow necklace of streaks on a buffy chest. The song is a faint two-note *"tsi-lick,"* which can be heard only at fairly close range. **Size:** Length 5 inches; wingspan 6.5 inches.

Habitat and Distribution: Found in tall, dense, unburned grasslands of eastern Kansas, west to Harvey and Dickinson counties.

Seasonal Occurrence: Summer resident. Arrives in April and departs in October.

Field Notes: Henslow's Sparrows require specific grassland conditions for nesting. They prefer prairie that has been unburned or ungrazed for at least two years. This habitat contains the accumulated dead vegetation they require for nesting. Since this habitat is found in different locations from year to year, Henslow's Sparrows are as well. Konza Prairie, near Manhattan, is a reliable location for them. Of all grassland birds, Henslow's Sparrows may have suffered the most dramatic population decline.

Ammodramus leconteii

Le Conte's Sparrow

Field Identification:
The Le Conte's Sparrow has a flat head, small bill, short tail, necklace of fine streaks on the buffy breast, white belly, streaked sides, and purple nape with fine streaks. The face is yellow orange with black markings, and the dark crown is divided by a white stripe. **Size:** Length 5 inches; wingspan 6.5 inches.

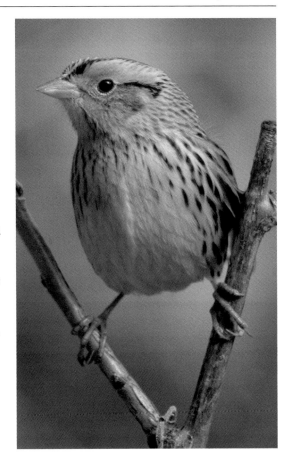

Habitat and Distribution:
Found in central and eastern Kansas in wet meadows, grassy wetlands, and sometimes tallgrass prairies.

Seasonal Occurrence:
Spring migrant in April and May; fall migrant in October and November. Small numbers winter in wetlands of southern and eastern Kansas.

Field Notes: Le Conte's Sparrows are seen more often in fall than in spring. At grassy wetlands such as the Baker Wetland, Marais des Cygnes Wildlife Area, Quivira National Wildlife Refuge, and Slate Creek Wetlands, they can be numerous in October and early November. They share habitat with Sedge and Marsh wrens. In the fall, they are responsive to "spishing" sounds and may closely approach the observer.

Nelson's Sharp-tailed Sparrow

Ammodramus nelsoni

Field Identification: This wetland species is similar to Le Conte's Sparrow but is darker overall. The face and breast are deeper orange, and the bill is longer. The crown is solid gray, lacking the white stripe of Le Conte's. The nape is also solid gray, not purple with streaks, as on Le Conte's. **Size:** Length 5 inches; wingspan 7 inches.

Habitat and Distribution: Found in central and eastern Kansas in wetlands with dense grass, especially prairie cordgrass, in very localized and specific habitat.

Seasonal Occurrence: Spring migrant in May. Fall migrant in October and early November.

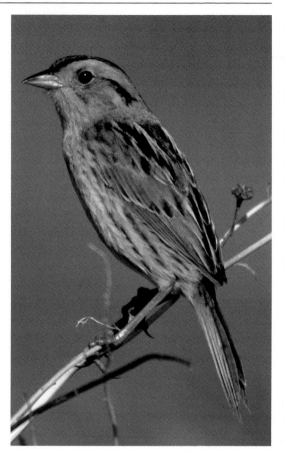

Field Notes: Nelson's Sharp-tailed Sparrows are rare migrants during the fall at a few locations, including the Baker Wetland in Lawrence and the Slate Creek Wetlands south of Oxford. They need to be carefully distinguished from Le Conte's Sparrow. Pay special attention to the crown and nape markings. This species is seldom observed in the spring.

Passerella iliaca

Fox Sparrow

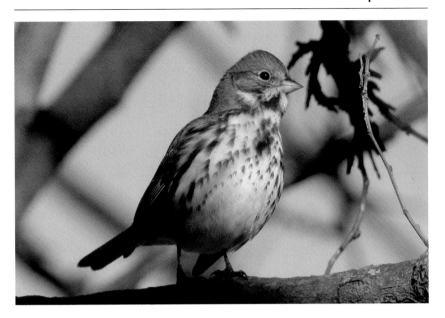

Field Identification: This large, colorful, long-tailed sparrow has a gray head. The crown, facial markings, wings, back, and tail are all reddish. The breast is white with bold, reddish streaks and a central spot. **Size:** Length 7 inches; wingspan 10.5 inches.

Habitat and Distribution: Found mostly in central and eastern Kansas. Prefers thickets and brushy areas, usually in or near wooded areas, especially where coral berry is abundant. It is rare in the west.

Seasonal Occurrence: Migrant and winter resident. Arrives in mid-October and departs in April. It is most numerous in March and November, as migrants swell the numbers of wintering birds.

Field Notes: Fox Sparrows are always a treat to find on a winter day in a brushy woodland thicket. They are usually seen singly or in flocks of four or five birds but will often join other sparrow species in loosely organized foraging flocks.

Song Sparrow

Melospiza melodia

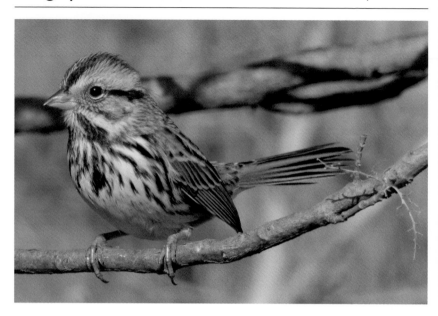

Field Identification: This long-tailed and rather dark-colored sparrow has streaked flanks and breast, with a central breast spot. It also has black markings on the face and sides of the throat, a streaked back, and rusty wings. The coarse call note is similar to that of the House Sparrow.
Size: Length 6 inches; wingspan 8 inches.

Habitat and Distribution: Found statewide in cattail marshes, also in brushy or weedy areas. Widespread winter resident, especially in the eastern half of the state.

Seasonal Occurrence: Migrant and winter resident. Arrives in October and departs in April. A few nest in the extreme northeastern counties near the Missouri River, occasionally farther south and west.

Field Notes: Song Sparrows are easily attracted by squeaking and "spishing" sounds. They actively twist and turn when flying through the cattails and weeds, eventually flying to another stand of vegetation with tail held upward. As the days grow longer in early spring, their melodious song is often heard.

Melospiza lincolnii

Lincoln's Sparrow

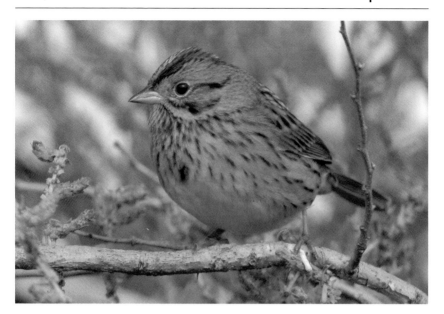

Field Identification: This species is similar to the Song Sparrow, but the face is grayer, the breast is buffier in color, and the streaking on the breast and flanks is finer. **Size:** Length 6 inches; wingspan 7.5 inches.

Habitat and Distribution: Found statewide in weedy areas and dense, brushy habitats, including prairies, urban parks, and woodland edges.

Seasonal Occurrence: Spring migrants are found in April and May. Fall migrants are found from September through November. A few remain for the winter in eastern Kansas.

Field Notes: Lincoln's Sparrows are fairly common migrants but are somewhat shy and retiring and so are not seen as often as other sparrows. Their wet-sounding call note is unlike the hoarse note of the Song Sparrow.

Swamp Sparrow

Melospiza georgiana

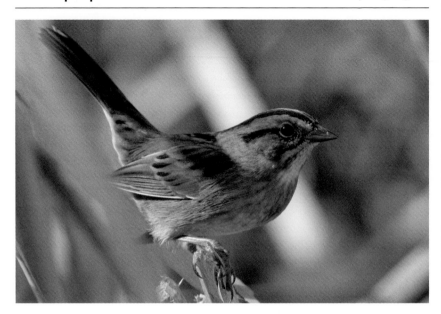

Field Identification: This wetland sparrow is dark overall, with dark reddish wings and reddish-orange flanks. The face and underparts are gray, contrasting with the bright white throat. **Size:** Length 6 inches; wingspan 7 inches.

Habitat and Distribution: Found in central and eastern Kansas, almost always in wetlands or dense vegetation near water, especially cattails and sedges.

Seasonal Occurrence: Migrant and winter resident. Arrives in October and departs in April. Most often seen in migration, especially in the fall.

Field Notes: Swamp Sparrows and Song Sparrows are often found in the same wetlands. Unlike the less selective Song Sparrow, Swamp Sparrows are restricted to this habitat and are never found far from water. They are difficult to see well, but with patience, you may eventually get a good look at this surprisingly colorful sparrow.

Zonotrichia albicollis

White-throated Sparrow

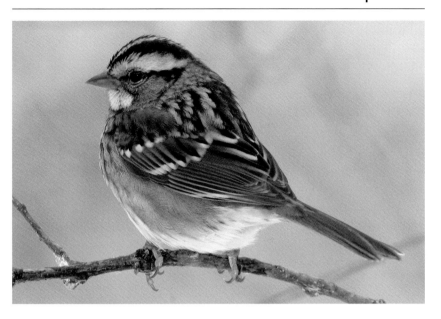

Field Identification: White-throated Sparrows always have a neatly outlined white throat and a yellow spot above the base of the bill. The head is striped with black and white, sometimes black and tan. They are grayish below, with brown wings and a striped back. **Size:** Length 7 inches; wingspan 9 inches.

Habitat and Distribution: Statewide in brushy areas in or near woodlands. Most numerous during spring and fall migration in eastern and central Kansas. Some remain for the winter, especially in the eastern half of Kansas.

Seasonal Occurrence: Migrant and winter resident. Arrives in October and departs in May.

Field Notes: These attractive sparrows are usually found in small flocks feeding on the ground under bushes. Their song is a series of clear notes, usually represented as *"Old Sam Pea-bo-dy Pea-bo-dy Pea-bo-dy,"* and is occasionally heard even on cold winter days.

White-crowned Sparrow

Zonotrichia leucophrys

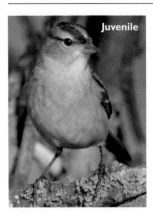

Juvenile

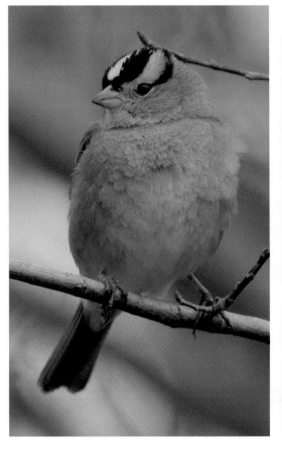

Field Identification: This distinctive sparrow has a head striped with black and white and a pink bill. Juveniles have a similar pattern, but the head stripes are red and gray. Otherwise, it has brown wings and upper back, with gray underparts, rump, and tail. **Size:** Length 7 inches; wingspan 9.5 inches.

Habitat and Distribution: Found statewide in open country, especially in weedy or brushy fields. Also found in woodland edges, yards, and parks. White-crowned Sparrows winter in large flocks in western Kansas and in smaller numbers in the east. During winter months, they are found in brushy areas adjacent to open country and are seen at bird feeders only occasionally.

Seasonal Occurrence: Migrant and winter resident. Arrives in October and departs in May.

Field Notes: Northbound spring migrants are often observed in parks and yards. White-crowned Sparrows are closely related to Harris's Sparrows, and during the winter the two species are often observed together in mixed flocks.

270

Zonotrichia querula

Harris's Sparrow

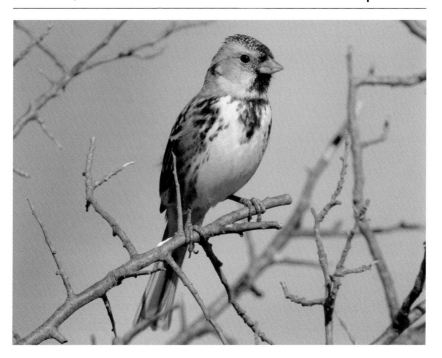

Field Identification: This is the largest sparrow in Kansas. Adults have a black crown, throat, and upper breast; a gray face and rump; brown wings; a white belly; and a pink bill. Younger birds have mostly brown heads, with limited black markings on breast and crown. The black facial plumage gradually increases as the birds mature. **Size:** Length 7.5 inches; wingspan 10.5 inches.

Habitat and Distribution: Found statewide in hedgerows, thickets, weedy areas, and woodland edge habitats. In Kansas, they can be found throughout the state in the winter months but are most numerous in the south-central counties.

Seasonal Occurrence: Winter resident. Arrives in October and departs in early May.

Field Notes: The winter range of Harris's Sparrows lies entirely within the Southern plains states. Their mournful, whistled songs and sharp *"chink"* notes enliven the winter landscape. Harris's Sparrows respond to "spishing" sounds by flying to the tops of thickets to investigate. In early spring, they begin to sing in earnest and in April and early May, Kansas populations swell with birds that have wintered farther to the south.

Dark-eyed Junco

Junco hyemalis

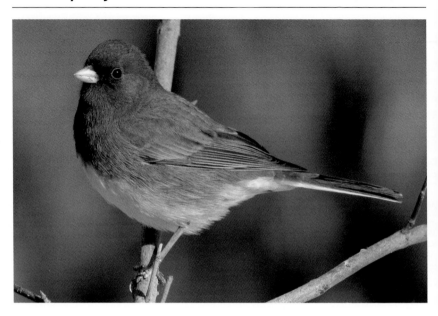

Field Identification: Several subspecies of this sparrow with varying plumages occur in Kansas. All have dark tails with prominent white outer feathers. The Slate-colored is always the most abundant subspecies and is uniformly slate gray with a white belly. The Oregon subspecies has a cleanly defined black hood and reddish back and sides and represents most of the other individuals seen in Kansas. **Size:** Length 6.25 inches; wingspan 9.25 inches.

Habitat and Distribution: Slate-colored subspecies occurs statewide. Oregon subspecies is also found statewide but is most likely to be found in western Kansas. Two other subspecies, the Gray-headed and

Pink-sided, are rare but regular in the far west. All are found in a variety of habitats, usually with some brush or other cover.

Seasonal Occurrence: Winter resident. Arrives in October and departs in April.

Field Notes: Juncos, sometimes called snowbirds, are one of the most abundant birds in Kansas during the winter and are frequent visitors to bird feeders. Sorting out the various subspecies can be challenging, especially because they often hybridize and produce a variety of intermediate plumages. Their call notes are similar to those of the Northern Cardinal but higher pitched.

Passer domesticus

House Sparrow

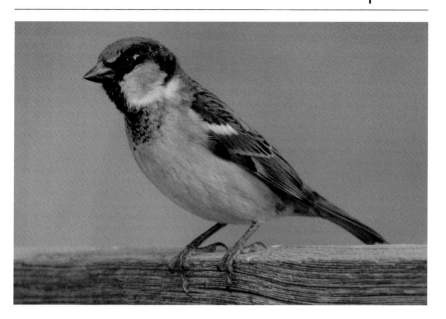

Field Identification: The male in spring and summer has a black throat and bib, gray crown, bright chestnut wings, and black-and-tan striped back. All colors are muted in the winter. The female has a reddish-brown cap, light eye line, striped back, and grayish-white throat and underparts. **Size:** Length 6 inches; wingspan 9.5 inches.

Habitat and Distribution: Found statewide, almost exclusively in association with humans in cities, towns, farmyards, and railroad tracks.

Seasonal Occurrence: Permanent resident.

Field Notes: Along with the Rock Pigeon and the European Starling, this European species was deliberately introduced in the nineteenth century and swiftly became one of the most abundant bird species of the urban American landscape. House Sparrows do no great damage to native bird populations and probably fill an ecological niche that would otherwise be unoccupied.

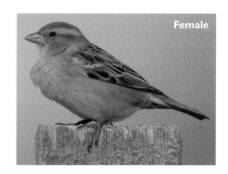
Female

Blue Jay

Cyanocitta cristata

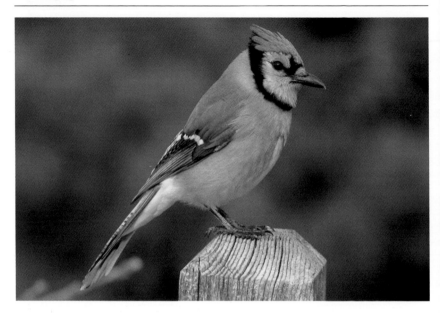

Field Identification: Unmistakable for any other species in Kansas, the Blue Jay is sky blue above with white wing markings and white below with black markings across the breast. It has a tall blue crest. **Size:** Length 11 inches; wingspan 16 inches.

Habitat and Distribution: Found statewide in woodlands and towns.

Seasonal Occurrence: Seen year-round, but substantial population movements occur.

Field Notes: Although five species of jays have been recorded in Kansas at least once, most are rare winter visitors to the far western counties. This is the only jay likely to be seen in most parts of Kansas. Blue Jays get a lot of bad press because of their raucous calls and their habit of occasionally predating the eggs and nestlings of other songbirds, but most people enjoy their bright colors and inquisitive habits. They are frequent visitors to bird feeders. In the spring and fall, large, loosely organized flocks of migrating Blue Jays are sometimes observed. Blue Jays often act as "sentries," announcing the presence of threatening species such as house cats.

Pica hudsonia

Black-billed Magpie

Field Identification:
The Magpie has a long, streaming tail; black head; white primaries (outer wings) and underparts; and blue-green wings, back, and tail. Its nasal chattering calls are loud and obvious. **Size:** Length 19 inches; wingspan 25 inches.

Habitat and Distribution:
Found in open country and farmlands in the western half of Kansas. Occasionally wanders to the south and east during fall and winter. Requires isolated stands of trees for nesting.

Seasonal Occurrence:
Uncommon permanent resident.

Field Notes: This colorful species brightens the landscape of northern and western Kansas. Its huge, domed stick nests are often grouped together in loose nesting colonies. Magpies tend to travel in social groups that are both conspicuous and vocal.

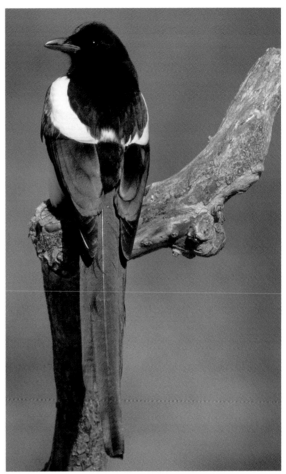

American Crow

Corvus brachyrhynchos

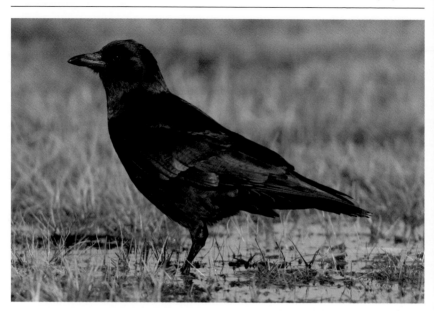

Field Identification: These larger relatives of the jays are entirely coal black, including eyes, bill, and legs. Their bill is long and stout. **Size:** Length 17 inches; wingspan 39 inches.

Habitat and Distribution: Found statewide in a variety of habitats.

Seasonal Occurrence: Permanent resident.

Field Notes: American Crows are adaptable and intelligent birds familiar to most Kansans. They have benefited from changes in the landscape brought by the "settlement" of the Great Plains. In winter, they gather in large roosts in some cities of central Kansas. They fly to surrounding rural areas during the day to feed on waste grain, returning to the warmth and safety of the city for the night. The roost at Wichita has been estimated in the hundreds of thousands of birds. Like Blue Jays, they act as watchdogs and will noisily mob Great Horned Owls and other avian predators. During the summer, along rivers in southeastern Kansas, you might encounter the **Fish Crow**. These are also all black but differ from American Crows by their smaller size and their higher-pitched, nasal calls. Fish Crows are a new arrival to Kansas but are expanding their range each year. They are always found near rivers and lakes.

Dolichonyx oryzivorus

Bobolink

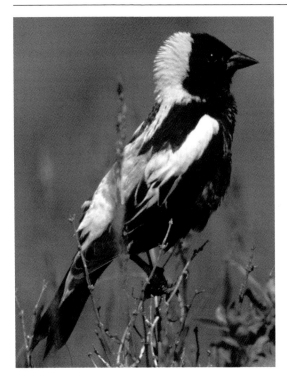

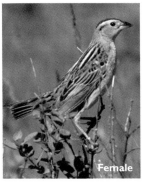

Female

Wildlife Refuge and in hay fields of extreme northeast Kansas.

Seasonal Occurrence: Migrant and summer resident. Spring migrants are seen almost entirely in May. The nesting population departs in July. They are seen less frequently in fall but have been reported through mid-October.

Field Identification: Breeding-plumaged males are black with a creamy yellow nape, a white rump, and large white wing patches. Females are streaked with black and brown above and are plain white below, with black and white eye stripes. Fall birds are rarely reported in Kansas but are similar to spring females and are yellow buff over much of their bodies. **Size:** Length 7 inches; wingspan 11 inches.

Habitat and Distribution: Migrant found mostly in eastern and central Kansas. They are rare in the west. In spring, they are almost always observed in alfalfa fields. They annually nest at Quivira National

Field Notes: In early May, flocks of several hundred Bobolinks are sometimes encountered feeding on insects in alfalfa fields. The large, grassy field at the northwest corner of Quivira National Wildlife Refuge is known as the "Bobolink Field" by birders throughout Kansas. It is the southernmost breeding site in the United States for the species. Park on the adjacent road and watch the field. During May and June, the males fly up from the grass and perform a showy display while singing their beautiful song.

Red-winged Blackbird

Agelaius phoeniceus

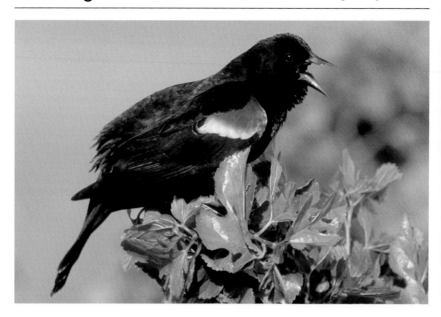

Field Identification: The male is all black except for the red-and-yellow blaze on the wing. The female does not look like a blackbird except for the sharply pointed bill; it is streaked above and below with brown and black and has a light yellow eye line. **Size:** Length 9 inches; wingspan 13 inches.

Habitat and Distribution: Found statewide in wetlands, agricultural areas, feedlots, roadsides, and pastures.

Seasonal Occurrence: Permanent resident. During the winter months, the population is at its largest, as substantial numbers move south from the northern states and Canada.

Field Notes: This is one of the most abundant birds in Kansas. Because it adapts to a variety of habitats, it nests in every county of the state. Wintering birds gather in immense flocks, usually at large wetlands with abundant cattails. These flocks can number in the millions and are an impressive sight as they disperse in the morning to feed and then return to the roost in the evening.

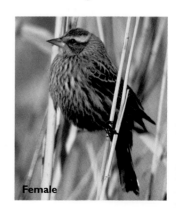

Female

Sturnella magna

Eastern Meadowlark

Field Identification: This plump, short-tailed bird of open country has a yellow breast with a prominent black V-marking. The broad white tail sides are visible on flying birds. Song is usually a simple four-note phrase: *"See me ... SEE you,"* highest and most strident on the third note. **Size:** Length 9.5 inches; wingspan 14 inches.

Habitat and Distribution: This is a nesting species in all but northwest Kansas. Prefers taller and moister prairies than does the Western Meadowlark.

Seasonal Occurrence: Permanent resident. During the winter, additional individuals move into Kansas from the northern states.

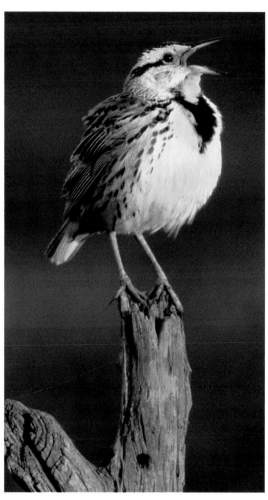

Field Notes: Eastern Meadowlarks are among the most visible birds of Kansas grasslands and cultivated areas. They spend most of their time on the ground but are often seen perched on fences or utility lines.

Western Meadowlark

Sturnella neglecta

Field Identification: The Western Meadowlark closely resembles the Eastern Meadowlark but differs subtly in plumage. The white edges of the tail are narrower, and on summer adults, the yellow throat plumage is more extensive. The simplest way to tell the two meadowlarks apart is by their song. The Western's song consists of a few clear, descending notes, followed by an odd gurgling that ends abruptly. **Size:** Length 9 inches; wingspan 14 inches.

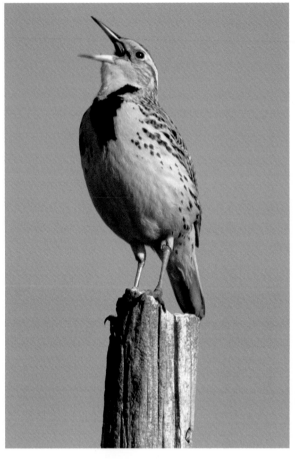

Habitat and Distribution: Inhabits all but southeastern Kansas. Prefers drier, shorter grassland habitats than does the Eastern Meadowlark.

Seasonal Occurrence: Permanent resident. Like the Eastern Meadowlark, many move into Kansas from the north during the winter.

Field Notes: In 1925, schoolchildren elected the Western Meadowlark as the state bird of Kansas. The two meadowlarks occur together across most of the state, but the Eastern is absent from the arid shortgrass prairie of northwestern Kansas, and the Western similarly shuns the comparatively moist southeastern counties.

Xanthocephalus xanthocephalus

Yellow-headed Blackbird

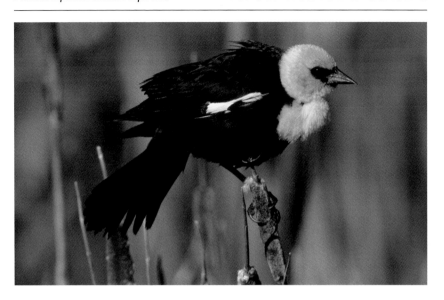

Field Identification: The male is unmistakable, with the yellow head and breast, black body and wings, and bold white wing patch. The female and young males have a dull yellow face, breast, and eye line, with the remainder of the plumage being dark brown. The unusual song of the males has been compared to a loud, squeaky barn-door hinge. **Size:** Length 10 inches; wingspan 15 inches.

Habitat and Distribution: Migrants are found statewide in wetlands and rural areas. Their summer distribution is erratic and local, always in expansive cattail marshes of central and western Kansas.

Seasonal Occurrence: Migrant and summer resident. Arrives in mid-

April and departs in September. Occasionally a few linger into November and December.

Field Notes: This is the most colorful blackbird in Kansas. In the spring, look for large, noisy flocks feeding in cattle feedlots, often with other blackbirds. In the summer, they nest in large colonies at wetlands such as Quivira National Wildlife Refuge and Cheyenne Bottoms.

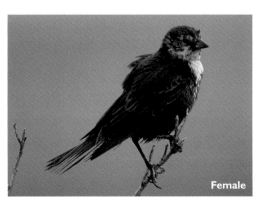

Female

Rusty Blackbird

Euphagus carolinus

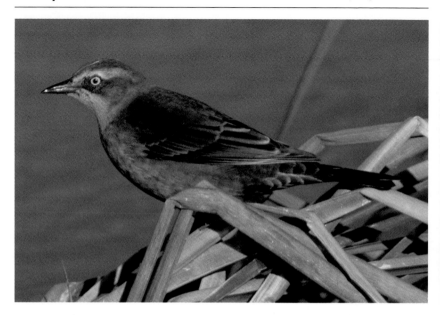

Field Identification: The plumage of the breeding male is all black with a yellow eye, but most seen in Kansas are in winter plumage and have pale golden-brown edging on the feathers. The plumage of the breeding female is grayish with a yellow eye and in winter is golden brown, with a small black mask. Vocalizations are complex and include high-pitched, squeaky notes. **Size:** Length 9 inches; wingspan 14 inches.

Habitat and Distribution: Found in moist woodlands, mostly in the eastern half of Kansas.

Seasonal Occurrence: Winter resident. Arrives in late October and departs in April.

Field Notes: Rusty Blackbirds are usually found in small, vocal flocks. Because their habitat preference is specialized, they are only occasionally observed in mixed-species blackbird flocks. Rusty Blackbirds nest in the northern boreal forests, and their numbers, like those of several other boreal nesting species, have declined significantly in the past twenty-five years.

Euphagus cyanocephalus

Brewer's Blackbird

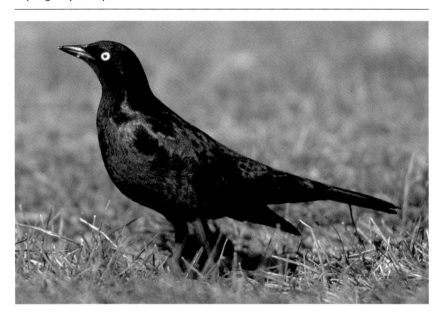

Field Identification: The male is black, with an iridescent sheen from late winter through the summer, duller in color at other seasons. The female is dark gray with a lighter-gray head and dark eye. Brewer's and Rusty Blackbirds are similar in appearance and occasionally occur together but are usually separated by habitat. Rusty Blackbirds are usually found in small flocks along wooded streams; Brewer's are fond of open farm country. **Size:** Length 9 inches; wingspan 15 inches.

Habitat and Distribution: Found statewide in rural areas. Most numerous in central and western Kansas. Look for them around farms, feedlots, and anywhere cattle are present.

Seasonal Occurrence: Winter resident. Arrives in September and departs in April.

Field Notes: Brewer's Blackbirds can be found in large numbers in the winter, often in flocks with other blackbird species.

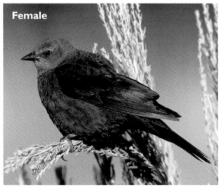
Female

Common Grackle

Quiscalus quiscula

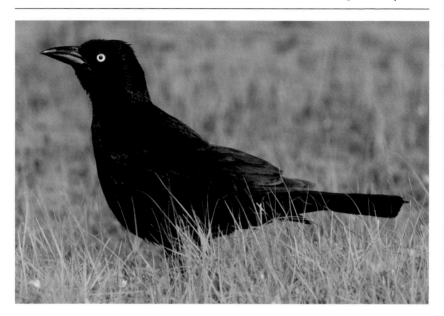

Field Identification: Males are iridescent bronze on most of the body, with a purplish sheen on the head and a long tail that is flared at the end. Females are similar, but the iridescence is muted. **Size:** Length 12 inches; wingspan 17 inches.

Habitat and Distribution: Found statewide in a variety of habitats, often abundant in towns and on farms.

Seasonal Occurrence: Permanent resident. Common in the summer, much less so in the winter months. Migrants are abundant in March and April and again in October and November.

Field Notes: The arrival of large numbers of grackles in March is one of the early signs of spring. Males perform an entertaining courtship display on urban lawns, throwing their heads back, puffing out their feathers, and making high-pitched squealing calls as they attempt to impress the females.

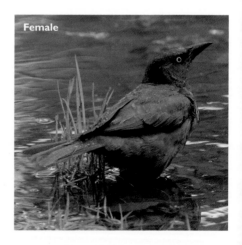

Female

Quiscalus mexicanus

Great-tailed Grackle

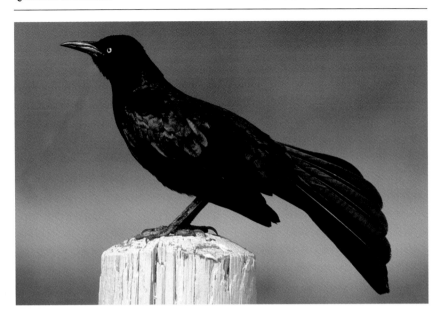

Field Identification: This is the largest blackbird in Kansas. The male is iridescent purple, with a long bill and a ridiculously long, wedge-shaped tail. Females are grayish-brown with a pale throat and eye line. Their loud, chattering, whistling calls are given year-round. **Size:** Length 18 inches; wingspan 23 inches.

Habitat and Distribution: Found statewide in cattail marshes, cattle feedlots, and urban areas.

Seasonal Occurrence: Permanent resident. Widespread in summer. In winter, most depart from northern and western Kansas.

Field Notes: Great-tailed Grackles are a relatively recent addition to the bird life of Kansas. In the 1960s, they began to colonize the state from the south and are now established in many areas. They are also a familiar sight in urban areas, where they often select groves of arborvitae or cedar trees as nesting sites. They often forage in parking lots for waste food and dead insects that have fallen from the grilles of vehicles.

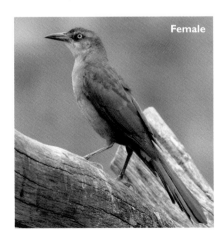

Female

European Starling

Sturnus vulgaris

Field Identification:
In summer plumage, Starlings are dark-bodied with white spots on the back, a purplish sheen on the head, and a yellow bill. In winter plumage, the entire body is spotted with white, the head is mostly gray, and the bill is black. **Size:** Length 8.5 inches; wingspan 16 inches.

Habitat and Distribution:
Found statewide, usually near towns, farms, feedlots, or other man-made habitats.

Seasonal Occurrence:
Permanent resident.

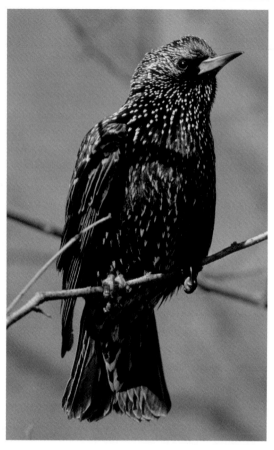

Field Notes: Starlings were introduced to North America in the late nineteenth century and within a few decades had expanded their range across the entire continent. They have become one of the foremost pest species in North America. Huge flocks gather in the fall and winter at feedlots and grain fields. Starlings nest in tree cavities and frequently compete with native birds for nest sites.

Molothrus ater

Brown-headed Cowbird

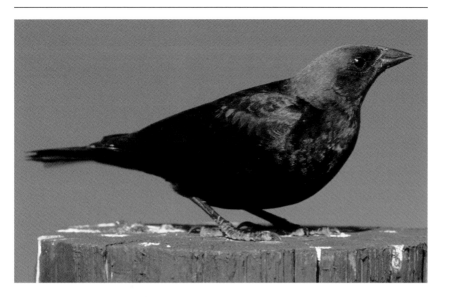

Field Identification: The male is glossy black with a brown head. The female is light brown with a pale throat. Their bills are shorter and more conical than those of other blackbirds. **Size:** Length 7 inches; wingspan 12 inches.

Habitat and Distribution: Found statewide in grasslands, brushy areas, and woodland edges. True to their name, they often feed on the ground near herds of cattle.

Seasonal Occurrence: Abundant migrant and summer resident. Arrives in early March; most depart in late October. Small numbers remain in southeastern Kansas during the winter months.

Field Notes: Brown-headed Cowbirds do not build their own nests but lay their eggs in the nests of other birds, leaving the host species to raise the young cowbirds as their own. They were originally restricted to the Great Plains and were a nomadic species, following the herds of bison. Changes brought by European settlement created new habitats, allowing their population to expand. During migration, especially in the fall, flocks of thousands can be observed.

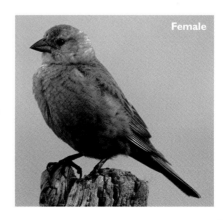
Female

Orchard Oriole

Icterus spurius

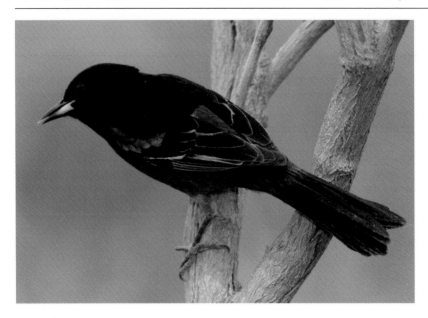

Field Identification: The adult male has a black head, back, wings, and tail and brick-red chest, belly, and wing marking. The female is lemon yellow below with grayish back and white wing bars. One-year-old males are similar to females, with a black mask and throat. **Size:** Length 7 inches; wingspan 10 inches.

Habitat and Distribution: Found statewide in brushy woodland edges, hedgerows, and groves of small or medium-sized trees surrounded by open areas.

Seasonal Occurrence: Summer resident. Arrives in May and departs in late July. Some migrants from farther north are seen into September.

Field Notes: Orchard Orioles are often heard before they are seen. They usually sing their melodious song while hidden in dense foliage. They are easily found in western Kansas, where nesting trees and adjacent open areas are available. They feed on insects in weedy fields and crops such as alfalfa. One-year-old males often associate with paired adults and assist in defending the nesting territory.

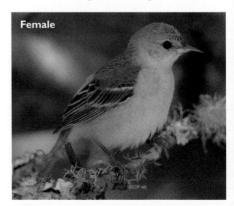

Female

Icterus galbula

Baltimore Oriole

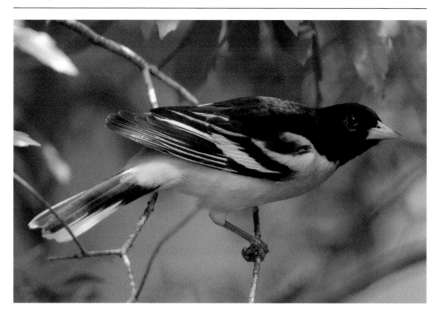

Field Identification: The male has a black head, back, and wings and orange underparts, rump, and tail sides. Males have one orange and one white wing bar. The female is light orange below and light brown on the head and back, with white wing bars. **Size:** Length 9 inches; wingspan 11 inches.

Habitat and Distribution: Found statewide in urban yards, parks, and open woodlands, especially those with cottonwoods. Nests in most of the state, but in the westernmost counties it is seen only during migration.

Seasonal Occurrence: Summer resident. Arrives in late April and departs in September.

Field Notes: This is one of the most colorful birds found in Kansas.

When wild fruits such as mulberries or hackberries ripen, small flocks of orioles congregate to devour the fruit. Orioles can be attracted to special nectar feeders and to feeders that offer orange halves and grape jelly. Their abandoned, sock-like nests are obvious after the leaves have fallen in autumn.

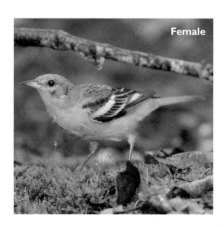
Female

289

Bullock's Oriole

Icterus bullockii

Field Identification: The male has a black throat and upperparts and an orange face and underparts. The large white wing patch is prominent. The female has a yellow-orange head and breast, gray back, and white belly. **Size:** Length 9 inches; wingspan 12 inches.

Habitat and Distribution: Nests in riparian woodlands and towns in the western fourth of Kansas. Migrants are occasionally seen farther east in both spring and fall migration.

Seasonal Occurrence: Migrant and summer resident. Arrives in May and departs in September.

Field Notes: The Bullock's Oriole replaces the closely related Baltimore Oriole as a nesting species in western Kansas. The ranges of these two orioles meet in Kansas, and hybrids may show various markings of both species. Bullock's Orioles are common along the Arkansas and Cimarron rivers and their tributaries, where their bright colors and pleasing song make this bird a refreshing sight.

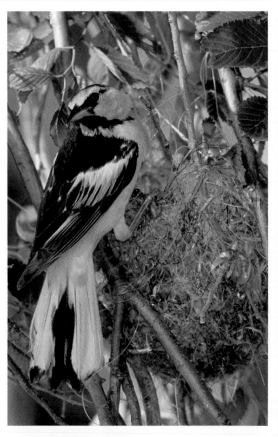

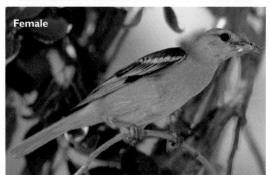

Female

Piranga olivacea

Scarlet Tanager

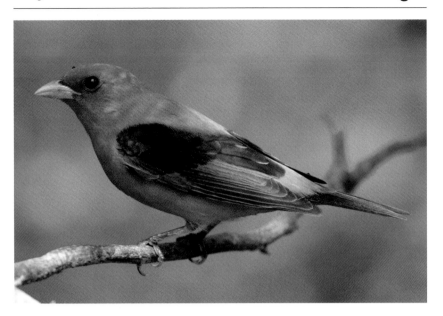

Field Identification: The male in breeding season is a deeper shade of red than the Summer Tanager, with jet-black wings and tail. Females and fall males are yellowish-green with dark wings. **Size:** Length 7 inches; wingspan 11.5 inches.

Habitat and Distribution: Nests locally in mature riparian hardwood forests of eastern Kansas. Migrants occur in central Kansas but only rarely in western Kansas.

Seasonal Occurrence: Migrant and summer resident. Arrives in late April and departs in late September.

Field Notes: Male Scarlet Tanagers are spectacular in appearance and never fail to please a crowd of birders. In Kansas, they are considerably less common than Summer Tanagers during the nesting season, but they can be found at a few locations, such as Fort Riley, the Fort Leavenworth Bottomlands, and Marais des Cygnes National Wildlife Refuge.

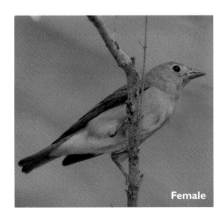

Female

Western Tanager

Piranga ludoviciana

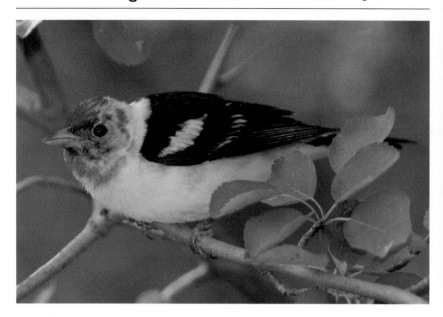

Field Identification: The breeding male Western Tanager has a bold black-and-yellow pattern and red head. Females and fall males are yellow green, with black back and wings and white wing bars. **Size:** Length 7 inches; wingspan 11.5 inches.

Habitat and Distribution: Found in woodlands and towns in the westernmost counties.

Seasonal Occurrence: Spring migrant in May; fall migrant in September. They are seen more often in the fall than in the spring.

Field Notes: This tanager is one of the sought-after western species that draw birders to western Kansas during spring and fall migration. The best chance for finding one is during September in Morton County, both in the town of Elkhart and in the woodlands along the Cimarron River.

Piranga rubra

Summer Tanager

Field Identification: The male in breeding season is entirely red with a long, whitish bill. The female is greenish above and dull yellow below. Some spring males look "in between," mostly yellow green with blotchy red areas or red with greenish wings. A sharp *"spi-tuck"* call is often heard. **Size:** Length 8 inches; wingspan 12 inches.

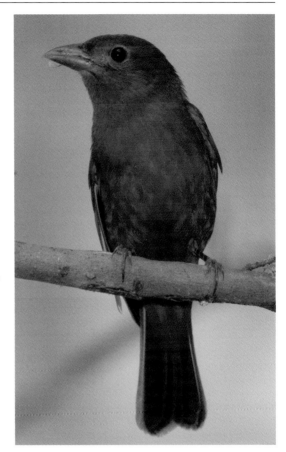

Habitat and Distribution: Nesting birds are found from the Flint Hills eastward in wooded areas. They are strongly associated with oak forest but can be seen in other woodland communities as well. In the Flint Hills, they are found in isolated stands of oaks surrounded by prairies. Migrants are often found in the west during migration.

Seasonal Occurrence: Summer resident. Arrives in late April and departs in September.

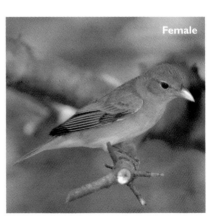

Female

Field Notes: Summer Tanagers are fairly common in areas of eastern Kansas with appropriate habitat. Their rich, warbling song and guttural call notes announce their presence in the dense canopy.

Northern Cardinal

Cardinalis cardinalis

Field Identification: Both sexes are crested, with a black mask and red bill. The male is crimson, and the female is brown with red shafts in the wings. Juveniles are similar to females but have a black bill. **Size:** Length 9 inches; wingspan 12 inches.

Habitat and Distribution: Found statewide in woods, brushy areas, parks, and yards. Considerably less common in western Kansas, but the population there is expanding.

Seasonal Occurrence: Permanent resident.

Field Notes: Northern Cardinals are a familiar bird to many Kansans. They are frequent visitors to yards and bird feeders and are among the most colorful species seen there. They readily nest in yards and parks. As trees and shrubs mature on the high plains of western Kansas, Cardinals have begun to colonize these towns and can now be seen to the Colorado state line.

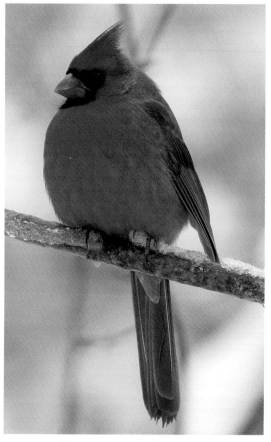

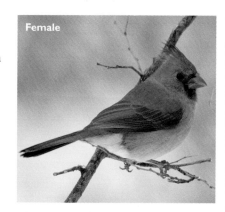

Female

Pheucticus ludovicianus

Rose-breasted Grosbeak

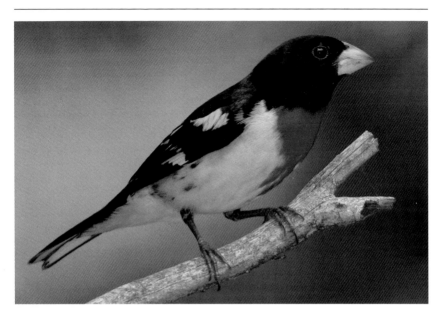

Field Identification: Males have a large conical beak, a black head and upperparts, a red breast, and white underparts. White wing patches are prominent on flying males. Females have a striped face, brown back, and white breast with heavy streaking. The fall male has an all-pale bill but is otherwise similar to the female Black-headed Grosbeak. **Size:** Length 8 inches; wingspan 13 inches.

Habitat and Distribution: This bird nests in northeastern Kansas in riparian woodland and upland hardwood forest. It is a widespread migrant in eastern Kansas and a rare but regular migrant in the west.

Seasonal Occurrence: Spring migrants are seen in late April through mid-May; fall migrants in September and early October. It is a summer resident in northern and eastern Kansas.

Field Notes: Rose-breasted Grosbeaks can be frustrating to see well. They often sing their rich, warbling song from the densest canopy in the forest. Learn their metallic *"chink"* note, as it often is the first sign of their presence.

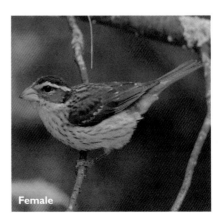
Female

295

Black-headed Grosbeak

Pheucticus melanocephalus

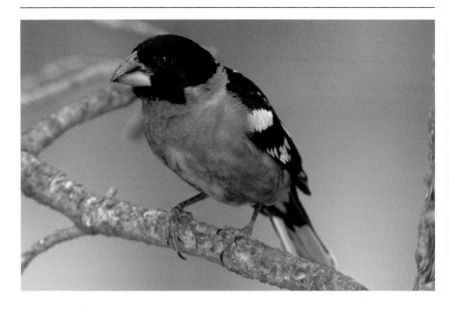

Field Identification: The male is orange, with a black head, back, and wings, and has white wing patches similar to those of the male Rose-breasted Grosbeak. The female is similar to the Rose-breasted female, but the underparts are buffier and the streaking finer and less extensive. In both sexes, the upper mandible of the bill is dark in all plumages, unlike the entirely pale bill of the Rose-breasted Grosbeak. **Size:** Length 8 inches; wingspan 12 inches.

Habitat and Distribution: This is a nesting species in the riparian woodlands of northwestern Kansas. It is a widespread migrant in the west and is a rare but regular migrant east to the Flint Hills.

Seasonal Occurrence: Spring migrants are seen from late April through

mid-May. Fall migrants are seen in September and early October.

Field Notes: This is one of the few species that is more common in northwestern Kansas than in any other area of the state. Black-headed and Rose-breasted Grosbeaks are closely related, and hybrids between the two species are sometimes seen, especially in the central part of the state, where their nesting ranges converge.

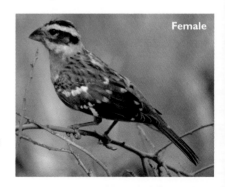
Female

Passerina caerulea

Blue Grosbeak

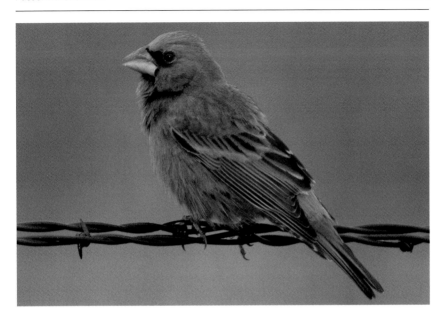

Field Identification: Males are all blue with reddish-brown wing bars and a large, conical bill. Females are entirely grayish-brown with light wing bars. The burry, warbling song is helpful in detecting their presence. A hard, metallic call note is often heard.
Size: Length 7 inches; wingspan 11 inches.

Habitat and Distribution: Found in brushy areas, edge habitats, fencerows, and scrubby vegetation. Occurs statewide, but more numerous in the southern half of the state.

Seasonal Occurrence: Summer resident. Arrives in mid-May, later than most other summer species, and departs in mid-September.

Field Notes: Look for these colorful birds in thickets and dense edge vegetation. In areas of appropriate habitat, such as the Cross Timbers and Red Hills, they are abundant, and many can be seen in a single day. They are often seen feeding in tall weeds near roadsides.

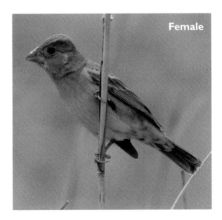

Female

Indigo Bunting

Passerina cyanea

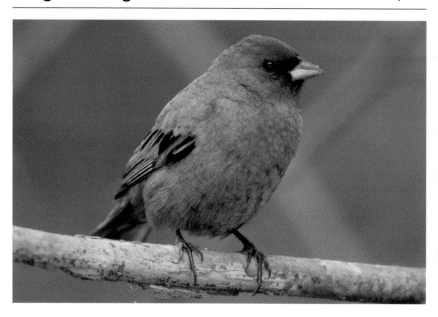

Field Identification: The summer male is entirely deep blue, giving way to a patchy blue-and-gray mix in the fall. The female is grayish-brown with blurry streaking below (see comments for Lazuli Bunting). It is possible to confuse both males and females of this species with the Blue Grosbeak, but one look at the bill will resolve any identification confusion. Also notice the reddish-brown wing bars on the male Blue Grosbeak. **Size:** Length 5.5 inches; wingspan 8 inches.

Habitat and Distribution: Found in riparian woodlands, hedgerows, and towns. Nests in the eastern two-thirds of Kansas, rarely farther west. Migrants are found statewide.

Seasonal Occurrence: Summer resident. Arrives in late April and departs in mid-October.

Field Notes: Indigo Buntings are among the most common summer species of eastern Kansas, and their loud, warbling, repetitive songs are heard into August. They sing from high, exposed tree perches throughout the day, even on the hottest days of summer.

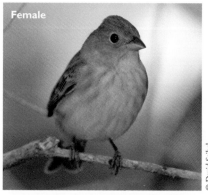

Female

© David Seibel

Passerina amoena

Lazuli Bunting

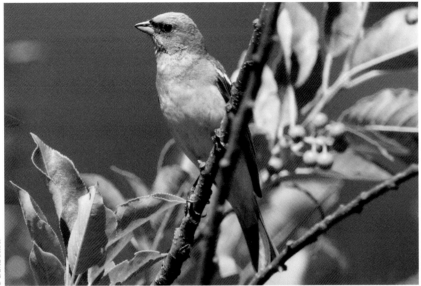

© David Seibel

Field Identification: The male has a blue head, upperparts, and wings; orange bib; white belly; and prominent white wing bars. The female is uniformly grayish-brown with narrow wing bars. Females can be difficult to distinguish from female Indigo Buntings. Indigo females usually have a paler throat and vague streaking on the breast. Lazuli females have a grayer throat and lack any markings on the underparts. **Size:** Length 5.5 inches; wingspan 9 inches.

Habitat and Distribution: Migrants are found in towns and woodlands statewide. It is a regular migrant in the west and a rare migrant east to the Flint Hills.

Seasonal Occurrence: Spring migrants are seen in late April and early May; fall migrants in late August and early September.

Field Notes: Lazuli Buntings do not remain in Kansas to nest for the most part, but they have done so a few times in the westernmost counties.

Painted Bunting

Passerina ciris

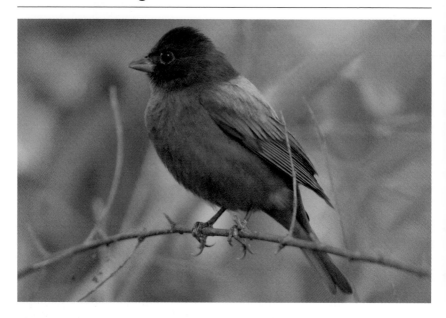

Field Identification: Arguably the most colorful bird in Kansas, the male is crimson below, with a green back and a blue head with red eye ring. The female is bright greenish-yellow. The warbling song is similar to the Blue Grosbeak's but is higher-pitched and shorter in duration. **Size:** Length 5.5 inches; wingspan 9 inches.

Habitat and Distribution: Found in brushy or open-wooded hillsides in southern and eastern Kansas. It nests west to Clark County and north to Jefferson County.

Seasonal Occurrence: Summer resident. Arrives in early May and departs in late August.

Field Notes: Many Kansans are amazed to learn that such a colorful bird can be seen in their state. Even people who live in areas where they are relatively common are often unfamiliar with them. The males usually sing from a partially concealed perch near the top of leafy trees, rarely perching in the open. As with many birds, knowing their song is useful in locating them. They are most abundant in the Red Hills and Cross Timbers regions.

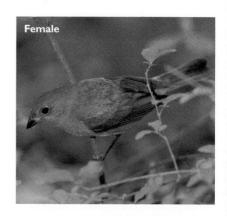

Female

Spiza americana

Dickcissel

Field Identification: The male has a yellow throat and breast with a black bib, a yellow eye line, russet wings, and a gray breast and nape. The female is similar but does not have the black bib or yellow breast. **Size:** Length 6 inches; wingspan 10 inches.

Habitat and Distribution: Found statewide in tall and mixed-grass prairies, agricultural fields, and weedy areas.

Seasonal Occurrence: Summer resident. Arrives in May and departs in October.

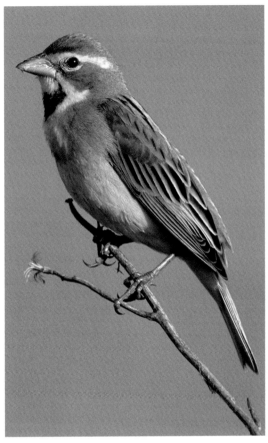

Field Notes: Dickcissels are one of the most abundant birds in Kansas, despite their habit of nesting in wheat and alfalfa, which are often harvested during their nesting season. The males sing from atop tall plants, fence posts, or thickets. Scanning across a wheat field will often reveal singing males. During migration, listen for their distinctive single *"buzz"* notes, which they often give while in flight.

Purple Finch

Carpodacus purpureus

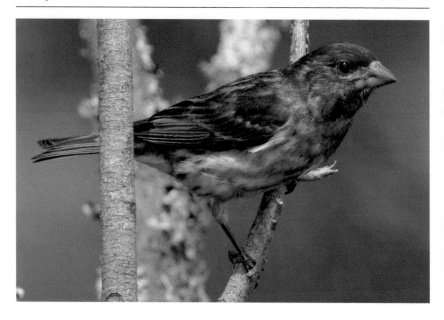

Field Identification: The male is raspberry purple on the head, breast, back, and wing edges. Unlike the abundant House Finch, males lack streaking on the flanks. The female has a brown back and head with white stripes on the face and white underparts with heavy dark streaks. Female House Finches lack strong facial markings and are dingier below. **Size:** Length 6 inches; wingspan 10 inches.

Habitat and Distribution: Found statewide but mostly in the eastern half of Kansas, in woodlands, brushy habitats, and towns.

Seasonal Occurrence: Winter resident. Arrives in November and departs in April.

Field Notes: This is one of several "northern finches" that birders hope to find in the winter. They readily visit bird feeders. Purple Finches are scarce in most years but occasionally invade Kansas in large numbers, usually east of the Flint Hills.

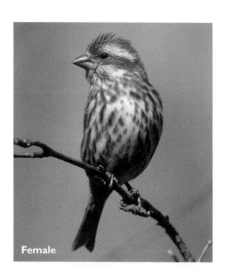

Female

Carpodocus mexicanus

House Finch

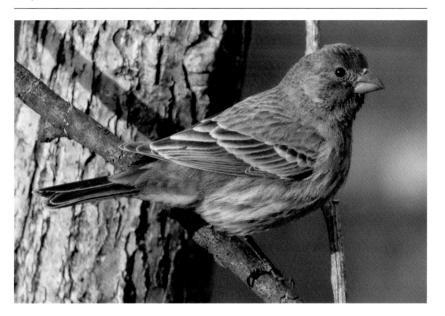

Field Identification: The male is red on the crown, throat, breast, and rump and is otherwise brown with weak wing bars. The red plumage is more crimson and more restricted than that of the Purple Finch. The female is gray brown above and has dingy underparts with obscure streaking. It lacks the strong facial pattern and well-defined breast streaks of the female Purple Finch. **Size:** Length 6 inches; wingspan 9.5 inches.

Habitat and Distribution: Found statewide in weedy fields, in towns, and around farms.

Seasonal Occurrence: Permanent resident.

Field Notes: House Finches expanded their range in North America

significantly in the twentieth century. Until the 1970s, they were found only in southwest Kansas, but they are now abundant throughout the state. They frequently nest in hanging plant baskets and are often the most numerous species at bird feeders. During the winter, they often gather in flocks of several hundred birds and wander widely in search of food.

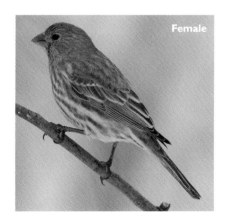

Female

303

Pine Siskin

Carduelis pinus

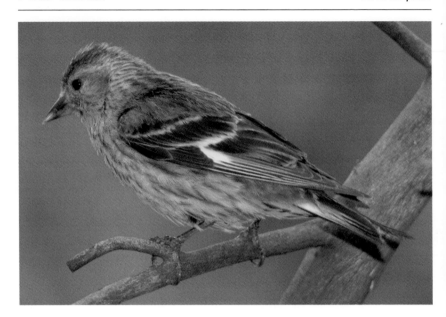

Field Identification: This small, brown finch has a sharp, pointed bill; notched tail; and heavy streaking on most of the body. Adults have a long yellow wing stripe, which appears as a wing bar on perched birds, and wing and tail feathers with yellow edging. The distinctive call is an ascending, high-pitched buzz. **Size:** Length 5 inches; wingspan 9 inches.

Habitat and Distribution: Found statewide in pines, other conifers, weedy fields, and sunflower patches; also at bird feeders.

Seasonal Occurrence: Winter resident. Arrives in October and departs in May. A few pairs occasionally remain to nest.

Field Notes: These small, energetic finches often associate with American Goldfinches, to which they are closely related. Like several other finch species, they can be abundant one year and virtually absent the next. During "invasion years," when siskins move into Kansas in large numbers, they noisily swarm sunflower- and thistle-seed feeders.

Carduelis tristis

American Goldfinch

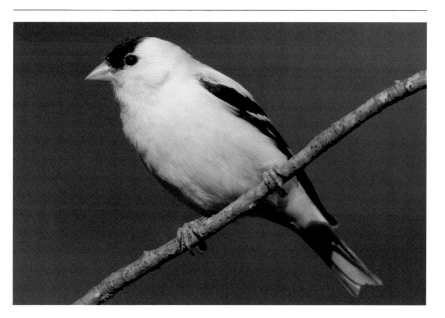

Field Identification: The summer male is bright yellow with black wings, tail, and crown. Females and all winter birds have black wings and yellow wing bars and are grayish with a variable amount of yellow on the face and breast. They have an undulating flight and while flying often give a three- or four-note call every few seconds. **Size:** Length 5 inches; wingspan 9 inches.

Habitat and Distribution: Found statewide in prairies, weedy fields, brushy areas, open woodlands, cities, and towns.

Seasonal Occurrence: Permanent resident, but populations vary in abundance seasonally and from year to year.

Field Notes: This colorful finch is found in open country throughout Kansas. American Goldfinches nest later in the summer than almost any other songbird, often laying eggs in early August. Like Pine Siskins, they sometimes visit feeders in large flocks and consume significant amounts of sunflower and thistle seed.

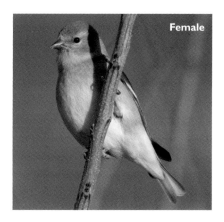

Female

Red Crossbill

Loxia curvirostra

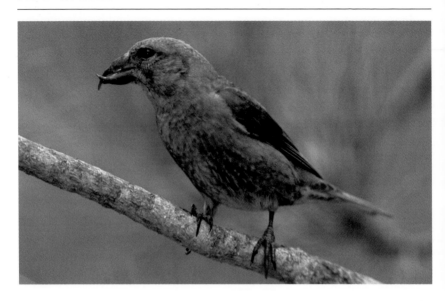

Field Identification: Both sexes have dark wings and large bills, with the mandibles crossed like tin snips. Males are brick red; females are yellowish. They are usually seen in flocks and communicate frequently with hard call notes. **Size:** Length 6 inches; wingspan 11 inches.

Habitat and Distribution: Found statewide in pines and other coniferous trees and sometimes in weedy fields.

Seasonal Occurrence: The occurrence of this rare species is erratic and unpredictable. It can appear at any time of the year, but most sightings occur during the winter months.

Field Notes: The erratic movements of Red Crossbills are triggered by the pine-cone crops of the boreal forests of Canada and the Rocky Mountains. When these crops fail, they wander onto the plains in search of food. Look for them in areas with abundant pines. They use their specialized bills to extract seeds from the cones. Sites that often attract crossbills during invasion years include the Fort Hays State University Experimental Farm, the pines below the dam at Perry Reservoir, and Sim Park in Wichita.

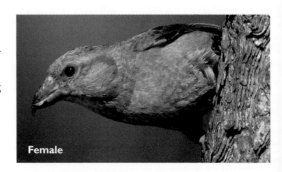

Female

Kansas Birding Hot Spots

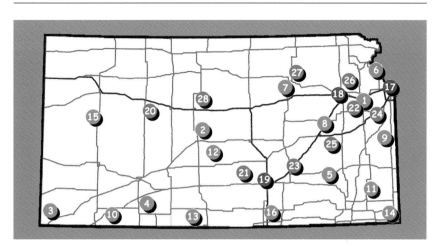

1	Baker Wetland	14	Schermerhorn Park
2	Cheyenne Bottoms Wildlife Area	15	Scott State Park
3	Cimarron National Grassland	16	Slate Creek Wetlands and Chaplin Nature Center
4	Clark State Fishing Lake		
5	Cross Timbers	17	Kansas City Area
6	Fort Leavenworth and Weston Bend	18	Topeka Area
7	Fort Riley	19	Wichita Area
8	Lyon State Fishing Lake	20	Cedar Bluff Reservoir
9	Marais des Cygnes Wildlife Area and Marais des Cygnes National Wildlife Refuge	21	Cheney Reservoir
		22	Clinton Reservoir
		23	El Dorado Reservoir
		24	Hillsdale Reservoir
10	Meade State Park	25	John Redmond Reservoir
11	Neosho Wildlife Area	26	Perry Reservoir
12	Quivira National Wildlife Refuge	27	Tuttle Creek Reservoir
13	Red Hills	28	Wilson Reservoir

Kansas Birding Hot Spots

The following list of locations should by no means be taken as a comprehensive selection of birding sites in Kansas. Rather, this list is intended to give the reader an idea of how rich and varied the birding possibilities are throughout the state. Many readers will likely live in or near the large urban centers of Kansas City, Topeka, and Wichita, so attention has been given to popular birding locations in or near each of these cities. In several of the primary hot-spot descriptions, additional nearby birding hot spots are also briefly discussed. These supplemental sites are noted in boldface in the text. The Natural Kansas Web site, found in this book's Birding Resources section, has information on additional birding sites throughout Kansas.

Quivira National Wildlife Refuge

Quivira National Wildlife Refuge (NWR) reigns supreme among Kansas birding destinations. Located in Stafford County about thirty miles west of Hutchinson, its twenty-one thousand acres encompass a variety of wetland habitats, extensive sand prairie, and upland woods. Although nearby Cheyenne Bottoms Wildlife Area often has equal or greater numbers of birds, Quivira has a greater variety of habitats and also has superior "viewability" because of the dynamics of its roads and habitats.

Three hundred forty species of birds have been seen in Stafford County, and most of these have been observed at the refuge. Quivira is an excellent birding destination at any season. It is most renowned for the variety of waterfowl, cranes, herons, shorebirds, and other wetland species that can be seen during spring and fall migration. The greatest variety of birds can be found from late April through late May in the spring and from mid-July through early October in the fall. During the summer months, many of these birds remain to nest, including wetland specialists such as American and Least Bitterns, King and Virginia Rails, Common Moorhen, Snowy Plover, Black-necked Stilt, American Avocet, and Least Tern. During the summer, the upland areas have many nesting Eastern and Western Kingbirds, Bell's Vireos, Field Sparrows, and Baltimore Orioles. In late fall, species diversity declines significantly, but huge flocks of geese, ducks, and Sandhill Cranes are usually present, remaining into the winter months as long as open water remains. As many as one hundred Bald Eagles may be found hunting these flocks on some days. During the winter months, numerous hawks and owls are present, and flocks of Harris's and American Tree Sparrows, Dark-eyed Juncos, and other winter birds enliven the brushy sandhills.

The two primary wetlands at Quivira are the Little Salt Marsh at the south end of the refuge and the Big Salt Marsh on the north end. There are numerous smaller wetland impoundments throughout the refuge, and the route outlined here will take you past many of them. The refuge headquarters is located on the south side of the Little Salt Marsh. The headquarters has a small interpretive

display, and you can obtain maps, a bird checklist, and other useful information there. From the headquarters, proceed north on a dirt road that follows the eastern and northern shores of the Little Salt Marsh and then zigzags north and east for several miles to a small parking area by the environmental education classroom and public restroom (these are the only restroom facilities available). A one-mile walking trail, called the Migrant Mile, begins and ends here; it includes a long boardwalk across a cattail marsh. From the restroom, continue north for four miles (passing many smaller wetlands that usually offer good birding) until you reach a T intersection. Turn left (west) and proceed one mile to the beginning of the Wildlife Drive. This three-mile loop road offers the single best opportunity to see the diverse wildlife of the refuge. If your schedule allows you to visit only one part of Quivira, the Wildlife Drive should be the place. Wetlands border the drive on both sides for most of its length, and viewing opportunities abound. Where the loop road returns to the county road, you can turn right (east) and go about one mile to a large mudflat area north of the road, which is often the best shorebird site at Quivira, although in times of drought it is dry and barren. After checking this area, turn around and go back to the west for two miles to an extensive wet sedge meadow on the north side of the road. Bobolinks nest in this field annually. The wooded area west of the meadow is on private land but can be birded reasonably well from the road and often produces additional species.

To reach Quivira from U.S. 50, go east from Stafford for six miles to the small town of Zenith, where you will see a sign for Quivira. Turn north on the paved county road and proceed eight miles to the headquarters.

Cheyenne Bottoms Wildlife Area

Cheyenne Bottoms is the most extensive wetland in Kansas. It lies in a sixty-square-mile basin in the central part of the state. Over 320 species of birds have been recorded on the refuge. The entire wetland covers about 41,000 acres. The Cheyenne Bottoms Wildlife Area consists of 20,000 acres managed by the Kansas Department of Wildlife and Parks (KDWP). An additional 7,300 acres adjacent to the public land is owned and managed by the Nature Conservancy.

This wetland complex is characterized by dramatic fluctuations in water supply, and there are years when water is distressingly scarce or entirely absent. Because of the massive population of larval insects inhabiting the extensive area of mudflats at the Bottoms, it is the single most important stopping point for migratory shorebirds in the interior United States. Up to 45 percent of the entire population of some North American shorebird species, such as Wilson's Phalarope and White-rumped Sandpiper, passes through the Bottoms in spring, during years when habitat conditions are favorable. Shorebird migration is at its peak during April and May in the spring and July through October in the fall. On

an exceptional day, you can find twenty-five or more shorebird species. In addition to the shorebirds, there is an excellent variety of grebes, waterfowl, herons, cranes, rails, gulls, terns, and sparrows present during migration, and many of these remain to nest. In summer, look for American and Least Bitterns, Black-crowned Night-Herons, all three egret species, American Avocets, Black-necked Stilts, Forster's and Black Terns, and Yellow-headed Blackbirds. During the fall migration, numbers of shorebirds are usually somewhat less dramatic, but flocks of Double-crested Cormorants and American White Pelicans are usually present, along with numerous postbreeding egrets and herons. Late in the fall, large flocks of waterfowl and Sandhill Cranes can be found. Look for Marsh Wrens and Le Conte's Sparrows in October and November. During the winter, diversity and overall numbers of birds are considerably lower, but there are usually good numbers of raptors, including Rough-legged and Ferruginous Hawks and both Bald and Golden Eagles.

The extensive dike system was expanded and upgraded during the 1990s. It divides the area into pools that allow management of the ever-fragile water supply. Most of the dikes at the Bottoms have roads on them, and many of these roads are accessible to the public. They provide the best viewing opportunities for birding. The central pool is surrounded by a perimeter of roads, and three roads lead from this inner ring to the edge of the area. Due to the ongoing efforts at water conservation and cattail control, it is difficult to predict from year to year where the best birding will be. Concentrate your search on areas where there are extensive areas of mudflats or shallow water. On windy days, the shallow water is forced to the windward portions of the pools, and shorebirds move onto the exposed mudflats in search of food. In areas of dense cattails, carefully watch the edge of the vegetation and you might spot a Least Bittern, Virginia Rail, or Common Moorhen.

In drought years, the best birding is usually along the east and south sides of Pool 1A. There are often mudflats or shallow water in this pool even when the rest of the refuge is dry. At the north end of the refuge is a black-tailed prairie dog town about one mile south of the town of Redwing. Here Burrowing Owls can usually be found from April through October. Look for them standing on fence posts or on the burrow mounds in the dog town. If you want to pad your trip list with some passerine species, visit the large stand of cottonwoods about a mile west of the headquarters. To reach the Nature Conservancy property, go north from the headquarters building for four miles. After crossing a low-water bridge, turn right (east) at the next corner and follow the road past an extensive wetland area that often has numerous birds. This road should definitely be avoided after heavy rains.

To reach Cheyenne Bottoms from Great Bend, take K-156 northeast for six miles to the Kansas Wetlands Education Center. Be sure to check out the inter-

pretive displays, pick up a map, and inquire about recent bird sightings. Enter the Bottoms by turning north across from the Education Center.

Cimarron National Grassland

The Cimarron National Grassland (CNG) and the adjacent town of Elkhart are popular destinations for Kansas birders. Because of their location in the extreme southwest corner of the state, many western species of birds that are rare elsewhere in Kansas are relatively easy to find. The CNG is managed by the U.S. Forest Service. It was created after the Dust Bowl years of the 1930s, when the federal government bought up a substantial portion of the land in Morton County, removed it from cultivation, and began to restore vegetation on the barren landscape. Today, healthy riparian woodlands are found along the Cimarron River, flanked by shortgrass prairie and sagebrush habitats. Lying just to the south of the CNG, the town of Elkhart is an oasis of trees and water that also attracts many interesting birds.

During both the spring and fall migrations, a variety of western species are seen, including Rufous Hummingbird, Common Poorwill, Dusky Flycatcher, Townsend's Warbler, and Western Tanager, among many others. The months of May and September are probably the most popular with birders, as the greatest variety of western species can be found then. Also seen each year are a surprising number of migratory eastern species that have wandered westward from typical migration routes. In summer, look for abundant Cassin's Sparrows, Lark Buntings, Orchard Orioles, and Bullock's Orioles. Rock Wrens are present in the rocky outcrops north of the Cimarron River, and large prairie-dog towns attract numerous Burrowing Owls. A stable population of Lesser Prairie-Chickens is present, and in most years the U.S. Forest Service has a blind that can be reserved to view the Prairie-Chickens' booming activity in March and April. Scaled Quail are present year-round. During the winter months, a substantial population of Ferruginous Hawks is found on the CNG, along with many other raptor species such as Cooper's Hawks, Merlins, Prairie Falcons, and both Bald and Golden Eagles. Other winter specialties include Long-eared Owl, Townsend's Solitaire, and Chestnut-collared Longspur.

Begin a tour of Elkhart in the cemetery at the northeast corner of town and the dense shelterbelt north of the cemetery, where many rare birds have been found. The adjacent wastewater treatment plant for the city of Elkhart has roads around the pools and even has signs welcoming birders to the property. As the only significant body of water in the entire county, it attracts an amazing variety of shorebirds, waterfowl, and other water-dependent species. After checking this area, proceed north on K-27 for about three miles to the **Tunnerville Work Station**, which has extensive pine plantings where many birds, including Long-eared and Barn Owls, may be found. From Tunnerville, continue north on K-27

to the Cimarron River. Much of the land along the river is within the CNG, where you are free to explore as you wish. There are roads that follow both the north and south sides of the river and offer many access points. To visit two of the most well-known sites on the CNG, go about a half mile north of the bridge over the Cimarron River on K-27 and turn left (west) onto the north river road. Drive west for about two miles to reach **Middle Spring**, a watered oasis where many interesting birds have been found. About two miles farther west, you reach a famous landmark called **Point of Rocks**, which offers an excellent view of the river valley and has many Rock Wrens nesting on the rocky outcrops. Check the scrubby brush below the rim for birds.

Scott State Park

Scott State Park is an isolated oasis of water and woodlands on the high plains of western Kansas, located about ten miles north of Scott City. The centerpiece of the park is Lake Scott, created by a dam on Ladder Creek. The lake lies in a rugged canyon of impressive size. Habitats include rocky slopes, shortgrass prairie, cattail marsh, and woodlands.

A birding trip to this site at any time of the year is rewarding, and western species are well represented at all seasons. Almost 270 species of birds have been seen in Scott County, and the majority of those have been seen at this location. During the summer, the park is home to a diverse group of species, including Common Poorwill, Say's Phoebe, Bell's Vireo, Rock Wren, Yellow-breasted Chat, Black-headed Grosbeak, and Bullock's Oriole. In the winter, numerous waterfowl, raptors, and passerines are attracted to the park. The variety of raptors is especially good in the winter and usually includes Ferruginous Hawks, Merlins, and Prairie Falcons. Also in winter, be alert for western species such as Townsend's Solitaire and roosting Long-eared Owl. Many interesting birds have been observed in the park during both spring and fall migration.

Following the shore on the west side of the lake is a paved road that allows you to reach most of the habitats found in the park. Check all of the stands of trees, but do not ignore the grassland and brushy habitats. Be sure to walk the Big Springs Nature Trail, where the Yellow-breasted Chats are especially abundant in summer. Rock Wrens and Common Poorwills inhabit the rocky cliffs. The campground with mature trees located near the Big Springs Trail is known locally as "the Grove" and is a prime birding site. Near the north end of the state park is a mostly undeveloped area known as Timber Canyon, which has produced good birds in the past. A paved road goes westward along the length of Timber Canyon before climbing back up to the arid plains that surround the park. Check the cattail stands below the dam and also those adjacent to the El Cuartelejo historic site for species such as Virginia Rail, Marsh Wren, and Swamp Sparrow, which are wintering species in most years. The lake itself is the largest body of water

in this area of Kansas and consequently attracts many species of waterfowl and other water-dependent species, especially in winter, when human use of the park is minimal.

Scott State Park is located about ten miles north of Scott City in Scott County. Take U.S. 83 north from Scott City for ten miles to the junction with K-95 and proceed west on K-95 to the park entrance. If you are coming from the north, the junction of U.S. 83 and K-95 is about thirty-five miles south of Oakley. The well-known Monument Rocks are only a few miles away to the northeast and are a good sightseeing stop.

Meade State Park

An isolated oasis of trees and water on the cultivated western plains, Meade State Park is the western outpost for several eastern species and has a history of attracting unexpected birds. It is located about thirteen miles southwest of the town of Meade. Due to its location in the semiarid high plains, the lake acts as a magnet for waterfowl, rails, shorebirds, and other aquatic species. An extensive area of upland woodland at the upper end of the lake, cattail marshes, and shortgrass prairie provide diverse habitat for the birdlife.

During the summer months, resident birds include Mississippi Kite; Chuck-will's-widow; Great Crested Flycatcher; and Baltimore, Bullock's, and Orchard Oriole. In the winter, look for waterfowl as long as the water is unfrozen; watch also for various raptors, including Prairie Falcon, and western species such as Townsend's Solitaire. A large fire killed many trees in the park during the 1990s, and the abundant standing dead timber still attracts a substantial number of woodpeckers. Barred Owls and Carolina Chickadees are residents, and this is the western limit of their range in Kansas. Be sure to check the large stands of cattails for rails and Marsh Wren. During spring and fall, bird-banding operations conducted at Meade State Park over many years have documented an excellent variety of migratory birds.

To reach Meade State Park, go south from Meade on K-23 for eight miles. The highway curves to the east, and the entrance to the park is reached after another five miles. Park roads encircle the lake. There are several hiking trails through the woodland areas.

Meade County, like other areas of southwestern Kansas, has many ephemeral wetlands that are known as "playas." One of the largest of these is the **Lakeview Playa**, which is located four miles east of Meade on the south side of U.S. 160. Although it is on private land, this playa can be easily viewed from the highway and from a dirt road on the east end of the playa. When water is present, these playas attract numerous waterfowl, herons, and shorebirds.

About twenty miles west of Meade State Lake is **Arkalon Park**, another oasis of habitat that attracts numerous birds throughout the year. This large rural park

is owned by the City of Liberal and is located within a corridor of riparian cottonwood forest along the Cimarron River. Marshy areas near the river attract Black-crowned Night-Herons, Marsh Wrens, and other wetland species. In the summer months, this park has a robust population of Bullock's and Orchard Orioles. During both fall and spring migration, many interesting migrants have been found here. If a trip through the area takes you past this park, it can be a productive birding stop. The entrance is about eight miles northeast of Liberal, marked by a small sign on the north side of the highway. To reach Arkalon from Meade State Lake, proceed west for fifteen miles on Meade County V Road to the intersection with U.S. 54, then proceed southwest for about three miles on U.S. 54. After the highway crosses the river, proceed west for one more mile, where a sign marks the entrance to the park and adjacent golf course. Several maintained nature trails in the park wind through the undeveloped areas of the park, and all can produce good birds.

Clark State Fishing Lake

Clark State Fishing Lake is an oasis of water and woodlands on the high plains. This lake, and the surrounding property, is one of the jewels of Kansas public lands. It lies in an impressive canyon formed by Bluff Creek.

The bird life here is similar to that at Meade State Park, with a slightly more eastern influence. Because Clark State Fishing Lake is substantially deeper than Meade, it attracts more species of diving ducks as well as other species such as cormorants, pelicans, loons, grebes, gulls, terns, and Osprey. During the winter, some waterfowl remain as long as the lake is unfrozen. Park roads provide access to the entire lake. The road on the eastern rim of the canyon offers an exceptional view of the lake. In addition to typical birds of summer, listen for Rock Wrens singing from the canyon rim and Common Poorwills calling just after dusk. Eastern Bluebirds are present year-round and are joined by Mountain Bluebirds during some winters.

Below the dam is an area of open woodland dominated by cottonwoods, which is usually worth the short time it takes to check for birds. At the upper end of the lake is an extensive stand of dense woodland. Follow the park road along the east side of the lake to its terminus to reach the entrance to a nature trail that traverses this woodland.

To reach Clark State Fishing Lake from U.S. 54, turn south at the town of Kingsdown onto K-94 and proceed for ten miles to the lake entrance. The road abruptly descends into the deep canyon.

Fort Riley

Fort Riley was one of the original forts on the Kansas frontier during the nineteenth century and is still a major army post. Because it was established so early

in the settlement period, portions of the fort have remained mostly undisturbed for over 150 years. The forest here is climax hardwood forest that seems as though it should belong much farther east. While much of the post is off-limits to the general public, several areas are open to birders. The most notable of these is known as the Pet Cemetery trail. A morning hike on this trail during June when the nesting birds are in full song is a rewarding experience.

Summer breeding species include Yellow-throated Vireo, Black-and-white Warbler, Kentucky Warbler, Summer Tanager, and Scarlet Tanager. Birding is exceptional during the spring migration in late April and May. Trips in late summer and early fall also typically produce a good list of migrants.

You must have a valid driver's license, vehicle registration, and proof of automobile insurance to gain access to the fort. As you enter Fort Riley from the east, via Ogden, you are on Huebner Road. Huebner Road traverses the fort, exiting at the bridge across the Republican River at the point where the river joins the Smoky Hill to form the Kansas River. Huebner Road becomes Grant Avenue on the northeast corner of Junction City. The Pet Cemetery trail is located directly north of the west end of the Fort Riley Cemetery, located on Huebner Road just west of what is known locally as "Main Post." Take the short drive north from Huebner Road and park in the small parking lot on the south side of the pet cemetery. Walk on the road around to the back and off to the right. After a short climb up the hill, you will see that the trail divides into three narrower footpaths. The one to the left is the longest and goes through some of the best birding areas. After about one mile, it eventually ends at Moon Lake. The middle trail goes straight up the side of the hill and ends at the Outdoor Chapel, where there is a panoramic view of the three river valleys. The trail on the right is a longer, gentler ascent to the same Outdoor Chapel area.

There are several other productive birding areas in the Junction City area. The **Highland Cemetery** in southeastern Junction City has produced many interesting birds over the years. It is an especially good location for invasive winter species such as Red-breasted Nuthatch, Townsend's Solitaire, Red Crossbill, and Pine Siskin. It is also worth checking during spring and fall migration, when a variety of migrants can be observed. The cemetery entrance is on Ash Street, just west of the intersection of Ash Street and Webster Avenue. The eastern edge of the cemetery usually offers the most productive birding. Nearby **Milford Reservoir** is one of the best reservoirs for birding in Kansas. Loons, grebes, waterfowl, and Bald Eagles are all possible during migration and throughout the winter months. Two exceptional areas at Milford are the spring-fed wetland below the dam, which is located near the Milford Nature Center and Milford Fish Hatchery, and the Milford Lake Wetlands north of the K-82 causeway, immediately east of Wakefield at the upper end of the reservoir.

Lyon State Fishing Lake

Lyon State Fishing Lake is a small lake in the heart of the Flint Hills north of Emporia. Two species, the Long-eared Owl and the Smith's Longspur, draw birders here each year. On the south side of the lake is a substantial stand of eastern red cedar trees, which in most winters has at least a few roosting Long-eared Owls. In some years several dozen owls spend the winter here. Carefully peer into the trees and look for the owls perched close to the tree trunks, often stretched vertically to camouflage themselves. Avoid disturbing the owls, which could cause them to abandon the roost entirely. At dusk, they can be seen leaving the roost to hunt in the surrounding area.

While Smith's Longspurs are relatively common throughout the Flint Hills in winter, the private ownership of land in the region makes it difficult for birders to get to areas where they can see these unique sparrows. Just south of Lyon State Fishing Lake is a large tract of prairie that is usually mowed in late summer, leaving it short for the winter months. Smith's Longspurs are almost always present in this field. The pasture is privately owned, making it necessary to remain on the road and wait for the often restless longspur flocks to take flight. Listen for their rattling calls and check flying birds for the small but obvious white wing patches and buffy underparts. Sprague's Pipits are regular in April and October in these same fields but are almost impossible to find without walking the hay fields.

Short-eared Owls are often seen near the lake at dawn and dusk during the winter. In the spring, booming Greater Prairie-Chickens are usually present somewhere in the area surrounding the lake. Drive rural roads slowly while listening for them at dawn in late March and April, especially when the winds are light and there is no precipitation. The cedars and brush thickets surrounding the lake attract Sharp-shinned and Cooper's Hawks, Golden-crowned Kinglets, Yellow-rumped Warblers, several species of sparrows, and other species during the winter. Bell's Vireos and Eastern Towhees nest in these thickets during the summer. The lake itself usually has a good selection of waterfowl in spring and fall.

To reach Lyon State Fishing Lake, go north from Emporia on K-99 for eleven miles to the junction with K-170, then east on K-170 for two miles, where there is a sign for the lake. Follow the gravel road north (passing the hay fields on both sides) to reach the lake. After birding the lake, you might wish to visit nearby **Melvern Reservoir**. To reach Melvern, continue east on K-170 for another thirteen miles, where a sign directs you south to Melvern's Sundance Area, which has a considerable variety of habitats, especially weedy areas that attract large mixed-species flocks of sparrows. During drought years, there are substantial mudflats at Sundance, which attract numerous shorebirds. After birding Sundance, continue east for eight miles on Osage County W. 329th Street to the junction with U.S. 75, continuing east for two miles to Melvern Dam. Below the dam is a sizable

lake in the camping area, which often attracts an excellent variety of waterfowl, loons, grebes, gulls, and terns.

Red Hills

The Red Hills are a scenic area of rugged, colorful country located mostly in Barber and Comanche counties along the Oklahoma border in south-central Kansas. The habitat consists of extensive mixed-grass prairies interspersed with dramatic buttes and ravines, which shelter extensive stands of eastern red cedar and other trees. The Salt Fork and Medicine rivers and their tributaries have mature woodland along their banks. Despite the absence of public land, the mostly unspoiled countryside and limited traffic in this sparsely populated country make an auto tour highly worthwhile. Regardless of the season, a diverse variety of birds can be expected on a trip to this beautiful area.

An interesting mixture of eastern and western birds is found in the Red Hills. Several eastern woodland species such as Carolina Wren, Tufted Titmouse, and Blue-gray Gnatcatcher reach the western edge of their range in Kansas. In contrast, several western species reach their extreme eastern range limit. These include Lesser Prairie-Chicken, Rock Wren, and Cassin's Sparrow. The area also has a distinct southern influence, best characterized by the Greater Roadrunner, which is not found regularly anywhere else in Kansas, and a robust population of Painted Bunting during the summer. The Red Hills are renowned for attracting large flocks of Mountain Bluebirds in some winters; they are attracted by the substantial crop of cedar berries. Thousands can be seen in a single day during an auto tour taken during major invasion years, but totals in the hundreds are more typical. In years when the cedars fail to produce many berries, Mountain Bluebirds are extremely scarce or even absent.

For a rewarding auto tour that samples the varied habitats of the Red Hills, proceed west on U.S. 160 from the town of Medicine Lodge for four miles to the intersection with Gypsum Hill Road (paved). Go south on this road for eighteen miles, eventually reaching the intersection with Hackberry Road near the Oklahoma state line. Turn right and take Hackberry west for sixteen miles until you reach the intersection with Aetna Road. Proceed north on Aetna Road for approximately twenty miles until you again reach U.S. 160. Go east for one mile to Sun City Road. Turn north on Sun City Road and proceed for another eight miles to the small town of Sun City, where you might want to stop for a sandwich or a beverage at Buster's (a renowned local institution). From Sun City you can either return to Medicine Lodge on the River Road (paved) or, if you want to sample even more of this beautiful country, take the River Road northwest for another ten miles to the small town of Belvidere. Pay particular attention to the steep and narrow draws you encounter throughout this drive. These are most

effectively checked by getting out and observing on foot. Many of the roads on this route are gravel roads, and because of the composition of the soil, they are treacherous to drive if there has been recent rainfall or melting snow.

Slate Creek Wetlands and Chaplin Nature Center

The Slate Creek Wetlands are a patchwork of public and private lands located about ten miles south of the small town of Oxford in Sumner County. The KDWP land covers about four square miles. Adjacent privately held areas, mostly owned by hunting clubs, cover several additional square miles. Birding Slate Creek adequately requires some hiking, as most of the wetland areas are not close to roads. Although usually seen in smaller numbers, the expected bird species are much the same as those found at other Kansas wetlands. Watch for waterfowl, shorebirds, herons, rails, and other wetland species. Slate Creek is well known for producing a variety of sparrow species, particularly during October and November. Nelson's Sharp-tailed Sparrow is found here probably more regularly than at any other Kansas location. Several other less common sparrow species, such as Le Conte's and Swamp, are seen here each year in good numbers, often in association with Sedge and Marsh Wrens. During the winter, this is one of the most reliable locations for Short-eared Owls in south-central Kansas.

To reach one of the best spots, travel south from the town of Oxford for five miles on S. Oxford Road. At the intersection with 60th Street, turn right and go west for two miles to Greenwich Road, and then go south for one more mile. Here you will see an observation tower and a small parking area. Cross the gate and follow the road, which curves around one of the larger water impoundments, west on foot. When you reach the west side of the pool, and if it is October or November, be especially alert for Nelson's Sharp-tailed Sparrows in the taller patches of prairie cordgrass near the water's edge. You will usually find surprisingly large numbers of Le Conte's Sparrows on a hike at this time of year.

To visit one of the best areas on private land, return to Oxford Road and proceed south to 90th Street. Turn right and proceed west on the primitive road as far as you can go by car, then continue on foot. This road should be driven with extreme caution if there has been any recent rain. After you have gone down the slope into the lowland area, you reach an area with wetlands on both sides of the road, often including a good area of mudflats on the south side. The road itself is public, but the entire area on both sides of the road is privately owned. Please do not trespass in this area.

The nearby **Chaplin Nature Center** is reached by returning to Oxford Road and continuing south. The paved road curves east for one mile to the town of Geuda Springs, then continues south, now named Geuda Springs Road. Continue south from Geuda Springs on Geuda Springs Road for two miles, and then proceed east for three miles to the entrance. Located on the west bank of the

Arkansas River, Chaplin is owned and operated by the Wichita Audubon Society and preserves two hundred acres of natural habitats, which include bottomland forest, broad sandbars, and native prairies. An interpretive building offers additional information on the area. A staff naturalist lives on the grounds, and a number of programs are offered throughout the year. Over 225 species of birds have been observed on the property, including nesting Pileated Woodpecker, Chuck-will's-widow, Wood Thrush, and Summer Tanager. A wide variety of migrants occur in spring and fall. During the winter, Bald Eagles can usually be observed foraging along the Arkansas River.

Cross Timbers

The Cross Timbers is a unique hilly habitat of scattered upland oak forests interspersed with expanses of prairie. The predominant tree species are blackjack and post oak, which seem small in comparison with other species of oak. Because they grow in shallow, rocky soils, even trees that are hundreds of years old have trunks less than eighteen inches in diameter. This fragile, threatened habitat occurs in a patchy distribution that extends from southeastern Kansas through northeastern Texas. In Kansas, Cross Timbers habitat is found from Chautauqua County north to Woodson County. Several rivers, including the Caney, Elk, Fall, and Verdigris, flow through the region, and all have healthy tracts of riparian forest that attract many species of birds.

Year-round residents of the Cross Timbers include Wild Turkey, Greater Prairie-Chicken, Cooper's and Red-shouldered Hawks, Barred Owl, Red-headed and Pileated Woodpeckers, and numerous other species. During the summer, look for species such as Whip-poor-will; Chuck-will's-widow; White-eyed, Yellow-throated, and Red-eyed Vireos; Blue-gray Gnatcatcher; Wood Thrush; Louisiana Waterthrush; Black-and-White and Kentucky Warblers; Scarlet and Summer Tanagers; Blue Grosbeak; and Painted Bunting. In the winter months, several hawk species, Ruby-crowned and Golden-crowned Kinglets, Brown Creeper, Hermit Thrush (rare), and various sparrow species are present. During spring and fall, an excellent variety of eastern migrants can be expected.

Several locations offer opportunities to sample the birding in this unique habitat. Public lands at both the **Fall River** and **Toronto reservoirs** have substantial tracts of Cross Timber habitat within their boundaries. Be sure to hike the Ancient Oaks Trail on the north shore of Toronto Reservoir. The trail begins and ends at the small parking area located just outside the entrance to Cross Timbers State Park, about two miles south of the town of Toronto.

Woodson State Fishing Lake is relatively small but is widely considered to be the best single tract of public land for birding in the Cross Timbers region. A perimeter road encircles the lake, allowing easy exploration of the area. Be sure to check the woodlands below the dam, as the moist hardwood forest attracts birds

not found in the upland oak forest surrounding the lake. Woodson State Fishing Lake is reached by taking U.S. 54 west seven miles from the town of Yates Center, then traveling south on gravel roads for another five miles.

In Chautauqua County, there are no significant public lands, but several stretches of road allow an excellent opportunity to experience this beautiful country. **Chautauqua County Road 96**, between the tiny towns of Hewin and Elgin (marked by small and faded signs for the "Wee-kirk Trail"), is one of the most scenic drives in Kansas. It crosses the Caney River several times during this drive. Listen for Yellow-throated Warblers at these river crossings, as they have been found here several times in recent years, especially in April, when the males are singing. Another excellent drive is the winding road between the towns of Elk City and Sedan on **Chautauqua County Road 808**, where the White-eyed Vireo, Blue Grosbeak, and Painted Bunting are often observed.

Neosho Wildlife Area

This three-thousand-acre wetland is located just east of the town of St. Paul in Neosho County. It is the largest wetland in southeast Kansas. It is separated into three pools by levees and located in an old oxbow of the Neosho River. The extensive water lotus and partially submerged dead trees combine with other geographical dynamics to make it vaguely reminiscent of a southern swampland. You almost expect an alligator to swim by, but the closest you will come is a glimpse of the numerous long-nosed and short-nosed gar that inhabit the lake. A perimeter road encircles the wetland and lake area and is bordered by riparian woodland along the Neosho River.

Like other Kansas wetlands, Neosho harbors large mixed flocks of waterfowl in early spring and late fall. Substantial numbers remain through the winter, as long as water remains open. Shorebird habitat is more limited than at other Kansas wetlands, but small numbers of shorebirds can always be found during migration, and they can be numerous when favorable habitat conditions exist. The north end of the refuge is dominated by wetland grasses, including prairie cordgrass. In the fall and winter, this is a good place to look for wetland sparrows such as Swamp and Le Conte's among the more numerous sparrow species. Rusty Blackbirds are increasingly rare in Kansas, but Neosho still has a wintering population from November through March in most years. In summer, look for Wood Duck; Snowy, Great, and Cattle Egrets; both species of Night-Herons; and other wading birds. A large colony of nesting Tree Swallows inhabits the dead trees in the southern pool. The woodlands on the west and south sides of the wetland harbor Red-shouldered Hawk, Barred Owl, Pileated Woodpecker, and other typical species of the eastern woodlands year-round. Summer residents include Acadian Flycatcher, Yellow-throated Vireo, Prothonotary Warbler, Northern Parula, and Summer Tanager.

To reach Neosho Wildlife Area, proceed east from the town of St. Paul on K-57 for one mile. The entrance is on the south side of the highway, and the perimeter road begins there. After birding the refuge, you may wish to check a nearby site along the Neosho River for woodland species. On the edge of St. Paul, just east of the rest area, a dirt road leads south to the river, where it dead-ends where a bridge once stood. This is an excellent site for all of the woodland species listed above.

Schermerhorn Park

The heavily forested Ozark Plateau barely grazes the southeastern corner of Kansas in portions of Cherokee County. Schermerhorn Park, located along Shoal Creek near the town of Galena, is a superb birding location in this unique area.

During April and May, the park is one of the best places in Kansas to observe migratory eastern songbirds such as flycatchers, vireos, thrushes, and warblers. During spring migration, over twenty species of warbler have been seen in a single day. Summer residents include four species of vireos and at least ten warbler species. This is a reliable location for Yellow-throated Warblers, which nest here annually. Listen for the nasal caws of Fish Crows along Shoal Creek. Winter birds are typical of eastern Kansas woodlands, often including Purple Finches.

To reach the park, take K-26 south out of Galena for 1.5 miles. The park entrance is on the east side of the highway, just north of the bridge over Shoal Creek. Park your vehicle and explore both the area along the creek and the upland forests on the bluffs above. The Southeast Kansas Nature Center is located in the park. Exhibits of animals and plants native to the area are displayed throughout the center. Environmental education classes and workshops are offered each month. The adjoining park grounds, trails, and creek make a perfect setting for birding. A large observation window offers excellent views of water features designed to attract birds. Visitors are usually pleasantly surprised with the wide variety of activities and materials available.

Several other areas in Cherokee County offer good birding opportunities. Located two miles west of Galena, **Empire Lake** is a good place to look for waterfowl, grebes, gulls, and other waterbirds as well as terrestrial species in the adjacent woodlands. The area near the Boater's Clubhouse on the east shore offers a good vantage point for the lake. The wastewater treatment ponds just east of the nearby town of **Baxter Springs** on the south side of U.S. 166 attract many species of waterfowl during migration and through the winter. The **Mined Land Wildlife Area** is a 14,500-acre tract of land that was heavily strip-mined in the early twentieth century. Now owned by the Kansas Department of Wildlife and Parks, it sprawls over a broad area about twenty-five miles northwest of Galena and Baxter Springs. Its mix of grasslands, woodlands, and brushy areas ensures an interesting list of birds regardless of the season.

Fort Leavenworth and Weston Bend

Located in northeast Kansas near the city of Leavenworth, Fort Leavenworth lies on the west bank of the Missouri River. The Weston Bend of the river curves east and south around the fort and preserves the largest surviving tract of old-growth bottomland forest on the lower Missouri. This 5,900-acre Military Reservation includes the 2,500-acre Weston Bend Bottomlands, considered by many to be the foremost site for viewing migratory warblers and other neotropical songbirds in Kansas. It also harbors breeding populations of several woodland species that are rare nesting species elsewhere in Kansas.

The abundance and diversity of these songbird species make a trip during early May an exceptionally rewarding experience. When a "fallout" event occurs during the peak of migration in the first two weeks of May, twenty or more species of warblers can be seen. Many Kansas birders are amazed at the sheer numbers of colorful migratory species, such as Rose-breasted Grosbeak, Eastern Towhee, and Scarlet Tanager, which can sometimes be seen in the dozens, as opposed to the individuals that are the norm in most of the state.

The oldest trees date to the time of Lewis and Clark, and in this forest dominated by oak, sycamore, and pecan is found the largest nesting population of Yellow-throated Warblers in Kansas. Also be alert for the Cerulean Warbler, which is rare but nests regularly in these bottomlands. Other noteworthy nesting species include American Redstart and Scarlet Tanager. Broad-winged Hawk and Ovenbird are rare nesting species in the upland forests. In addition to the forest habitats, a number of sloughs, wetlands, and weedy fields contribute greatly to the diversity of bird life at Weston Bend. Listen for displaying American Woodcocks near the small lake at the beginning of the Taildike Trail. Look for Sedge Wrens and an excellent variety of sparrows in the wet fields and sloughs, especially during fall migration.

To reach the Weston Bend Bottomlands, take Metropolitan Avenue (U.S. 73) to the entrance of Fort Leavenworth at 7th Street. You will need a photo ID to enter the base, and vehicles are subject to search. After passing through the main entrance, continue north on Grant Avenue, following road signs directing you to the Sherman Army Airfield. Approximately two miles from the entrance, Grant Avenue turns to the west in front of the now abandoned U.S. Disciplinary Barracks (USDB). Continue past the USDB and turn right (north) onto Bluntville Street, a road that follows the west wall of the old prison facility. Bluntville Street merges onto McClellan Avenue, which takes you to the airfield. At the airfield, cross the railroad tracks and turn left, setting your odometer to zero, to access the levee road known as Chief Joseph Loop. Several unimproved roads and foot trails lead into the forest from the levee; the most well known and longest, the Taildike Trail, is at the 2.6-mile point, where the levee road meets the Missouri River. This trail follows the riverbank around the perimeter of the entire Weston Bend.

This bottomland area, and areas of the upland woods, are active hunting areas from September through January. Those entering the woods on foot at this time of the year must wear the specified blaze-orange clothing and hat, and many birders prefer to simply remain on the levee roads during these months.

A starting point for a tour of the upland forest habitats begins at the intersection of McClellan Avenue and Sheridan Drive. This is the intersection across the railroad tracks from the airfield buildings and control tower. Proceed up the hill on Sheridan Drive, going northwest, resetting your odometer to zero. The first stop is the Military Prison Cemetery at 0.2, which has a small parking area. The second stop is the Fort DeCavagnial Picnic Area at 0.8, which has ample parking. These two areas, and the roadside between them, are excellent, easy-access birding spots.

Back on Sheridan, at 2.2 miles turn left down the hill onto McPherson Avenue. At 2.7 miles, past the Fort Leavenworth Hunt, turn left (north) onto a gravel road marked with a sign for Camp Miles, Boy Scouts of America. Follow this loop road for access to roadside birding and various hiking and horseback trails. A prime departure point is where the gravel road takes a hard left up the hill. There is a sign here that marks the Heritage Trail, one of several signs for this trail. Several hiking and horseback trails depart from here in various directions. Be sure to get your bearings in these deep woods and explore. Up the hill on the gravel road 0.1 mile farther is a clearing in the woods used by the Boy Scouts. This is another excellent place with easy access to explore and to take various trails.

As you continue on the gravel road, the loop takes you back to McPherson Avenue. From here you can turn left to take you back to the main area of the fort, or you can turn right to retrace your path back to Sheridan Avenue.

Located across the river on the tall bluffs on the Missouri side, and therefore technically outside the purview of this book, is Missouri's **Weston Bend State Park**. Most birders familiar with the area include this park as part of any visit to the area. If your schedule allows it, this top-notch birding site of upland forest habitats should be visited as well, as it has habitats and bird species that are scarce or absent in the lowland forests found on the Kansas side of the river. It can be reached by crossing the Missouri River on Metropolitan Avenue and continuing north on Highway 92 to Highway 45. Take Highway 45 north to the park entrance in 1.5 miles. Shortly after passing the entrance station, turn left into the parking lot for the hike/bike trail. A three-mile loop trail begins and ends at this parking lot. Walking the entire length of this trail in May can produce an exceptional list of warblers and other migrant songbirds.

Baker Wetland

The Baker Wetland on the southern edge of Lawrence is the best-known publicly accessible wetland in northeastern Kansas, where marsh habitats are scarce. Its

573 acres are owned and managed by Baker University. The broad mudflats of central Kansas wetlands such as Quivira and Cheyenne Bottoms are mostly absent, replaced by low-lying grassy areas that are wet for much of the year. In late summer or during times of drought, the marsh can be nearly dry.

An impressive 246 species of birds have been observed in this area of less than one square mile. Waterfowl, herons, and shorebirds are seen from early spring through late fall. Specialties of the area include American Bittern, Least Bittern (rare), Yellow-crowned Night-Heron, Sora, Virginia Rail, Sedge Wren, Marsh Wren, Swamp Sparrow, Le Conte's Sparrow, and Nelson's Sharp-tailed Sparrow (rare). Fifteen or more sparrow species can be seen on favorable days in spring and fall.

The marsh is bisected by two perpendicular dike roads, which divide the wetland into quadrants. There are additional trails around the perimeter, except on the east side of the property. There are two access points to Baker. On the north edge of the marsh, there is a parking area on 31st Street, located halfway between Haskell and Louisiana Streets. Here you will find a kiosk with a map of the wetland and other useful information. The wooded area around the north parking lot is often a good spot for warblers and other passerines in both spring and fall. On the east edge, there is a smaller parking area at the intersection of 35th Street and Haskell. Cross the gate at either entrance and slowly walk along the dike roads into the marsh. Look carefully for rails at the edges of dense vegetation bordering open water. In the northeast quadrant is a large nesting box on poles that has been used by Barn Owls for many years. The southwest quadrant has traditionally been the best area for Le Conte's and Nelson's Sharp-tailed Sparrows. Look for them in October and early November. Adjoining the marsh on the south is riparian woodland bordering the Wakarusa River.

Marais des Cygnes Wildlife Area and
Marais des Cygnes National Wildlife Refuge

These federal and state-owned properties adjoin each other and together cover nearly fifteen thousand acres of prairie, mature deciduous woodland, wetlands, and a variety of transitional habitats. There are arguably more ideal examples of each of these habitats in Kansas, but no other single site in Kansas can compare in terms of the overall habitat diversity that exists at Marais des Cygnes. A full day spent birding here at any time of the year will produce an impressive list of grassland, wetland, and woodland species.

Three hundred twenty-one species of birds have been identified on the refuge, and 117 of these have been documented as nesting species. During early spring and late fall, concentrations of waterfowl often number in the tens of thousands, including most of the species of ducks and geese included in this book. Many

of these remain through the winter months, along with good numbers of Bald Eagles and other raptors. Shorebirds are another attraction when one or more of the pools are drawn down, creating extensive mudflat habitat. The hardwood forest at Marais des Cygnes is renowned for attracting many species of migrating flycatchers, vireos, thrushes, warblers, tanagers, and sparrows. Over thirty species of warblers have been found here. Several wet meadows add to the mix of habitats and often produce Sedge Wren, Le Conte's Sparrow, Henslow's Sparrow, and other species of the marshy prairies. Nesting species include a number of warblers, including Yellow-throated, Cerulean (rare), Kentucky, Black-and-White, and American Redstart. Other summer species include American Woodcock, Whip-poor-will, Chuck-will's-widow, White-eyed and Yellow-throated Vireos, and Summer and Scarlet Tanagers.

The KDWP headquarters is located about five miles north of Pleasanton on U.S. 69. About two miles south of the KDWP headquarters, there are water impoundments on both sides of the highway, where a variety of birds can be observed with ease from the shoulder of the road. One mile south of the KDWP headquarters, just south of the bridge over the Marais des Cygnes River, turn west onto a winding gravel road that travels along the edge of Unit A (the largest conservation pool), dead-ending after one mile. One of the most popular areas on the refuge is reached by turning west onto E. 1700 Road just north of the refuge headquarters until the railroad tracks are reached. Before crossing the railroad tracks, turn north onto the road that runs below a steep wooded slope parallel to the river. Parking and walking somewhere along this segment of road is highly recommended. For the next mile, it leads through excellent-quality hardwood forest, emerging at another large pool of the wildlife area, Unit G. Unit G is encircled by a perimeter road. Another road popular with birders is reached by going north from the KDWP headquarters for 1.5 miles to a corner where there is a small cemetery. Turn west at this corner and drive west for about a mile to a prominent gas-pipeline control structure on the south side of the road. This is another good place to walk around, looking and listening for birds. The land here is privately owned, so do not leave the road. As you continue west, the forest becomes progressively more mature. When it reaches the T intersection, turn south and follow this road as it zigzags south and west to Boicourt.

Two nearby sites in Linn County are also excellent birding destinations. About fifteen miles southwest of Pleasanton, the **Dingus Natural Area**, located near Mound City, preserves a superb tract of old hardwood forest. It is owned by the Kansas Ornithological Society, and birders are welcome to wander the 167-acre area freely, although there are no trails or other amenities. To reach the Dingus Natural area from Mound City, proceed south on K-52 for one mile and turn right onto W750 Road. Go west one mile to the T intersection and proceed left

up a steep hill to Lewis Road. Turn right on Lewis Road and follow it as it curves left to become W750 Road again. Continue for one mile. After crossing under a high-voltage line, you will see a sign marking the area on your right.

La Cygne Lake is another good birding area located close to Marais des Cygnes. The large lake attracts waterfowl, grebes, loons, gulls, and other water-birds. **Linn County Park**, located on the west side of the lake, has significant areas of brushy woodland habitats. To reach Linn County Park, take the La Cygne exit on U.S. 69 and follow the sign to the entrance about two miles north. Wrapped around the east and north sides of the lake is the **La Cygne Wildlife Area**. To reach the east shore area, proceed east from the La Cygne exit. Cross the dam and turn north at the first intersection. Go two miles north and then back west for a mile to a parking area. The north end of the lake is a productive birding loca-tion, especially along W399 Road and Rockville Road. The entire area surround-ing this lake is one of the best places in Kansas to observe displaying American Woodcocks during the spring.

Wichita Area

Birding locations in the Wichita area are numerous. Discussed here are a few of the most popular ones. Because of its habitat diversity, one of the best birding sites in the city is **Chisholm Creek Park**. Habitats in the park include tallgrass prairie, riparian woodlands, hedgerows, ponds, and a small wetland. The Great Plains Nature Center, located at 6232 E. 29th Street North, provides access to the east end of the park and has well-designed interpretive exhibits relating to Kansas wildlife. The park has several miles of paved trails. This is an excellent lo-cation to find migrants in both spring and fall. Over two hundred species of birds have been recorded here, including twenty-eight species of warblers and twenty species of sparrows. A boardwalk over the wetland area is a good place to look for elusive wetland birds such as Sora, Virginia Rail, Least Bittern, and Marsh Wren. In the fall, the extensive thickets of dogwood throughout the park are attractive to a variety of migratory warblers, vireos, and other songbirds.

Located in central Wichita, **Maple Grove Cemetery** has some of the largest coniferous trees found in Wichita, many of which are over one hundred years old. This is an outstanding birding spot, particularly during fall migration and the winter months. The entrance is on the east side of Hillside Avenue, just north of the stoplight for 9th Street. This is the most reliable place in Wichita to find Townsend's Solitaire during the winter. During invasion years, species such as Red-breasted Nuthatch and Red Crossbill are often seen.

Oak Park preserves the oldest mature hardwood forest in the Wichita area and has long been regarded as the best single place to find migrating warblers and other woodland songbirds in Wichita. Thirty-five species of warblers have been seen in this small park. During the first half of May, many local birders make a

morning walk in the woods part of their daily routine. Oak Park is located north of downtown Wichita in the Riverside neighborhood. From the corner of 13th Street North and Waco Street, go south two blocks to 11th Street, then proceed eight blocks west to the park. Park on 11th and explore the woods using the network of footpaths.

Sedgwick County Park is a large, sprawling park located just west of the Sedgwick County Zoo. There are entrances on 21st Street North and 13th Street North, both located about a quarter mile east of Ridge Road. The best area for birding is along Big Slough Creek at the western edge of the park. There are extensive stands of cattail along the creek, which usually have Black-crowned Night-Herons, egrets, and Common Yellowthroats in the summer months. In the winter, this is a good place to look for Wilson's Snipe, Virginia Rail, Marsh Wren, and Swamp Sparrow. The small lakes in the park usually have a good selection of waterfowl from fall through spring.

Located at the northwest edge of Wichita is an extensive sandpit that covers over 150 acres. Informally known among birders as the **LaFarge Sandpit**, it is owned by the adjacent LaFarge Company, which manufactures cement. This large and deep body of water is the best place in the immediate vicinity of Wichita to view waterfowl and other aquatic species of birds. From the West Street exit on K-96, go 1.5 miles south to the intersection with 29th Street. Turn west on 29th and park where you can see a good portion of the lake. The lake is fenced and posted, and a spotting scope is needed to identify birds that are on the far side of the lake. During the summer, the lake is usually devoid of birds, but from October through May, it attracts a wide variety of species. The best time to bird here is the hour before dusk, when waterfowl and gulls return to the lake for the night after foraging elsewhere during the day. Because the water is so deep, it remains open in winter when all other bodies of water in the area have frozen, including nearby Cheney Reservoir. When this is the case, the birding here can be lively.

Topeka Area

Several Topeka areas offer excellent birding opportunities. Peregrine Falcons have nested on high-rise buildings in the downtown area several times. Both Clinton and Perry Reservoirs are less than thirty minutes away and offer rewarding birding, especially from fall through spring. A few Bald Eagles nest at both lakes, and they are numerous in the winter months at these impoundments.

Felker Park, located in central Topeka at 2560 SW Gage, is the most popular destination for local birders. The park has a good stretch of riparian timber and areas of grasslands and wetlands. Over 135 species of birds have been recorded at this location. It is especially popular at the peak of warbler migration during the first half of May and during the southward migration in late August and early

September. Summer and winter birds are typical of eastern Kansas. To reach the park from I-470, take Exit 4 and proceed north on SW Gage Avenue. After a slight curve in the road, proceed for three more blocks to the park entrance and parking lot on the east side of the street. The best habitat is found along the Orville Rice Nature Trail, which winds along Shunga Creek on the south side of the park.

Located at the southeast edge of Topeka at 3131 SE 29th Street, **Lake Shawnee** has produced over 180 species of birds. The lake covers 410 acres and is surrounded by public recreation lands administered by Shawnee County. It is the best location in the immediate Topeka area to observe waterfowl, loons, grebes, and shorebirds. Migratory songbirds are often seen on the grounds as well. There are access roads along the eastern and western shores, from which you can scan the lake for waterbirds. At the north end of the lake along the west side you can park in the dam overlook and walk down to the overflow to search for shorebirds. The gazebo "point" at the lake has long been an exceptional area for attracting migrating warblers and other passerines in May and also offers a good vantage point from which to scan the lake for birds. To reach the gazebo area, turn north from 45th Street onto the road that parallels the west side of the lake. Park west of the first large shelter house on the right, and walk north. After a couple hundred yards, you will reach the gazebo. The entire area around the gazebo and shelter house produces good birding. Be sure to check the big oak trees in the middle of the point.

Located just a few blocks from Lake Shawnee at the southeast corner of 25th Street and Highland Street is **Dornwood Park**, which preserves 110 acres of mature forest, riparian woodland, and prairie. These habitats can be sampled along several nature trails. This is another popular birding area during the peak of spring migration in May, when many species of vireos, thrushes, warblers, tanagers, and sparrows can be seen. Cooper's Hawks have nested in the park several times.

Shawnee State Fishing Lake, located northwest of Topeka, offers a more rural atmosphere. The public land covers 640 acres, which includes a substantial area of tallgrass prairie, especially on the west side of the lake. The marshy area below the dam is a productive birding area in October and November for species such as Marsh Wren, Le Conte's Sparrow, and Swamp Sparrow. In spring and fall, the lake attracts migrating waterfowl, loons, grebes, gulls, and shorebirds. During the summer months, there are numerous Dickcissels, Grasshopper Sparrows, and other grassland species. Listen for singing Sedge Wrens, which are sometimes found in good numbers during August. Henslow's Sparrow has nested on private land just south of the public land several times. On the north end of the lake is an area of riparian woodland that is worth checking. To reach the lake from Topeka, take U.S. 75 north to 62nd Street, then go west three miles to Landon Road, then north two miles to 86th Street, then west one mile to the lake entrance.

Kansas City Area

Kansas City and the surrounding metro area sprawl over an area of several counties. Despite extensive urbanization, a number of outstanding birding areas are available. Because it is located on the Missouri border, the local bird life is decidedly eastern in composition.

The **Overland Park Arboretum** occupies three hundred acres and is located southwest of the intersection of 179th Street and Antioch Road in Overland Park. The riparian habitat in the park along Wolf Creek is some of the best available in the Kansas City metro area. The majority of the property is devoted to maintaining natural ecosystems, which include steep limestone bluffs, native prairies, and hardwood forests. Over five miles of wood-chipped trails allow easy access to the arboretum property. This is an excellent site for observing migratory songbirds in both spring and fall. Nesting species include Pileated Woodpecker, Kentucky Warbler, and Northern Parula. During the winter months, bird feeders at the park are always filled and attract many birds, often including Purple Finches. To reach the arboretum, go south on U.S. 69 from Overland Park. Exit at 179th Street and proceed west approximately one mile to the Arboretum entrance on your left (south). The arboretum is not open until 8:00 A.M., so early-morning birders should start their day elsewhere.

Shawnee Mission Park is administered by Johnson County Parks and Recreation. Together with the adjoining Mill Creek Streamway, this 1,250-acre site offers the greatest habitat diversity of any single site in the Kansas City area, including a large lake, extensive upland and riparian woodland, prairie grassland, and marshy wetlands. One local birder has recorded 215 species of birds at this park. The lake attracts loons, grebes, waterfowl, Osprey, Bald Eagle, shorebirds, and a variety of gulls and terns, according to the season. The woodlands and prairies attract impressive numbers of migratory thrushes, vireos, warblers, and other songbirds in spring and fall. In winter and summer, a trip to this park will produce most of the expected bird species of eastern Kansas. The general area below the dam is one of the most productive birding areas in the park and is a reliable location to observe displaying American Woodcocks on calm evenings in March. The observation tower in the southwest corner of the park offers a good overview of the area. To reach the park, take the 87th Street exit from I-435, go west for a short distance to Renner Road, then north on Renner to the main entrance at 79th Street. A perimeter road encircles the lake, as do hiking trails. In the upland forest north of the dam are numerous hiking trails. The lake can be easily viewed from the dam and also from the boat ramp on the north side of the lake.

Adjoining Shawnee Mission Park on the west is the **Mill Creek Streamway Park**, which is a narrow band of public land extending for seventeen miles along Mill Creek between the city of Olathe on the south, and the Kansas River at Nelson Island on the north. The streamway is mostly riparian habitat along most

of its length, but the loop below the dam at Shawnee Mission Park has some excellent meadow habitat, where an excellent variety of sparrows can be found, especially during October and November. Several other segments of the Mill Creek Streamway are favored by local birders. The **Midland Drive** access point is in Shawnee, west of I-435 at Shawnee Mission Parkway and Midland Drive. From the parking lot, walk the asphalt trail to the west along Little Mill Creek, then cross the footbridge and follow the trail south into the upland forest. Follow the trail as long as time allows, then retrace your steps back to your car. The riparian areas along the creek and the trail into the woods can be excellent in spring, fall, and summer. Reach the **Wilder Road** access point in Shawnee by taking Holliday Drive west from I-435 and following the signs. From the parking lot, walk the asphalt trail along Mill Creek toward the Kansas River. The terminus of the Mill Creek Streamway Trail is a loop trail at Nelson Island through prime Kansas River floodplain forest.

The **Ernie Miller Park and Nature Center** is small at 114 acres, but it is popular with local birders. The park consists mostly of upland and riparian woodland, but there are also some grassland and transitional habitats. A nature center on the grounds includes bird feeders and a water feature that can be viewed from indoors. There are three miles of nature trails. This park is most noteworthy for producing a number of warblers during spring migration, but it offers good birding throughout the year. The entrance to the nature center is located west of K-7 Highway approximately one mile north of the intersection of K-7 and Santa Fe Street in Olathe.

Shorebird habitat is difficult to find in northeast Kansas. Located just west of the town of Gardner, the KCP&L Wetland Park, known informally as the **Gardner Wetlands**, has provided Kansas City birders with an accessible location for shorebirds and other wetland species during spring and fall migration. A number of shorebird species have been observed here that had not previously been recorded in Johnson County, including Hudsonian and Marbled Godwits, Dunlin, and others. Other interesting species recorded here have included American Bittern, Sora, and Least Tern. This site was developed by the Kansas City Power and Light Company. To reach the Gardner Wetlands, go west from Gardner on U.S. 56 and turn south onto Waverly Road. The wetlands are on your left (east) after you cross the first set of railroad tracks. There is a viewing blind along the perimeter trail. The best viewing of this area is from the east-west levee between the two main pools.

Large Reservoirs

Located throughout eastern and central Kansas are many large reservoirs that provide good birding opportunities. Most of these were constructed in the 1960s and 1970s for irrigation, flood control, and municipal water supplies. The cre-

ation of these large lakes where none had existed before brought many changes to the birdlife of Kansas. Many bird species that were rare before the 1960s are now found much more frequently. Kansas ranks among the lowest of the fifty states in terms of public land ownership when calculated as a percentage of total land area, so collectively, the reservoirs are an invaluable resource of public lands for birding and other outdoor activities. Since so much of Kansas is cultivated, the areas of native habitat adjacent to the large reservoirs serve as oases for birds and other wildlife amid the vast crop monocultures that cover most of the state.

The strategy for birding at these impoundments is generally the same, regardless of which area you are visiting. Most of them have a road or foot access atop the dam, which provides a panoramic view of the lake. Typically there is a developed park area along one or both shores in the area nearest to the dam, which offers additional vantage points to scan the lake for birds. The upper ends of the lakes usually have places for shoreline access. These less-developed areas of the reservoirs usually are allowed to revert to native habitats and are attractive to game birds, raptors, songbirds, and other birds, making a visit to them at any season of the year worthwhile. Most of the lakes have maps and other information available at the headquarters, usually located in the vicinity of the dam.

These reservoirs are most popular with birders from late fall through early spring, when they attract the greatest diversity of birds. Late October through November are the most exciting times to visit because of the many species of loons, grebes, waterfowl, gulls, and terns that can be found. Flocks of Franklin's Gulls often number in the tens of thousands or even hundreds of thousands at this time of the year. During the winter, many of the reservoirs freeze over for only a few weeks, if at all, and continue to attract many birds as long as open water is available. In spring, migrants occur from late February through May. Recreational use of the lakes by boaters, fishermen, and campers is greatest from May through September, but the less-used upper ends of the lakes often continue to attract interesting birds. Space prohibits a complete or comprehensive discussion of all the reservoirs, but a few deserve special mention.

In northeastern Kansas, **Clinton Reservoir**, located just west of Lawrence, is one of the most frequently visited lakes. The Wakarusa Causeway on the west side is a good place to see a diverse list of birds, including nesting Bald Eagles and Painted Buntings in the summer. The Bloomington Beach area often attracts interesting shorebirds, gulls, and terns. Located conveniently close to both Lawrence and Topeka, **Perry Reservoir** offers good birding from the Rock Creek arm of the lake and has several good wetland areas on its perimeter, including the Lassiter, Ferguson, and Kyle marshes. **Hillsdale Reservoir** is relatively close to the Kansas City area. The areas at Hillsdale most often visited by birders are the Big Bull Creek arm of the lake, the Little Bull Creek arm, and the Antioch Marsh located on the west side of the lake. Hillsdale has hosted nesting Bald Eagles.

In the Flint Hills region, Melvern Reservoir and John Redmond Reservoir are the lakes most visited by birders. (See the discussion of Lyon State Fishing Lake for more information on Melvern.) **John Redmond** is a popular birding destination. The upper end of the lake is part of the Flint Hills National Wildlife Refuge. At the upper end of the lake is an extensive wetland area, located on 20th Road three miles east of the town of Hartford. The spillway below the dam usually has a number of birds present, feeding on stunned fish at the water outlet. Also below the dam is a small wetland, which attracts waterfowl and shorebirds, as well as a nice stand of hardwood timber where woodland birds can be observed.

Tuttle Creek Reservoir, located just northeast of Manhattan, is long and narrow, with many miles of shoreline. The outlet area is often a good birding stop, especially when a major release of water is taking place, as birds gather to forage for stunned fish below the outlet tubes. The River Pond State Park area below the dam is generally considered to be the best birding site at Tuttle and is a good place to see Bald Eagles during the winter. Farther up the lake, the Carnahan Cove and Stockdale Point areas are popular birding destinations.

Cheney Reservoir, located about twenty-five miles west of Wichita, has excellent habitat for passerines at the DeWeese Park area (look for nesting Rose-breasted Grosbeaks here in early summer), and the Spring Creek Nature Trail adjacent to the Smarsh Campground is a surprisingly good birding spot in spite of its small size. The Red Bluff area on the east side of the lake is closed during the winter but is open from March through September and should be checked whenever it is open. **El Dorado Reservoir**, located just northeast of the town of El Dorado, is located in the Flint Hills and produces an interesting mix of woodland, prairie, and aquatic birds at all seasons. In early spring, listen for booming Greater Prairie-Chickens and the rattling calls of Smith's Longspurs in the prairies surrounding the lake. There is a nature trail through the woodlands on the south end of the dam, but the largest area of publicly owned timber at El Dorado is located west of K-177. This woodland has produced nesting Red-shouldered Hawk, Pileated Woodpecker, and Kentucky Warbler.

Wilson Reservoir has been one of the most popular birding destinations in the northwestern quadrant of Kansas and is one of the best birding lakes anywhere in the state. It is large and deep, surrounded by scenic, rolling-hill country associated with the Saline River Valley. A full day can easily be spent birding the lake and adjacent public lands. Mountain Bluebirds are usually present during the winter. This is also one of the most likely locations for finding Northern Shrikes in the winter. In spring and fall, large flocks of migrating Sandhill Cranes pass overhead. On the south side of the lake, Wilson State Park and Minooka Park, along with Lucas Point on the north side, offer good vantage points for scanning the lake for waterfowl, loons, and grebes. Below the dam is an area of

natural habitats, including riparian woodland, cattail marsh, brushy thickets, and prairie, which usually produces a nice variety of birds.

Lying southwest of Hays on the Smoky Hill River, **Cedar Bluff Reservoir** is the westernmost large water impoundment in the state. The arid shortgrass prairie habitat surrounding the lake includes sagebrush and yucca. This vegetation, combined with the numerous rocky cliffs and rock outcrops in the area, gives the lake a decidedly western look. Beyond the aquatic species one might expect, several interesting terrestrial species can be encountered in the areas adjacent to the lake. These include Black-billed Magpie year-round; Rock Wren, Bell's Vireo, and Yellow-breasted Chat in summer; and many species of hawks and falcons, Northern Shrike, and Mountain Bluebird in the winter. Several large plantings of cedar and pine trees at the lake attract large roosts of Long-eared, Short-eared, and Barn Owls in the winter, which have on several occasions numbered in the hundreds of birds. Below the dam is an extensive area of marsh, prairie, and wooded habitat that always provides good birding.

Birding Resources

Recommended Books

If this book has whetted your appetite to learn more about birds in Kansas, the most authoritative book on the topic is *Birds in Kansas, Volume 1* and *Volume 2,* written by Max Thompson and Charles Ely (Lawrence: University Press of Kansas, 1989 and 1992). These books summarize all of the scientific and distributional information for each bird species that has been documented in Kansas. Another book on the shelf of every serious Kansas birder is *The Kansas Breeding Bird Atlas* by William Busby and John Zimmerman (Lawrence: University Press of Kansas, 2001). The breeding bird atlas was a massive effort to map the breeding populations of birds throughout the state. The results of the project are summarized in this book, which has separate accounts and range maps for each species. For more detailed information on most of the birding hot spots discussed in this book, as well as many other birding locations in Kansas, two additional books published by the University Press of Kansas are strongly recommended. An especially useful book is *A Guide to Bird Finding in Kansas and Western Missouri,* written by John Zimmerman and Sebastian Patti (Lawrence: University Press of Kansas, 1988). Although it was published nearly twenty years ago, it remains an invaluable tool for planning birding trips in Kansas, with detailed navigational directions to a substantial number of locations, an in-depth discussion of the birds you might expect to find, and other helpful information. *Watching Kansas Wildlife,* by Bob Gress and George Potts (Lawrence: University Press of Kansas, 1993), is another book you should own when exploring natural areas of Kansas. While not geared strictly to birders, it also has a large volume of useful information pertaining to exploring wildlife areas throughout the state. Most birders also carry a copy of the *Kansas Atlas & Gazetteer,* published by DeLorme (Yarmouth, ME: DeLorme, 1997). This eighty-page atlas features detailed maps of the state that are invaluable when exploring the back roads of Kansas.

Birding Organizations

This is a list of birding clubs and organizations that are relevant to Kansas birding. For each, we have provided a mailing address and/or Internet URL, if available.

American Birding Association: The ABA is a national organization of birders with many members in Kansas. It publishes three periodicals, all well-written and informative sources of birding information. It also operates a sales division that offers a broad selection of birding books, optics, and other birding gear.

American Birding Association
4945 N 30th Street, Suite 200
Colorado Springs, CO 80919, USA
Telephone: 800-850-2473 or 719-578-9703

Fax: 719-578-1480
URL: www.americanbirding.org

Kansas Ornithological Society (KOS): This is the statewide organization devoted to birds. Its members include both professional ornithologists and amateur birders. The society publishes a scientific bulletin and a newsletter, both quarterly. A weekend field trip is held in the spring, usually in early May, in a productive birding area somewhere in Kansas. A fall meeting in early October has one day devoted to the presentation of academic papers on birds and a half-day of field trips after that. The fall meeting is usually held in a larger metro area or at a college or university. Through the Kansas Bird Records Committee, KOS maintains and publishes the checklist of Kansas birds. It also coordinates and publishes the results of the Christmas Bird Counts. The society owns and maintains the Dingus Natural Area in Linn County. Its Web site is well maintained and has a number of informative Web pages and helpful links. Visit this Web site for the most accurate contact information: www.ksbirds.org.

National Audubon Society chapters: Kansas chapters of the National Audubon Society offer informative meetings and interesting field trips throughout the year. Meetings and trips are open to the public, do not require membership, and are usually free. The following contact information is subject to change. Updated contact information for these chapters is available at www.audubon.org/states/index.php.

Jayhawk Audubon Society
PO Box 3741
Lawrence, KS 66047
http://skyways.lib.ks.us/orgs/jayhawkaudubon

Kanza Audubon Society
10178 W 293rd Street
Reading, KS 66868

Leavenworth Audubon Society
1007 N 2nd Street
Lansing, KS 66043
913-727-3871

Northern Flint Hills Audubon Society
PO Box 1932
Manhattan, KS 66505-1932

785-539-5519
www.k-state.edu/audubon

Smoky Hills Audubon Society
PO Box 2936
Salina, KS 67401
http://puter.hosted.nex-tech.com/smokyhillsaud/main.htm

Southeast Kansas Audubon Society
1322 S. Edith
Chanute, KS 66720
620-431-1723

Sperry-Galligar Audubon Society
PO Box 205
Pittsburg, KS 66762
http://pwp.surfglobal.net/rmangile

Topeka Audubon Society
PO Box 1941
Topeka, KS 66601

Wichita Audubon Society
PO Box 47607
Wichita, KS 67210
www.wichitaaudubon.org

Burroughs Audubon Library and Nature Center
21509 SW Woods Chapel Road
Blue Springs, MO 64105
816-795-8177
www.burroughs.org

Internet Sites
KSBIRD Listserv: http://listserv.ksu.edu/archives/ksbird-l.html
Many Kansas birders subscribe to this free e-mail listserv devoted to Kansas birds.
KSBIRD is a useful tool. Use it to become acquainted with birders across the
state and to learn a great deal about birds. The web address above will take you to
the archive page, from which you can access the subscription Web page. Use the
archives by typing the name of a bird or birding location you would like to learn
more about. You will be able to access previous discussions on the topic.

Natural Kansas: www.naturalkansas.org
This is a great omnibus Web site with an exceptional number of useful features and links. It has a wealth of information on all aspects of the natural world in Kansas, including outstanding wildlife viewing sites, hiking trails, driving tours, and upcoming events related to wildlife viewing. Bookmark this one.

Kansas Department of Wildlife and Parks: www.kdwp.state.ks.us
This Web site provides much useful information about all of the fishing lakes, wildlife areas, and state parks in Kansas as well as a variety of general wildlife news.

Hot Spot Web Sites: The Web sites below are all specific to locations mentioned in the hot-spot accounts. These Web sites offer additional information on current conditions, regulations, upcoming events, and other information. Many of them also provide maps and additional birding information.

Quivira National Wildlife Refuge: www.fws.gov/quivira
Cheyenne Bottoms Wildlife Area: www.cheyennebottoms.net
Cimarron National Grassland: www.fs.fed.us/r2/psicc/cim
Cross Timbers: www.uark.edu/misc/xtimber
Great Plains Nature Center: www.gpnc.org
Overland Park Arboretum: www.opprf.org/Arboretum.htm
Johnson County Parks: www.jcprd.com/parks_facilities/directory.cfm
Ernie Miller Nature Center: www.erniemiller.com
Gardner Wetlands: www.gardnerkansas.gov/parks/park-wetlands.php

Complete Species List for Kansas

WHISTLING DUCKS
____ Black-bellied Whistling-Duck
____ Fulvous Whistling-Duck

GEESE AND SWANS
____ Greater White-fronted Goose
____ Snow Goose
____ Ross's Goose
____ Brant
____ Cackling Goose
____ Canada Goose
____ Trumpeter Swan
____ Tundra Swan

DUCKS
____ Wood Duck
____ Gadwall
____ [Eurasian Wigeon]†
____ American Wigeon
____ American Black Duck
____ Mallard
____ Mottled Duck
____ Blue-winged Teal
____ Cinnamon Teal
____ Northern Shoveler
____ Northern Pintail
____ Garganey†
____ Green-winged Teal
____ Canvasback
____ Redhead
____ Ring-necked Duck
____ [Tufted Duck]†
____ Greater Scaup
____ Lesser Scaup
____ King Eider†
____ Common Eider†
____ Harlequin Duck†
____ Surf Scoter
____ White-winged Scoter
____ Black Scoter

____ Long-tailed Duck
____ Bufflehead
____ Common Goldeneye
____ Barrow's Goldeneye
____ Hooded Merganser
____ Common Merganser
____ Red-breasted Merganser
____ Ruddy Duck

PHEASANTS
____ Ring-necked Pheasant

GROUSE
____ Ruffed Grouse
____ Sharp-tailed Grouse
____ Greater Prairie-Chicken
____ Lesser Prairie-Chicken

TURKEYS
____ Wild Turkey

QUAIL
____ Scaled Quail
____ Northern Bobwhite

LOONS
____ Red-throated Loon
____ Pacific Loon
____ Common Loon
____ Yellow-billed Loon†

GREBES
____ Pied-billed Grebe
____ Horned Grebe
____ Red-necked Grebe
____ Eared Grebe
____ Western Grebe
____ Clark's Grebe

PELICANS
_____ American White Pelican
_____ Brown Pelican

CORMORANTS
_____ Neotropic Cormorant
_____ Double-crested Cormorant

DARTERS
_____ Anhinga

FRIGATEBIRDS
_____ Magnificent Frigatebird†

HERONS
_____ American Bittern
_____ Least Bittern
_____ Great Blue Heron
_____ Great Egret
_____ Snowy Egret
_____ Little Blue Heron
_____ Tricolored Heron
_____ Reddish Egret†
_____ Cattle Egret
_____ Green Heron
_____ Black-crowned Night-Heron
_____ Yellow-crowned Night-Heron

IBISES
_____ White Ibis
_____ Glossy Ibis
_____ White-faced Ibis
_____ Roseate Spoonbill†

STORKS
_____ Wood Stork†

VULTURES
_____ Black Vulture
_____ Turkey Vulture

FLAMINGOS
_____ Greater Flamingo†

HAWKS, KITES, AND EAGLES
_____ Osprey
_____ Swallow-tailed Kite
_____ White-tailed Kite†
_____ Mississippi Kite
_____ Bald Eagle
_____ Northern Harrier
_____ Sharp-shinned Hawk
_____ Cooper's Hawk
_____ Northern Goshawk
_____ Harris's Hawk†
_____ Red-shouldered Hawk
_____ Broad-winged Hawk
_____ Gray Hawk†
_____ Swainson's Hawk
_____ Red-tailed Hawk
_____ Ferruginous Hawk
_____ Rough-legged Hawk
_____ Golden Eagle

FALCONS
_____ American Kestrel
_____ Merlin
_____ Gyrfalcon†
_____ Peregrine Falcon
_____ Prairie Falcon

RAILS AND GALLINULES
_____ Yellow Rail
_____ Black Rail
_____ King Rail
_____ Virginia Rail
_____ Sora
_____ Purple Gallinule
_____ Common Moorhen
_____ American Coot

CRANES
____ Sandhill Crane
____ Whooping Crane

PLOVERS
____ Black-bellied Plover
____ American Golden-Plover
____ Snowy Plover
____ [Wilson's Plover]†
____ Semipalmated Plover
____ Piping Plover
____ Killdeer
____ Mountain Plover

STILTS AND AVOCETS
____ Black-necked Stilt
____ American Avocet

SANDPIPERS
____ Spotted Sandpiper
____ Solitary Sandpiper
____ Spotted Redshank†
____ Greater Yellowlegs
____ Willet
____ Lesser Yellowlegs
____ Upland Sandpiper
____ Eskimo Curlew
____ Whimbrel
____ Long-billed Curlew
____ Hudsonian Godwit
____ Marbled Godwit
____ Ruddy Turnstone
____ Red Knot
____ Sanderling
____ Semipalmated Sandpiper
____ Western Sandpiper
____ Least Sandpiper
____ White-rumped Sandpiper
____ Baird's Sandpiper
____ Pectoral Sandpiper

____ Dunlin
____ Curlew Sandpiper†
____ Stilt Sandpiper
____ Buff-breasted Sandpiper
____ Ruff†
____ Short-billed Dowitcher
____ Long-billed Dowitcher
____ Wilson's Snipe
____ American Woodcock
____ Wilson's Phalarope
____ Red-necked Phalarope
____ Red Phalarope

GULLS
____ Laughing Gull
____ Franklin's Gull
____ Little Gull
____ Black-headed Gull†
____ Bonaparte's Gull
____ Mew Gull†
____ Ring-billed Gull
____ California Gull
____ Herring Gull
____ Thayer's Gull
____ Iceland Gull†
____ Lesser Black-backed Gull
____ [Glaucous-winged Gull]†
____ Glaucous Gull
____ Great Black-backed Gull
____ Sabine's Gull
____ Black-legged Kittiwake

TERNS
____ Least Tern
____ Gull-billed Tern†
____ Caspian Tern
____ Black Tern
____ Common Tern
____ [Arctic Tern]†
____ Forster's Tern

SKIMMERS
_____ Black Skimmer†

JAEGERS
_____ Pomarine Jaeger†
_____ Parasitic Jaeger
_____ Long-tailed Jaeger†

ALCIDS
_____ [Long-billed Murrelet]†

PIGEONS AND DOVES
_____ Rock Pigeon
_____ Band-tailed Pigeon†
_____ Eurasian Collared-Dove
_____ White-winged Dove
_____ Mourning Dove
_____ Inca Dove
_____ Common Ground-Dove

CUCKOOS
_____ Yellow-billed Cuckoo
_____ Black-billed Cuckoo
_____ Greater Roadrunner
_____ Groove-billed Ani

BARN OWLS
_____ Barn Owl

OWLS
_____ [Flammulated Owl]†
_____ Western Screech-Owl†
_____ Eastern Screech-Owl
_____ Great Horned Owl
_____ Snowy Owl
_____ Burrowing Owl
_____ Barred Owl
_____ Long-eared Owl
_____ Short-eared Owl
_____ Northern Saw-whet Owl

GOATSUCKERS
_____ [Lesser Nighthawk]†
_____ Common Nighthawk
_____ Common Poorwill
_____ Chuck-will's-widow
_____ Whip-poor-will

SWIFTS
_____ Chimney Swift
_____ White-throated Swift†

HUMMINGBIRDS
_____ Broad-billed Hummingbird†
_____ Magnificent Hummingbird†
_____ Ruby-throated Hummingbird
_____ Black-chinned Hummingbird
_____ Anna's Hummingbird†
_____ Costa's Hummingbird†
_____ Calliope Hummingbird
_____ Broad-tailed Hummingbird
_____ Rufous Hummingbird
_____ Allen's Hummingbird†

KINGFISHERS
_____ Belted Kingfisher

WOODPECKERS
_____ Lewis's Woodpecker
_____ Red-headed Woodpecker
_____ Red-bellied Woodpecker
_____ Williamson's Sapsucker†
_____ Yellow-bellied Sapsucker
_____ Red-naped Sapsucker†
_____ Ladder-backed Woodpecker
_____ Downy Woodpecker
_____ Hairy Woodpecker
_____ American Three-toed Woodpecker†
_____ Northern Flicker
_____ Pileated Woodpecker

FLYCATCHERS

____ Olive-sided Flycatcher

____ Western Wood-Pewee

____ Eastern Wood-Pewee

____ Yellow-bellied Flycatcher

____ Acadian Flycatcher

____ Alder Flycatcher

____ Willow Flycatcher

____ Least Flycatcher

____ Hammond's Flycatcher†

____ Gray Flycatcher†

____ Dusky Flycatcher

____ Cordilleran Flycatcher†

____ [Black Phoebe]†

____ Eastern Phoebe

____ Say's Phoebe

____ Vermilion Flycatcher

____ Ash-throated Flycatcher

____ Great Crested Flycatcher

____ Great Kiskadee†

____ Cassin's Kingbird

____ Western Kingbird

____ Eastern Kingbird

____ Scissor-tailed Flycatcher

____ [Fork-tailed Flycatcher]†

SHRIKES

____ Loggerhead Shrike

____ Northern Shrike

VIREOS

____ White-eyed Vireo

____ Bell's Vireo

____ Black-capped Vireo†

____ Gray Vireo†

____ Yellow-throated Vireo

____ Plumbeous Vireo†

____ Cassin's Vireo†

____ Blue-headed Vireo

____ Warbling Vireo

____ Philadelphia Vireo

____ Red-ryed Vireo

JAYS, MAGPIES, AND CROWS

____ Steller's Jay

____ Blue Jay

____ Western Scrub Jay

____ Mexican Jay†

____ Pinyon Jay

____ Clark's Nutcracker

____ Black-billed Magpie

____ American Crow

____ Fish Crow

____ Chihuahuan Raven

____ Common Raven

LARKS

____ Horned Lark

SWALLOWS

____ Purple Martin

____ Tree Swallow

____ Violet-green Swallow

____ Northern Rough-winged Swallow

____ Bank Swallow

____ Cliff Swallow

____ Cave Swallow†

____ Barn Swallow

CHICKADEES AND TITMICE

____ Carolina Chickadee

____ Black-capped Chickadee

____ Mountain Chickadee

____ [Juniper Titmouse]†

____ Tufted Titmouse

BUSHTITS

____ Bushtit

NUTHATCHES
____ Red-breasted Nuthatch
____ White-breasted Nuthatch
____ Pygmy Nuthatch†
____ Brown-headed Nuthatch†

CREEPERS
____ Brown Creeper

WRENS
____ Rock Wren
____ Canyon Wren†
____ Carolina Wren
____ Bewick's Wren
____ House Wren
____ Winter Wren
____ Sedge Wren
____ Marsh Wren

KINGLETS
____ Golden-crowned Kinglet
____ Ruby-crowned Kinglet

GNATCATCHERS
____ Blue-gray Gnatcatcher

THRUSHES
____ [Northern Wheatear]†
____ Eastern Bluebird
____ [Western Bluebird]†
____ Mountain Bluebird
____ Townsend's Solitaire
____ Veery
____ Gray-cheeked Thrush
____ Swainson's Thrush
____ Hermit Thrush
____ Wood Thrush
____ American Robin
____ Varied Thrush

THRASHERS
____ Gray Catbird
____ Northern Mockingbird
____ Sage Thrasher
____ Brown Thrasher
____ Curve-billed Thrasher

STARLINGS
____ European Starling

PIPITS
____ American Pipit
____ Sprague's Pipit

WAXWINGS
____ Bohemian Waxwing
____ Cedar Waxwing

SILKY FLYCATCHERS
____ Phainopepla†

WARBLERS
____ Blue-winged Warbler
____ Golden-winged Warbler
____ Tennessee Warbler
____ Orange-crowned Warbler
____ Nashville Warbler
____ Virginia's Warbler
____ Northern Parula
____ Yellow Warbler
____ Chestnut-sided Warbler
____ Magnolia Warbler
____ Cape May Warbler
____ Black-throated Blue Warbler
____ Yellow-rumped Warbler
____ Black-throated Gray Warbler
____ Black-throated Green Warbler
____ Townsend's Warbler
____ Hermit Warbler†
____ Blackburnian Warbler

_____ Yellow-throated Warbler
_____ Pine Warbler
_____ Prairie Warbler
_____ Palm Warbler
_____ Bay-breasted Warbler
_____ Blackpoll Warbler
_____ Cerulean Warbler
_____ Black-and-white Warbler
_____ American Redstart
_____ Prothonotary Warbler
_____ Worm-eating Warbler
_____ Swainson's Warbler†
_____ Ovenbird
_____ Northern Waterthrush
_____ Louisiana Waterthrush
_____ Kentucky Warbler
_____ Connecticut Warbler
_____ Mourning Warbler
_____ MacGillivray's Warbler
_____ Common Yellowthroat
_____ Hooded Warbler
_____ Wilson's Warbler
_____ Canada Warbler
_____ Painted Redstart†
_____ Yellow-breasted Chat

TANAGERS
_____ Summer Tanager
_____ Hepatic Tanager
_____ Scarlet Tanager
_____ Western Tanager

SPARROWS
_____ Green-tailed Towhee
_____ Spotted Towhee
_____ Eastern Towhee
_____ Canyon Towhee
_____ Cassin's Sparrow
_____ Bachman's Sparrow†

_____ Rufous-crowned Sparrow
_____ American Tree Sparrow
_____ Chipping Sparrow
_____ Clay-colored Sparrow
_____ Brewer's Sparrow
_____ Field Sparrow
_____ Vesper Sparrow
_____ Lark Sparrow
_____ Black-throated Sparrow†
_____ Sage Sparrow†
_____ Lark Bunting
_____ Savannah Sparrow
_____ Grasshopper Sparrow
_____ Baird's Sparrow
_____ Henslow's Sparrow
_____ Le Conte's Sparrow
_____ Nelson's Sharp-tailed Sparrow
_____ Fox Sparrow
_____ Song Sparrow
_____ Lincoln's Sparrow
_____ Swamp Sparrow
_____ White-throated Sparrow
_____ Harris's Sparrow
_____ White-crowned Sparrow
_____ Golden-crowned Sparrow
_____ Dark-eyed Junco
_____ McCown's Longspur
_____ Lapland Longspur
_____ Smith's Longspur
_____ Chestnut-collared Longspur
_____ Snow Bunting

GROSBEAKS AND BUNTINGS
_____ Northern Cardinal
_____ Pyrrhuloxia†
_____ Rose-breasted Grosbeak
_____ Black-headed Grosbeak
_____ Blue Grosbeak
_____ Lazuli Bunting

____ Indigo Bunting
____ Painted Bunting
____ Dickcissel

BLACKBIRDS AND ORIOLES
____ Bobolink
____ Red-winged Blackbird
____ Eastern Meadowlark
____ Western Meadowlark
____ Yellow-headed Blackbird
____ Rusty Blackbird
____ Brewer's Blackbird
____ Common Grackle
____ Great-tailed Grackle
____ Brown-headed Cowbird
____ Orchard Oriole
____ Bullock's Oriole
____ Baltimore Oriole
____ Scott's Oriole†

NORTHERN FINCHES
____ Brambling†
____ [Gray-crowned Rosy-Finch]†
____ Pine Grosbeak
____ Purple Finch
____ Cassin's Finch
____ House Finch
____ Red Crossbill
____ White-winged Crossbill
____ Common Redpoll
____ Pine Siskin
____ Lesser Goldfinch
____ American Goldfinch
____ Evening Grosbeak

OLD WORLD SPARROWS
____ House Sparrow

† Fewer than ten Kansas records
[] Hypothetical species

This list was compiled from records of the Kansas Ornithological Society, Kansas Breeding Bird Atlas Project, and the Kansas Biological Survey.

This checklist contains 467 species. Of the 470 species documented to have occurred in Kansas, three species are not included because they no longer occur. The Passenger Pigeon and Carolina Parakeet are extinct, and the Gunnison Sage-Grouse has been extirpated from the state.

The taxonomic sequence and nomenclature used in this list follow the *Check-List of North American Birds,* 7th edition, American Ornithologists' Union (1998, updated through the 47th Supplement, 2006 [*Auk* 123: 926–936]).

Acknowledgments

A number of people provided helpful comments on various aspects of the text, especially with regard to the Kansas hot-spot accounts. These were Dan Gish, Dave Henness, Mark Land, Robert Mangile, Chuck Otte, Sebastian Patti, Linda Phipps, John Schuckman, Lisa Weeks, and Dave Williams. Mary Janzen graciously agreed to proofread and review the entire text for continuity. Bill Busby was instrumental in the initial conception of the book and also provided a helpful review of the manuscript. Jim Burns, Steve Metz, Judd Patterson, David Seibel, and Gerald Wiens provided additional photographs. Jim Mason provided the Kansas Birding Hot Spots map.

Index to Bird Names

For species with multiple index entries, page numbers in boldface refer to the primary discussion of the species within the text.

Index to Place Names

For places with multiple index entries, page numbers in boldface refer to the primary discussion of the place within the text.